Electrographic Architecture

Electrographic Architecture

New York Color, Las Vegas Light, and America's White Imaginary

Carolyn L. Kane

UNIVERSITY OF CALIFORNIA PRESS

University of California Press
Oakland, California

© 2023 by Carolyn L. Kane

Library of Congress Cataloging-in-Publication Data

Names: Kane, Carolyn L., author.
Title: Electrographic architecture : New York color, Las
 Vegas light, and America's white imaginary / Carolyn
 L. Kane.
Description: Oakland, California : University of
 California Press, [2023] | Includes bibliographical
 references and index.
Identifiers: LCCN 2022051968 (print) | LCCN 2022051969
 (ebook) | ISBN 9780520392595 (cloth) | ISBN
 9780520392601 (paperback) | ISBN 9780520392618
 (ebook)
Subjects: LCSH: Lighting, Architectural and decorative—
 Social aspects. | Lighting, Architectural and
 decorative—History. | White in architecture.
Classification: LCC NA2794 .K36 2023 (print) | LCC
 NA2794 (ebook) | DDC 729/.28—dc23/eng/20221209
LC record available at https://lccn.loc.gov/2022051968
LC ebook record available at https://lccn.loc
 .gov/2022051969

32 31 30 29 28 27 26 25 24 23
10 9 8 7 6 5 4 3 2 1

Buildings don't need the whitest white or even a single white surface to be white. Just the thought that there is such a surface somewhere, acting as the background against which everything else in the world is judged, is enough.

—Mark Wigley, *"Chronic Whiteness,"* 2020

By an odd fate, the very metaphysicians who think to escape the world of appearances are constrained to live perpetually in allegory. A sorry lot of poets, they dim the colors of the ancient fables, and are themselves but gatherers of fables. They produce white mythology.

—Jacques Derrida, *"White Mythology,"* 1971

Contents

Illustrations

White like No Other

It has come to be recognized [that] light in itself is one of the
greatest of advertising forces in modern business.

—"A Plan for a White Way," 1915

"New York's main artery is the greatest city artery in the United States,"
Scotsman Stephen Chalmers declared of Times Square in a 1904 issue of
the *New York Times*. Alongside numerous national and international
newspapers, trade journals, and magazines, Chalmers sang the praises
of the Square as the newly minted home of the *New York Times* and
pinnacle of mankind's "perfection."[1] The Square was the "supreme
being" and "triumph" of civilization at the center of the country's com-
mercial capital—the capital of capitals—a truly exceptional entity all
unto itself. From the 1900s to the present, Times Square has "shimmer[ed]
like a pyrotechnic Rome . . . spangled with a thousand flecks of light and
color."[2] Rome indeed: another capital of capitals whose fall at the end of
the Roman Empire now presages the demise of American exceptional-
ism (both real and imagined) at the dawn of the twenty-first century, but
I am getting ahead of myself.

CAPITAL OF THE TWENTIETH CENTURY

A century and a half ago, New York City was still climbing to the top
of the food chain as if nothing was manifest destiny but the attainment
of national and international omnipotence.[3] And, certainly, for most of
the past century, New York City and Times Square functioned as the
biggest, brightest, and most supreme urban center in the world. Much
of the city's "greatness" originated from its 1811 zoning grid, which

permitted buildings to rise no more than one and a half times the width of the street, while narrow widths allowed as many buildings as possible to populate the area. New York City's "Euclidean clearness," Le Corbusier wrote in 1964, gave it "immense and beneficent freedom for the mind."[4] Exactly one century later, in 1911, the greatness of the city and Square were further catapulted into bright-light supremacy with the advent of electric signs and street lighting, followed by incandescent illuminants in the homes and workplaces of the wealthy. Also in this year, E. Leavenworth Elliott declared that New York City's "miles of brilliancy and beauty of illumination" was testament to its true "excellence."[5] Unstated was the fact that, to be "the best lit city," New York also needed to be the wealthiest city, which, in the American context, was also to say the whitest city.[6] The power to light costs money.

Before New York City's and Times Square's claims to fame as the world's brightest and lightest, Paris and Berlin played a brief role as international "cities of light,"[7] until European metropolises were hindered by legal restrictions limiting the quantity and intensity of illuminated advertising. Only in America could a truly supreme white-light imaginary take shape.

America would be the greatest, but not the first. Public lighting was introduced to Parisians first, albeit for reasons of control, not grandeur. In 1667, King Louis XIV ordered Parisian police to install tallow-lit lanterns illuminated on city streets and required residents to keep candles and oil lamps in their windows to prevent criminals' free reign in a darkened, unsurveilled city. This use of light to sanitize and restrict bodies and spaces remains intact in France and, now, throughout most of the developed world. In America, however, the development of supreme white light in urban and suburban centers over the past century sprang forth *first* for reasons of capital, and only secondarily for purposes of surveillance and control. American novelist Edith Wharton (1862–1937) touched on this distinction when she condemned Paris's failed attempts to imitate America's electric excesses, with its thousands of gas and electrical lights along the Champs-Elysées. In 1928, another like-minded critic penned, "Paris is proud to be known as the City of Light, but she wants it to be intellectual rather than electric."[8] That is to say, reserved and "tasteful" (i.e., white, in the old-world sense of the term) for the benefit of aristocratic traditions and moral (Christian) factions of society that benefit from them. In short, the Parisian City of Light was supreme only because it was void of the crass, popular

colors that, by contrast, made the cities born of American capital so exceptional.[9]

In America, such taste-based confines were not only relaxed; they were completely abandoned in the unfettered pursuit of entrepreneurial greatness. Street and commercial lighting districts known as "white ways" were developed in cities across the country to boast new businesses and innovations, followed by the democratization of domestic lighting for interiors. Granted, zoning issues ensued to ensure electric signs would be banned from affluent residential neighborhoods like Fifth Avenue; in more commercially zoned districts like Times Square, electric signs were readily embraced and, by the end of the twentieth century, *required* to be bigger, brighter, and lit during all hours of the day.

In sum, over the course of the past century, a white imaginary developed in America, fueled by entrepreneurial success, technological and scientific innovation, and an emergent polychromatic landscape of light and color previously unimaginable. *Electrographic Architecture: New York Color, Las Vegas Light, and America's White Imaginary* charts this history by focusing on the technical and aesthetic development of large-scale illuminated signage in New York City's Times Square and Las Vegas's Freemont Street, with special attention to the understudied role whiteness has played in these transformations.[10]

While polychromatic, electrographic architecture may seem an unlikely candidate to allegorize America's white imaginary, it is precisely for this reason—and for the claims to diverse and democratic color in places like Times Square (in the most ethnically diverse metropolis on the eastern seaboard)—that it is a prime candidate. Drawing on technological histories of illuminated light, architecture, and aesthetics, the book interrogates one of the most untapped questions of our times: How do the visual diversity, unpredictability, and heterogeneity of American urban centers like New York City also perpetuate historically entrenched legacies of Western chromophobia running alongside the proliferation of urban capital?

To be clear, *Electrographic Architecture* is not a book about racial politics. It does not analyze socioeconomic histories of race, or explore the demographic ramifications of white power in the history and culture of the United States. Nor does the book study how the unequal distribution of light across urban space perpetuates race and class inequity,[11] though it does recognize strong correlations with all of the above. Rather, the book questions how white mythologies run through the

material history of illuminated architecture in two major American metropolises, New York City and Las Vegas, in ways that resonate with broader histories of power and light.

. . .

This introduction contextualizes technology studies alongside critical and traditional approaches to color studies in the creative arts. Chapter 1 and 2 then analyze historical constructions of whiteness from the origins of Western architecture through Le Corbusier's white militancy, followed by an examination of the ways American whiteness intersects with the country's unfettered pursuit of bright white light and power. When entrepreneurs like Thomas Edison, J.P. Morgan, John Jacob Astor, and Cornelius Vanderbilt financed public lighting systems in American cities, they fashioned a nationwide conflation of the capacity to generate synthetic light with entrepreneurial capital. Chicago's "White City" (1893) and Broadway's "Great White Way" (1892–1945) are analyzed in chapter 3 as reinforcing this surprisingly still-unconscious link between material and symbolic forms of white power.

In chapter 4, I chart advertising executive Douglas Leigh's innovative Times Square signage from the 1930s through the 1950s, analyzing how a new genre of polychromatic "spectaculars" catalyzed an American ethos of consumerism, with Times Square lauded as its biggest and brightest emblem. *Electrographic Architecture* next takes temporary leave of the Square, in chapter 5, to consider how the Young Electric Sign Company's (YESCO's) development of Las Vegas spectaculars in the 1930s through the 1960s steered the transformation of the neon palette from a signifier of prosperity and optimism in the early part of the century to a symbol of social and economic decline by the early 1970s, determining the backdrop for the book's return to Times Square during a sad state of fiscal degeneration, the subject of chapter 6.

The book's penultimate chapter (6) analyzes selections of electronic art from American artist Jenny Holzer to recount how the economically undesirable colors of crime, drugs, and prostitution put a temporary hold on America's former mecca of commercial greatness, until New York City mayor Rudy Giuliani commenced its mass gentrification in the late 1990s and early 2000s, resulting in the urban Disneyland that Times Square is today. The book concludes with an examination of the Square's newly sanitized digital colors, primed for the informatic control spaces of the twenty-first century where a white imaginary persists, not only through the polychromatic spectacles of diversity ostensibly

offered to "everyone" but also, through so-called smart tech, which, under the auspices of participatory play and sharing, surveil, discipline, and whitewash anew all who come in proximity to it.

By bridging the histories of technology and aesthetics, *Electrographic Architecture* weaves a critical narrative about the key role that illumi- nated light and color have played in the formation of America's white imaginary over the past century. To restate: this is not a book about race theory but instead a history of Times Square's electrographic urban light, viewed through the combined lenses of color studies, media history, architecture, and aesthetics. The book offers new insight into one of the central questions that media scholars, architects, and historians of technology repeatedly turn: How can we use and speak about light and color in the world today in ways that are productive and commemorative while remaining critical of the systems of power undergirding them?

By drawing on archival research, interviews, and visual analysis, *Electrographic Architecture* illustrates how Times Square's polychromatic landscape of light serves as a complex symbol of America's deepseated dreams of utopic transcendence and material escape, coupled with fears of loss, ephemerality, and obsolescence in the face of newer and more powerful entities. In America's twentieth-century imaginary, whiteness aimed to become everything but itself: colored, lit, and vital. This seemed to be the only covert way for whiteness to persist, undetected in the turbulent times that characterize the previous century and much of the first quarter of this one. The remainder of this introduction contextualizes *Electrographic Architecture*'s theoretical positions within and against color studies and histories of electric light. It concludes with a discussion of my analytic methods and a more detailed overview of the book's chapters.

COLOR: A CRITICAL OVERVIEW

The ancient question "What is color?" has yet to be adequately answered.[12] A preliminary set of problems arise from the fact that everyone sees color differently. Twenty people may be exposed to the same object, yet each will see it in a unique way. Moreover, when one attempts to recall the color of the object in one's mind, one usually remembers it in a hue darker than it actually was. This is because a person's physiology, history, culture, and memory uniquely structure their visual perception. As Bauhaus colorist Josef Albers puts it, if one says the word

"red" and 50 people are listening, it should be "expected that there will be 50 reds in their minds. And . . . all these reds will be very different."[13] Color is the ephemeral and elusive medium through which people relate to one another, both in the present and in the (mediated) past.

Responses to color further diversify across gender, linguistic, and ethnic divides. While only 0.5 percent of Caucasian women are red-green colorblind, up to 8 percent of Caucasian men are, including Mark Zuckerberg (potentially explaining Facebook's primarily blue tonality). This percentage shifts across racial and ethnic groups, so that only 1 percent of Indigenous males, 2.9 percent of Saudi Arabian men, and 3.7 percent of men from India are deemed colorblind.[14] Language and nomenclature further exacerbate color problems. Philosopher Ludwig Wittgenstein argues that the English phrase *red-green* denotes a fundamentally insecure relationship between color and language by invoking an impossible color reality.[15] Color is an elusive "language game," he writes, whereby one assumes a color like "grey-green" denotes a consistent hue but is in fact "indeterminate and relative to specific contexts and situations."[16] For Wittgenstein, Albers, and numerous others before and after them, indeterminacy and flux lie at the heart of color and its infinite manifestations as a relational media. Color is, in a sense, our always already, ever-changing surround; a media ecology that is in many ways perceptible but is in many more ways covert and unconscious.

Humans are in theory capable of seeing innumerable colors even though an English-speaking culture can recognize and name an average of only thirty different colors. Designers, color physicists, and artists can train themselves to see and name more colors than the layperson, but these specialists are far from the majority. Seeing color is a matter of cultural, aesthetic, historical, and political training. Countless artists and scientists have devoted their life's work to classifying, harnessing, and controlling color-ordering systems, but these attempts all inevitably fail, because, as I have argued elsewhere, color—like subjectivity—is always on the move, shifting, transforming, and escaping the rules and protocols that attempt to contain it. We must therefore begin with, and consistently return to, color's double bind: any effort to classify or control it as a stable object of inquiry inevitably contributes to its use in epistemic and ontological violence, and yet naming, understanding, and classifying color is one of the few means available to use color in any practical or standardized way.[17] In short, color's intrinsic transience, compounded by its material diversity, ensures it is a rich subject of

investigation in multiple fields, across manifold times and places. In this study, however, I focus on only one, singular aspect of white and colored light.

The following section addresses the field of color studies conventionally construed, then looks at more recent interventions in the field as it intersects with film, new media, and architecture, before concluding with a brief overview of critical whiteness studies (CWS).[18]

EARLY MODERN COLOR

The study of color in the global Northwest tends toward one of two general approaches: the objective and the subjective. Following Empedocles's emission theory of vision, Plato (429–347 BC), by way of Socrates, approached color through the lens of subjective perception to propose that the "pores of the eyes" consist of "fire and water" through which humans perceive white and black.[19] In the *Timaeus*, Socrates argues that "the pure fire which is *within us* . . . flows through the eyes in a stream smooth and dense" and later that "the light that falls from within [travels to] meet an external object."[20] A subject's capacity for visual discernment is, in these views, mediated through the body and brain but, given Plato's well-known metaphysical prioritization of abstract mathematical Forms over sense perception, it should come as no surprise that such mediated visions were ultimately regarded as deceptive and unreliable. Sophists, rhetoricians, and painters were "creator[s] of phantoms," he argued, "technicians of ornament and makeup," but by far the most poisonous of simulacra was color: a cosmetic and false appearance Plato likened to a "multicolor drug"[21] that, like the Sophists' "gaudy speeches" and "glistening words," seduced the listener with its "ambiguity and deceiving sparkle."[22] Unlike words, however, color does not have the benefit of a signifying capacity beyond itself. In short, color holds to nothing and to no one, and herein lies its main source of perceived fear and danger in the inherited legacies of the global Northwest.

For Plato, the most sensible way to deal with the "color problem" was to relegate it to the realm of artifice and deception. Similarly, for modern philosopher Immanuel Kant (discussed in chapter 1), a preliminary solution was to codify colors as "merely charming," dismissing a priori their seriousness relative to true aesthetic Beauty and Form.[23] As a marginalized and secondary phenomenon, color was associated with nothing beyond decorative charm or mimetic supplement.[24] It was

believed to be safe there, where it continue to seduce the senses through deceptive means because it would always already be excluded from the hierarchy of the Beautiful and transcendental aesthetic of the Sublime, let alone logic or reason. For centuries now, color has had to maintain this subordinate status as deceptive and secondary Other, linked only to falsity, defect, superfluous décor, irrational women, and racial and ethnic minorities.[25]

In contrast to Plato, Aristotle (384–322 BC) formulated an empirical theory of vision rooted in the colors observed *in the world*, which he then classified into various color systems. For example, in his discussion of the rainbow, he determined light and color to move through a transparent medium: "colour sets in movement not the sense organ but what is transparent, the air."[26] Color for Aristotle was not *in* the subject—the "sense organ"—as it was for Plato, but rather in the objective world. In his critique of Plato's emission theory, Aristotle writes, "If the visual organ proper were really fire, which is the doctrine of Empedocles, a doctrine also taught in the *Timaeus*, and if vision were the result of light issuing from the eyes like a lantern, why should they not have had the power of seeing even in the dark?"[27] For Aristotle, and many color theorists after him, light and color exist as relational media, physical properties of objects in the external world. Herein lie the seeds of two dramatically distinct approaches to color in the West. While there are many contradictions and exceptions, these general polemics establish two archetypes for color studies that have remained intact for thousands of years.[28]

In the early nineteenth century, this same polemic between the subjective and the objective resurfaced in Goethe and Newton's famous color debates. In 1810, after decades of rationalized color-ordering systems in early modern science, romantic poet Johann Wolfgang von Goethe (1749–1832) attempted to return color to its pre-Socratic, Homeric lifeworld. His *Zur Farbenlehre* (*Theory of Colors*) glorified color for all of its inconsistencies and mysteries, making subjective perception—in marked contrast to Newton's 1704 color theory—the most central and sacred to human experience, in service of achieving the "highest aesthetic ends."[29] For Goethe, color arose "*in* the spectrum" between black and white, a phenomenological observation dating back to Aristotelean antiquity.[30] Although Goethe's insights were not immediately accepted, he initiated for modern color studies what is referred to in Continental philosophy as the "Copernican turn," insisting that color depends on subjective perception and, contrary to Newton, was not derivative of pure white light.

In contrast, Sir Isaac Newton (1643–1727) worked in a dark chamber sealed off from the world to conclude in 1704 that all spectral colors combined to form white light.[31] For Newton, white light was "indivisible and absolutely homogeneous, a pure entity, fundamentally separate from color."[32] It was this "absolutely distinct"[33] character of whiteness that made it the only light-based substance that somehow still included, reflected, refracted, and deflected all the Other colors as its derivative. In Newton's view, white was the original and primary source of light (and knowledge), constitutive of "a kind of universal representation, capable of standing in for the complete color spectrum."[34] Any and all color was thus a by-product, subject to quantification against the invisible axiom of pure whiteness, therein laying the foundation for Western color science. Goethe saw this theory as "retarding" color studies by removing color from the lifeworld and the "perishable and variable properties of natural phenomena [and] lived experience," as Jonathan Crary puts it.[35] In response, Goethe wrote his *Theory of Colors*.[36]

As a result of Goethe's 1810 interventions, perceptual color in the nineteenth century became part and parcel of a new, modern psyche shaped by subjective experience in the world, bolstering the cloudy and (nonobjective) color visions under which the Romantics and eventually the phenomenologists and Impressionists laid claim to an idiosyncratic perception of color in opposition to rational, detached methods of color analysis favored in psychology, science, and industry. In chapter 1, I expand on the ways Goethe's theories may have been radical but did not manage to escape the epistemological framing of European culture in the nineteenth century, rooted in ideologies of great, white, northern supremacy.

CRITICAL WHITENESS STUDIES

While discourses on critical whiteness have grown in recent years, deep and expansive critiques of chromophobia have barely impressed the surface of technological histories of light, architecture, aesthetics, and media art practices.[37] This book is inspired by a coterie of exceptions and interventions in these fields, which I here bridge with the media arts and histories of Western color, applied to theory and practice. While the book's focus is the material history of illuminated light in the built environment (*not* critical race theory), I nonetheless offer an overview of critical whiteness studies, which stems from the social sciences and critical race theory as a launching pad from which future questions may be

posed and, ideally, connected to future interrogations of color's material and aesthetic histories.

Biological and scientific evidence has sufficiently demonstrated the historical and genetic priority of Black people in the genealogy of the human species, making the pressing question about race not "How did black people come about?" but rather, as Marilyn Nissim-Sabat suggests, "How did white and other light-skinned peoples come about?"[38] Further, how have Euro-American cultures of whiteness blinded us to this history and the ongoing, pervasive landscapes of what bell hooks terms "white supremacist capitalist patriarchy"? In other words, how do we not see white as a skin color when all Other colored persons seem to be fixed and defined by this superficial attribute alone? Notions of so-called fixed, objective "pigment" are always already "a product of a stylized repetition of acts"[39]—whether these ideas derive from histories of violence, exclusion, or, I will add, something as deceptively benign as synthetic chemistry and its stunning gamut of artificial hues.

As an offshoot of critical race theory (CRT), critical whiteness studies (CWS) is defined as the investigation of white power and privilege in a racist society. As with CRT, the "critical" in CWS is positioned *before* whiteness, in alignment with the aims and ambitions of critical theory. However, while CRT examines the effects of systemic racial marginalization on minoritized communities, CWS analyzes how this marginalization occurs through an inversely proportionate framework of the racially privileged.

The field was officially recognized in the 1980s, when academics expanded critical race theory by averting the "critical gaze" away from the marginalized "racial object,"[40] as Toni Morrison put it, and toward the supposedly colorless ("pure" and "indivisible," to reinvoke Newton), white racial subject.[41] While "many academics still focus their attention on nonwhites,"[42] and CWS has by no means "supplanted the study of racial and ethnic minorities in the United States,"[43] as Marcus Bell observes, CWS has seen a renewed interest in the field in recent years, from rereadings of Frantz Fanon's award-winning *Black Skin, White Masks* (1952) and Robin DiAngelo's controversial *White Fragility* (2018). Prior to CWS, so long as studies in race theory focused on persons marked by race—that is, those deemed "the problem" and subject to violent pathologizing—white people remained "safe" and hidden from racist thought and educational systems.[44] Whiteness remained invisible, "pure" like the mythology of heavenly white light it claimed as its own. CWS is valuable precisely because it removes this veil and

reroutes the critical eye back to the so-called "indivisible," transcendent white subject.[45]

As noted, a preliminary wave of CWS is attributed to the work of white academics in the 1980s, though the field now recognizes precursors in W. E. B. Du Bois, Ida B. Wells, James Baldwin, David Wellman,[46] Richard Wright, Joyce Ladner, and Frantz Fanon, whose notion of "colonial compartmentalization," or the spatial configuration of race, illustrates how whiteness is just as much about systems of power tethered to land and space as it is about singular bodies.[47] From this idea, cornerstone works from the 1980s emerged, including Peggy McIntosh's "White Privilege and Male Privilege" (1988), followed by her 1989 article, "White Privilege: Unpacking the Invisible Knapsack." McIntosh calls out numerous metaphors contouring the "assets" of white privilege, including her own "invisible package of unearned assets," likened to a "bank account" of "safety and security."[48] These unearned social, political, and economic advantages, she argues, are unacknowledged and exclusively possessed by white people.[49] This is not to say that white people are not discriminated for other reasons (gender, sexuality, class, disability, etc.), or do not work hard for what they achieve; it is merely to point out that they have also been given a significant head start, insofar as whiteness is the "default racial category"[50] for judging social, moral, and existential worth, the false ground of normalcy from which all other colors derive.

In 2009, McIntosh built on her earlier work by identifying five elements of US white, male, capitalist ideology. She here critiques the emptying out of once powerful and politically charged words like *privilege* and *diversity* into vacuous expressions circulating in mainstream public discourse. Sara Ahmed concurs, noting in 2007 that, in academia, a truly white world is one that *appears* to welcome difference, as a token, yes, but also as a strategy of dissimulation that perpetuates whitewashing while feigning the opposite.[51] These insights may inspire ongoing investigations into the ways a rhetoric of progressive politics is likewise appropriated to achieve apposite results throughout multiple facets of contemporary culture.

McIntosh's work is complemented by such iconic contributions as Toni Morrison's *Playing in the Dark: Whiteness and the Literary Imagination* (1992) and a host of social-scientific analyses of whiteness that lie beyond the scope of this book. One example is Robin DiAngelo's popular but contentious latecomer, *White Fragility* (2018), based on her 2011 article of the same name. *White Fragility* argues that white people

in North America thrive through protected and racially insulated environments. These environments are "comfortable" insofar as they consist exclusively of white people. As a result, white people develop no resilience or capacity to "tolerate racial stress" while dealing with people of color. This "fragility" and "reduced psychosocial stamina," DiAngelo argues, make almost any interaction or conversation about race "intolerable" for most whites.[52] Despite the controversy it provoked, DiAngelo's book does offer a snapshot of the ways whiteness can be coded as a fragility and yet persist as hegemony.

Electrographic Architecture extrapolates from these insights to paradoxes of whiteness by bridging them with the technological histories of light in New York City and Las Vegas. For example, one salient theme running through this book's pages is whiteness's consistent capacity to control material practices of light while acting as an abstract signifier and non-entity. In CWS, this tension surfaces as one between social realism and the symbolic. Cabrera and Corces-Zimmerman, for instance, argue that whiteness "is an empty social category . . . defined primarily by what it is not (People of Color) instead of what it is."[53] They build on Toni Morrison's claim that whiteness does not exist except in contrast to the imaginary Other represented by "People of Color,"[54] itself echoing the work of Frantz Fanon, W. E. B. Du Bois, Richard Wright, and James Baldwin. Seminal CWS scholar David Roediger likewise contends that "whiteness is nothing but false and oppressive,"[55] as does CWS scholar George Lipsitz, who defines whiteness as "a delusion, a scientific and cultural fiction that like all racial identities has no valid foundation in biology or anthropology."[56] DiAngelo also concurs, defining whiteness as "a constellation of processes and practices rather than a discrete entity (i.e., skin color alone),"[57] while Ruth Frankenberg describes it as a multidimensional social process that allows white people to see themselves as "unmarked and unnamed."[58] Isabel Wilkerson also relies on symbolic definitions of whiteness to address how race, like caste, operates as an "architecture of human hierarchy, [a] subconscious code of instructions for maintaining . . . a four-hundred-year-old social order."[59] While it may seem odd to view whiteness as an immaterial abstraction, several decades of CWS scholars have suggested this is precisely how we must understand it.[60]

At the same time, as many of the above-noted scholars suggest, viewing whiteness as symbolic or mythic in no way detracts from the concrete realities of white racism. In the United States, the material effects of white racism are ubiquitous, wherein whiteness has been a "founda-

tional component of anti-minority policies ranging from slavery to . . . the genocide of Native Americans, eugenics, *de jure* and de facto racial segregation, Japanese internment, Operation Wetback, and the rise of the prison–industrial complex."[61] This list may go on to include the minutiae of the everyday and the seemingly innocuous algorithms in the "smart city," reenacting centuries of racial bias. In the same way that "buildings don't need the whitest white or even a single white surface to be white,"[62] a person does not need to have white skin to subscribe to or perpetuate white power.[63]

Ecuadorian philosopher Bolívar Echeverría's concept of "whiteness" (*blanquitud*) is especially useful here for its description of the "*homo capitalisticus*,"[64] a type of human produced from the joint forces of modernity and capitalism. Building on Max Weber's theory of the Protestant ethic as that which binds white ethnic persons to the root and "spirit of capitalism," Echeverría argues that ethnic whiteness is "subordinated to the identitarian order"[65] of civilizational whiteness, to the extent that civilizational whiteness, like colonialism, expands across multiple historical and culturally constructed modalities.[66] Though the former derives from the latter, civilizational whiteness (*blanquitud*) is not synonymous with ethnic whiteness (*blancura*). Echeverría clarifies, "The term *blanquitud* is meant to remind the reader that the kind of racism based on *blancura* has not entirely disappeared."[67] To invoke one term is to always already infer the other. Put differently, cultural "whiteness" (*blanquitud*) is a condition of "civilizatory totalization," bound up in the longue durée of capitalist modernity. Cultural "whiteness" includes ethnic attributes[68] that almost always measure up with, or derive from, white ethnicities (so-called white people), but whiteness itself extends along a more pervasive, "civilizational" axis. The result is a new type of "civilizational white" (*blanquitud*), a human being who, regardless of race, class, or ethnicity, exemplifies the productivist ethos of capitalism.

Echeverría's work aligns with investigations of whiteness that illustrate how it, like all racial categories, is not fixed or deterministic but instead develops over time as a "fluid, malleable, and complex" category.[69] Consider, for example, how the groups considered "white" in America have changed through time and space. When Jews and Italians first immigrated to the United States in the early twentieth century, they were only accepted as "probationary whites."[70] They could not become full citizens before "earning" their whiteness in the eyes of the law. Today, Jewish and Italian immigrants are largely accepted as "white," alongside a number of other immigrant communities that faced similar

challenges upon their arrival (chiefly the Irish, Polish, Russians, and Eastern Europeans).[71]

Stories of "passing" further undermine social and legal categories of whiteness as consistent and fixed. By showing how some bodies can count as white in some places, at some points in time, but not others, whiteness is upended as relative and contingent on the vested interests of those in power. Those in power benefit from whiteness's capacity to operate as invisible and undetected, allowing white power to proceed unchecked and sustain itself as a cultural dominant. In fact, whiteness is *most* effective in those places where it is least detected, in the body or wall that lacks white pigment but perpetuates symbolic violence.[72] *Electrographic Architecture* borrows from these insights to theorize how the material and figurative attributes of white light and spectacle-based urban illumination allegorize the development of America's white imaginary over the course of the last century and a half.

WHITENESS AND THE CREATIVE ARTS

Lasting critiques of whiteness in the creative disciplines (art, visual studies, film, media studies, and especially aesthetics, philosophy, and architecture) have been few and far between. In fact, the history of Western architecture could not be harder pressed to find titles that do not succumb to a perennial chromophobia. In 1923, Le Corbusier, progenitor of Modernism and the International Style, confirmed as much, declaring, "Colour is suited to simple races, peasants and savages."[73] "Let's have done with it," he continued in 1925; "it is time to crusade for whitewash and Diogenes."[74] Modern architecture's unspoken axiom of compulsory whiteness has henceforth remained de rigueur.[75] At the same time, closer examination reveals that whiteness in architecture predates Le Corbusier by centuries. Consider the denial of polychrome in Greco-Roman antiquity, refuted even when scholarly evidence appeared to the contrary in the fourteenth and nineteenth centuries.[76] As a result, color-focused approaches in architectural theory and practice have remained scarce, infrequently cited, published in lesser-known or nonacademic presses, or self-consciously positioned outside mainstream cultural practices.[77]

There are less than a handful of exceptions. Mark Wigley's *White Walls, Designer Dresses: The Fashioning of Modern Architecture* (1995) and his recent "Chronic Whiteness" (2020) provide the sole comprehensive, critical accounts of whiteness in the history of architecture. Where *White Walls, Designer Dresses* unpacks Le Corbusier's obsession

with whiteness and mid-century fashions, Wigley's 2020 essay links whiteness to architectural history. Wigley elegantly conceptualizes whiteness as a "trans-historical" repetition of Western origin myths dating back thousands of years, while marking them as still active in the present. Any analysis of whiteness must operate through this dual focus of the past and present, Wigley argues, akin to a forensic critique exposing each single pulse to be linked to an entire structure spanning "time and space."[78] Western architecture has been "unwilling to demolish its own exclusionary house," but such demolition is required for any lasting destruction of chromophobia to persist and move beyond patronizing and "imprisoning" Others "under the banner of diversity."[79]

In technology studies, few publications have addressed the history of colored light. Some have even embraced considerations of race as color, but none have directly articulated how whiteness operates therein.[80] In cinema and media studies, scholarship on color was for some time exclusive to film theory.[81] After the publication of my own *Chromatic Algorithms: Synthetic Color, Computer Art, and Aesthetics after Code* and Susan Murray's *Bright Signals: A History of Color Television*, the field made inroads into color in computing and television.[82] However, only periodically have these predominantly white scholars—myself included—forged connections between histories of color dyes and illuminants with race and ethnicity, and almost never as a function of whiteness.[83] More recent works have begun to address how histories of digital technology intersect with critical race theory,[84] and while *Electrographic Architecture* is deeply inspired by these volumes, it focuses on whiteness not as race but as a contradictory and paradoxical force in the long history of Western culture.

Given the book's focus on two specific geographical sites, questions of space must be brought into the mix. Space and place are so central to critiques of race and colonialism that "race" is itself, George Lipsitz writes, "produced by space."[85] Lipsitz's *How Racism Takes Place* (2001)[86] introduces the notion of the "the white spatial imaginary," which I draw on in *Electrographic Architecture* to delineate how America's white imaginary is located in the hyperbolic consumer spaces of the spectacle-based modern US city. Related research has addressed how such racist government practices as redlining, blockbusting, restrictive covenants, and municipal incorporation have led to the formation of America's privileged white suburbia (touched on in chapter 5), in contrast with neglected inner-city neighborhoods and the urban poor (so much so that the word *urban*, writes Eric Avila, has become synonymous with "Black").[87]

Electrographic Architecture draws from and inverts the focus of these titles, bringing them into the material history of illuminated light in New York City and Las Vegas by asking, Can a critique of whiteness be leveraged in these same spaces, where whiteness seemingly does not reside? If white suburbia is epitomized by homogeneity, containment, and predictability, can the visual diversity, unpredictability, and chromatic heterogeneity of Times Square and Las Vegas also emulate and perpetuate the workings of white power in less obvious ways?

ANALYTIC METHODS

As new technologies play an increasingly prominent role in everyday life, the need to place them at the center of critical and aesthetic analyses becomes imperative. New media are never wholly new, being always already built on the political and historical conditions of the past. In *Electrographic Architecture,* I draw from two established approaches in media history and theory (media archaeology) and visual studies (aesthetics). While these methods are inextricably bound, for the purpose of this discussion, I temporarily separate them.

Media Archaeology

Defined as the archival examination of the materiality of media objects, media archaeology breaks from traditional epistemologies and hermeneutic models to argue that an image, screen, or material platform through which informational content is delivered is just as important as the content itself. The field derives from Foucault's concept of archaeology as well as his and Nietzsche's concepts of genealogy—defined as a set of relations that run horizontally, and in opposition to, official, chronological histories. Foucault set this stage when he ironically referred to the archive as the "historical *a priori*," placing concrete, material history prior to the formation of concepts and knowledge systems in the present. In the historical a priori, the material artifacts of the world are reconstrued as an archive in and of itself, from which the conditions of possibility for all knowledge and power can emerge.[88]

The notion of a historical a priori simultaneously harks back to Nietzsche, who argued in *On the Genealogy of Morality* (1887) that the relevant material of a genealogy is based on shattering disillusionments that a subject causes a presumed effect. Nietzsche provides the example of a lightning flash. Where the "popular mind" separates the flash from

the lightning, or the doer from the deed, and "takes the latter for an action" called "lightning," the two cannot in fact be separated. He writes, "The doer is merely a fiction added to the deed."[89] It is the "seduction of language," Nietzsche maintains, that "conceives and misconceives all effects as conditioned by something . . . by a 'subject.'"[90] While Nietzsche's discursive focus deals primarily with language and its effects, his underlying insight—that a subject is formed through circumstantial events in time and space—was later adopted by Foucault, and together, their work laid the foundation for what is now known as media archaeology.[91]

More recent articulations of media archaeology likewise place the materiality of a technology in the position of what Friedrich Kittler provocatively calls the "*media a priori*," and what Zielinski refers to as the "deep time" of the media—a cyclical and alternative time that forces thought in another, nonlinear direction.[92] Unfortunately, media archaeology and CWS have not yet been formally connected, though their strong complementarity is worth noting (and maintaining, as attempted in the following pages). Homi K. Bhabha, for instance, has suggested that the task of CWS is to "reveal within the very integuments of 'whiteness' the agonistic elements that make it the unsettled, disturbed form of authority that it is."[93] Likewise, media archaeology aims to reveal the contradictions and paradoxes in dominant accounts of media history. For both, authoritarian narratives turn out to be white mythologies, prompting a return to Echeverría's insight that "mass media do not grow tired of reminding everyone in a slyly threatening way of the fact that whiteness lurks underneath 'whiteness.'"[94] In this way, *Electrographic Architecture*'s critical archaeology of illuminated lighting in New York City and Las Vegas invokes a technical whiteness that resonates beyond the history of technology alone, implicating itself in ideological histories of whiteness as often one and the same.

Aesthetics (Visual Studies)

Research in aesthetics typically derives from Western philosophy and theories of representation. In the context of this book's study of polychromatic electric signs, it will suffice to note antecedents in Western phenomenology.

Defined as an investigation of being and appearing in the world, phenomenology is committed to finding new models of human experience, perception, and freedom that resist rational and normative conventions. However, while the classic phenomenologists argue that the essentially

ahistorical bracketing (Husserl) of authentic human experience (Heidegger) and pure perception (Merleau-Ponty) is possible, I update this claim to argue that human and machine perceptions are inextricably fused in what I have previously theorized as the "algorithmic lifeworld."[95] In this way, perception is indisputably shaped by subjective experience in conjunction with political, cultural, and historical circumstances. I further concede here that light and color technologies are integral to modern experience and shape the conditions of possibility for creative practice.

In sum, by combining visual studies and media archaeology, it becomes possible to provide a sustained investigation of America's white imaginary as embodied in its electrographic architecture.

OVERVIEW OF THE BOOK

Electrographic Architecture charts the evolution of large-scale electric spectacles in urban centers (primarily in New York City, Chicago, and Las Vegas)[96] to argue that their development runs isomorphic to a unique yet unremarked form of American capital that I am calling "America's white imaginary." The book's six chapters and conclusion chart how white, whiteness, and the white imaginary figure as consistently reoccurring tropes in five core registers: the history of architecture (white paint, whitewashing, and mythologies of neoclassical white); Judeo-Christian legacies (as a symbol of purity, virginity, and virtue); Western philosophy (epitomized in the Enlightenment light of the eye/"I"); Western science (i.e., Newton's claim that all color derives from white light); and in the history of electric illumination. While the chapters unfold in a loose chronological order, moving from the origins of chromophobia in the history of Western architecture to the development of material and symbolic whiteness in electric illumination and smart technologies, certain sections of certain chapters jump ahead several decades (or centuries), while others jump back in time to establish context.

Following this introduction's framing of the history of technology, Western aesthetics, and color, chapter 1, "Synthetic White," zeroes in on the inherent paradoxes of whiteness to offer a critical archaeology of its role in the origins of Western architecture through Le Corbusier's obsession with ascetic white paint. On one hand, whiteness claims exclusive rights to transcendental knowledge, moral superiority, and ahistorical objectivity. On the other hand, whiteness is only ever a syn-

thetic effect of historical repetition, a compounding of one coat of white paint layered on top of another. Rooted in this contradictory logic of mythic originality and a posteriori negation, the chapter shows how whiteness's claims to purity, lightness, and truth are, time and time again, leveraged through violent acts of destruction and erasure.

Chapter 2, "Edison's White Light Empire," builds on chapter 1's critical archaeology to consider the development of synthetic light from early experiments with electricity to Edison's 1879 incandescent bulb. Edison's white light empire is then aligned with the American drive to be the best, first, largest, brightest, and whitest, constituting a central trait of the nation's white imaginary.[97] By establishing how America's white imaginary is bound by a twofold tension between the ideologies of power and possession, chapters 1 and 2 lay a necessary foundation for the remaining chapters.

Chapters 3 through 5 analyze the development of new electric color palettes for large-scale signs from the end of the nineteenth century through the postwar era. The advent of these "spectaculars" engendered the development of places like Times Square as meccas of entertainment, fashion, nightlife, and by the 1900s, cutting-edge electrographic advertising. New York City's "Great White Way," a sector of midtown Manhattan decked in bright white lights in the wake of Chicago's 1893 "White City" at the Columbian World's Fair, serves as the epicenter of this formation. Chapters 3 and 4 submit that while Chicago's White City forged an early training ground for an American ethos of visual possession by way of spectacle-based consumption, this white light zeitgeist came to full fruition only along New York's Great White Way.

Chapter 4, "Douglas Leigh's Times Square Spectaculars," further investigates the national drive for supreme illuminated-light forms through an analysis of the truly original large-scale electric sign work created by the provocative American advertising executive Douglas Leigh. Leigh's astounding Times Square spectaculars led to a multimillion-dollar business and the overall "whitening up" of Broadway in the garb of cheap commerce, novelty, and exhibitionism.

Chapter 5, "The Young Electric Sign Company and Las Vegas Neon," takes temporary leave of Times Square to map the archaeology of neon from early developments in Europe in the 1910s to its eventual obsolescence in American urban centers in the 1970s. The chapter focuses on the work of the Young Electric Sign Company (YESCO) to illustrate how Las Vegas neon (not Times Square's) was the supreme site of American glamor and the technological advancement of this medium

from the 1930s through the 1960s. By the early 1960s, however, Las Vegas neon lost ground to cheaper and more efficient polycarbonate plastics and fluorescent lighting systems. The chapter ends by returning to Times Square, where the shadow side of a now-abandoned neon palette came to symbolize the new era of social and economic decline.

Chapter 6, "Jenny Holzer's Light Art as Urban Critique," picks up where chapter 5 ends, with the problematic legacies of white flight and the ways it served as a scapegoat for neoliberal agendas to "rejuvenate" Times Square. While the Square's "Disneyfication" did not materialize until the late 1990s and early 2000s, the interim involved numerous tensions between activists, city and state policymakers, private developers, and shifting zoning regulations. This chapter explores these mechanisms through the work of American artist Jenny Holzer (b. 1950), whose use of large-scale LED signage in Times Square evaluated these neoliberal agendas in the early 1980s. Holzer's work is selected as the sole body of critical creative work discussed in the book as it offers one of the first uses of large-scale electrographic architecture in Times Square in the early 1980s to analyze the urban space it was situated in. Although such self-conscious critiques subsisted in the avant-garde prior to postmodernism, in Holzer's work we find a fresh variation in the form of electrographic architecture, for the public and not the exclusivity of the white cube. Finally, when we review Holzer half a century later, the chapter argues, her work can and must be reread as foreshadowing contemporary realities of Times Square and a broader culture of surveillance capitalism.

The book's conclusion, "Chromophobia in the Smart City," brings us to twenty-first-century Times Square and its network of data-based surveillance and control proffered by smart technologies coupled to large-scale digital spectacles, enticing tourist-consumer-citizens into so-called participatory exchanges. Using the case studies of "Hershey's World" (2002), Coca-Cola's "#WhatsInAName Campaign" (2015), and "Android: Be together. Not the same" (2014), the chapter highlights forays into a new paradigm of informatic whiteness in which white is no longer found in a light or surface per se, or in a multihued advertisement for beer, cigarettes, or gasoline, but instead in the informatically entwined data-subject. Far from radicality, the conclusion illustrates how these uses of Artificial Intelligence in twenty-first century electrographic architecture evidence only the most tried and true strategies of whiteness, eviscerating social and historical context to conceal those essential and formless ingredients that give human life real color.

Synthetic White

10,000 BC–1700 AD

He judges not merely for himself, but for everyone.

—Immanuel Kant, 1790

Imagine the results of the Law of Ripolin. Every citizen is
required to replace his hangings, his damasks, his wall-
papers, his stencils, with a plain coat of white Ripolin. . . .
Once you have put Ripolin on your walls you will be master
of yourself [and] think clearly.

—Le Corbusier, 1925

Whiteness imparts contradiction. In the global Northwest, this white-
ness has for centuries claimed the exclusive right to transcendental
knowledge, moral superiority, and universal objectivity, even though
whiteness is also only ever a synthetic effect of historical construction.
As one fresh coat of whitewash is painted on top of another, each new
layer appears natural and true, erasing awareness of what came before
it. This kind of whiteness is pervasive in Western culture, yet it remains
one of its most unconscious, unexamined attributes. Given that white-
ness's primary mode of engagement with the world ensues by way of
obfuscation and disappearance, how do histories of technology and aes-
thetics grapple with these contradictions in ways specific to them?

 This chapter unpacks these queries through a critical archaeology of
this specific kind of synthetic whiteness that, in Euro-American contexts
from Greco-Roman antiquity through Christianity, Enlightenment
knowledge systems, and architectural Modernism, has evidenced itself
time and again as an overblown, totalizing, yet absconding force in

culture and thought. The chapter interrogates the complex ways this type of whiteness has, time and again, imperceptibly imbued itself in cultural narratives and habits of perception. For example, if Western thought proceeds in bearing "no white perspective," as Arnold Farr suggests, "but only the universal, impartial, disinterested view from nowhere,"[1] then whiteness has succeeded as *the* perspective, which is to say, unbridled and unchecked. This chapter challenges such processes by analyzing the material artifacts and historical effects of whiteness's false claims to ahistorical objectivity, strewn aside after each new interval of its self-made, whitewashed history, making it seem as if it was always already there.

As noted in the introduction, there are many instances and instantiations of whiteness in the world; however, the philosophical concept of whiteness, as I approach it in this book, and this chapter in particular, is "the One" that operates as an overstretched and totalizing force in the global Northwest and, in this way, runs alongside equally fraught histories feigning omniscient drives for greatness and supremacy, the strongest of which bind Euro-American imaginaries. When I henceforth refer to whiteness, it is almost exclusively in this respect.

The chapter unfolds through a series of chronologically structured, though often-overlapping, subsections. For example, my analysis of Le Corbusier's adoption (and rejection) of architectural whiteness is discussed prior to the whitewashing of Greek antiquity for the main reason that Le Corbusier's whiteness (like all forms of whiteness) can be understood only as a duplication of a prior coat of whiteness, in this case one rooted in neoclassicism's false interpretation of antiquity's whiteness. In short, whiteness persists through archaeological strata that simultaneously move backward and forward in time. Scrutiny of one iteration sheds light on another, aiming to, eventually, bring the entire edifice into question.

THE WHITE HOUSE

Contrary to conventional accounts that fasten whiteness exclusively to Euro-American contexts, whiteness must instead be understood as belonging to a multitude of cultures, as old as civilization itself.[2] From approximately 10,000 to 4,500 BC in the Near East, a four-thousand-year transition ensued from the Stone Age's nomadic tribes of hunter-gathers, to a Neolithic period of foragers residing in semisubterranean mud-lined oval spaces and wood-brush canopies, to settler-based agri-

culture communities with permanent enclosures.[3] Mark Wigley suggests that these protoarchitectural shelters indoctrinated a new form of static cohabitation and protodomestication between humans, animals, and plants that simultaneously fashioned itself as an unanticipated incubator for new forms of disease and illnesses that, in turn, required ritual cleaning and cleansing. The archetypical white house was thus a petri dish for manufacturing and storing pathogens. As a result of these "inter-species intimacies,"[4] humans grew collectively weaker (for example, the introduction of mass tuberculosis infection during this time led to a collapse of the human spine and an overall decline in human health).

Early settler communities responded to the influx of disease by developing techniques to purify the archi-white house, to sanitize and cleanse it of potentially harmful dirt and disease, and henceforth, whitewashing was born—in the East, that is, through the work and ingenuity of people of color—as a means of ensuring human, plant, and animal survival. Evidence of this development can be found around the world, from white West Africa to the Mayan White Way. It "is not that architecture was whitened," Wigley writes, but it is "*only* architecture inasmuch as it [is] white."[5] The skin of a body that houses a people and the skin of a people that protects it are both, in the end, merely weak coats of armor in the face of death and disease—permeable membranes dependent on perpetually new coats of defense to secure their longevity.

Whitewashing became a question of race and ethnicity only when such practices were appropriated as a form of possession, as a kind of property claimed by one group over another. In short, whiteness became a weapon of exclusion, oppression, and control. One early segue into this variation is found in the Greek physician Hippocrates's (460–370 BC) "On Airs, Waters, Places" (400 BC) which lays out a form of protoracial profiling linking Northern, Southern, Western, and Eastern cultures to scales of sickness and health. This is hardly the full-fledged racial profiling that today marks dark-skinned bodies as antithetical to white ones, but it is an ur-theory of skin color as indicator of health and intrinsic merit. If bodies are awash in too much color, Hippocrates argued, whether this be whiteness or darkness, the health and ecosystem are threatened. In particular, the Northern Scythians, known for their light skin tone, were seen by Hippocrates as "flabby in their constitution," unable to adequately hunt or demonstrate athleticism. Their "tawny" light skin was "parched by the cold,"[6] he argued, rendering them "by no means prolific."[7] "Good" health fell in the middle zone, in a color balance between light and dark.

In his "Theory of Colors," Aristotle likewise argued that the amount of color inhering in an object indicated its relative health. When a plant reached the stage of its most intense green or a flower its most intense hue, it indicated a being flourishing at the height of its life force.[8] Unlike Hippocrates, however, Aristotle maintained that these changes marked a natural part of an object's life cycle, not a prototheory of racial hierarchy. Because we have become only too familiar with essentialized links between skin color and race and ethnicity in contemporary culture, these examples offer a refreshing reframing of naturalized assumptions, revealing the constructed nature of the ways skin color (whether of a body or a home) has, since the origins of civilization, played a role signifying health and wealth, which is to say, power and privilege.

In the first century BC, Roman architect Vitruvius (approx. 80–15 BC) built on Hippocrates's links between architecture and skin color as relative indicators of health. In his ten-volume *On Architecture* (*De architectura*, approx. 30–15 BC), Vitruvius focused on the role of design in creating beneficial uses for air, light, and water in the service of good health and in avoiding "pestilent places," like the "epidemics" found in "plague-ridden regions" in the South.[9] Like Hippocrates's human health ideal, Vitruvius's was also, to some degree, located in between the extremes of black and white, though he ultimately privileged lightness over darkness. This is most clearly illustrated in his address to women, whom he understood as a form of property and instructed to "not poison yourself or whiten your face to make yourself seem more beautiful."[10] Vitruvius esteemed so-called natural whiteness for its truth-telling properties, as distinguished from a face disguised by white paint and colorants feigning a natural beauty that did not belong to it. The same maxim applied to polished white stucco, which, he argued, should always appear "naturally" shiny and clean, highlighting any artificial dirt or disease that threatened to taint its "pure" white skin. Whiteness thus became a sociobiological sieve, a filtering mechanism through which a culture discerned and dissected what it deemed to be clean, healthy, and valuable, and what, by contrast, must be expunged as dirt and deadly threat.

As societies evolved, so too did the technology used to produce materials used to build living spaces, developing into what is now taken as architecture proper, even as the word continues to carry the ancient weight of whiteness with it. Architecture *must* forge itself as original, a firstness and bestness denoted by its prefix *arch-*, deriving from the Greek ἀρχι (arkhi), meaning chief, beginning, or leading or, in proto-Indo-European, meaning to begin, rule, or command. The second part of

the word derives from the Greek *techné*, meaning to make, build, or construct. In essence, to build an origin *after the fact* (nothing could be whiter) but appear to have done so beforehand, as if a bona fide gift of the gods or, better, a divinity in and of itself. Architecture must be "set up" as "shockingly white," Wigley writes, in order to conceal the labor-intensive processes of extraction and manufacture that always come later (the cleanup job of polishing and sanitizing).[11] Pure white surfaces are *made*, constructed through years of exclusion and erasure in order to appear natural, prior, true, and original. The militancy of whiteness in Le Corbusier's architectural modernism offers what is likely the strongest case in point. Before moving on to whiteness in antiquity, Christianity, and the Enlightenment, we turn to Le Corbusier's white world, highlighting his extraction and erasure of colored Otherness from "the East" in the service of promulgating the supremacy of white modernism.[12]

LE CORBUSIER'S COLOR

A "plain coat of white Ripolin," Swiss-born architect Le Corbusier (born Charles-Édouard Jeanneret, 1887–1965) wrote in 1925, is an "important act in life," a force of "productive morality"[13] that eradicates darkness and "all that is not correct."[14] It is not difficult to find such provocative and racially explicit statements throughout his published writings; the challenge is articulating how Le Corbusier's *celebration of color*, in his early and late life, also fed into this seemingly unwavering faith in whitewash.

Le Corbusier's obsession with white began in the early 1920s, just after the debut of Ripolin, a commercial brand of ready-mixed paints developed in the Netherlands at the end of the nineteenth century by chemist Carl Julius Ferdinand Riep. The Ripolin brand boasted its antibacterial properties in architectural and hospital journals in 1913, alluding to studies proving that bacteria like cholera, diphtheria, typhus, staphylococcus, and tuberculosis could not survive on its hard enamel surfaces. Ripolin's washable paint soon became the obvious paint of choice for clinics, hospitals, and sanatoria throughout Western Europe.[15]

Ripolin was the start. Its deadening white would soon achieve paradigmatic status throughout architectural modernism, primarily through Le Corbusier's calls for compulsory cleaning (a prerequisite for "mastery" of oneself and one's home), waxed by overtly racist declarations that "color . . . is suited to simple races, peasants and savages.[16] Let's be done with it, he continued in 1925: "Every citizen" should be required

FIGURE 1.1. Ripolin advertisement in the Australian magazine *Building* (3, no. 23-12 [July 1909]). A "ready for use" paint with a "porcelain"-like finish. The commercial brand of ready-mixed paints boasted an impermeable and washable enamel, free from the colors of dirt and disease.

to "replace his hangings, his damasks, his wall-papers, his stencils, with a plain coat of white Ripolin," so that French (or German) society can spot and purge all colored Others not like it.[17] This purge toward a new kind of "purely" synthetic whiteness doubled as a theory of modernism and morality; a testament to the ways new building technologies (concrete, open floor plans) could bolster myths of industrial progress, prevailing over the dirt and darkness of the past by paying heed to a new modern savior: chemical whitewashing.

But let us not forget that such "superior" whitewashing practices were first developed in the preindustrial East and attributed to Le Corbusier and modernism only after the fact. Le Corbusier first observed whitewashing rituals directly on his 1911 "Voyage d'Orient," when he served as an apprentice draftsman for Peter Behrens's office in Berlin and was still known as Charles-Édouard Jeanneret. Between May and November, Jeanneret and his friend art historian Auguste Klipstein visited Asia Minor, the Balkans, Constantinople (Istanbul), southern Italy, and Greece. Their journey began with the goal of rejecting Western mythologies of the East as "unclean" and "filthy."[18] Jeanneret anticipated visiting the "great white walls of temples" in Constantinople, Asia Minor, Greece, and southern Italy, all sites that—he believed—would help him dismiss the "gossamer architecture" he so disliked in the North.[19] The goal was forgotten, however, once color entered the scene. His travel journals offer extensive, deeply poetic reports on the Mediterranean's rich golds, its sensuous hues, and moist air and earth, akin to an "ideally shaped vase from which the heart's most profound feelings will flow."[20] Such colors "elude reason," he wrote, serving only as "a source of light and joy and a harness of living strength."[21] These magical hues invoked in Jeanneret a celebration of life at its most vital, as they did for Hippocrates and Aristotle before him.

Until they didn't. The opulent colors of the lifeworld soon proved too overbearing for Jeanneret, catapulting him over the threshold of reason into what can only be described as a pseudo-psychedelic trip, enhanced by the resin wine he drank along the way.[22] On the last leg of his journey in Greece, his prior beliefs in fixed structure and form seemed to dissolve entirely. In Athens, Jeanneret noted the striking colors he saw reflected off the Parthenon's surface, rendering it in his journal in pink, red, and green. His vivid reinterpretations of the Western monument are almost unrecognizable, though, ironically, these intoxicated yet celebratory hues are more historically accurate than many photographic renderings have shown. Subtle clues are offered in

his thin black outline of three steps, vertical bars signifying columns, and a receding backdrop indicating height, essentially loose lines hardly indicative of a mighty empire that once sat continental supreme.

By the end of his journey, Jeanneret had loosened to the point that he claimed to see color without looking. With "eyes half closed," he contended, one could give way "to the intoxication of the fantastic glazes, the burst of yellows, the velvet tone of the blues."[23] Like Aristotle and Goethe before him, he likened his surrender to color to being caught in an "animated fight between brutal black masses and victorious white elements."[24] Even if this was only a color memory, recorded once he returned to safe and sober Switzerland, it is still remarkable to see Le Corbusier's placement of architectural color at the *center* of experience, between the extremes of white and black, where unfettered color thrives as essential and vital.

But color eventually pushed Jeanneret too far. A sobering coat of whitewash was perhaps inevitable, if not en route, then certainly by the time the gray ethos of Western Europe befell him again. In a sense, the belief in transcendental white light had been with him the whole time, temporarily nullified by witnesses' insatiable need to cull novel forms of color-as-entertainment from the whimsical ways of (Eastern) Others and make it its own. It is perfectly apropos for the self-absorbed white imaginary to endorse and even engage a non-Western, "oriental" culture's intoxicating and dreamlike colors (even the Kantian sublime, as we will see, ventures a liaison with the whimsical and irrational). This foray is offered as a "safe" flirtation from above, legislated by the very code that, a priori, attempts to eradicate and marginalize it. While in the East, Jeanneret allowed himself to be (temporarily) seduced by polychromatic spectacles. Once they got too close, however, he pushed back, put his white coat back on, and returned home.

Selected excerpts from Jeanneret's travel notebooks chart this gradual shift from delight to repulsion with color, even as his more intoxicated final entries continue to celebrate it. This begins with pithy comments about dirt and bedbugs and eventually transitions into full-blown encounters with incessant insects, intolerable dirty walls, squalid interiors, noxious smells, and "diarrhea, delirium, and disorientation,"[25] which, by the end of the journals, have become a reoccurring trope.[26] On the tail of the journey in Constantinople, Jeanneret records himself as fully immersed in deadly color as the effects of the 1911 cholera epidemic were "sweeping all the East," rendering him unable to "hold" color's beauty anymore. He reports witnessing "dead bodies being

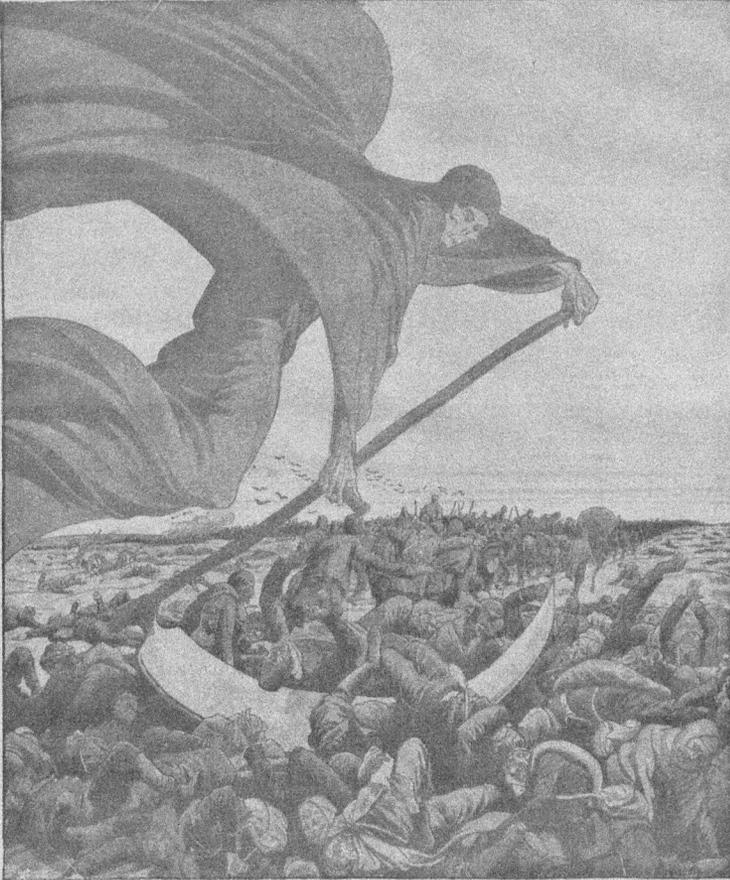

Le Petit Journal

ADMINISTRATION
41, RUE LAFAYETTE, 61

5 CENT. SUPPLÉMENT ILLUSTRÉ 5 CENT.

ABONNEMENTS

Les manuscrits ne sont pas rendus

27me Année

Numéro 1.150

DIMANCHE 1er DÉCEMBRE 1912

SEINE et SEINE-ET-OISE.. 2 fr. 3 fr. 50
DÉPARTEMENTS............ 2 fr. 4 fr. »
ÉTRANGER................ 2 50 5 fr. »

LE CHOLÉRA

FIGURE 1.2. *Le Petit Journal*, December 1, 1912. The cover of this French newspaper depicts the colors of darkness and death that overtook troops during World War I as the cholera epidemic dimmed the opulent colors of the East.

carried away" on the streets, "faces exposed, green and covered with flies."[27] The epidemic was then at its highpoint, killing a hundred people per day in the city. Jeanneret and Klipstein were forced into an "onboard quarantine"[28] before absconding Constantinople for safety in Athens. Shortly thereafter they were forced into a second "stinking quarantine" for four days on the island of St. George. The colors of the East were growing darker by the day and the once-intoxicating Mediterranean blue sky turned "black."[29]

How could notions of a safe and pure, sanitized white utopia *not* relodge itself as an imaginary reprieve, an idealized haven to return to after his risqué flirtation with the Orientalism of the Other turned deadly? A mere four years after his return to Switzerland, Jeanneret confirmed as much, declaring "all that bric-a-brac [from the East] I treasured disgusts me now."[30] White had won. Even after Jeanneret observed ancient whitewashing rituals in his first few weeks in Constantinople, which he accurately linked to the origins of human civilization,[31] once he was back in Western Europe, he refashioned them as essentially "modern," whitewashing whiteness itself as original to European modernism.

SANITIZED COLOR

By 1923, Jeanneret had renamed himself Le Corbusier and, beyond the above-noted promotion of white, he had been collaborating with French painter Amédée Ozenfant (1917–25) since 1918, coauthoring a truly whitewashed theory of color under the auspices of "Purism." The bulk of their work together consisted of writings, paintings, and architectural projects made between 1918 and 1925 and most notably their book, *Après le Cubisme* (1918), articulating the Purist ideals in conjunction with the first Purist exhibition held at the Galerie Thomas in Paris in 1918. A series of articles in the magazine *L'Esprit Nouveau*, founded by Belgian writer and poet Paul Dermée (1886–1951), furthered the Purist agenda, including offerings from such well-known figures as Fernand Léger and Paul Signac.

While feigning as an architectural theory of *color*, Purism actively condemned both it and décor of any sort as "poisons" that destroyed the natural integrity of an edifice or canvas alike. Purism's officially sanctioned colors, known as the "large gamma" or "major scale," consisted of muted hues like yellow ocher, sienna natural, sienna burned, ultramarine blue, white, black, and a selection of equally low-chroma derivatives, set in marked contrast to the synthetic, chemical colors then

embraced by a number of contemporaneous modern artists.[32] Purism's secondary hues, used with much less frequency, were brighter and were called the "dynamic scale." This range included a "disturbing" citron yellow, orange, vermilion, and other "animated" and "agitated" colors, while its tertiary palette (the "transitional scale") included tinted hues like madders, emerald green, and the colors of the lakes.[33]

The Purist mandate for austere, objective portrayals of everyday mass-produced objects turned on a rejection of almost all related art styles and movements of the time. Their rejection of Cubism was based on its capacity to render multiple points of view on a single, two-dimensional plane, while their dismissal of Neo-Impressionism turned on what they presumed to be an inaccurate rendering of perceptual light and color (ironically, just like Jeanerette's intoxicated rendering of the Parthenon).[34] Cubism also lacked an essential "narrative aspect," the pair argued, exhibiting "no difference whatsoever between the aesthetics of a carpet and that of a Cubist painting."[35] Even Fernand Léger, whom the Purists worked closely with on early issues of L'Esprit Nouveau, took an approach to architectural color that they dismissed as too "ornamental" and unmodern. In essence, Purists aspired to use simple shapes and forms to achieve a universal aesthetic of and for industrial machinery[36]—the epitome of the modern style, they believed, and one that Le Corbusier elsewhere internationalized across the globe.

By 1924, Le Corbusier and Ozenfant left the magazine, but their call to strip down colorful interiors remained intact. To "be master of yourself, [your house, and] to think clearly,"[37] Le Corbusier declared in his 1925 Law of Ripolin, whitewash was a prerequisite. But it was not the bare-bones approach to design, or the wish to discard the materialisms of the past, that made Purism unique; rather, it was the fact that the Purists leveraged their pursuits *through color*—the most ephemeral and structure-defying visual phenomenon that humans have access to. There is also the irony that the Purists' attempt to celebrate the new by dismissing the past turned on a retroactive recuperation of classical geometric ideals (yet another coat of whitewash lost in the mix) and so-called "pure," preindustrial colors.

Such contradictions inundate Le Corbusier's most famed period from the 1920s through the 1930s, when he preached the necessity of white-wash using only Purism's preapproved colors. The *Pavillon de l'Esprit Nouveau* (1925), for instance, was painted in ten different colors (white, black, light gray, dark gray, yellow ochre, pale yellow ochre, burnt sienna, dark burnt sienna, and light blue),[38] while his *Pavillon des*

Temps Nouveaux (1937) displayed a red-painted canvas backdrop, a green wall on the left, a gray one on the right side, an entrance painted in blue, a roof made of translucent yellow materials, and a floor of yellow gravel. He justified such decisions by claiming that this "little" bit of color retroactively solidified the centrality of white. Or, as he put it in 1926, "my house will only appear white when I have placed the driving forces of colors and values in the right places. . . . The white, which makes you think clearly, is supported by the powerful tonicity of the color."[39] He was not incorrect. Colors have time and time again been used as an adjunct to support the centrality of whiteness. It is only by naming a color "Other" that axiomatic whiteness can retain its hegemonic suppositions. It is also likely that Le Corbusier had here drawn on his psychedelic experiences in the East a few years prior, when too much color overwhelmed him. He had learned his lesson: only a dash would suffice as a gentle reminder of what is truly true and correct.

To be fair, the overbearing whiteness that has come to define modern architecture was not all Le Corbusier's fault, even though it is almost exclusively the white plaster of his Maison Citrohan model (1920) and the Ozenfant Atelier (1922), the Villa La Roche (1923–25), and the Petit Maison for his parents on Lake Geneva (1924) that have been perennially discussed and reproduced, through black-and-white photography and textbooks celebrating them as modern demigods; mankind's final stripping away of the dangerous and seductive colors in favor of a pure, dead white.[40] In this way, as a symbol of modern innovation and greatness, whiteness rose to the status of an unspoken religion but did so only by whitewashing away the many cultures and techniques that it drew from, which we now return to.

THE EASTERN FACE OF "WESTERN" ANTIQUITY

From around 4000 BC to 300 AD, the Egyptian empire bore widespread influence on Greek culture and what was to become a Greek style of art and architecture, evidenced in the Greeks' retention of profiled figures, depicted with flat lines and contours and angular or distorted body shapes. The pre-Greek style, like the Egyptian, was rendered as an objective, external visual field, akin to Western perspective insofar as visual space was a priori rationally delegated.[41] When a nascent Greek aesthetic developed around 600 BC, it diverged from the Egyptian one by turning to subjective perception, or "the knowledge of the artist rather than reality."[42] One example is Socrates's insistence in

Book IV of Plato's *Republic* that he would only want to be caught paint-
ing a sculpture that exhibited the "fairest colors on the fairest parts of
the animal," which, he naturally assumed, would be "purple for the
eyes."[43] In his view, a bold purple was the best way to render *what
appeared to him*—a complete affront to what is still conventionally
(and incorrectly) perceived as a puritan white aesthetic of antiquity. The
transition from Egyptian to Greek aesthetics thus illustrates a move
away from what would de facto in classical, Western art (namely, so-
called objective perspective and crisp white forms) toward instead the
visualization of the subjective and impressionistic. Moreover, the fact
that a tendency toward objective realism first emerged in Africa, *not
Europe*, further undermines the ways yet another coat of whitewash has
placed colored origins under erasure in the service of false claims to
Western culture's original "perspective."

As Greek artists continued to work in this proto-Impressionist fash-
ion, they adorned statues with artificial eyelashes, yellow and green
irises, copper lips and nipples, silver teeth and fingernails, and blue hair
and beards.[44] Even the statue of Athena, goddess of wisdom and war-
fare, was festooned with a golden-colored robe, a goatskin shield, and
red lips and glowing blue eyes made of precious stones to simulate a
flashing effect on top of her "flesh-coloured stone head."[45] After the first
big attempt to build a shrine for the goddess at the top of Athens's
Acropolis failed due to the Persian invasion in 480 BC, Athena was
housed inside the new Parthenon, built between 447 and 432 BC and
dedicated to her by city general and statesman Pericles (495–429 BC).
Athena sat at its center with exuberant colors complementing the
equally bold architectural polychrome around her.

Indeed, the Parthenon, contrary to common thought, was designed
from the start to exude strong, bold colors. The pagan sanctuary had kept
its proud polychrome intact for almost a thousand years, until its destruc-
tion at the end of the Roman empire, followed by a massive fire in the
third century AD, which destroyed the roof and interior. By the end of the
sixth century AD, the Parthenon's ruins were transformed into a Christian
church named "Parthenos Maria," in allusion to the Virgin Mary, until
the thirteenth century when it was transformed again into a Roman Cath-
olic church during the Latin empire of Constantinople, which lasted for
two and a half centuries.[46] Throughout its Christian tenure, countless
coats of whitewash bleached away the chromatic origins and façades of
the original. Pale-bodied frescoes were added, attesting to the newfound
truth of its superior, ostensibly unprecedented occupants.

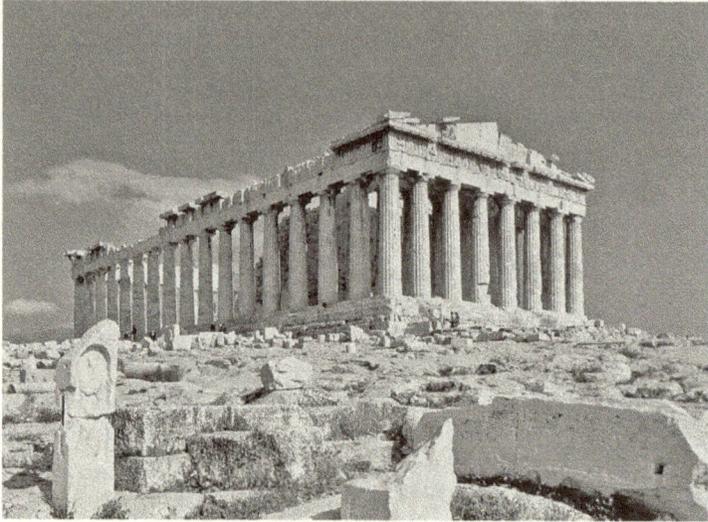

FIGURE 1.3. The Parthenon, Athens, Greece. The archival remnants falsely led historians and archaeologists to believe for centuries that the ancient pagan temple was exclusively white. Photographed by Steve Swayne, 1978.

The Parthenon and its surrounds were surrendered again when Athens was invaded by the Ottoman Turks in 1457. The Christian frescoes were then subject to a new kind of whitewashing, and the pagan temple qua church became a Turkish mosque. As the Ottoman empire expanded over several centuries through southeastern Europe, Asia, and parts of northern Africa, whitewashing was implemented throughout its major cities as law. In Constantinople, whitewash took on the seriousness of religion, an "urban principle and effect defining the whole city,"[47] eventually becoming, several centuries later under the reign Mustafa Kemal Atatürk, part of a government-sponsored crusade aligning whiteness with the supremacy of ethnic Turks.[48]

In 1687, during the Morean War (1684–99), a Venetian missile was launched into the Parthenon, exploding a massive supply of Turkish gunpowder stored inside that destroyed numerous sculptures and architectural artifacts, and wounding hundreds of soldiers and citizens. In the 1700s, then mufti of Athens Mahmud Efendi falsely argued that Pericles had never commissioned a polychromatic pagan temple to honor Athena but had instead intended an all-white building to be there from the start, on par with King Solomon's Jerusalem shrine. Efendi thus instructed his people to build in its place "an outstanding and magnificent temple, unsurpassed in quality. Its walls should be of pure white

marble. The roof . . . should be supported on beams of white marble too, and . . . its ceilings and substructures [should also] be constructed of white marble."[49] Most striking in these relatively late chapters in the Parthenon's history is not the expected whitewashing but rather the great lengths to which Eastern cultures also went, time and again, to cast a coat of whiteness over the colors that came before them from the West (which, before that, came from the East).[50] In the end, distinctions between East and West matter less than the fact of whitewashing as a strategy of transhistorical, transcultural erasure and control.

The Parthenon is invoked here as my primary case study, but it is hardly an aberrancy. When colored statues from antiquity were discovered in Italy in the fourteenth century, they too were dismissed as misnomers, attributed to the culturally "backward" Middle Ages.[51] Archaeologists did not bring forth additional evidence of Greco-Roman polychromatism for another three centuries, until the mid-1700s, when influential German historian Johann Joachim Winckelmann (1717–68) and a team of archeologists encountered "leftover specks of pigment on the surfaces of some marbles"[52] during an excavation. Not surprisingly, this evidence was dismissed, explained away as having belonged to the ancient Etruscan peoples of Northern Italy, not the Greeks, who, they reasoned, could never have created art or architecture in such a tasteless fashion.[53] Winckelmann went so far as to develop an entire edifice of false claims to support Neoclassicism's inaccurate perception of Greek polychrome. Color "should have but little share in our consideration of beauty,"[54] he wrote. It was white, and only white, Winckelmann argued, that determined the relative beauty of a body.[55]

By the eighteenth and nineteenth centuries, at the height of colonial rule and the transatlantic slave trade, it had become illegitimate to even acknowledge that the greatest accomplishments of ancient Greece were once decked in color, let alone bold color of African and Indian descent.[56] Even as late as 1949, claims to Greek polychromatism remained dangerous. German archaeologist Kurt Wilhelm Marek, publishing in Germany under the pseudonym C. W. Ceram, reported the "plastic works of the ancient Greeks were gaily coloured" and statuary were "deeply dyed with garish pigments."[57] It is apropos that Marek published under a pseudonym in the immediate aftermath of the Third Reich, especially given Hitler's exclusive embrace of white marble in what he (falsely) presumed to be the pure white of antiquity. A pseudonym also permitted Marek's research to circulate without fear of his own persecution. Persecution of the ideas he advocated, however, was a different matter. The ideological scaffolding was already too strong; too many (still

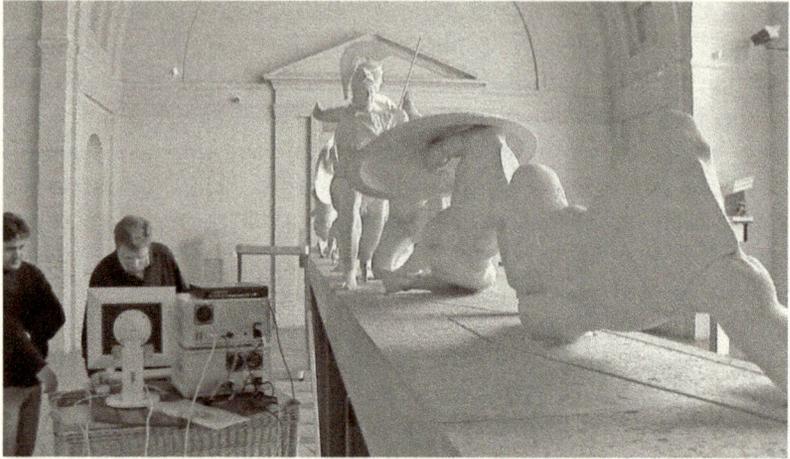

FIGURE 1.4. Video still from Vinzenz Brinkmann, *Bunte Götter* (Gods in Color; Stiftung Archäologie, 2005). This frame shows Brinkmann using spectral technology to detect color analogs for ancient sculptures.

FIGURE 1.5. Video still from *Coloring the Past: An Interview with Vinzenz Brinkmann and Ulrike Koch-Brinkmann* (Fine Arts Museums of San Francisco, 2017). This frame shows a 1989–2003 reconstruction of a Trojan archer from the west pediment of the Temple of Aphaia on Aigina (ca. 480 BC).

largely unconsciousness) ideologues were eager to jump to the defense of the primacy of European whiteness.

By the late twentieth century, technological advancements for detecting color in ancient artifacts promised to bid adieu to these historical fallacies. Objective scientific evidence would, it seemed, finally confirm that almost all Greek sculpture and architecture had been adorned in polychromatic brilliance, "tarted up as any [statue] in Las Vegas," as McCown puts it.[58] In the early 1980s, German graduate student Vinzenz Brinkmann found new evidence of Greek polychromatism while using advanced tools to conduct research for his graduate degree at the Ludwig Maximilian University in Munich. To see the color in more detail, he developed a special lamp that could highlight the artifacts' surface colors but soon realized it was not even needed. Traces of colors could be detected by the eye alone. Brinkmann's initial blindness to the color right in front of him again illustrates how a "collective blindness"[59] has shaped an entire paradigm of chromophobia that continues to thrive in the present just as much as it has in the past.

Even those equipped with sophisticated new scanning technologies—from X-ray to ultraviolet, infrared, fluorescence and Raman spectroscopy—sustained scientific evidence, and new channels of data distribution have not fully swayed from the false notions of whiteness. A handful of curators and conservators, now equipped with these tools, have begun "reexcavat[ing] in our own museums"[60] to confirm the existence of color, such as Courtauld Institute conservator Giovanni Verri, who determined in 2007, by way of "luminescence under infrared light,"[61] the presence of ancient Egyptian blue pigment, but many of the same challenges remain in play. Historians who now accept these chromatic pasts still have difficulty seeing the colors as having been real, let alone elegant or tasteful. For instance, classics professor Fabio Barry in 2018 maintained that the "boldly colored" re-creation of Emperor Augustus at the Vatican Museum looked like a "cross-dresser trying to hail a taxi."[62] In Margaret Talbot's account of her own encounter with a colored reconstruction of Athena, she admitted the "painted and gilded . . . [statue] looked awful: her golden robes had a blinding shimmer, her eyes were a doll-like blue, and her lips could have beckoned from a lipstick ad," reminding her of a "Jeff Koons piece that revels in its tackiness."[63] Even after witnessing these colors directly, our mass "negative hallucinations"[64] blind us to them.

Future scholarship in the history of chromatic media requires such nuanced analyses, placing cultural blindness and material artifacts in a

productive tension. Consider, for instance, simplistic interpretations of the *Republic* that maintain Plato, through the character of Socrates, banned all artists and image makers. Sophists, rhetoricians, and painters, Plato argues in Book VII of the *Republic*, are "creator[s] of phantoms . . . technicians of ornament and makeup."[65] But by far the most poisonous of simulacra for Plato was color: a cosmetic and false appearance that, like the Sophist's "gaudy speeches" and "glistening words," seduce the listener with their "ambiguity and deceiving sparkle."[66] Unlike words, however, color does not even have the benefit of carrying a signifying capacity beyond itself. Color answers to nothing and to no one, and herein lies the source of its danger and fear. But this analysis directly contradicts the pro-color citations from Socrates noted above—how, then, can one make sense of it? Throughout the *Republic*, which, we must recall, is itself framed as a dream, Socrates invokes metaphor, poetry, and double-play to suggest that we *cannot* live without art and poetic expression, which is also to say, color. Colors may be dangerous and abstract, yes, but only because they are so powerful and vital to being. We must keep this productive tension in mind as we move into Christian whiteness and all that lies after and alongside it.

CHRISTIAN WHITE

Mythic whiteness could not be more apropos to Christian imagery.[67] Even amidst common acknowledgments that Jesus was not "white" but instead a dark-skinned Jewish man from Galilee (now Israel), millions of postcards, placards, statues, and related paraphernalia continue to depict him as pale-skinned with blue eyes and light-colored hair. This white-washing of the flesh was instigated through medieval and Renaissance religious imagery, beginning with the central characters of Jesus and Mary, whose newfound lightness came to signify a transcendental relation to being, symbolically implicating all light-skinned Christians as "good" and blessed by a special "culture of light," as Richard Dyer puts it.[68] In some cases, the skin of Jesus and Mary was rendered so white, it appeared to glisten on its own, scintillating and transcending earthly matter altogether, while, in other cases, the surface of their skin was fashioned as a source of light in itself, illuminating nearby faces but never sanctioning them to appear as light, white, and pure as Mary's and Jesus's.[69] The characters surrounding Mary and Jesus simultaneously began to appear darker, inadvertently emphasizing the protagonists' lightness. If darker figures were depicted worshipping the same white

Christ, Dyer observes, such images could be used as religious advertisements, bolstering Christianity's global aspirations alongside European colonialists.[70] By the start of the nineteenth century, the iconic image of Jesus as a fair-skinned white man with blond hair and blue eyes had been ingrained in the Western imaginary as natural and immortally true.[71] Once again, historical amnesia of colored Otherness erects a seemingly ahistorical, universal axiom: the whiter the skin, the closer to God.

Richard Dyer further considers how Christian motifs of light and dark uphold unspoken gender norms and ritualized heterosexuality. If Jesus and Mary epitomize the religion's tension between pure spirit (Jesus) and the virginal body (Mary), then, when extrapolated along gender lines, the implied "ideal" for the male is a militant, hard and lean, disciplined body that also signifies a messianic triumph over the flesh. Likewise, the Christian ideal for the female is pure and virginal, yet also somehow child-rearing. Her paradox is that a woman must be fully devoted to breeding the masculine seed of Christian might while also somehow managing to abstain from bodily exchange or pleasures of the flesh in order to remain pure. Each gender's contradictions pose logical paradoxes still pervasive in (ostensibly) secular factions of contemporary culture.[72]

At the same time, the Christian whitewashing of skin, gender, and sexuality did not appear out of thin air. Rather, like all forms of whiteness, it was fashioned only through a series of iterations that came before it, typically violent in nature, muting the past with a fresh coat of deceitfully innocent paint. Consider, for example, two pre-Christian appeals to "pure" whiteness and women found in the work of Greek military leader and former student of Socrates, Xenophon (431 BC–354 BC).

In his *Memorabilia*, Xenophon submits that a "virtuous" woman (versus a "fallen" one) turns on the distinction between the artificial and the natural. A woman of preferred beauty, he argues, is one who is "fair to see and of high bearing . . . [of] purity [and] eyes with modesty," with a "sober" figure, dressed in a "robe of white."[73] By contrast, a less attractive woman, he determines, is one of artifice and contrivance, being "plump and soft, with high feeding,"[74] adorning herself with makeup to "heighten [her] natural white and pink" and heels to "exaggerate her height."[75] Dressed in this way, she "disclose[s] all her charms," especially when caught stealing "a glance at her own shadow."[76] The sham of color is seen as tantamount to the deception of unattractive women, marked by vanity, gluttony, and indulgence in earthly pleasures, essentially the antithesis to the moral and sensual restraint of the "good," white, Christian woman.

In a later text, Xenophon attacks what he also perceives to be the falsity of attractive women. A woman's virtue is undermined when she adopts the "trick"[77] of rubbing "white lead" on her face to "look even whiter than she is."[78] This deceit, he confides to Socrates, is compounded when she uses "alkanet juice to heighten the rosy colour of her cheeks" or "boots with thick soles to increase her height."[79] These are of course the same tactics used by so-called unattractive women, but the implication here is that when they *succeed* in deceiving—appearing natural and real instead of obviously contrived, producing the effect of real beauty— they are even more repellent (what could be more threatening to whiteness than a woman or color assuming power without detection?). Xenophon concurs. When colors and deceitful ornaments work, which is to say they fail to "disclose" their deceitful nature, they operate akin to faulty merchandise at the marketplace. When selecting a wife, much like purchasing produce at the market, he argues, one should look for the best coloring, which, in his view of women, was a lack of coloring altogether. The "undisguised" body, he instructs, is the "most delightful."[80]

But, lest we forget: "undisguised" skin is still skin, whether on fruit, architecture, or women. No matter how free from blemishes, ornament, or makeup it may appear, skin always bears a surface color of some sort. All skin acts as a concealer: a sanitizing surface and protective dressing for the messy (earthly) matter (fluid, organs, and pests) that lie beneath. Vanity and adornment in a woman's outer appearance are viewed as unattractive because they come too close to home, to that delusionary coat of whitewash that must appear intrinsic and true. If skin, color, or women show themselves as they sincerely are, as powerful and strong in their capacity to seduce the eye and mind, their effectivity threatens to undermine the mythologies of patriarchy and Christianity that keep them dull.

RENAISSANCE WHITEWASH

In the name of health and prosperity "for all," Renaissance men continued to litigiously whitewash the already whitened foundation that lay before them. From houses to bodies, nothing was off limits. The female body was no longer compared to the color of seasoned produce but, now, to dead objects like art and architecture. Renaissance author and architect Leon Battista Alberti (1404–72) best exemplifies this in his writings, which, conveniently, borrowed from Plato, Vitruvius qua Hippocrates, and Xenophon.

Alberti was born in the Genovese colony of Pera (now Istanbul) at the beginning of the fifteenth century. His mother died during an outbreak of the eastern plague, after which he was obliged to move with his father from Western Italy to Venice, where he received a classical education and attended the University of Bologna. Like Le Corbusier, the colors of death and disease trailed closely behind him, tantalizing him to seek the purity of transcendental whiteness as a refuge. These proclivities first appear in his *De re aedificatoria* (*On the Art of Building*, 1443 and 1452), which opens with a lengthy, puritanical discussion on the health in buildings. He draws from Roman scholar and agriculturalist Marcus Terentius Varro who, in 30 BC articulated what can be taken as a proto-theory of germs, based on his observation of potentially contagious microbes in a swamp. Such "tiny atom-like creatures," Alberti acquiesces, could imperceptibly move through the air and enter the nose or mouth, threatening death to those inside the space. [81] His proposed solution came in the form of aggressive domestic sanitization, beginning with the manufacture of lime plaster, a natural disinfectant that, he instructed, should be manufactured with white stones (white clay with small pores or limestone) by placing it in a fire to produce the best white without impurities.[82] The stones should be finished with "the smoothest and whitest surface possible"[83] so that any (colored) foreign bodies could immediately be detected for prompt removal.[84]

In the tenth book of *De re aedificatoria*, Alberti connects the West's early modern aesthetic austerity to a (presumed) civilizational permanence. He cites Cicero's translation of Plato's *Republic*, where ornaments of any sort are banned in favor of the eternal beauty of "perfectly clean . . . white."[85] This allegiance to the classical aesthetic reappears throughout *De re aedificatoria*, especially when alluding to Vitruvius's above-noted address of whitewashing as a means of controlling the "air, light, and water" in order to avoid "pestilence, epidemics and plague."[86] Alberti then takes it a few steps further, however, to loop in race and gender, declaring that only the Romans are fit to "take command" in the house and society, due to their balanced skin color, which is neither too dark nor too light but "temperate," signifying their well-balanced "intelligence, health and courage."[87] To support his claims, Alberti cherry-picks extracts from Plato's *Republic* to highlight its appeal for organizing societies in ways that "free" upper-class men from "any contamination from the common people" and protect the demos "from the Contagion of Foreigners."[88]

In another of Alberti's early texts, *Della Famiglia* (*On the Family*, 1435–44), he echoes Xenophon's dictates in the *Oeconomicus* for "proper" household management. In a conversation between two of the text's three main speakers, Giannozzo explains to Lionardo how he "convince[d his wife] of the danger, as well as of the shame," in wearing makeup, and of the related (economic) necessity for her to remain humble, "virtuous," and "chaste."[89] The section is worth citing in full:

> Thus I spoke to my wife. To convince her still more fully of the danger, as well as of the shame, in a woman's covering her face with the powders and poisons which the silly creatures call make-up, see, dear Lionardo, what a nice lesson I gave her. There was a saint in the room, a very lovely statue of silver, whose head and hands alone were of purest ivory. It was set, polished and shining, in the center of the altar, as usual. "My dear wife," I said to her, "suppose you besmirched the face of this image in the morning with chalk and calcium and other ointments. It might well gain in color and whiteness. In the course of the day the wind would carry dust to it and make it dirty, but in the evening you would wash it, and then, the next day, cover it again with ointments, and then wash it again. Tell me, after many days of this, if you wanted to sell it, all polished and painted, how much money do you think you would get for it? More than if you had never begun painting it?[90]

When a woman's worth is likened to the market value of a "natural" (nonpainted) statue, her exchange value is cemented to appearance alone. The cleanest and purest body (i.e., the highest-valued body) is the one that *appears* protected from "besmirching." If one is caught contriving appearances of cleanliness or purity, by covering the face "with white powder, brazilnut dye, or other make-up," one "spoils" and "wears out" one's market value.[91] Axiomatic whiteness and lightness converge through capital exchange. This passage also sheds light on the ways in which control over women's bodies in Christianity was linked to theology until the Renaissance, when more secular concerns in cultural exchange and law took precedent and the artificial whitening of a woman's face with chalk was eventually prohibited by law.[92] How else to ensure the procurement and retention of whiteness's power and property if not by smuggling it in under the banner of "natural" female beauty?[93]

. . .

By the late sixteenth century, a slew of developments in science and technology cemented the knowing "I" of reason with the white eyes claiming it. Giovanni Battista della Porta (1537–1615) developed the

camera obscura, Johannes Kepler (1571–1630) introduced the first theory of optic lenses, Galileo Galilei (1564–1643) advanced work with telescopes, and René Descartes (1596–1650) employed geometry to illustrate how the principles of light refraction are mitigated through mediated space. All men and devices coalesced in the pursuit of scientific truth, in and through white light, confirmed by the white eye/I of so-called objective reason.

As noted in the introduction, Sir Isaac Newton made one of the most successful pursuits in color studies in the early eighteenth century. Working in a dark chamber sealed off from the (life)world, Newton used prisms and optical techniques of refraction to split beams of "pure" white light into multiple prismatic colors. By 1704, he affirmed to the scientific community that all color derived from white light. White light was pure, whole, and unified, he maintained—a "universal representation"—until it was downgraded by matter, the stuff of the material world that destroyed it by breaking it into color.[94] Once pure white light was downgraded to a secondary status, color could then be quantified (and controlled) into seven distinct hues, he argued, thus propounding a theory of light and color that has since set the foundation in much of the sciences. That Newton's use of seven colors—versus eight or six—was a subjective choice based on his knowledge of the musical scale has conveniently been left out of his "objective" account of the spectrum.

Newton's theory of pure white light and derivative color remained largely intact until it was challenged, not by an Enlightenment scientist but by Romantic poet Johann Wolfgang von Goethe. In his 1810 *Zur Farbenlehre (Theory of Colors)*, Goethe reglorified the phenomenological colors of Antiquity, praising them for their inconsistency and complexity.[95] *Zur Farbenlehre* openly leveraged a tirade against Newton's 1704 *Opticks* by lauding subjective perception as primary in color studies. Color for Goethe (and for Aristotle before him) did not "derive" from pure whiteness or result in seven distinct hues thereafter, but rather emerged from the subtle edges *between* light and dark. Newton's approach "retarded" color studies, Goethe argued, as it removed color from the lifeworld and robbed it of "the perishable and variable properties"[96] that imbue color with its real power to defy the arbitrary rules and protocols that attempt to encompass it.

At the same time, for all he did for color, Goethe's Romanticism did not escape the pervasive self-absorption of white power. Elsewhere in *Zur Farbenlehre* Goethe interprets whiteness as a form of pure and exclusive power ascribed to northern European ethnicities. Only

"uncivilized nations, uneducated people, and children," Goethe writes, "have a great fondness for colours in their utmost brightness."[97] When Europeans import bright and bold dyes from Southern, "primitive" countries, he continues, they subtly integrate them back into their "more refined" tastes and "avoid vivid colours in their dress, the objects that are about them."[98] Goethe thus idealizes phenomenological, experiential color as a poetic and ephemeral delight, while elsewhere he denigrates nonwhite persons, like Plato, Vitruvius, Alberti, Kant before him and Le Corbusier after him. Such xenophobic statements must at this point be seen as more predictable than shocking. Even as a so-called proponent of color, Goethe, like many of us in the global Northwest, have inherited centuries of unconscious ontological and epistemological whitewashing.

In sum, Goethe's white imaginary illustrates how both he and Newton, despite antagonisms in their theories of color, privileged white light and the whiteness of Northern Europe. Goethe's claims for pure whiteness merely reflect the prevalent ideology of European colonialism at a time when, Linda Alcoff notes, "human groups were being allocated a moral and social status based on color."[99]

At the same time, such practices, as we have seen, extend back through several centuries, making it impossible to find a European thinker or practitioner from antiquity through the Enlightenment who did not in some way uphold the values of mythological whiteness. Even modern critiques of "pure white light"[100] and "transparent truths" in the work of Friedrich Nietzsche (and, less surprisingly, Martin Heidegger) cater to notions of grandeur and supremacy, attributes that have made their work attractive to the far right.[101]

THE WHITE EYE OF REASON

Loosely positioned in the eighteenth century, the European Enlightenment is defined by an expansive white imaginary, magnifying the Renaissance's purification of bodies and spaces into a totalizing episteme, fortified, again, by so-called objective actors endowed with the exclusive power of universal judgment. Because the pervasiveness of the Enlightenment's white imaginary falls beyond the scope of any single study, I here focus only on excerpts from the era's most iconic (and arguably problematic) thinker, Immanuel Kant (1724–1804).

The Enlightenment paradigm culminates with, and is subject to critique in, Kant's capstone works—the *Critique of Pure Reason* (1781),

Critique of Practical Reason (1788), and *Critique of Judgment* (1791). This trilogy, in addition to his later *Anthropology from a Pragmatic Point of View* (1798), an annual lecture series that Kant gave from 1772 through 1796, provides the most fruitful points for interrogating whiteness in Enlightenment thought, with an eye turned toward the aesthetic and moral claims leveraged therein.

In the *Anthropology*, Kant introduces to the German university "anthropology" and, later, "geography" as serious branches of academic study. This fact may come as a surprise, given Kant's normative and exclusive tethering to so-called Continental philosophy, but closer inspection reveals it is not a divergence from philosophy, due to the unique way Kant interpreted these terms (a) as a branch of metaphysics and (b) as inextricably bound "twin sciences." In this work, Kant proposes a new method for the study of "man" in varying historical epochs, in conjunction with axioms perceived to be fixed, permanent, and enduring in human nature (what will later form the basis of Kant's "moral law"). His theory leads him to conclude that while racial differences between groups are innate, they could be observed only externally, in the physical world (binding the anthropological to the geographical). This implicit racial hierarchy, once it was covert and safely embedded in Kant's "moral law," soon became the handmaiden of outward racial bias and, increasingly, systemic stratification in the Enlightenment's various quasi-scientific racial grammars.

Other selections from the text evidence a more explicit racism. For example, "the white race," he writes, "possesses all motivating forces and talents in itself."[102] Or, as offered in section 4 of his *Beobachtungen über das Gefühl des Schönen und Erhabenen* (*Observations on the Feeling of the Beautiful and the Sublime*, 1764), a race-based outline of "national characteristics" drawing from the four-continent system noted by Linnaeus in 1735, including white (Europeans), yellow (Asians), black (Africans), and red (American Indians), with a climatic coating (as introduced by Comte de Buffon qua Hippocrates) to create a hierarchical chart of skin color as evidence of "racial" value, albeit doubling as a chart of humankind's geographical-psychological (moral) classifications:

STEM GENUS: white brunette

First race, very blond (northern Europe), of damp cold.

Second race, Copper-Red (America), of dry cold.

Third race, Black (Senegambia), of dry heat.

Fourth race, Olive-Yellow (Indians), of dry heat.[103]

Unfortunately, such claims are common in this text and many others of this era, and yet they are rarely highlighted in the thousands of philosophy courses devoted to Kant and his "pioneering" contributions to the field. Nonetheless, my concern here and throughout much of this book is to identify when, where, and how whiteness operates through more subtle routes, without being detected, at least not at first.

To start, consider the role of color in Kant's aesthetics. In his early aesthetic philosophy, color (in the fashion of Plato, Vitruvius, and Alberti) is relegated to the domain of "merely agreeable things" that speak to the "tongue, the palate, and the throat" but never beyond it—eternally barred entry to the transcendental aesthetic. White remains absent from this discussion, presumed to be a noncolor that escapes both critique and the materiality of being. Enlightenment whiteness rides high on transcendental aesthetic judgment, remaining absent and therefore seemingly objective, endowed with the exclusive power to designate Other objects and phenomenon as Beautiful or not. Moreover, transcendental aesthetic judgments are necessarily deemed universal ("the claim to universality is such an essential factor of a judgement by which we describe anything as beautiful"),[104] and thus perpetuate white mythologies of originality by virtue of absconding from contingency or flux.

Revisiting Kant's *Critique of Judgment* also allows us to reconsider the intricate ways whiteness infiltrates Enlightenment distinctions between subject and object, as an extension of the distinction between the particular and the universal. For example, *how* one arrives at decisive judgments of Beauty is contingent on *who* is doing the judging, where one does it, and for whom. The first step in this edifice is the passage from the particular to the universal. Instead of considering one's singular interests or delight (a preference, say, for the color violet or apple pies), one must evaluate an "object as . . . containing [the] ground of delight for *all* human beings."[105] One must suspend personal pleasure to "judge not merely for himself, but for everyone," and only then is he (and it is typically a he) able to "speak of beauty as if it were a property of things."[106] Kant provides another example in Section 33 of the *Critique of Judgment* when he explains how one acknowledges a single "tulip is beautiful" and then extrapolates from that point to claim that "all tulips are beautiful." But who is this "one" permitted to make universal claims, and who is

excluded? The shift from the particular to the universal invokes a fresh coat of whitewash apropos to the Age of Reason, smuggled in under the auspices of an unproblematic transcendence from "one's" particular subjectivity to the lofty abstractions of aesthetic judgement proper. The "one" who makes this move is also the one who can readily detach from unmarked bodily matter to make claims "for everyone," safely, inconspicuously, and without being challenged in the process.

The move from the particular to the universal is pervasive not only in Kant's work but also in much of the canon of Western philosophy. David Lloyd argues that this structural logic instantiates a "hierarchy of the senses" that privileges (whitewashed) abstract truth over base matter, engendering a racialized (white) "subject without properties"[107] qualified by an undisputed authority.[108] Likewise, in George Yancy's view, "whiteness" necessarily constructs a sense of selfhood as a "site of exclusive transcendence."[109] Who has the right to presume and judge "for everyone" is clear: the subject who cannot be seen, labeled, or embodied in the lifeworld, an imaginary "One" forever unmarked by gender, color, sexuality, class, religion, or ethnicity. The conditions of possibility for producing "universal" judgments are thus very much about color insofar as the particularity of the latter is removed from the equation in order to clear the way for the former.[110]

A similar dynamic runs through Kant's theory of the public sphere. While my focus in *Electrographic Architecture* lies with architecture and aesthetics, it is worth pausing to understand these undercurrents as further evidence of how yet another coat of whitewash imperceptibly permeates the history of political philosophy. In the eighteenth century, Kant viewed the apex of "civilized" human development as a "disinterested" public sphere, one that (ostensibly) congregated knowledge and values for the eponymous good of "all." In order for knowledge to rise above the level of the "common" and "vulgar" into the civilized, public sphere, it was necessary for the "*sensus communis*" to draw from a collective knowledge base, a "shared" faculty of judgment, and then, in turn, determine the appropriate "mode of representation" for "*all* other men in thought."[111] Once again, judgment by a few is presumed to adequately stand in for all, repeating the same above-noted move from the particularities of a (privileged) few to the universal. Here, however, we also see a tautology ensuring the move from a "vulgar" material base of "common" sense to a so-called general One, a priori excluding diversity. The very notion of a "public sphere," by this definition, erases the conditions of possibility that would allow for internal difference.

The public sphere is another One—singular, generic, invisible—what Bolívar Echeverría theorizes as the *blanquitud* of whiteness that becomes law.[112] As Lloyd puts it, "Universality is attained by virtue of literal indifference: this Subject becomes representative in consequence of being able to take anyone's place . . . a pure exchangeability."[113] Lloyd's invocation of exchangeability returns us to capital markets—for women and fruit—and their affiliation with commercial aesthetics, further explored in chapters 3, 4, and 6 in the context of large-scale electric spectacles.

. . .

In sum, in Western European intellectual traditions deriving from the Enlightenment, a white imaginary of superiority persists through an often-unconscious yet privileged capacity to become absent and universal, epitomizing the white subject as a "subject without properties."[114] Self-absorption through obfuscation operates as yet another layer of epistemic violence[115] that occurs each time a (white, invisible) subject is permitted to stand in for a common view or universal claim about a people or the world itself.

The following chapters depart from Europe's white imaginary to consider how consonant structural claims incur in America's white imaginary. This chapter's expansive genealogy has highlighted whiteness's perennial malleability, articulating the way it slips and slides through the dirt and mud of the home; the propertied wife; Western philosophy; and Christianity. I have attempted to use critical media archaeology to illustrate how whiteness is in no way tied to universal, transhistorical, or objective axioms, yet, because it remains so deeply ingrained in the global North and West, many people, especially so-called white people, fail to see it, even when looking.

Chapter 2 builds on this critical archaeology to chronicle the path of synthetic lighting systems in the United States, from early experiments with man-made light, through Edison's incandescent light bulb in 1879, to battles for ownership and control of the new white light empire. Together, chapters 1 and 2 lay a foundation for understanding the complex ways American whiteness imbues itself, consciously and unconsciously, in the history of electrographic architecture.

Edison's White Light Empire

1750–1881

The power of light is twofold, signifying a material source of illumination and a symbolic axis through which the former gains cultural value. As a result, access to the brightest and best-quality light has always been a question of power and privilege. Whether primitive oil lamps, candles, incandescent bulbs, or condos in the sky and LED jumbotrons in Times Square, the allocation of light's material resources is shaped by the way a culture uses light-as-power to manage and control bodies in space.

French philosophers Michel Foucault (1926–84) and Gilles Deleuze (1925–95) independently theorized two models of social control equally dependent on light and power: the "disciplinary society"[1] and the "society of control,"[2] respectively, both of which apply to this twofold facet of light-power. The "disciplinary society," according to Foucault, emerged in the eighteenth and nineteenth centuries and extended into the early twentieth century and was characterized by a social and political infrastructure of surveillance, optics, and vision for policing bodies through discrete zones and spaces (*discipline* is a translation of Foucault's French term *surveiller*). In a disciplinary regime, a subject-effect is created through a series of mechanical yet fictitious relations: a subject believes he is being watched, even if he is not (what Althusser later theorized as "interpolation"). Foucault invokes Jeremy Bentham's Panopticon, where prisoners are positioned in a circular formation of cells all facing inward toward a central (opaque) tower, a symbolic extension of a central surveilling eye that produces a psychological

condition wherein the subject's behavior shifts in response to the *idea* of being watched.[3] Contemporary examples include tracking workers through video feeds openly installed in the workspace, and the hyperbolic surveillance of travelers at an airport.

Cast as an extension of, and in contrast to Foucault's disciplinary model, is Gilles Deleuze's 1990 theory of the "society of control." For Deleuze, the society of control emerged in the period following the Second World War and extends through the present. Characterized by the breakdown of discrete boundaries and the ongoing, continual processing of information, technologies of the society of control emerged from postwar cybernetics and information systems. These technologies encompass codes, passwords, capture systems, and tracking technologies.[4] Examples include tracking workers, citizens, and customers through RFID (radio-frequency identification) chips, cell phone data, and user behavior.

While the distinction between these two regimes indicates a fundamental shift from the deployment of optics for controlling bodies to the use of information systems to do so, both are nonetheless rooted in the visual field. Even digital passwords and social media networks require users to see, input data, and swipe cards in order to trigger behind-the-scenes algorithmic processing (and thus the book's conclusion argues that today's seeing eye is the algorithmic eye). In this way, both the disciplinary society and the society of control belong to what Richard Dyer nominalizes as a wider "culture of white light"[5] undergirding the history of the global Northwest. And, indeed, both models position the logos of the seeing or knowing eye/I of reason as the pure, white light of truth.

More recent scholarship on Dyer's "culture of light" has articulated its predication on racialized bodies. "The ontological conditions of blackness" in the West, Simone Browne observes, is integral to all theories of surveillance.[6] Browne draws from John Fiske's work, which draws from Foucault's and George Orwell's works, to argue that "today's seeing eye" is unequivocally "white."[7] This is not to propose that only white people monitor persons who are not white, but rather to indicate, again, that the pervasiveness of whiteness in the global West extends well beyond the surface of white light and bodies, to attitudes and behaviors rooted in invisible and yet pervasive systems of power and control. As Isabel Wilkerson puts it, social hierarchy "is not about feelings or morality. It is about power—which groups have it and which do not."[8]

Where chapter 1 charted an archaeology of whiteness through the combined developments of Euro-American philosophy, architecture,

and Christianity, this chapter extrapolates these forms of acumen into the history of the lightbulb and related sources of illuminated light implemented in America in the nineteenth and early twentieth centuries. It begins with some backtracking through pre-electric, man-made sources of artificial illumination (oil, gas lamps, and candles) and then turns to the profound advent of electric light in the 1890s. The chapter next focuses on Thomas Edison's white light empire, a model of American entrepreneurship largely synonymous with America's new white imaginary.

ELECTRIC LIGHT PRECURSORS

The light and fire from the sun provided a primary source of food and warmth for the planet for millions of years. Ancient Egyptians believed sunlight offered mystical healing properties, while the harnessing of fire on earth came only after hard-won techniques rubbing hard and soft wood together to ignite a flame.[9] Fire on earth, like the fire from the sun, was seen as a symbol of mystery and destruction.[10] Ancient bonfires were seen to conflate "the unruly powers of fire" with a Dionysian "outpouring of ecstasy,"[11] Wolfgang Schivelbusch notes, facilitating a visual pleasure in light-based spectacle that has captivated human civilization ever since (today, the blue-lit screens hailing our unwavering attention offer yet another case in point).

Greco-Roman cultures developed open-flame lamps with semi-enclosed reservoirs to protect the oil from dirt, flies, and wind while still allowing the flame to burn in open air. Gradual improvements led to lamps created from shells, pottery shaped in the form of slippers, and the use quality fats and oils with a sufficient concentration of tallow to ensure a clean and steady burn. Rare and expensive oils like beeswax were used by the privileged and wealthy, such as the Roman Catholic Church, while those without access to quality oils resorted to pressed oil from fish, vegetables, or whatever was available, settling for "less pure" sources to heat food during the day and provide light during the night.[12] On both ends of the spectrum, people grew to depend on sources of artificial illumination, even as the systems of illumination they used were far from reliable (candles tended to melt in warmer weather and the intensity of the flame diminished as it burned down the wick).[13]

By the Middle Ages, human activities still largely depended on available daylight.[14] In many cities, the end of daylight hours was announced by clanging bells declaring "all ordinary citizens were required to return

to their home for curfew."[15] In some cities, inhabitants were required to hand over their house keys to authorities to ensure they would not go out after dark and would extinguish their cooking fires, the disregard of which would result in hefty fines. Prior to the advent of street lighting (an early form of social control by way of illuminants), enforcing a curfew and restricting peoples' movement after sundown was a central means of maintaining order.[16]

Compulsory curfews doubled as a surveillance tool for monitoring the activities of a city's or town's inhabitants and the entry of foreigners.[17] When the gates to a city closed after dark, officials unraveled chains across the roads to bar entry, while designated watchmen roamed the streets with torches and lanterns to detect misconduct. Light-controlled cities and towns, like whitewashed homes and wives (see chapter 1), needed protection from the intrusion of foreign Others. These night watchmen, valorized in HBO's *Game of Thrones* (2011–19), for example, were often the sole group of inhabitants equipped with a night light. Some night watches consisted exclusively of authorities, but more often than not they were composed of regular working citizens charged with the additional task of getting up in the middle of the night and standing watch on the city.

According to a number of accounts, the origin of street lighting can be dated to London in the 1600s, where lamps were installed "for the purpose of diminishing crime."[18] Other sources locate the first street lighting systems to the installation of oil lamps on Parisian streets in 1667.[19] Either way, by the second half of the seventeenth century, major European cities from England to the Netherlands and central Europe had acquired some form of public illumination for their main throughways. As this occurred, once again, the wealthy and privileged were the first to access the scarce resources, including a steady supply of quality fuel and lighting materials to brighten and warm their homes and shops and to garner an ethos of safety and security that could only be gleaned from the power of clear, white light.

This widening gap between the power of the wealthy and the poor's lack of it was especially pronounced in France during King Louis XIV's (1638–1715) extreme hoarding of light resources. In the court itself, fresh candles were the only candles permitted to be lit. Candles that had been snuffed prior to their exhaustion were gathered by the court's "ladies-in-waiting," who made a practice of reselling the expensive wax in the town, where, on the other side of the courts' walls, peasants were

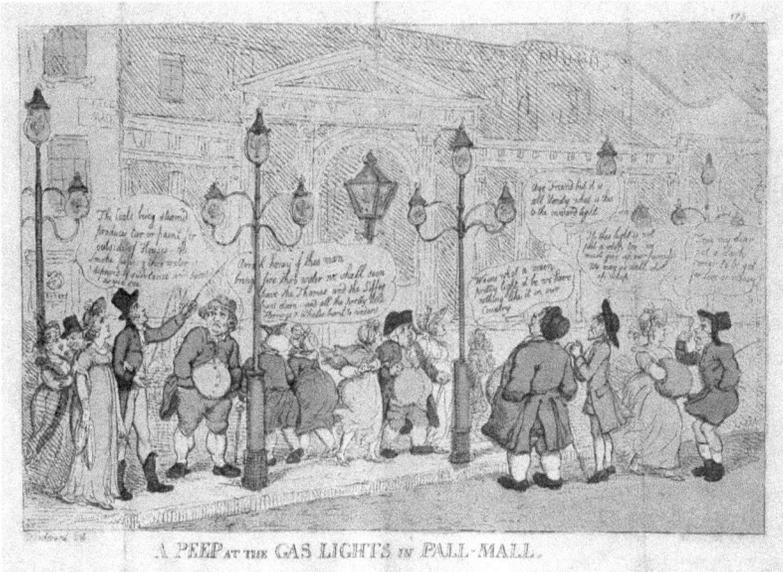

FIGURE 2.1. "Peep at the Gas Lights in Pall-Mall." Engraving by Thomas Rowlandson, 1809. Retouched. The illustration offers a caricature of the hoopla surrounding the installation of gas-burning street lighting on Pall Mall in London. Image courtesy of Wikimedia Commons.

starving from a lack of nutrition and fulfillment of their basic needs (let alone access to candles or beeswax for interior or exterior light).[20]

By the seventeenth century, a number of European and American cities made street-facing candle lighting mandatory in windows for several hours after sunset.[21] Such laws allowed authorities to monitor the comings and goings of residents and provide indirect street lighting where it was not yet installed. But, again, only those who could afford such lighting systems would benefit from the safety provided by this law.

As public street lighting developed over several decades, it quite predictably serviced financially lucrative neighborhoods first and foremost. By 1763, Paris had a population of roughly 600,000 people, but only 6,500 were equipped with street lighting.[22] In other cities, night watchmen continued to prowl the streets, especially in American cities (still viewed as a secondary colony relative to Europe) where many were left in the dark until the colonists turned to wood and oil products to produce illuminants, similar to the way the Greco-Romans had, several centuries prior, resorted to high-quality oils when they were without

wax. Such innovations helped watchmen in cities like Boston and New York keep their "iron fire baskets filled and burning"[23] through the night.

The American demand for lighting grew apace with the expansion of colonialism in the 1700s and the transatlantic slave trade.[24] After Benjamin Franklin (1706–90) was elected president of the Academy and College of Philadelphia in 1751 (what would become the University of Pennsylvania), he advocated laws for permanent white light on American streets, thereby expanding the rudimentary system of lighting he helped set up in Philadelphia to other cities in the nation.[25] To be clear, street lighting in the 1750s was hardly the street lighting we are familiar with today. Cities employed *réverbères*, oil reflector lanterns designed with a double wick and two reflectors inside a glass chimney to enhance the illuminated light cast by the flame. One reflector was positioned directly above the flame to reflect light downward, while the second, concave reflector was placed beside the flame to "direct the light outward."[26] The lamp's use was restricted to wealthy persons and city centers not so much because of its cost as because of the amount of oil it required. "Brilliance came at a price," Brox writes, and "the [poor] knew it."[27]

For the wealthy and privileged, white light also meant a newfound freedom to travel through previously obfuscated nighttime landscapes. The formation of the "public sphere," as Jürgen Habermas would later term it, was largely contingent on institutions acquiring access to light for night life, including theaters, urban societies, associations, evening lecture series, and of course, coffeehouses and restaurants serving tea, coffee, chocolate, and other stimulants. In eighteenth-century Paris, artificial illuminants became increasingly common among the well-to-do who preferred new lifestyles, spending time out at night, hosting and attending parties and dances, and waking up later in the day without having to go to work.[28] These nocturnal light luxuries became a catalyst for dissent in Paris, just as they had in Versailles during the reign of Louis XIV. Parisians took to lantern smashing as a symbol of defiance and rebellion against the oppressive state regime. The darkness produced by the aftermath of a smashed lantern created chaos, but also a temporary place of alterity that seemingly escaped the controlling eyes of the law.[29]

Coincidentally, it was not until innovations in street lighting caught up with the social demand for it and a growing number of petitions for more light at home and work that public lighting systems became cheaper and widespread. This was in large part due to the work of several scien-

tists, among them Swiss scientist François-Pierre Ami Argand, whose 1780 Argand oil lamp offered several notable improvements on previous technologies. For one, Argand oil lamps permitted oxygen to enter at its base, creating a flame that could emit light ten to twelve times more efficiently than preexisting sources. For another, the lamp generated very little soot or smoke, improving air quality. The apparatus was also silent and malleable, and perhaps most important, it was economical. The shopping arcades of Paris and London in the late eighteenth century were the first public spaces illuminated with Argand lamp systems. The gas industry invested in elaborate underground piping networks to avoid the hazards and pitfalls of bulky wiring hanging from utility poles (a severe drawback recently encountered with the construction of telegraph and telephone wires).[30] In London, nearly fifty gas meters, equipped with several hundred miles of underground gas lines were used to supply light for more than forty thousand public gas lamps.[31] By the 1820s, gas lighting had been installed in New York, Chicago, and Baltimore.[32]

Gaslight seemed ideal. When it worked, coal gas combustion burned with a whiter, clearer flame, improving on the reddish-orange glow produced by previous light systems such as oil lamps, tallow, whale oil, or candles.[33] Gaslight's relative cleanliness and proximity to whiteness is also how New York City's "Great White Way" attained its moniker at the end of the nineteenth century (see chapter 3) and a new world of nighttime play and nocturnal desire finally reached the public en masse. At the same time—as we are now well aware—gas lighting was far from utopic. It quickly became evident that gaslight was highly toxic. Not only did gas inhalation cause headaches and sweating, but the burning of gas also emitted a significant amount of ammonia, sulphur, and carbon dioxide. Gas inhalation was so pervasive that by midcentury gas poisoning became a standard method of committing suicide.[34] Gaslight was also unreliable and highly volatile, relied on crude equipment, and produced an excess of heat in interior spaces.[35] The flame alone produced so much soot and acid residue that it "blackened the ceilings" and tarnished upholstery and paintings with a yellow-brown to black smoke.[36] Because it also consumed a large amount of oxygen in interior spaces, people suffered headaches in poorly ventilated rooms; from the start, gas lighting was therefore restricted to large, open spaces such as factories, opera houses, and theaters.[37]

Producing fuel for gas, we are also now acutely aware, is environmentally damaging. Gas fuel is fabricated as a byproduct of the distillation of bituminous coal into coke, which generates hydrogen sulfide and

carbonic acid, two compounds that release a noxious smell into the air and contaminates the soil and groundwater.[38] According to a report published by the Medical Officer for Health in 1860, in London alone 386 million cubic feet of gas escaped into the soil every year. Other accounts double this number.[39] Moreover, factories producing coal, with its foul smells and toxins, were often located in poor, industrial neighborhoods (as their analogs still are today). In sum, the perception of gas as an ideal form of clean white light was short-lived.

ELECTRIC LIGHT

In 1893, a General Electric Company report entitled "Triumphant Industries" opened with Emerson's claim that if "steam was half an Englishman,"[40] electricity must be "half American."[41] He was quite correct. But why? What is it about electricity that makes it so American? Or, more to the point, what is it about America that has made the power of bright, electric light so central to its material and fantastical being?

Prior to its American debut, some of the first developments in electric lighting were conducted by British chemist and member of the Royal Institution of Great Britain, Humphry Davy (1778–1829), who furthered Count Alessandro Volta's (1745–1827) work with electricity through a series of electrolysis experiments that led to two pivotal discoveries. First, an 1802 demonstration of ephemeral incandescent light using a platinum filament that illuminated once it was heated to a very high temperature.[42] Even though Davy's incandescent illumination could not be controlled or stored, it nonetheless served as the first of its kind and a direct precursor to Edison's iconic bulb. Second, in 1808, Davy exhibited a fascinating new phenomenon known as arc lighting, a powerful hybrid of gas and electric light that produced illumination from an electric discharge between heated and spaced carbon electrodes.[43] Davy demonstrated his arc light at the Royal Society in London, powered by an extremely large battery consisting of two thousand pairs of plates that he developed in his laboratory's basement. His demonstration awed members of the Society as his "Voltaic arc" passed a current through a stick of charcoal (serving as a conductor) and then jumped between two additional pieces of charcoal placed at either end, which he slowly began to pull apart until a "brilliant blue-white light leapt across the heated air between them."[44]

Harnessing arc light for commercial power was a top priority for American entrepreneur and inventor Charles F. Brush, and he accom-

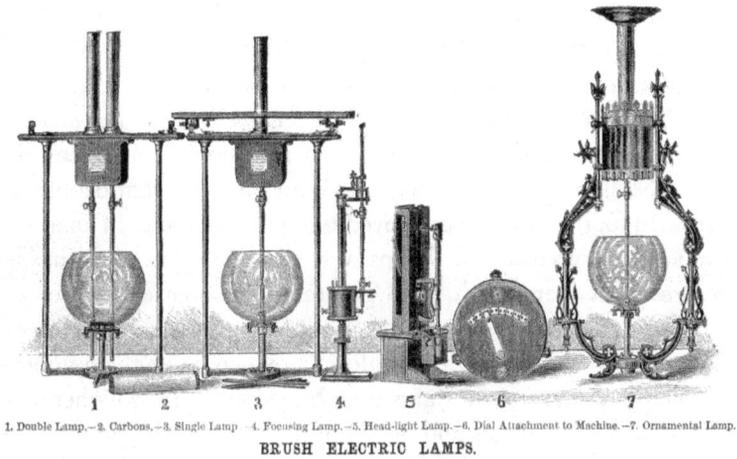

1. Double Lamp.—2. Carbons.—3. Single Lamp 4. Focusing Lamp.—5. Head-light Lamp.—6. Dial Attachment to Machine.—7. Ornamental Lamp.
BRUSH ELECTRIC LAMPS.

FIGURE 2.2. Brush Electric Company, 1881, woodcut print. Seen here are a variety of the hybrid gas and electric arc lights made by the Brush Electric Company of Cleveland, Ohio. Image courtesy of *Scientific American.*

plished it in 1876 with a series of designs for affordable and reliable lamps.[45] Along with improved constant-current dynamos, based on English scientist Michael Faraday's 1831 rudimentary generator, Brush's arc lamps were primed for implementation on city streets.[46] The first major installation occurred in Paris in 1873, but by 1876, arc lighting had been made commercially viable across the continent, thanks in large part to Brush and the work of Russian electrical engineer Pavel Yablochkov, who had moved to Paris in 1875 to develop "Yablochkov candles," or functional arc lamps made of carbon filaments insulated by plaster of Paris or a clay mineral known as kaolin. In collaboration with Belgian engineer Zénobe Gramme, Yablochkov installed his lamps in Parisian department stores on the Avenue de l'Opéra in 1877, and again in 1878 at the Place de l'Opéra for Paris's third World's Fair, the Exposition Universelle, held from May through November.[47] Shortly thereafter, he installed the same lighting systems along the Victoria Embankment in London and in a number of other European cities, typically on major streets and throughways.[48] It was the Brush Electric Light Corporation, however, that dominated the lighting industry in England (and eventually in America), its stock reaching an approximate valuation of $4 million by 1881.[49]

In the American market, Brush publicly unveiled twelve of his two-thousand-candle power lamp devices in Cleveland's public square in

April 1878, marking the installation of the first permanent public street lighting in the nation. On July 4, 1879, he debuted his lamps once again at Niagara Falls and, later the same year, established the California Electric Light Company and the Brush Electric Company in 1881.[50]

Even though the quality of Brush lights marked a dramatic improvement on the dirtier, yellow tinting of oil and gas lights that people were accustomed to, their brilliance proved *too* overwhelming. In an attempt to temper their intensity, the lamps were placed on top of twenty-foot poles, but even there, each lamp generated an intense circle of light between 200 and 300 feet in diameter.[51] Reports from the time consistently note their "harsh, unearthly glow,"[52] which made them unbearable for many. Even after the lights were hung significantly higher on the street than the existing gas and oil lamps, their light still "poured down over large areas," bounced off walls, and entered so far inside homes, one could "see the flies on the walls and read a newspaper streets away from the source."[53] Brush developers next implemented white globules made of frosted or opalized glass and, in some cases, "opal and lemon colored globes" to appeal to the "fair sex"[54] and to mitigate their overall harshness. While the filters alleviated some of the starkness, the lamps remained relatively intense and most uses were restricted to large factories, retail settings, and outdoor spaces.[55]

Electric generators that could consistently subdivide electric currents would help, but that need remained unfilled. Further, without subdividing systems, an accident in one part of the system would jeopardize the entire circuit, not to mention preventing the manipulation of currents to travel in smaller packets to reach longer distances.[56] There was also still an acute need for a light standardization system that would regulate the flow of electric currents across different lamps and power systems. These tasks fell to Thomas A. Edison.[57]

AN AMERICAN EMPIRE

Thomas Alva Edison's (1847–1930) white light empire was quintessentially American. Business and profit were the goal, and increasingly larger spectacles with brighter, whiter lights were the best means of achieving it. This is not to say that America's iconic inventor-hero did not also work exceedingly long hours and was not extremely dedicated to his work and team of engineers—over the course of his life, Edison acquired 1,093 patents, the most issued to any individual to date.[58] Rather, it is to say that each innovation was always topped by aggres-

sive showmanship, business savvy, and a team of lawyers eager and willing to attain market control. Because numerous books have already covered the fascinating life and history of this figure,[59] in this section I focus only on how Edison's introduction of the incandescent bulb intersects with the book's analysis of a specific form of American entrepreneurship in step with the formation of the country's white imaginary. I am also less concerned with the technological specificities in this history than with the ways Edison's visible and invisible market strategies secured him an international monopoly by leveraging "fake news" (as we call it today); alignments with high-powered investors; antagonistic patents, legal disputes, and cartel arrangements; and dubious public marketing and self-promotion strategies.[60] After a brief biography, the remainder of the chapter turns to an exegesis of these four, intimately intertwined tactics.

Edison was born on February 11, 1847, in Milan, Ohio, though he grew up in Michigan, witnessing radical innovations at the dawn of the electric age. At the age of twelve, he took a position on the Grand Trunk Railroad selling newspapers and candy and, unbeknownst to his employers, set up a laboratory in the baggage car to conduct chemistry experiments and launch the *Grand Trunk Herald*, the first newspaper published on a train from a printing press rigged in the baggage car. While on duty one day in 1849, Edison noticed a three-year-old boy in danger of getting hit by an oncoming box car. He swiftly recused the child and the appreciative father rewarded him with lessons in telegraphy, which eventually helped land him a series of jobs as a telegraph operator between 1863 and 1868.

Edison next went to work for Western Union in Boston, but resigned within a year, after declaring his goal to become a full-time inventor. When he moved to New York City in 1869 to pursue this objective, he was homeless but, before the end of the year, had secured his first patent for the electric vote recorder.[61] Shortly thereafter, he secured a second patent for his electric stock ticker (1871).[62] After selling these patents to finance the construction of his Newark laboratory, where he moved his work to in 1872, he stayed for four years, then relocated to Menlo Park, where he would remain for several years and, by November 15, 1878, found the Edison Electric Light Company (EELC).

Edison was one of the first scientist-entrepreneurs to fortify the truly American bond between innovation and profit. His projects were systematically conceived to "incorporate economic factors within technical designs,"[63] as Thomas Hughes puts it, including his 1877 goal to

find an effective means of subdividing light. The capacity to subdivide a powerful current into derivatives would, as we now know, yield enormous profit as it enabled electric light to service interior spaces, which preexistent arc light systems could not. As long as he "set the price for light equivalent to the [then-still-dominant] price of gas light,"[64] Edison reasoned, he would be on "the path for the greatest profits."[65] There is of course nothing wrong with turning a profit; what was questionable were the ways he did it.

Fake News: White Light Economics

The first and perhaps best-known instance of the EELC's questionable tactics occurred in the well-known rivalry between Edison's DC (direct current) and Tesla's AC (alternating current).

Born in Croatia to Serbian parents, Nikola Tesla (1856–1943) immigrated to New York in 1884,[66] and after a brief stint at the Edison headquarters and a fallout between him and Edison regarding the relative merits of direct versus alternating current, Tesla relocated to Lower Fifth Avenue (now West Broadway) to perfect his elegant polyphase system of AC dynamos, transformers, and motors. His genius inventions were quickly recognized in the industry, purchased by George Westinghouse in 1885, and featured on the front page of the *Electrical Review* in August 1886.[67] Tesla's AC system—which is to say Westinghouse's system—posed the greatest threat to the Edison empire.

After developing a rudimentary DC electric current in 1878, largely modeled on preexisting gas systems, and using it to patent the first commercially viable incandescent bulb in 1880 (and much-needed improvements in 1881), Edison promoted the bulb as markedly "softer" and gentler on the senses than the crude outdoor arc lamps, or than (what he posited as) the dangerous AC bulbs.[68] Edison and assistant William J. Hammer traveled throughout the United States and abroad exhibiting their bulb in grand displays and theatrical presentations ostensibly illustrating how his light was superior to and avoided the hazards of Tesla's AC system, claims he "proved" by using AC current to publicly electrocute "dogs and cats by wiring them to metal plates" and "frying them with volts."[69] Such gruesome and unnecessary performances were merely part of the EELC's larger public relations strategy to acquire success at any cost, even if it involved generating "fake news."

EELC's next step was persuading the New York State Legislature to make electric power voltages of 800 volts illegal, which would have

criminalized Tesla's experiments and ended the use of alternating current in New York.[70] If the state criminalized high-powered electric currents, the rest of the country would follow suit, he reasoned, and the Edison empire would retain its monopoly. His plan was ruined at the last minute, however, when George Westinghouse stormed the courthouse and threatened to "sue everyone in sight for conspiracy."[71]

Tesla endeavored to counter Edison's ghastly demonstrations of AC current by proving that it was safe through public performances permitting the current to flow through his body at extremely high voltages. He—like the ancients—reframed electricity as a medium and phenomenon that could promote life and health. It was only when it was handled incorrectly, Tesla argued, that it could become dangerous.[72] In February 1892, Tesla gave two lectures in London and Paris during which he used Geissler tubes to procure spectacular effects by bombarding gases with high-voltage alternating currents.[73] One of his phosphor-coated tubes was arranged to spell out the word LIGHT, an allusion to, and upstaging of, Edison's assistant William Hammer's performance in London eleven years earlier, when he used direct current to spell out "EDISON" using incandescent bulbs.[74] Tesla's demonstration was deemed a sensation and a provocation in the scientific community. Further, because his AC current could travel long distances to those who lived outside the city center (unlike the DC system, which could travel only short distances), he was able to promote AC power as the "people's power."[75] By 1889, a device was developed that combined both systems, which EELC ceded to, while the AC current became dominant elsewhere. It was not until 1910 that Edison admitted his DC system "had been his greatest career blunder."[76]

Investor Power

The launch of Edison's power station at 255–257 Pearl Street in Lower Manhattan in 1882 was the first central electric station in the country. Pearl Street is a long winding street, stretching from Fulton Street to Battery Park at the southern tip of Manhattan and charting a central vein through the city's lucrative financial district. Prior to the Pearl Street Station, the Wall Street district had made its name in the annals of artificial illumination as the first location in the country supplied with public lighting of any sort—gas lamps and then arc lights. The New York Stock Exchange (founded in 1817) was outfit with three large, sixty-six-bulb chandelier-style fixtures known as "electroliers"

that hung above the main trading floor and several hundred miles of underground gas mains supplied fuel to approximately forty thousand public gas lamps around it.

From the start, Pearl Street was backed by wealthy Wall Street financiers, including the president and general counsel of Western Union and, most notably, John Pierpont Morgan Sr. (1837–1913). J. P. Morgan Sr., also referred to as Pierpont, was notorious for his mass bankrolling of the country during its Gilded Age of rapid-fire entrepreneurialism in the late nineteenth and early twentieth centuries. Pierpont controlled numerous multinational corporations, including US Steel, International Harvester, AT&T, and Western Union, and was especially enthusiastic about Edison's business.

Pierpont's brownstone mansion at 219 Madison Ave. was, in 1882, the first private home equipped with electric lighting, albeit with a hybrid coal-burning and electric setup.[77] The task of outfitting Pierpont's home was charged to Luther Stieringer, who dug a cellar underneath the mansion's stables to equip it with a steam engine and boiler that powered the generator.[78] In addition to the frequent short circuits and breakdowns, which required constant maintenance by the Edison Electric Illuminating Company, Pierpont's neighbors complained about the exceedingly noisy and noxious smell of its coal-burning generator and claimed to "shudder when the boiler started up" every afternoon. The generator also emitted a great deal of smoke and fumes into the immediate area, which was unacceptable to neighboring residents on affluent Madison Avenue.[79] Complaints aside, interior electric lighting had become a domestic reality, even if only for the wealthiest of the wealthy.

On September 4, 1882, Edison publicly launched the Pearl Street Station by flipping a switch to instantaneously send electricity to Pierpont's Wall Street office, publicly cementing the nascent bond between capital and the power of light in what would become one of thousands of bright-light spectacles in New York City in the years to come. By the end of 1882, the Pearl Street Station could also light parts of the surrounding neighborhood, including the offices of the *New York Times*, then still located at 41 Park Row in the heart of the financial district. Despite the EELC's grand spectacle and big-name backers, however, investors began to express concern with the hefty sums of money they had invested in Pearl Street and the continued lack of any significant return.[80] The station could still service only a load of 400 lamps or, eighty-two customers at one time, all of whom needed to be in propinquity to Pearl Street. By 1884, the station's capacity grew to 508

customers, but the limitations of Edison's DC system loomed heavy.[81] Not only was DC current limited by distance but, as it traveled farther from the central station, the force of its current greatly diminished. As a result, an Edison customer could not be located more than a half mile from the central generator. This limitation alone led to the eventual downfall of DC power in the face of Tesla's above-noted alternating current and its capacity to travel long distances and serve a more diverse customer base.

If that were not enough, the cost of running the Pearl Street Station proved to be much higher than projected (the station did not turn a profit until five years after it opened).[82] The company took to the road to pitch its DC systems to isolated plants and hotels, banks, mills, iron-works, and theaters located around the country.[83] Circa 1883, there were 352 isolated Edison plants in operation, not including the Pearl Street Station, but by the end of 1884, the number had plummeted to only 18.[84] As long as the numbers on the balance were not in the red, the EELC could continue to string investors along. At least for a time. As the limitations of DC power and the high cost of operating Pearl Street became increasingly apparent, faith (and money) withdrew, rico-cheting to Tesla's AC system, now under the auspices of Westinghouse. When the Pearl Street Station burned to the ground in 1890, and all its facilities were destroyed save for one dynamo, Wall Street had already lost interest. Edison and his staff worked round the clock for eleven days to make the necessary repairs but, nevertheless, by 1895, the sta-tion was dismantled and taken out of service.[85]

A few blocks north, Tesla's AC system was transmitting high-voltage current through electric wires and, by 1883, had increased the voltage for transmission over distances and (to avoid an unnecessary surge) decreased the current at the receiving end of a home or factory. West-inghouse set up the first alternating current distribution system in 1886 and garnered a series of "high profile contracts"[86] to provide small power stations for the St. Louis post office, the New York State capitol building, the Pennsylvania Railroad's eight Hudson River ferries, the World's Columbian Exposition in Chicago in 1893 (see chapter 3), and eventually, the world's first large-scale central generating station at Nia-gara Falls in 1895. By 1891, there were nearly five times as many AC stations in the United States as there were DC stations, a clear testament to industry's and the public's preference for the AC system.[87] Moreover, as the United States and other developed countries began to use electric-ity for an increasing number of activities, and as populations expanded

outward from city to suburb, and from the East to the West Coast, the capacity for electricity to travel longer distances became a necessity. Together, these factors ensured that Tesla's system would succeed over direct current systems, and yet, it is Thomas Edison's name, not Tesla's, that is most famously lauded in survey histories of electric light.

Legal Disputes, Patent Wars, and Cartels

A significant portion of Edison's notoriety is due to another set of GE's legal tactics, rooted in high-powered litigation and patent lawsuits, aggressively leveraged to cut through red tape by any means necessary. As smaller competitors took a stake in the incandescent bulb industry, new, independent electric plants and brands entered the market. The influx of new brands of bulbs, in particular, generated controversy as to whether developers had created a unique product or had infringed on Edison's patents.[88] To secure its monopoly, GE engaged in frequent legal disputes, patents wars, and acquisitions to purchase rights from its competitors, in ways not unlike the antitrust suits brought against companies like Facebook more than a century later as a result of aggressive mergers and acquisitions pursued to rise to the top of the heap. In a best-case scenario, a patent suit against a less powerful rival would result in an acquisition that would reaffirm GE's control of the light industry.[89] Not surprisingly, the company acquired the moniker "Electric Trust."[90]

By 1890, Edison, the Thomson-Houston Electric Company (which acquired the Brush company in 1889), and Westinghouse were the three giants monopolizing the American lighting industry. The number shrunk to two in 1892 when a merger between the Edison General Electric Company and Thomson-Houston formed the General Electric Company (GE). By the mid-1890s, General Electric and Westinghouse controlled 75 percent of the American electrical industry and 95 percent of American lamp sales.[91] The two powerhouses battled it out through competitive pricing (including underpricing), styling techniques, and hundreds upon hundreds of patent-infringement suits.[92] In 1892, the US Supreme Court found in favor of the Edison patent and forced Westinghouse to stop production, but even so, the patent wars waged on. By 1896, more than three hundred patent suits were already in play between General Electric and Westinghouse. In March 1896, General Electric cofounder and president Charles A. Coffin negotiated a trust agreement between General Electric and Westinghouse. The arrangement outlined the terms of a duopoly, dictating that the two giants

"exchange licenses to all of their patents except those for electric light-ing."[93] The agreement favored General Electric in a 5:3 ratio: for every five patents given to GE, only three would be returned to Westinghouse. Once again, the scales tipped toward GE as it secured its fate as the definitive (white) power of American light.

After the Supreme Court adjudication, Westinghouse obtained the rights to the Sawyer-Man patents for "Stopper lamp" bulbs and "quickly retooled to make non-infringing lamps" until 1897, when Edison's pat-ents expired.[94]

. . .

As these public-facing debacles ensued, behind the scenes yet another series of highly questionable cartel arrangements was negotiated by GE business magnate Samuel Insull (1859–1938). Insull is credited with engineering a new managerial class of workers who ran "giant corpora-tions publicly owned by thousands of investors"[95] and with transform-ing electricity from a luxury item to a prosaic facet of American life by way of an affordable, national electric grid (which the National Acad-emy of Engineering in 2003 named the country's "greatest engineering achievement of the twentieth century"). Insull accomplished this by using strong-arm tactics, fraud, and related illegal endeavors.[96]

Early on, Insull worked as Edison's personal secretary in New Jersey; however, because of personal disagreements with his boss, he left in 1892 to seek his own fame and fortune managing the then-struggling Chicago Edison Company. He renounced his $36,000 salary in New Jersey in exchange for $12,000 per annum in Chicago, determined to turn things around.[97]

The cost of electricity was his first frontier. At the turn of the century, a central electric station would typically own all the wiring and appli-ances distributed to customers.[98] The problem was that electricity was still 50 percent more expensive than gas and thus relatively uncompeti-tive on the commercial market.[99] Insull began slashing prices; in 1897, he cut the cost from 20 cents per kilowatt-hour to 10 cents, and he imposed an additional 1-cent drop every year thereafter until prices reached 2.5 cents per kilowatt-hour by 1909.[100] Not surprisingly, Chi-cago customers flocked to sign up with the cheaper electric lighting sta-tions. In 1892, there were only 5,000 Chicago Edison customers, but by 1906 there were more than 50,000. By 1913, the number had risen to 200,000.[101] By investing in the construction of several large generators, Insull was also able to meet the increased energy demands of homes,

offices, factories, and the public infrastructure (which included electric street cars and lighting systems).[102]

As Insull continued to reduce costs, he concurrently developed a metered pricing system to measure individual customer electricity use (versus flat-rate billing).[103] Because the price of electricity was falling, its use was on the rise—thanks to Insull's synchronized efforts to market GE electricity far beyond its primary use for lighting.[104] Consumers were persuaded to increase their home, work, and general energy use by way of purchasing newly available electric gadgets, ranging from telephones and radios to refrigerators and lawnmowers. Insull even formed an advertising department in GE to publish the magazine *Electric City* and agreed to provide free electricity to stores in Chicago that agreed to showcase GE advertising materials.[105]

Insull's less-than-honorable "bribing and cajoling" tactics were no secret. He is known to have bribed streetcar companies to purchase power in larger-than-necessary amounts, manipulate "numerous city councils for the necessary permits to build plants and string wires,"[106] and cajole politicians to develop his new, demand-based pricing business model. He was eventually charged with fraud for these activities and, although the jury acquitted him of all charges, his reputation was permanently tarnished.[107]

Not surprisingly, Insull also excelled in corporate pyramid schemes. In early 1897, GE had established a cartel with the Incandescent Lamp Manufacturers Association (ILMA) and, as noted, with Westinghouse.[108] Together, the firms fixed output and pricing. General Electric was "allotted 50 percent of the market, Westinghouse about 12 percent, and the remaining 35–40 percent went to all the others."[109] As a result, the price of lamps instantly increased by 30 percent.[110] On July 2, 1890, the US Congress responded by passing the Sherman Antitrust Act, the first federal legislation to outlaw monopolistic business practices. The terms aimed to encourage free market competition by regulating interstate commerce and preventing trusts from achieving dominant market status. Even before the Sherman Antitrust Act was applied in a court of law against any specific corporation, GE was on the lookout for it, and its scheming thus grew more covert.[111] In 1901, General Electric CEO Charles A. Coffin (formerly of the Thomson-Houston Electric Company and responsible for negotiating the above-noted duopoly with Westinghouse in 1896) devised a scheme to further dominate the lamp market, but to avoid raising suspicions, GE would avoid "crushing small competitors"[112] and instead would allow smaller companies to

maintain a façade of independence, even as it bought them out.[113] Insull led the charge. So long as he manufactured a veneer of GE's (and Westinghouse's) market diversity, his corporate pyramid schemes and "questionable accounting" incurred no consequences.[114]

When GE's patents began to expire in the 1920s, unlicensed developers came forward with improvements on preexisting products.[115] GE reacted by further cultivating its standing cartel schemes. In December 1924, the company (represented by its British subsidiary, International General Electric and the Overseas Group) made similar arrangements with a group of leading international electronic industry businessmen, known as the Phoebus cartel,[116] a global white light alliance including such powerhouse companies as Osram (Germany), Philips (the Netherlands), and Compagnie des Lampes (France). Together, the Phoebus cartel met and colluded to set international standards for fixing the price of electric lighting and limiting factory production quotas to increase demand despite production capacity.[117] Its members also agreed to set limits on the number of hours each bulb would burn, thereby boosting the sales of more bulbs (a tactic known as planned obsolescence). Germans witnessed the average life of an electric bulb decrease from 1,800 hours in 1926 to 1,205 hours in 1933–34.[118] Eventually, the Franklin D. Roosevelt administration (1933–45), as part of the New Deal, passed additional laws to actively limit the development of monopolies and "utility pyramids" that stymied free market competition.[119] While such histories offer a glimmer of hope that the law might continue to impede planned obsolescence, it has not, and, as a result, such corporate strategies have become only more de facto in high tech.

Marketing and Self-Promotion

General Electric's early advertising strategies offer yet another set of historical precursors to the contemporary landscape of aggressive marketing and promotion. As antitrust laws became increasingly restrictive, GE responded by reconceiving its corporate strategies to focus less on research and development and more on advertising and influencing public opinion.[120] Consider the fact that Edison was neither the first nor the sole scientific investigator to develop a stable incandescent electric lamp. In the 1850s, three decades prior to Edison's bulb debut, German mechanic Heinrich Göbel (1818–93) demonstrated a viable carbon filament lamp, and while he did not patent it until 1882, after he had been living in New York City for seventeen years, it was a sustainable

improvement on the Geissler system of vacuum tube lighting that preceded it.[121] In 1897, German scientist Walther Nerst invented the Nerst lamp, an incandescent bulb with a metal oxide filament of magnesium, calcium, and rare earth minerals that produced a more natural-color light and was twice as efficient as Edison's carbon filament.[122] Yet neither the Nerst bulb nor Göbel's lamp succeeded on the market, likely because of their failure to undertake comparably bellicose steps toward market domination.

Another example is English physicist Sir Joseph Wilson Swan's 1879 bulb, successfully debuted and demonstrated as a reliable form of incandescent lighting several months prior to Edison's. Swan's prototype used a carbonized rod filament (a sewing thread), and his own home became his display case, the first home in the world to be decorated with incandescent bulbs.[123] Swan was given several patents for his lamps, which he later sold to Brush, while his company, Swan United, was sold to the Edison company in 1882 to form the merger "Ediswan." In short, Edison's bulb did not acquire market dominance based on its technological ingenuity.

Being neither the first nor the sole inventor to develop a stable incandescent lamp, Edison was, however, the most forceful with his advertising and public relations campaigns, including his unabashed self-promotion in one of the country's first mass, white light spectacles. On New Year's Eve 1879, the company strategically aligned the launch of the Edison brand name with the country's love of fireworks and visual showmanship. By unveiling his electric lightbulb outside his Menlo Park research laboratory on December 31, Edison wed the future of the American imaginary to the company's success through the brilliance of the Edison bulb.[124]

GE's promotional efforts next advanced at the then-popular World's Fairs and industrial exhibitions. At the International Exposition of Electricity in Paris in 1881, the Edison booth exhibited a gargantuan display of incandescent bulbs positioned to spell out the word EDISON. The company also displayed its bulbs on the staircase of the grand exhibition hall, so visitors would encounter two massive electric E's next to a portrait of the inventor, revolving under spotlight.[125]

The Edison spectacles would not have been so successful without the work of the relatively unknown William J. Hammer, one of the most talented electrical engineers of the day. Hammer worked for Edison from 1878 to 1890, during which time he devised a number of impressive displays to promote the brand. For the Edison display booth in the Crystal Palace at the International Electrical Exposition in London in

1882, Hammer engineered a giant, hand-operated electric sign, the content of which was, once again, Edison's own name. For this device, he wired a series of bulbs together in an electric circuit connected to a commuter switch that allowed him to turn parts of the sign on and off at will.[126] He also developed "rheostats" for the system, which allowed for the dimming of lights.[127] The overall effect created the illusion of an animation as EDISON was spelled out, letter by letter, until all six letters came on, and the sign flashed on and off.[128]

In 1883, Hammer improved the sign for a Berlin debut, fitting it with an automatic motor to drive the flasher.[129] For the International Electrical Exhibition in Philadelphia in 1884, Hammer designed a lavish booth with a plethora of promotional materials publicizing the range and flexibility of electric light. The booth featured functional lighting, an electrolier, countertops with technical demos, illuminated objects, electric signs, and a statue with "upturned arms holding electric lamps on either side of Edison's own bust."[130] He also fashioned a thirty-foot "Column of Light," consisting of twelve hundred incandescent bulbs spiraled around the central column, equal to the number of bulbs produced at the Edison factory in a single day.[131] Hammer coordinated the bulbs on the column to flash on and off in sequence, fostering the illusion of upward-moving light while the name EDISON flashed at the base.[132] Through Hammer's work, the Edison brand name was made synonymous with spectacular displays of electric illumination and, henceforth, became standard at fairs and exhibitions—until the fairs themselves were outmoded by film and television. It is unlikely that Hammer realized the special effects he created would become key visual tools in the development of the electric landscape over the next century but, either way, it was clearly by way of Hammer's visual effects that GE's promotional materials furthered the Edison brand's quintessentially American mythology as the best, brightest, and first.[133]

A second set of semiotic-based marketing tactics was developed through General Electric's incandescent bulb campaigns. As the bulb came close to achieving what the company claimed to be a godlike supremacy on world markets by the late 1880s, its advertising campaigns grew increasingly arrogant. Beginning in 1887, text and images implicated the preeminence of Edison's white light and its capacity to shine as the whitest of white lights. One advertisement from an 1887 Edison catalog featured a giant lightbulb with golden rays of sun emanating from it. Inside the lightbulb, the italicized text reads: "Its superiority to all other illuminants." Another such ad featured a GE lightbulb

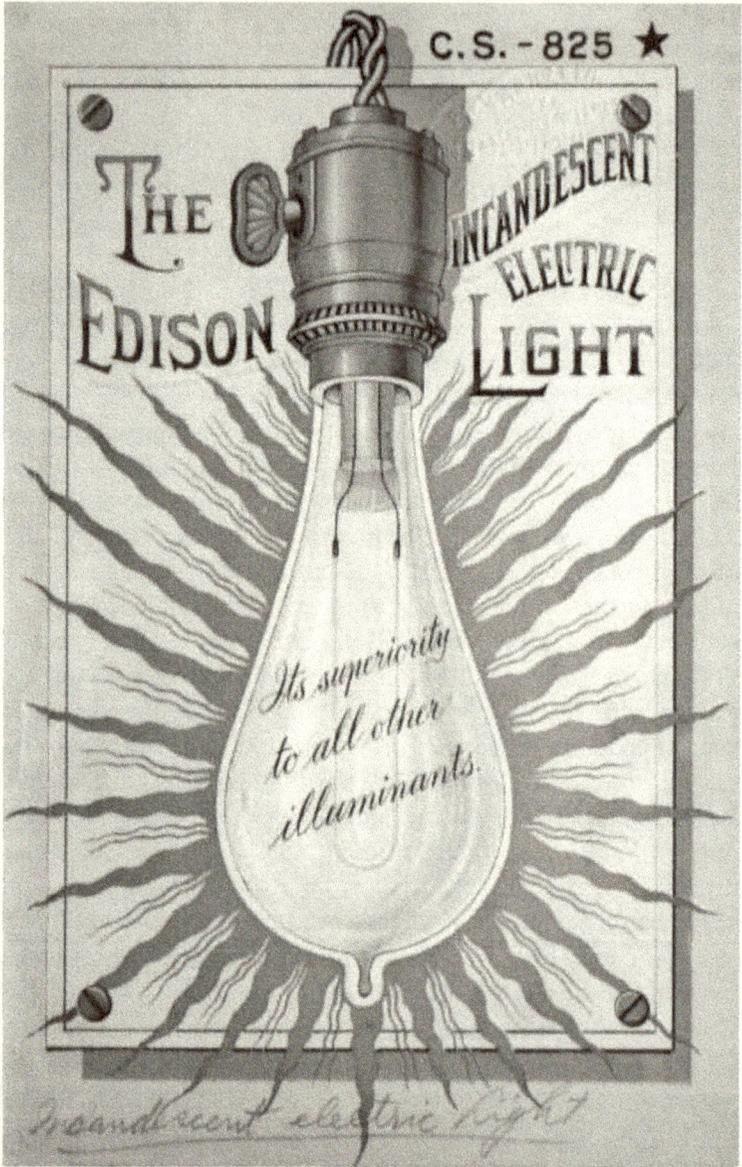

FIGURE 2.3. Cover of 1887 Edison Electric Light Company catalog. "The Edison Incandescent Electric Light: Its superiority to all other illuminants." Image courtesy Internet Archive.

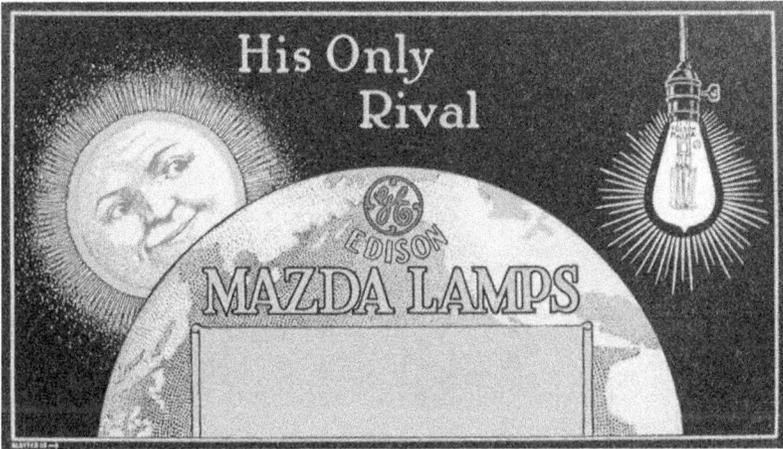

FIGURE 2.4. "His Only Rival: GE Edison Mazda Lamps," ca. 1909–1929. This public advertisement boasts the companies' claim to shining white light so bright it was only rivaled by the sun. Author's collection.

floating in space, unrealistically unconnected to any wiring or grid, doubling as a stand-in for the globe with a sun behind it. The text and image together implied that Edison's "only rival" was the sun. The "dream" for earthly white light hegemony, as yet another ad suggested, had finally "come true."

As General Electric's wheelhouse churned out bulbs over the course of the twentieth century, it became the global manufacturer for GE, Ediswan (in Britain), Compagnie des Lampes, French Mazda, Toshiba, and Westinghouse through 1945. Most fame accrued to their notorious "Mazda" lamp, launched in 1909 and named after Ahura Mazda, the transcendental Persian God of Zoroastrianism that symbolized the wisdom of light. In a full-page advertisement for Mazda lightbulbs in *Popular Electricity and Modern Mechanics* in 1914, the copy read: "Another triumph of Mazda service," while another ad, from a 1917 issue of *Popular Science Monthly*, emphasized the white light Mazda would offer the home.

In sum, GE's claim to and acquisition of a national and global light monopoly were rooted in a combination of legal manipulations and hard-hitting marketing tactics that linked the company's public image to American mythologies of firstness, bestness, and, as the following example illustrates, liberty and freedom.

On March 26, 1883, the wife of entrepreneur and railroad tycoon Cornelius "Commodore" Vanderbilt, Mrs. Cornelius Vanderbilt II

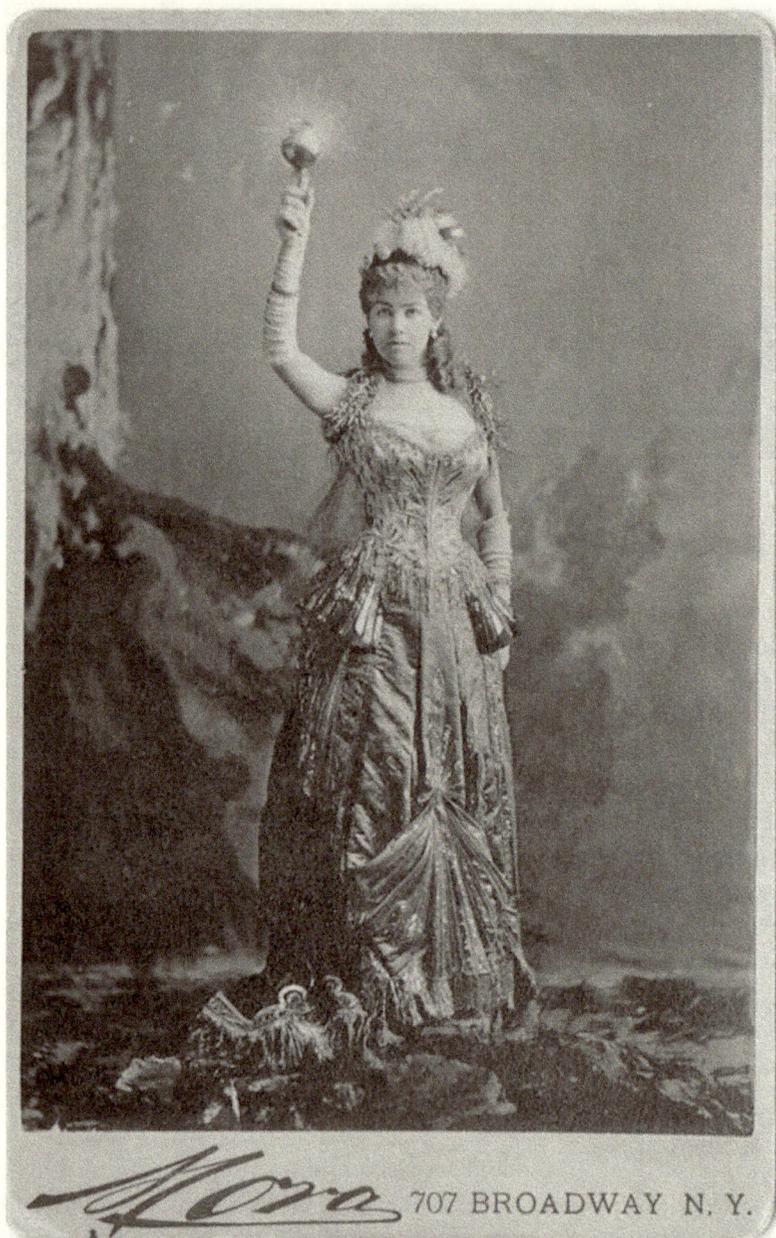

FIGURE 2.5. Mrs. Cornelius Vanderbilt II (Alice Gwynne, née Claypool) in electric light dress. Mrs. Vanderbilt arrived at her sister-in-law's costume ball on March 26, 1883, wearing this gown by Charles Frederick Worth, named "The Spirit of Electricity." She poses as the Statue of Liberty, holding up her right arm with a small silver bowl in her hand emanating a glowing light.

(Alice Claypool Vanderbilt), arrived at the costume ball thrown by her sister-in-law, Mrs. W.K. Vanderbilt (Alva), dressed as an electrically lit Statue of Liberty. The ball took place in W.K. Vanderbilt's new home, a mansion at 660 Fifth Avenue and 52nd Street, newly equipped with Edison incandescent lighting, also courtesy of Luther Stieringer. The ball was planned both to serve as a housewarming for the mansion's new occupants and, because Pierpont's house had only been wired for electricity one year prior, to strategically secure the family and its mansion on the roster of Manhattan elites, a goal that had proven elusive for the family in the past.[134] After some gossip and maneuvering with the delivery of her invitations, Mrs. Vanderbilt managed to fasten the attendance of key actors: Mrs. Caroline Schermerhorn Astor, her daughter Carrie, and Ward McAllister, three of New York's most elite who had previously denied the Vanderbilts access to high society life. Their attendance at her ball would reverse this fate and land her family the status she sought.

The affair also landed Mrs. Cornelius Vanderbilt a seat in fashion history. In a number of photographs of her electric light dress, she poses in the manor of the Statue of Liberty, holding up her right arm with a small silver bowl in her hand as it emanates a glowing white light. The dress was named "The Spirit of Electricity" and was inlaid with delicate gold embroidery and layers of luxurious fabric designed by Charles Frederick and Jean-Phillippe Worth of the House of Worth.[135] In her brilliant Statue of Liberty dress, framed by her family's newly lit electric home, Mrs. Cornelius Vanderbilt served up a gentle reminder of the Vanderbilts' confirmed arrival in New York's high society.[136]

WHITE OUT

This chapter has shown how the relationship between electric light, finance, and the American city (and New York City in particular) are woven into a single tapestry in which one thread always reinforces the power and potency of the others. In the history of electric lighting in the United States, private funding ensured that artificial lighting went first to the wealthy and only later to the poor. This was especially the case in New York City, where that singular modern architectural icon of monolithic American power—the skyscraper—would not have been possible, or even feasible, in the absence of practical electricity. Without it, elevators could not deliver people to higher floors, and without artificial illumination, many of the lower floors would not receive adequate lighting.

In the United States, the flourishing of bright, white, and well-illuminated city spaces was bound up with business and commerce from the start. General Electric paved the way. Its management did "all in its power to gain, maintain, and control self-regulating oligopolistic markets."[137] Doing so allowed it to achieve market dominance, much as other American corporate giants have done, from Standard Oil, US Steel, and the American Tobacco Company, through Facebook, Amazon, and Google. Between 1876 and 1900, Edison Electric grew from "virtually nothing" into a $200 million industry with $6 million in reported profit. By 1910, Edison's profits rose to $10.8 million and, by 1930, to $57.5 million (equivalent to approximately $94 million in 2023).[138] The difference between GE and earlier trusts, David Nye suggests, is that previous American corporations were able to secure a monopoly only over raw materials for industrial processing, whereas General Electric excelled in almost all facets of production and distribution, from innovation and in-house research and development to attracting and maintaining a highly skilled workforce, a team of lawyers and hostile businessmen, and massive promotion and advertising campaigns,[139] thereby forging a purer version of American empire. But all empires have an expiration date. When GE's tungsten-filament patent expired in the 1930s, and unlicensed foreign competitors stepped in (namely from Japan), demonstrating they were able to manufacture the same product with significantly lower labor costs, the writing was on the wall.[140]

The "Great White Way"

1880s–1910

The Broadway Association approves and welcomes the new
spectaculars, they will greatly aid in the present campaign to
"whiten up . . . Broadway."
—*Signs of the Times*, 1938

Reverend S. G. Wood was known to ride his horse around Blanford,
Massachusetts, but was unknown to the community for some time as
the culprit who scoured for advertising placards to vandalize and rip
down, destroying more than seventy-five in the winter of 1880 alone.[1]
In his words, he was "devoted to keep God's world as beautiful as the
depravity of his fellow man [would] allow him."[2] He traveled with
nothing but "a wagon, a ladder, an axe [and] a spirit of wrath and
determination."[3] Sometimes his college-aged son would help, removing
signs for his father from higher elevations. Once businessmen in the
region learned it was the reverend who was responsible for defacing and
removing their signs, they demanded that he stop, but the minister
refused. The businessmen responded by securing legal permission to
post their advertisements on private property, but no sooner was it
granted than the reverend cashed in his community ties to secure per-
mission to remove them. He eventually ceased his activities but his
horse, according to Frederic A. Whiting, had a more challenging time.
Being so accustomed to the activity, the horse continued to stop when
riding by a sign, refusing to pass until it was torn down.[4]

Apocryphal or not, the anecdote begs this question: Why would a
man ostensibly dedicated to the peace and love of humankind be driven
to ongoing acts of violence and destruction?[5] This chapter offers a series
of responses by analyzing the power struggles over emergent genres of

advertising in American towns and cities at the turn of the past century, focusing on the tensions between the reserved yet lingering white light Puritanism of (Old World) Europe, and the explosive colors that marked the New World's white imaginary in the twentieth century. The chapter begins with an analysis of early forays into print-based public advertising (mainly in New York City), followed by a discussion of the "White City" at Chicago's 1893 World's Columbian Exposition, analyzed as a training ground for new forms of spectatorship and an American template for spectacle-based urban planning, rooted in the consumption of clean and sanitized visual space. This is followed by a historization of Manhattan as an island of "greatness," in many respects, but most notably as the site for the innovative sign work of Oscar J. Gude as it emerged along the city's "Great White Way" in the first half of the twentieth century. The chapter then returns to the City Beautiful debates in order to show how, prior to America's self-proclaimed world supremacy, moral anxieties between Old World white light and the New World's unabashed pursuit of capital shaped the landscape of the most supreme twentieth-century commercial mecca: New York City's Times Square.[6]

EARLY ADVERTISING

Even though sign advertising for shops had existed for millennia, it was not until the standardization of the printing press in the fifteenth century and the industrialization of colored inks in the nineteenth century that business owners gained access to sizable, reproducible, and consistent media for visual marketing. In America, the first billboards were leased in 1867, after which heated controversies emerged. With over 275 billposting businesses across the country, manufacturers from a variety of industries began testing the limits and effectiveness of the medium on billboards, walls, trees, and rocks. Even if their signs did not lead to direct sales, they reasoned, it would at least increase the cachet of the brand name. By 1869, billposting fences around New York City's post office were saturated with advertisements for medicines, soaps, perfumes, and travel, while Washington, DC's Pennsylvania Avenue featured a great procession of "right-angled" signs blocking bypassers' view of some of the city's coveted monuments.[7]

By 1906, the National Biscuit Company (NBC; a forerunner of Nabis-co) had become the largest advertising agency in the country, overseeing extensive campaigns reaching 30 million viewers per day.[8] The cumulation of its outdoor ads, the company boasted, was physically

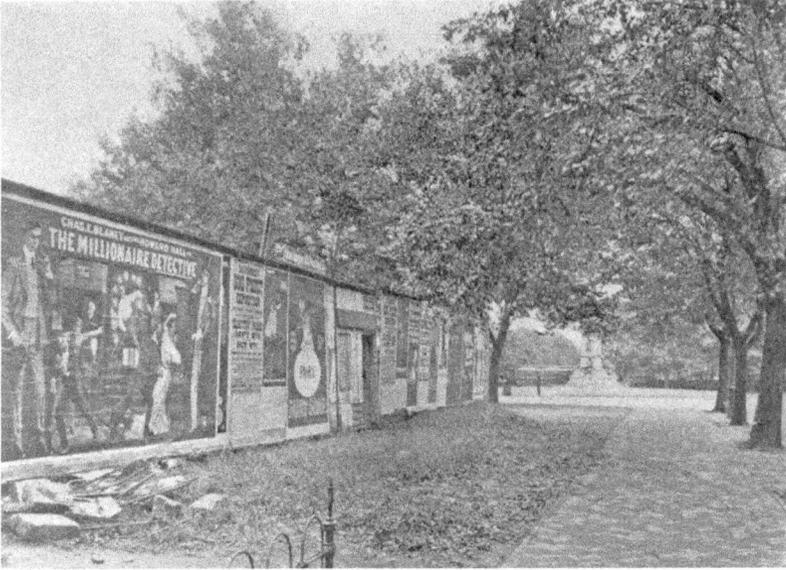

FIGURE 3.1. "Billboard Advertisements," 1st Street, Washington, DC (1908). At the beginning of the twentieth century, Pennsylvania Avenue in Washington, DC, featured a pageant of advertisements, ostensibly blocking the view to some of the city's coveted monuments. In this image, the billboard faces the Capitol, and in the distance, one can see the James A. Garfield Monument. Horace J. McFarland, University of California Libraries.

equivalent to the length of the Panama Canal from the Atlantic to the Pacific coast, painted on a continuous 5-foot fence.[9] The NBC was also one of the first to create advertising campaigns targeting immigrant markets. Under the direction of N. W. Ayer, these campaigns spoke to American newcomers through "Mother Goose" and "Zu Zu Ginger Snaps" wafers, crackers, and cookies branded, under the auspices of the "Uneeda Biscuit"[10] campaign. Bylines assured customers of the product's "purity" and "perfection" and, when advertised to women, of a wafer's "delicate and fragile" goodness.[11] As a result, NBC trailblazed large-scale signage for outdoor advertising, simultaneously fashioning mass markets for women, immigrants, and lower- and middle-class Americans.[12]

Infamous New York City–based circus entertainer P. T. Barnum (sponsored by NBC) was equally well known for his innovative advertising campaigns, one of which involved illuminated facades that lit Broadway for blocks[13] and, before that, large-scale advertisements painted on the side of Barnum's five-story American Museum (1841–65), on the corner of Broadway and Ann Street in New York City.[14] For the former, the

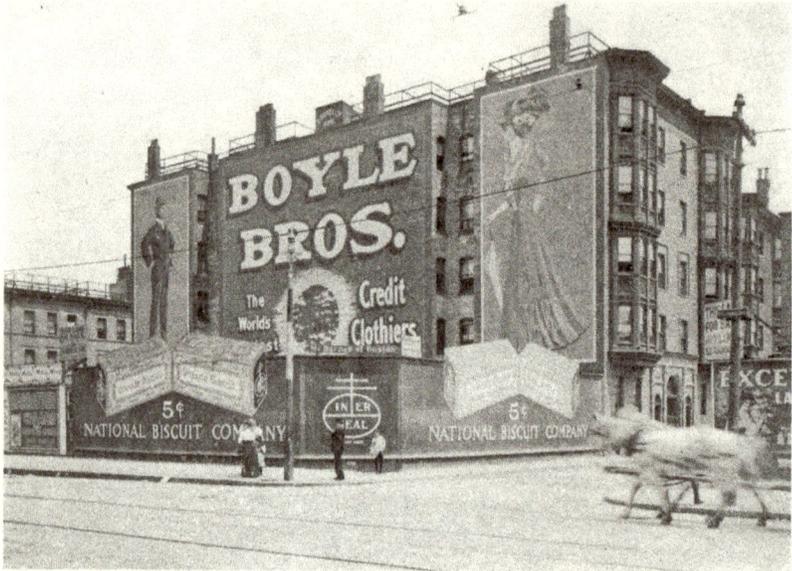

FIGURE 3.2. "A New England Corner—Columbus avenue, Boston, Mass.," circa 1906. The National Biscuit Company was at the time the largest advertising agency in the country. It ran extensive advertising campaigns that millions saw every day of the year. Horace J. McFarland, University of California Libraries.

building's facade was covered in limelight, a mixture of oxyhydrogen and calcium to generate a forceful theatrical glow that could be seen for blocks.[15] After Barnum joined forces with James Bailey and the Ringling Brothers to create "The Greatest Show on Earth," they began pasting equally enormous colored advertisements around the city,[16] boasting the zany spectacles found inside the museum, such as "Jumbo," the "largest elephant in the world"; the "first and only lady elephant trainer" of "war elephants"; elephants picking up other elephants with their tusks or dancing on their hind legs; and walruses at war with each other. Any image to draw customers inside was fair game for Barnum, even if it involved exploiting his patrons' "ignorance and credulity"[17] (another "fake news" precursor). Unlike Edison's relatively reticent fake news (chapter 2), however, Barnum's pursuit of high ticket sales led him to circulate articles in the press declaring his own exhibits "fake," which, he claimed, incited audiences to return again and again to see for themselves.[18]

Other early advertisers chose criminal routes. Known as "snipers" or "hot-doggers," these men traveled around painting or posting gratuitous advertisements on posts, rocks, boards, or any amenable surface,

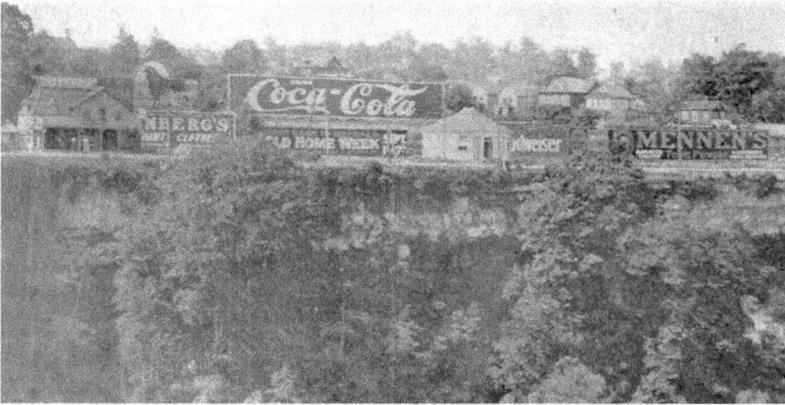

FIGURE 3.3. "A Niagara View," circa 1908. A Coca-Cola billboard, along with others, on the Canadian side of the American Steel Architectural bridge at Niagara Falls. The large-scale advertisements offended many, as they blocked a view of nature. Horace J. McFarland, University of California Libraries.

without the owner's permission.[19] In one case, at Niagara Falls in the late 1860s, a sniper painted the name of his quasi-mysterious patent medicine "ST 1860 X" on a large rock overlooking the falls.[20]

Not surprisingly, such legal and illegal activities catalyzed a passionate coterie of protesters who deemed the new world of advertising tasteless and immoral. By the 1860s, elite Americans and European visitors complained of advertising's obstruction of national monuments, city spaces, and nature's beauty. In 1908, one tourist criticized the concealment of "the magnificent view"[21] of Niagara Falls, blocked on one side by Coca Cola advertisements and a sign for Mennen's Toilet Powder above it.[22] Societies and national organizations formed to advocate against the advertisements, including the prestigious Municipal Arts Society (MAS; 1893); the City Beautiful (CB) movement (1893); the American League for Civic Improvement, and the American and Outdoor Art Association, which merged to form the American Civic Association (ACA) in 1904.[23] The ACA was particularly zealous in contending that advertising actively "disfigured the landscape."[24] A billboard was not only a "nuisance" to the public, and to immigrants and lower classes in particular, the association maintained, but also "an insult to the Creator."[25] All of the above groups collectively battled to retain what they perceived to be the aesthetic of purity of the American city and what lay beyond it. Even the *New York Times* was on board, as evidenced in a 1902 article that grumbled over the horrid street

illumination on Broadway, running from City Hall to Union Square, forming a "frightful spectacle" exacerbated "by the wilderness of discordant and shrieking signs."[26] Little did the *Times* editors know that the world of electric advertising was barely out of the womb and, within two years, the newspaper would relocate to its central pulse.

The ACA's first vice-president and secretary, Clinton Rogers Woodruff (1868–1948)[27] went so far as to compare billboards to opium addiction,[28] ranting about the way they ensnared customers with appeals for "lurid and sensational plays, tobacco, and alcoholic beverages."[29] The Woman's Health Protective Association (WHPA) of Brooklyn concurred, charging that the boards incited crime by functioning as "active accomplices" in illegal transgressions and failing to protect the morals of young boys and girls.[30] The ACA targeted ads depicting the use of firearms in "violent scenes," "partially draped women," and what it referred to as "dramatic pictures of the 'White Slave' type"[31]— alluding to the selling of (white) Christian slaves to darker-skinned owners. The WHPA pleaded with the courts to order the signs be removed in order to "protect the morals of [presumably white, Christian] boys and girls," but it did not get far: images of men with guns and scantily clad women pervade pop culture today without so much as a stir. In fact, the tides seem to have swung so far in the opposite direction that such images are now often bolstered by a rhetoric of "sex positive" feminism and the Second Amendment.

In New York City, the MAS and CB persistently deployed their privilege, education, and class status to corral policymakers into officiating zoning regulations in their favor. As a result, key ordinances were passed in 1909, 1916, and 1923, leading to a bona fide, albeit temporary, victory for the advertising detractors.[32] The first, which actually dates back to 1885, when Manhattan laws restricted the height of new tenement buildings to one and a half times the street width, was finalized in 1909, when the Supreme Court legalized these proportions as a blueprint for what has become iconic in Manhattan neighborhoods like the Lower East Side, China Town, and Greenwich Village.[33]

The 1916 regulation was more pertinent to the history of advertising in New York City, for the first time designating sign permissibility based on district and maximum mass per building (contingent on the 1909 law). It arrived on the tail end of heated protests against electric signage (also known as the sign wars) mounted between 1904 and 1916. The bulk of these opposers, not surprisingly, consisted of upper-class Euro-

American professionals, civic reformers, and swank Fifth Avenue inhabitants who had been rallying efforts under the auspices of the Fifth Avenue Association (FAA) since 1907.[34]

For the FAA, CB, and MAS, electric advertising was déclassé; a vulgar form of entertainment that reformers and professionals (including the *New York Times*) did not want to be associated with.[35] Their presumably superior aesthetic values derived from anachronistic European-qua-Protestant commitments to "plain speech and plain living,"[36] as Jackson Lears puts it, the essence of Old World whitewash, ripe with "a distrust of fantasy and sensuous display."[37] The reformers succeeded in America for some time, swaying politicians with claims of advertising's manipulative attack on the work ethic and asserting it was a diseased, "cancerous growth" symptomatic of a wasteful consumer culture.[38] Much of this rhetoric, it is now clear, was a thinly veiled disguise for securing vested interests in property and power. Accordingly, the final 1916 resolution determined that "distasteful" advertisements would be restricted to parts of the city frequented by "industrial workers and inhabited by immigrants who rented property,"[39] which is to say, *not* Fifth Avenue.

Fifth Avenue was further precluded from déclassé advertising through yet another series of battles. Due to noise, noxious smells, overcrowding, and subsequent threats to property value, immigrants and the factories they occupied also posed a menace to nouveau riche professionals and middle-class Americans on the avenue and thus, the FAA, which had since expanded to include luxury shops and hotels on Fifth Avenue, commenced the prohibition of factory work there.[40] FAA members asserted that immigrants and workers did not display the "exceptional character" of the "Fifth Avenue type" and, if factories were permitted there, "hundreds and thousands of garment workers ... [would be] swarm[ing] down upon the avenue for the lunch hour."[41] As one 1928 article in the *New York Times* put it, the prohibitory law was necessary to avoid an influx of the "wrong kind of people."[42] The eviction was won for Fifth Avenue north of 34th Street, a victory gained with the help of the Metropolitan Life Insurance Company, which threatened to refuse loans for losses above 34th Street, in conjunction with the association's threat to boycott manufacturers located in lofts above that street.[43] Once again, inflated discourses of public decency and taste provided a convenient veneer for ushering in and securing New World power, property, and prestige, a tactic that had already proved itself successful at Chicago's 1893 World's Fair.[44]

THE "GREAT WHITE CITY"

The World's Fairs began as annual exhibits for developments in indus-
try and culture, doubling as testing grounds for new products.[45]
Throughout the nineteenth and early twentieth centuries, they were
widely successful in the Euro-Americas, drawing people in by the mil-
lions, but, since the advent of Hollywood movies, television, and the
internet, their global attraction has diminished. Because a wealth of
scholarship already exists on these fairs,[46] I jump directly to the "Great
White City" at the 1893 Columbian Exposition in Chicago.

After William Hammer's monumental electric display for Edison in
1881 (chapter 2), World's Fairs were henceforth reorganized around
themes of electric light, from Chicago's Great White City in 1893, to
Buffalo's Electric Tower in 1901, San Francisco's Tower of Jewels in
1915, and New York's Trylon and Perisphere in 1939. In contrast to
their European precursors, American World's Fairs laid out increasingly
lavish, self-contained electric light complexes.[47] The bigger, the better
was the unspoken axiom of the nascent electric nation. Because electric
lighting was not yet readily available in the majority of American
homes, many traveled long distances to see the mesmerizing new spec-
tacles, participating in the national pride and a collective dream for ever
greater abundance in American cities of the future.

The hugely successful "White City" (WC) at the Chicago-based
Columbian Exposition ran from May through October of 1893 and
served as an especially potent vehicle in the reproduction of the "great"
(white) American imaginary in a number of US cities after the Colum-
bian Exhibition closed.[48] The exhibition drew in over 10 percent of the
country's population (then approximately 14 million people) and sold
more than 4 million guidebooks and souvenirs.[49] Chief planner Daniel
Burnham oversaw the WC's fabrication as the centerpiece of the fair,
located in the middle of its 633 acres and 400 buildings.[50] In its final
form, the WC contained more lights than any actual American city and
consumed more than three times the daily electricity used to illuminate
the entire city of Chicago.[51] Its electric feast for the eyes consisted of
200,000 incandescent bulbs tracing the edges of neoclassical arches,
towers, and all-white pinnacles rising 60 feet above the ground and
illuminating two enormous fountains from below that blasted 2,000
gallons of colored water per minute into the air. Sixty all-white gondo-
las were imported from Italy to journey its lagoons, and a massive,
electrically lit Ferris wheel, a moving sidewalk, and searchlights lit up

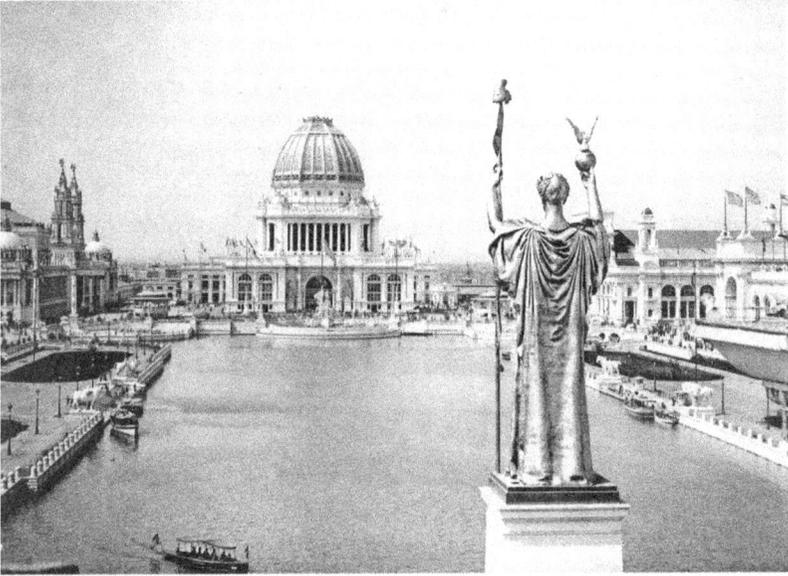

FIGURE 3.4. Looking west from the Peristyle, Court of Honor, and Grand Basin of the "White City" at the 1893 World's Columbian Exposition (Chicago). Photo by C.D. Arnold, one of the Exposition's official photographers. The White City emphasized clean, sanitized spaces for visitors' visual and psychological possession, setting up an imaginary of greatness for the future of the American city.

the city so powerfully, they could be seen in Milwaukee, almost a hundred miles away.[52] Six thousand additional arc lights were positioned on twelve-foot-high posts lining the paths and walkways, presenting a unified architectural landscape of pure white light augmenting the effect of the clean, whitewashed facades behind them in an undeniable allusion to the (self-projected) American outstripping of Greco-Roman classicism.

The sheer power of whiteness in the White City emanated from above, below, and the sides, igniting a paradoxical dream world for aspiring Americans and their future cities. By forging a bond between white light, electric power, and a distinctive form of American longing, the WC nurtured personal and collective desires for sanitized material luxuries, made available for "all" through the visual possession of the landscape's clean white lines, objects, and sanitized spaces. What was deemed "beautiful" in the White City was its aseptic aesthetic, a facet of the country's nascent imaginary that, as we now know, has since manifested only in select venues.

Photography played a key role in the WC's indoctrination of this mythical whiteness, also by way of visual possession. It was obvious that no single spectacle in the White City could be photographed on its own and that the entire city could not be photographed at once. Instead, the WC offered the *idea* of a city, Eric Gordon suggests, retroactively assembled through technological compositing and design.[53] Much of this assemblage occurred after the fact, by printing photographs, storing and circulating memorabilia, and recounting and displaying memories for others. Official photographs of the WC could be bought and sold as memorabilia, so that one could experience the city vicariously, but nothing trumped the capacity to capture and possess whiteness through one's own prosthetic eye.[54]

City planners and policymakers learned from this demand that American cities could be designed and packaged like any other commodity. Once consumers-qua-tourists were armed with a photographic device, a new relationship between the individual and the city could be nurtured, packaged, and sold. Photography henceforth became an essential tool in the branding and marketing of the American city as a free space for "all" to "possess, control, and assemble."[55] The concept dates back to 1888, when the Eastman Kodak Company introduced the handheld camera, making it possible for tourists and citizens (who could afford it) to travel to foreign cities and take photos of them for their personal use and possession. American whitewashing was no longer restricted to painted architectural facades and lights but now extended to the eyes that saw and captured what appeared before them.

The whiteness of the White City was thus both explicit and implicit.[56] On one hand, its whiteness can be characterized by a blinding vision that sees only itself, full of self-congratulation and proclamations of democracy, freedom, and access for a delusionary "all." On the other hand, the supremacy of whiteness in the White City was set up as a template for the future of many other American cities, which, in contrast to European precursors, aimed to overshadow their inhabitants with brazen spectacles of light and glory. In this way, the whiteness that thrives in the heart of commercial centers in many American cities imbues its inhabitants with this same paradoxical ethos of democratic righteousness, on the one hand, attained by individual mastery and possession, on the other.

Before discussing how this contradiction plays out in the "supreme" whiteness of New York City's "Great White Way," we must backtrack through some of the city's historical context.

MAPPING MANHATTAN

New York is *the* metropolis of the western hemisphere. . . . [Its]
supremacy in numbers and wealth and general magnificence makes it
the natural leader in those things which are the result of men and
money.

—E. Leavenworth Elliott, 1911

New York City's infamous Times Square is geographically discernible by two inverted triangles forming a twelve-block bowtie in midtown Manhattan. The tip of the first triangle begins at 45th Street and Seventh Avenue and moves southward along Broadway to its base at 42nd Street, and the tip of the second triangle begins at 45th Street and Seventh Avenue and moves northward along Broadway to 47th Street. While the colonized history of the neighborhood dates back to the Dutch annexation of New Amsterdam in lower Manhattan in the early 1600s, followed by its British seizure in 1664, it was the winning of the island in 1776 that is typically noted by Americans as the culminating event in the founding of the nation in July of that year.

When the commander of the British army, William Howe, arrived to attack the newly declared independent Americans in August 1776, he landed on what is now known as Staten Island. His troops and 130 ships secured control of the harbor and approached Manhattan from the East River. General George Washington was prepared for the attack, relocating from Boston to New York in April 1776 in anticipation of a breach at the port of New York—of great value to whoever controlled it. Once news of Howe's arrival on what is today East 37th Street reached Washington in June 1776, he ordered his troops south from their headquarters in Harlem while American general Israel Putnam brought his troops northward from lower Manhattan (where Washington also had troops positioned in anticipation of the British attack). The British fought aggressively. Washington called for reinforcements from Maryland and Delaware, and together, they drove the British to retreat in Brooklyn Heights. Because Washington had also strategically placed troops in Brooklyn, when the British arrived, they were forced to retreat even further, to New Jersey and Pennsylvania. This brief summary of events recounts only one episode in a much larger series of battles that together constitute the American Revolution, invoked here to highlight the great value already attributed to the island of Manhattan and its midtown crossings, simultaneously underscoring the brazenness of the American spirit.

This same brazen American spirit was of course also deeply imbricated in colonial violence. Native Americans had been living on the land that would become Manhattan for thousands of years before French colonists arrived in the 1600s, followed by a surge of English and Dutch. The Irish arrived in the 1840s and 1850s, followed by waves of Germans and Russians. Polish Jews and Italians immigrated to New York in the 1880s, followed in the twentieth century by waves of Jamaicans, Cubans, Puerto Ricans, Dominicans, Vietnamese, Chinese, and Koreans. Together these communities compose the colorful tapestry that makes greater New York City one of the most ethnically diverse metropolises in the world.

Back in the 1800s, however, the area that would become Times Square was still known as a site for dumping manure and a home for squatters who settled along a creek, known as the "Great Kill,"[57] that is now 42nd Street. Along what is now Broadway was a rolling dirt path of shantytowns and grazing cows called Bloomingdale Road.[58] When Dutch settlers moved northward on the island, they developed goat farms in proximity to the Great Kill, but it was not until several decades into the twentieth century that the area accrued value for its horse and carriage businesses.[59]

German immigrant John Jacob Astor catalyzed the transformation of the square from dumping ground to lucrative horse industry. Astor had arrived from Waldorf, Germany, in 1784 when the population of New York City was around 60,000. By the early 1880s, he and William Cutting purchased 70 acres of land stretching from (what is now) Broadway to the Hudson River, and from (what is now) 46th Street down to the Great Kill at 42nd Street. They paid $25,000 and on it built Eden Farm.[60]

The most radical transformation of midtown, however, and Manhattan more broadly, occurred in March 1811 when city surveyors, by way of the recently established city commissions of 1807, published the layout of the Manhattan grid. The fifty-four-page document announced that each of the cross streets would be positioned at a right angle to the avenue, tilted 29 degrees east of true north. Manhattan's gridiron plan was by no means original (it had been used in cities around the world for centuries), but it was here taken to especially ambitious lengths, in part because of the colonists' "predilection for control and balance,"[61] as Edwin Burrows and Mike Wallace put it. Armed with a rationalistic drive for order characteristic of English and Dutch cultures, the Manhattan grid sensibly moved from 1st Street, just above Houston in lower Manhattan, all the way up to 155th Street, in what is now Washington

Heights, while the avenues ran from east to west across the island, beginning with First Avenue on the east and extending to Twelfth Avenue along the Hudson. The avenues also designated major north-south throughways along the island (which the underground subway system would emulate a century later). By 1811, two thousand rectangular blocks had been mapped in the grid. Over two centuries later, the grid remains intact, with noted extensions to the north.

FROM DUMP TO DAPPER

On September 28, 1825, the city of New York purchased a chunk of John J. Norton's Hermitage farmland and filled in the Great Kill creek to build up 42nd Street. According to historian Ken Bloom, the city paid Norton $10 for the land,[62] less than half of the $23 that Dutch colonist Peter Minuit paid the Lenape Native Americans for the entire island of Manhattan in 1626.[63] A 42nd Street streetcar line was completed in 1839, and by the 1860s, the area north of 42nd Street was renamed Longacre Square, after London's Long Acre. By the 1870s, Longacre Square had become the heart of the city's horse carriage industry, comprising harness shops, wagon factories, stables, horse dealers, equipment suppliers, and occasional smoke and variety stores.[64] Antithetical to the hypersurveilled Disneyland that Times Square has now become, in the 1860s, the neighborhood was dark and foreboding at night, ripe with pickpockets and drunks, acquiring the short-lived moniker "Thieves' Lair."[65]

City developers devised plans to revamp the reputation of the Square from manure dumping ground, agrarian farmland, and cauldron of crime (the last of which would reappear in the 1970s, as discussed in chapter 6) to a cosmopolitan marketplace and mercantile capital of the country.[66] Midtown developers solicited the support of New York's leading merchants and bourgeoisie by emphasizing a promising economic future in the area, with an elevated culture distinct from the past.[67] The designers of Central Park in the 1850s deployed a similar strategy. By aligning uptown elites with visions of economic progress, developers fashioned the park as a public space for tasteful, "moral leisure activity,"[68] and promised to "eliminate the unpleasant, unexpected interactions that wealthy New Yorkers encountered on the lower Broadway promenade."[69]

By 1899, Longacre had made the shift, gaining a new reputation as a legitimate city neighborhood, filled with glamorous nightclubs, theaters,

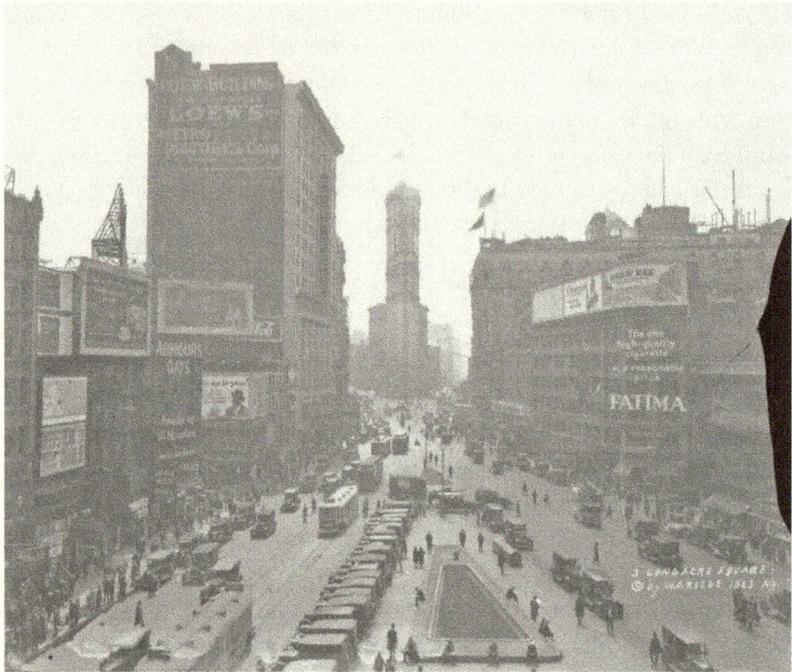

FIGURE 3.5. Longacre Square (now Times Square), Broadway and Seventh Avenue, looking south from 47th Street, New York City, 1923. Known as Longacre Square for its valuable horse and carriage industry, the area then featured the signature triangular island, known as Times Square after 1904. Image courtesy of the William J. Roege photograph collection, 1910–1937, New-York Historical Society.

and fashionable restaurants. As Ada Huxtable puts it, the new, fin de siècle reputation was "part bourgeois, part bohemian, characteristically sybaritic and shocking, extravagantly luxe, heavily Beaux Arts."[70] Flamboyant impresario and German-born businessman Oscar Hammerstein (1846–1919) built two major theaters in the district, the Olympia (1895) on Broadway between 44th and 45th Streets, and the Victoria (1899–1915) on the northwest corner of Seventh Avenue and 42nd Street.[71] In both, he constructed chic roof gardens for dining and performing in the summer heat.[72] The roof garden at the Olympia was transformed into an "amusement temple,"[73] while the garden at the Victoria was built up into a full-blown six hundred–seat theater known as the Theatre Republic (1900), leased to famed producer David Belasco, who featured live cows, wrestling ponies, boxing baboons, stunt bicyclists, a windmill and, at times, performances by Harry Houdini.[74] The Paradise Roof Garden, located on top of both the Victoria and the Republic, contained "ponds,

swans, and a rock grotto populated by monkeys."[75] Hammerstein events drew a huge crowd, seats were consistently filled, and bystanders stood on the sidelines eager to take any seat that might become available.[76] He went on to build two more famous theaters and roof gardens before going bankrupt in 1898 as the exceedingly high costs of production could not be maintained.

The luxurious Knickerbocker hotel was completed in 1902 on the southeast corner of Broadway and 42nd Street (now known as the Knickerbocker building), and the elegant Hotel Astor in 1904 (where it remained operative until 1967), on Broadway between West 44th and West 45th Streets. Both hotels added an atmosphere of chic affluence to the neighborhood.[77] The Astor offered its own private roof garden and cost approximately $7 million to complete (equivalent to $205 million in today's currency), while the Knickerbocker, built by John Jacob Astor IV, became the permanent residence for a number of prominent Manhattanites. Another shift occurred with William K. Vanderbilt's 1881 purchase of the American Horse Exchange at Broadway and Seventh Avenue, between 50th and 51st Streets. While Vanderbilt kept the Horse Exchange intact for several years as a "scrupulously reliable" center for thoroughbred horse trading, by 1910 the space was leased to chain theater owners Lee and J. J. Shubert, who transformed it into the Winter Garden Theater,[78] a move that, by this time, merely kept pace with the mass number of theaters relocating to the area.

To keep the neighborhood prosperous, Manhattan developers realized, they needed to expand their horizons and reconceive the relationship between economics and cultural space. Old World (European) strategies of exclusion based on privilege and class were largely abandoned, not for reasons of diversity and inclusion, but rather, for practicality in escalating the bottom line: profit. Unlike many of the government-subsidized state theaters[79] in Europe, American theaters fell in the domain of private equity. As a result, America's fastest-growing mecca was not driven by elite taste, family lineage, or the "character" of select patrons but instead by volume and turnover.[80] The more frequently spectacles changed and offered new novelties, the better chance it would have of being covered in the press and, in turn, the more people it could attract to an event or space on a given night.

The next step was expanding the consumer base. This was accomplished by targeting the inflow of immigrants and city workers. As Manhattan elites moved farther north, the entertainment industry and factories followed behind. At the same time, elites fought to ensure their

mid- and uptown neighborhoods remained exclusively residential, and thus developers could not capitalize on profits from endeavors there.[81] Immigrants and working-class families, however, were close by. Factories then required proximate worker housing, which was established south of Union Square in Tribeca and in what is now SoHo, and the workers who resided there now had money and leisure time to spend in the city's theaters, restaurants, and vaudeville houses.

ONE TIMES SQUARE

A new era for the Square was launched in 1904. The Times Tower was completed as the new home of the *New York Times*, formerly located downtown on Park Row.[82] Designed by neo-Gothic-inspired American architect Cyrus L. W. Eidlitz in 1904, the Times Tower at One Times Square replaced the Pabst Hotel (1899–1902) and stood as the second-tallest building in the world, after the Park Row Building in Lower Manhattan.[83] At 395 feet high, the Tower's ornate décor of limestone, terra-cotta, and brick concealed its internal infrastructure, consisting of the "stiffest steel frame ever constructed."[84] Its twenty-five stories included five levels below ground to accommodate the newspaper's presses and the new subway line.[85]

On opening day, April 19, 1904, New York City mayor George B. McClellan Jr. signed a document officially renaming the intersections of Broadway and Seventh Avenue, bounded on the north and south by 42nd and 47th Streets as "Times Square."[86] To celebrate its first New Year's Eve there, the *Times* produced an all-day spectacle of dramatic fireworks and illuminated displays from its rooftop.[87] The event proved such a success—approximately 200,000 people attended[88]—it quickly replaced the city's formerly popular New Year's Eve ritual of ringing the bells at Trinity Church (at 89 Broadway in Lower Manhattan).[89] When fireworks were outlawed in the city in 1906, the *Times* resorted to dropping a 5-foot, 700-pound wood and iron ball lit with one hundred 25-watt bulbs from the top of the Tower's 77-foot flagpole, an event now repeated for over a century.[90]

The year 1904 also marked the inauguration of the city's first underground subway. Known as the Manhattan Main Line, the transit network opened on October 27 and ran northward from City Hall along Lafayette Street and Park Avenue before turning west along 42nd Street. At Times Square it continued along Broadway to Harlem's 145th Street Station. Within a year, the Times Square subway stop had been used by

5 million people.[91] As foot traffic increased in the area, larger crowds gathered in the Square during the day and night, apace with the district's growing reputation for nighttime spectacles.[92] For advertisers and business owners, this translated to more eyeballs exposed to the city's iconic offerings. By 1911, surveyors estimated between 300,000 and 400,000 people passed through Times Square every day.[93]

The story of northward-moving money in fin de siècle Manhattan marks the first chapter in the formation of Times Square as an epicenter of culturally mediated fantasy, brought to a heightened pitch through polychromatic electronic signage. The speediest jaw-dropping colors of American commerce were no longer restrained by neoclassical white but instead chased after a newly formed popular aesthetic that, as Betsy Blackmar observes, was celebrated in the "personal fashion [of] display[ing] money—however obtained."[94] Not surprisingly, the section of Broadway most closely linked to the Square emerged as the first and most potent illustration of this new genre of display.

"WHITE WAYS"

As urban America developed, it drew its aesthetic sensibilities from the successes of the World's Fairs, mixing white light glamour with the optimism of industrial progress. American cities competed with one another by transforming portions of their urban centers into increasingly lighter, brighter, and whiter spaces, creating public spectacles for tourists and residents alike. When American developer Charles Brush first installed arc lamps in Cleveland, Ohio, in April 1879, residents crowded the public square to witness the event. "Ecstatic" sightseers wore "colored spectacles" and "broken bits of smoked glass over their eyes to avoid being blinded,"[95] while the opening of the White Way in New Haven, Connecticut, on December 15, 1911, included a grand parade of nine brass bands, motor cars, uniformed marching units, and the "businessmen of New Haven bedecked in silk top hats" with American flags draped over their right shoulders.[96]

Cities were quick to recognize that good lighting meant good business. And thus Brush continued to illuminate city centers across the Midwest from Wichita to Denver, San Jose, Flint, Minneapolis, and Detroit, each one gaining the moniker of a "White Way," typically a major commercial zone or intersection complemented by gas and electric signs to highlight a concentration of theaters, hotels, restaurants, and related venues. Numerous White Ways flourished in the United

States between 1885 and 1915, usually by means of a limited set of white or off-white arc lamps. By 1912, there were at least 220 White Ways in American cities,[97] each one offering a city or town a dose of national and local pride and faith in industrial progress wedded to American mythologies of light and power.

The conviction behind America's White Ways also extended beyond commerce, property value, and civic progress to reinforce notions of public health and safety.[98] For one, bright white lights facilitated fire and police departments, as they had done since the advent of the night watch several centuries prior, and solved congested traffic issues. They also aided in reducing crime by casting white light over previously darkened streets.[99] In the end, privately owned public lighting systems were proven so beneficial to so many parties that legislatures passed laws requiring them, even in the face of complaints and city ordinances enacted to limit the proliferation of electric signs (chapter 2).[100]

THE "GREAT WHITE WAY"

Broadway's Time Square is the number one outdoor sign spot in the world, and the number one busiest street corner is located at 42nd St. and Broadway . . . [in] the most famous and biggest city in the world!

—Virginia Sebastian, 1953

The "greatest" of all American White Ways was New York City's "Great White Way," running along Broadway between 23rd and 46th Streets.[101] By 1906, this portion of Broadway displayed "every modern light and light device known," including the enclosed arc lamp, the incandescent electric lamp in "every conceivable form of globe and shade," the flaming arc, Welsbach incandescent gas burners, Nerst lamps, Moore vacuum tubes, and even Cooper-Hewitt's mercury vapor lamp.[102] Midtown Manhattan's Great White Way was fashioned as the city's "electrical showcase"[103] where "every hour of the day [was] a business hour."[104] The press concurred. In 1906, Valentine Cook Jr. declared New York's Broadway the "best known and most frequented stretch of thoroughfare on the western Continent,"[105] and a 1911 issue of *Edison Monthly* affirmed, "In no other city in the world is so great a quantity of light centered around so small an area. . . . There are a few of the smaller displays in Paris and Berlin, one or two in London, but none of these present the riot of imagination and light that characterizes Broadway."[106] Writing for the *New York Times* in 1928, James C.

Young assented, claiming Broadway's cosmopolitan center "outshines Piccadilly Circus and it's other rivals in Paris."[107] If Paris was once the "city of light," Jenkins wrote in 1911, today it is nothing but a lingering "medieval gloom."[108] New York, New York was the "it" girl on the international scene, drawing in savvy tourists from around the world like "moths to a flame"[109] or a "Muslim toward Mecca."[110]

As numerous national and international newspapers, trade journals, and magazines sang out in agreement about Broadway's Great White Way, the neighborhood was increasingly lauded as the pinnacle and "perfection" of mankind, a "supreme being" and "triumph" of civilization.[111] No longer held back by Old World moralism or elite standards of taste, illumination in the American context eagerly embraced the brash colors of New World commerce, made possible by synthetic chemistry and architectural feats in science and technology. American success was—as it is today—measured in numbers (crowds, customers, datasets, and the brightness and intensity of light). Although such narrow views of success are problematic, in order to understand how it was ever possible, logical even, to invoke terms like *white light supremacy* with such ease and frequency, it has here been necessary to interrogate the political, commercial, and, in the following, penultimate section, the artistic and technological frameworks that came together to support these conceits.

THE BOTTICELLI OF BROADWAY

When New York's Great White Way launched itself onto the international stage at the end of the nineteenth century, Times Square was still known as Longacre Square. At the time, most streets and parks in the city, including Longacre, employed gaslight as their primary means of illumination.[112] Gas street lighting was installed along lower Broadway in 1825, from Battery Park up to Grand Street, but electric street lighting was not integrated into the existing gas lamp systems until December 1880, when Brush arc lamps were installed along Broadway from 14th to 26th Streets.[113] By the early 1890s, similar lighting systems were installed on most of the midtown cross streets, along the central avenues, from Third to Eighth Avenue, all the way up to Central Park.[114] By 1895, electric lights were instated in Longacre, and its former reputation as the dimly lit Thieves' Lair was on the way to obsolescence.[115] Those who could afford it purchased electric lighting for their business, reinforcing links between white light and wealth (as noted in the

previous chapter, only the wealthiest Manhattanites had by this time installed electric light in their homes).[116]

When select New York shop owners and merchants were ready to employ electric signage for interior or exterior use, it was sign magnate Oscar J. Gude (1862–1925) they turned to. True to American mythologies of the underdog, New York City–born Oscar Gude hailed from humble origins and worked his way to the top of the food chain, at times using violent and aggressive strategies to do so.[117] Gude had dropped out of school at the age of seventeen and by age twenty-one, was working as a sign hanger apprentice. Shortly after, he became head of the advertising department at a local soap company and, by 1889, founded what would be the city's leading outdoor advertising company for the next two decades, earning himself such monikers as "Lamplighter of Broadway," "Napoleon of Publicity," and "Botticelli of Broadway."[118] In 1894, he filed papers with the state listing capital assets for his business at $50,000. By 1906, his assets were filed at $500,000, by which time he was habitually credited in newspapers and trade publications as the "Creator of the Great White Way,"[119] having produced more than twenty large-scale spectaculars for Times Square alone between 1909 and 1915.[120]

Gude's monopoly on Great White Way signage secured him a place "in the pantheon of [Times Square] promotional geniuses," along with Adolph Ochs, Oscar Hammerstein, and Florenz Ziegfeld who together engineered the Square into an international consumer playground.[121] At the same time, one must wonder to what extent these Euro-Americans engineered America's landscape of fantasy and desire, vended to "everyone" for "free," only to end up lining the pockets of a few. Such questions must be kept in mind when considering the following descriptions of (only) five innovative polychromatic spectaculars from Gude's most creative era and their role in the development of an American imaginary rooted in "democratic" fulfillment and possession.

Manhattan Beaches (O. J. Gude Company, May 1892–1900)

Only thirteen years after Edison unveiled his incandescent bulb, the O. J. Gude Company forged its second large-scale use of the "flasher" billboard.[122] The well-known "Manhattan Beaches" sign (1892–1900) was located on the 60-by-68-foot north wall of the seven-story[123] Cumberland Hotel, where 23rd Street, Broadway, and Fifth Avenue cross—then considered the epicenter of the Great White Way (since 1902 it has

FIGURE 3.6. Still from Jessica Hupalo and Carolyn L. Kane's digital video re-creation of "Manhattan Beaches," by the O. J. Gude Company (1892–1900; compilation of video stills, 2019). Positioned on 23rd Street, where Broadway and 5th Avenue cross, at the epicenter of the Great White Way, the sign was the first animated spectacular of its kind. Because color photography and film were not then feasible, previous archival images of this sign have been restricted to black-and-white. Image courtesy of Jessica Hupalo and Carolyn L. Kane.

been the site of the Flatiron Building, designed by Daniel Burnham and Frederick P. Dinkelberg).[124]

This south-facing brick wall of the Cumberland Hotel was the "envy" of advertisers who sought possession of it,[125] ensuring they would have access to some of the city's densest foot and road traffic. Industrialist and president of the Long Island Rail Road (LIRR) Austin (A.J.) Corbin won the bid for the wall in 1885.[126] Prior to commissioning Gude's "Manhattan Beaches" in 1892, Corbin featured a painted advertisement on the site for Long Island homes (simultaneously promoting the LIRR to get there) using slogans like "Swept by Ocean Breezes,"[127] in reference to the luxurious ocean-facing resorts.[128] Gude's "Manhattan Beaches" sign was built on top of this sign, from skeletal steel frame to numerous flashing devices on the surface. Gude worked with the Edison General Electric Company to install the flasher technology, a preautomatic electric blinking system that required a workman positioned in a nearby

hut to pull a series of levers, one for each row of colored letters.[129] In block capitals consisting of red, yellow, blue, green, and white incandescent bulbs, the lines, ranging from 3 to 6 feet in length, read:

Manhattan Beach

Swept by Ocean Breezes

Manhattan Hotel

Oriental Hotel

Gilmore's Band

Brocks Fireworks[130]

The sign filled in line by line, each in a new color, and then went dark for several seconds, until the cycle repeated, every three minutes from dusk to midnight.[131]

"Manhattan Beaches" came alive on June 10, 1892.[132] At 80 by 60 feet wide, the sign towered above the proximate buildings on the triangular block and its 1,457 sixteen-candlepower polychromatic frosted bulbs drew a crowd every night.[133] Theodor Dreiser compared it to displays in Atlantic City and Coney Island, but, unlike those, the midtown Manhattan display took on a veneer of exclusivity, situated on the cutting edge of technology and advertising at a time when most of the city was still restricted to gas lighting and only the very wealthy could afford private electricity.[134]

Heinz (O.J. Gude Company, 1900–1906)

Gude's second extravagant spectacular involved a 50-foot-long incandescent green pickle in the same spot as the "Manhattan Beaches" sign. By 1900, the cost of electricity had fallen and flashing-sign technology was automated so that its blinking effects (also referred to as "talking signs") did not require full-time supervision.[135] From the start, Gude admired the way these flashing signs commanded a viewer's attention. These signs, he explained in 1912, "literally force [their] announcement on the vision of the uninterested as well as the interested passerby . . . everybody must read them, and absorb them, and absorb the advertiser's lesson willingly or unwillingly . . . making [them] part of one's subconscious knowledge."[136] The flasher technology evidenced for him a heightened relationship between sign art and the psychology of advertising that he would continue to proffer throughout his career.[137] For others, it evidenced Gude's "totally calculated" showmanship in

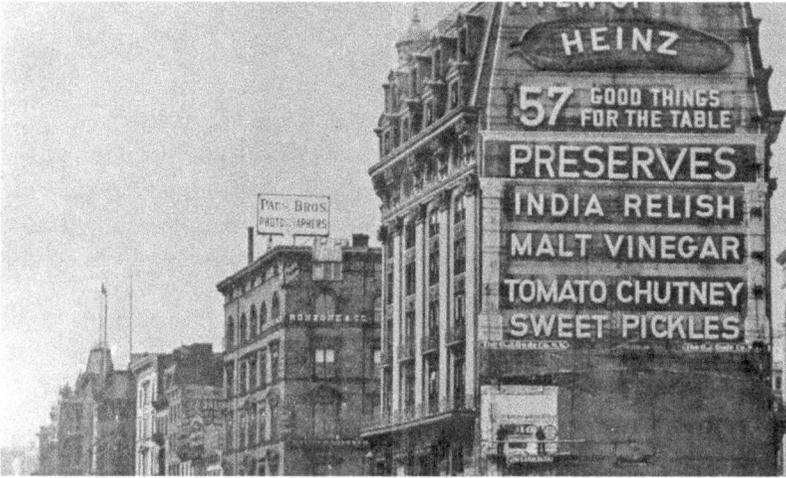

FIGURE 3.7. "A Few of Heinz 57 Good Things for the Table," O.J. Gude Company, 1898. Photographer unknown. 23rd Street looking north. Gude's extravagant spectacular for H.J. Heinz involved a 50-foot-long, flashing-green incandescent pickle. Author's collection.

catering to the bottom line.[138] From the start, Gude's goal was to "burn" products into consumers' minds and to do so with as "little conscious mediation as possible."[139] The flasher technology was ideal for this process, complemented by equally provocative techniques he adopted from the early cinema, including scantily clad women, close-ups of female faces, action scenes (boxing matches, acrobats, and horse races), and of course, phallic symbolism.[140]

The undeniably phallic green pickle for the Heinz Company, then one of the country's most important national merchandisers, was commissioned by company cofounder Henry John Heinz (1844–1919) who, after staying at a Madison Square hotel across the street from the Cumberland in 1898, noticed Gude's "Manhattan Beaches" sign and contacted him to create one for Heinz. The 50-foot-long blazing green pickle was erected within two years.[141] Flashing on and off and mimicking the color of the condiment, the sign foregrounded an incandescent orange and blue background with a giant white "57," with the names of Heinz's most popular products flashing below in block capital letters: Sweet Pickles, Tomato Chutney, India Relish, Malt Vinegar.[142]

Not all were pleased with the endeavor. Neighbors complained of its incessant "eerie visual throb of green and white,"[143] while its psychosexual implications offended others. The bulk of protests came from

those who saw the spectacular as a "vulgar" and tawdry affront to civilized city life.[144] These civic beautifiers compared the pickle to what, in their minds, was the more refined, floodlit, Beaux arts Dewey Arch in Madison Square Park across the street.[145] I return to the oppositional City Beautiful movement in the chapter's conclusion (ironically, the same oppositional movement that, a century later, fought to *retain* the veracity of bright signage in Times Square). In the meantime, I note three more early spectaculars from Midtown Manhattan's Great White Way, two from Gude and one from the Rice Electrical Company.

Miss Heatherbloom (O. J. Gude Company, 1905)

Circa 1905, Gude was commissioned by the Heatherbloom Petticoat Company to create the first large-scale spectacular in what was now officially Times Square. With $45,000 to work with (approximately $1.3 million in today's currency), Gude created an animated 50-foot-tall petticoat girl, modest by today's standards of sexual explicitness but racy circa 1905.[146] The animation contained more than two thousand bulbs in red, green, white, and purple and lasted several minutes, beginning with a young woman holding an umbrella as she walked in a series of gusts of wind and rain.[147] The lights forming her skirt and umbrella flashed on and off to create the illusion of wind unexpectedly pushing up the bottom of her red petticoat to reveal a "naughty glimpse" of her stockinged ankles, calf, and petticoat above her high-top shoes.[148] Miss Heatherbloom "stood unembarrassed" before thousands of onlookers who gathered nightly to stare as an invisible wind lifted the hem of her skirt.[149] Even though she was fully clothed, the erotic connotations expanded Gude's sign repertoire from flashing light and phallic pickles to sexually provocative women, effectively foreshadowing the more overt sex industry signage that would dominate the Square only a few decades later.[150] For the time being, however, the connotation was enough. Such sensuous imagery ultimately survived the city's moral debates, but as it did, Jackson Lears observes, "it was increasingly clothed in the sterile idiom of clinical frankness."[151] Petticoats were meant to protect and defend against "foreign" elements, not to invite them in.[152]

"Leaders of the World" (Rice Electrical Company, 1910)

Ellwood E. Rice of Dayton, Ohio, spent upward of $1.6 million in 1909 (nearly $7.8 million today) on what would become the most famous,

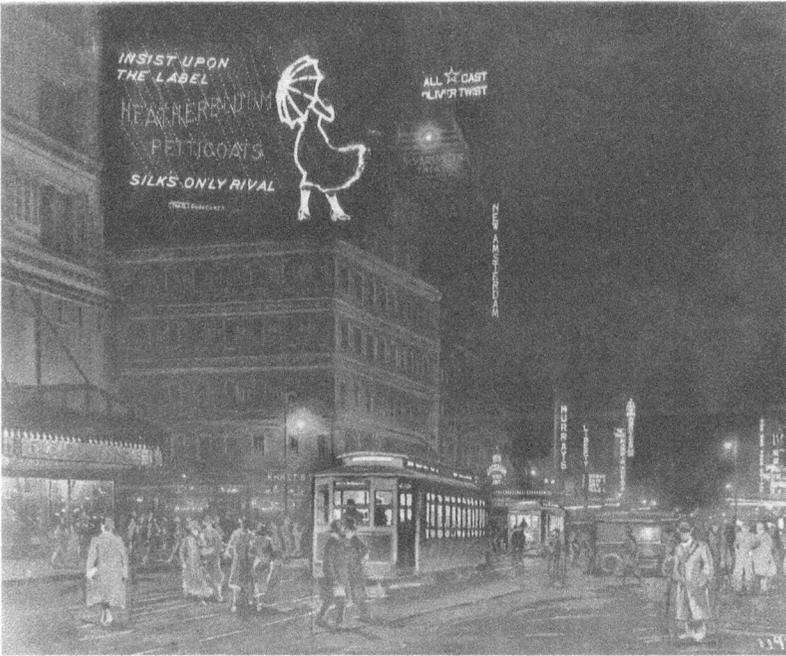

FIGURE 3.8. Heatherbloom Petticoats. "Insist upon the Label," O.J. Gude Company (1905). The Heatherbloom Company commissioned Gude to create the first large-scale spectacular in Times Square proper to advertise the company's petticoats. With $45,000 Gude landed on an animated depiction of a 50-foot-tall petticoat girl. Image courtesy of the OAAA Digital Archives Collection, Duke University.

press-friendly sign of the time.[153] The "Leaders of the World" sign (aka "Roman Chariot Race") stood seven stories tall (72 by 90 feet) and was constructed of 20,000 light bulbs generating 2,500 flashes a minute; requiring 70,000 electrical connections, 5,000,000 feet of wire, and 3,500 switches; and weighing 60 tons.[154] The sign took three months to complete and was so large, it needed to be shipped from Dayton to New York City in eight railroad cars, the leading chariot requiring a car of its own.[155] Once installed, the infrastructure was so elaborate, its concealment behind a complex of steel bars formed the physical equivalent of a three-story house.[156] The front of the sign was positioned on the south-facing side of the Hotel Normandie's roof on Broadway and 38th Street, doubling the hotel's height.[157] The contents of the sign advertised and emulated the then-popular Broadway show *Ben-Hur*. Even though the animation was automatic, the mechanism had to be carefully monitored by four men, three of whom patrolled the site from below, "armed

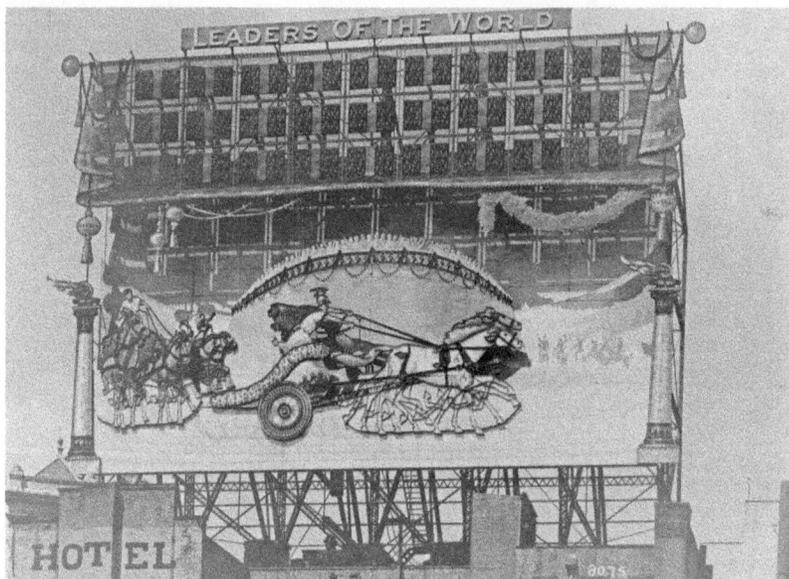

FIGURE 3.9. Ellwood E. Rice's 1909 "Leaders of the World" sign, also known as the "Roman Chariot Race" sign, was seven stories tall and constructed of 20,000 light bulbs generating 2,500 flashes per minute. Image courtesy of the OAAA Digital Archives Collection, Duke University.

with a powerful pair of field-glasses" and the fourth stationed from dusk till midnight at an open window in the nearby Rice Electric Display Company office (in the direct line of sight to the sign).[158] The following morning, any reported dead bulbs (from 150 to 200 bulbs per night!) or malfunctions would need to be repaired before the spectacle lit up again that evening.[159]

The thirty-second animation ran on a loop at a rate of 2,500 flashes per minute (40 flashes per second) to ensure seamless motion,[160] followed by thirty seconds of darkness. At the beginning of each "performance," a viewer would see the illusion of galloping horses in eight different positions by way of a flashing sequence of over thirty times a second, "far faster than the eye can follow." The result, David Nye observes, rendered their gallop perfectly.[161] The galloping horses pulled a blazing chariot and a giant driver in white tunic and crimson cape (the "biggest garments ever constructed in solid steel"[162]), equipped with "furiously spinning"[163] 8-foot wheels.[164] Each "splendidly sculptured" horse sent forth 80-foot flames[165] and a sharp light from its eye, suggesting a fight to the end. The horse's manes, tails, ears, and harnesses were

also outfit with small holes to accommodate more rapidly flashing electric lights, making it "impossible for the human eye to detect anything mechanical in the movement."[166] By changing the colored markings on the background of the screen,[167] Rice generated the effect of moving stadium walls and a track receding under the flying hoofs and revolving wheels.[168] Soon after the main chariot appeared, another pair of horses and chariot appeared onscreen as a close second. The manes and tails of the first set of horses and the cloak of the driver "flutter[ed] in the breeze," English writer and journalist Francis Arthur Jones observed, "giving a very realistic affect."[169] A new genre of street cinema was born, "free" for "everyone."

The ads surrounding the animation were also "free." As the horse race played in the structure's internal frame, bound by 35-foot columns, the outer frame played up to 150 fifteen-second commercial promotions, permitting up to 54 letters, each 4 feet high.[170] As Isenstadt explains, "It was an embryonic instance of a new kind of urban reading that exploited the eye's natural responsiveness to motion in order to smuggle an advertisement into the spectator's view."[171]

On its opening night, the sign drew a crowd of 20,000 people,[172] and every night after that, its performances continued to draw large crowds, at times halting traffic and, for weeks in the summer, requiring a special police unit to be assigned to Herald Square to keep traffic moving.[173] The crowds alone offered their own kind of spectacle, attracting people to return for repeat performances and to be a part of the scene.

The press swooned over "Leaders of the World," describing its animation as "more perfect and natural in its movement than the finest coloured cinematograph picture."[174] It should by now be obvious how narratives of "perfection" and "supremacy" could be so easily connected to such signs and the genre of illuminated light they both derived from and gave birth to, together forming a collective manifestation of America as the "leader of the world" during the nation's "great" Gilded Age.[175] Recall, too, that *Ben-Hur* is a Christian narrative, triumphing over the Jew who, in the end, converts to Christianity in order to "win the race."

Wrigley's (O.J. Gude Company, 1917–1924)

Gude's 1917 Wrigley's sign,[176] then touted as the "largest electric sign on the face of the earth,"[177] was located in the heart of Times Square on the sought-after roof of the thirty-three-story Deco-style Putnam Building at 1501 Broadway, between 43rd and 44th Streets (now the Paramount

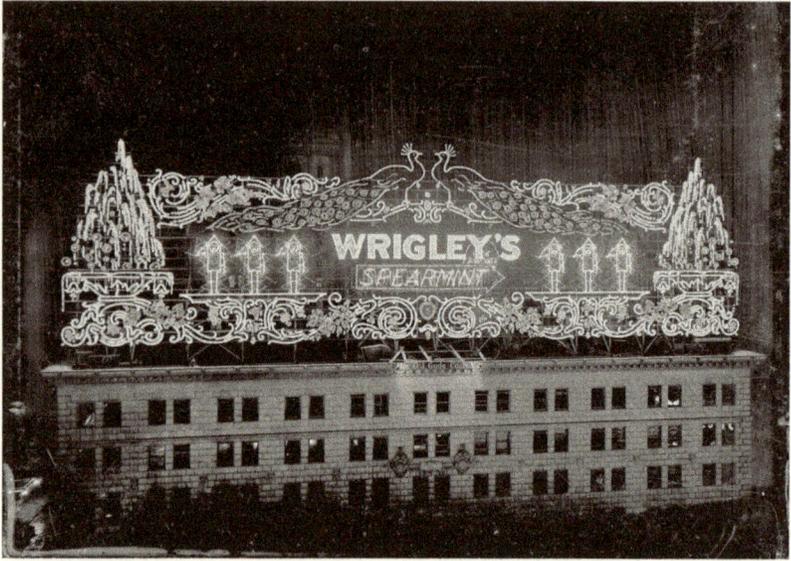

FIGURE 3.10. Gude's 1917 Wrigley's sign, then reputed to be the largest electric sign on the face of the earth, was located at the heart of Times Square on the roof of the Art Deco–style Putnam Building. Image courtesy of the William D. Hassler Photograph Collection, New-York Historical Society.

Building).[178] Chicago chewing gum magnate William Wrigley paid $700,000 ($100,000 per year) to lease the space, for which Gude's company designed a flashing sign, 200 feet long (the length of the entire block) and 100 feet high, featuring two twin peacocks perched on a branch.[179] The 60-foot-long peacock tails merged at the back to form a green and purple "feathery canopy over the central portion of the display."[180] Beneath them was the Wrigley's logo and text: "Wrigley Spearmint Gum." Flanking each peacock was a "drill team"[181] of six 18-foot "Spearmen" or "electrified brownies,"[182] with spears and pointy hats that acted out a series of twelve calisthenic routines in "eight different flashing arrangements,"[183] eventually coined the "Daily Dozen."[184] Thirty-four-foot fountains of blue bubbling water appeared on the outer edge of each team of Spearmen, framing the show in "vinelike filigree."[185] The message proffered by the brand was the promise of "energy, sharp taste, and luxurious well-being."[186] Using just over 17,000 multicolored lamps,[187] the sign was seen by an estimated 300,000 people per day[188] and held the longest lease in the Square, until 1924.[189]

By the time the sign came down in 1924, neon colors were all the rage along the so-called Great White Way, now garnering new monikers

as the "Rainbow Ravine" and "Color Canyon." Gude had by then left the country, having been in poor health since 1918. He sold his business and retired in 1919, donated his art collection to the Lotos Club, and moved to Germany, where he died seven years later at the age of sixty-three.[190] The company's new owners operated independently until 1925, when it folded into a larger sign conglomerate, along with twenty other independent sign companies.[191]

TIMES SQUARE SUPREME

In [the reformers'] view, public lighting was to be primarily white, austerely beautiful, and refined.
—David E. Nye, 1994

The chapter's penultimate section focuses on white lights, signs, and business owners who saw the new genre of electric spectaculars as enhancing the urban environment with impressive feats of illuminated advertising and technology, preparing the ground for the large-scale public spectacles we are familiar with today in cities around the world. In closing, I reframe these early feats alongside the earlier-noted political battles that sign makers waged.

The City Beautiful reformers eventually admitted that some urban signage could be permitted, so long as it was "tasteful,"[192] where taste was defined through the standards of classical aesthetics, rooted in restraint, purity, and of course, pristine white paint and light (analyzed in chapter 1). City Beautiful proponents thus advocated that American cities should emulate the grand monuments found in iconic European cities like Rome and Paris, accorded with "civilized" order, dignity, and harmony. At the heart of the CB movement was an intense insistence on tasteful floodlighting in the style of the White City and its neoclassical architecture.[193] Clean lines, symmetry, and order constituted a discerning decor that would "dignify" the "beauty" of the already white edifices, versus obstructing them with vulgar (colorful) advertisements.[194] That it would also perpetuate an ethos of a (monumental, great) power through the historically inaccurate construal of the whiteness of classical aesthetics did not seem to be an issue.

As noted, after the World's Columbian Exhibition closed, a number of American cities and World's Fairs emulated its template, reproducing this clean, sanitized aesthetic in the heart of their cities. Examples abound from Richmond, Virginia, to San Francisco. American city

planners like Daniel Burnham, Charles McKim, and Frederick Law Olmsted Jr. were commissioned to travel to European capitals, study the presumed aesthetic supremacy of their clean, commercial-free, "pure" white art and architecture and reproduce them in the United States. This would also be the last time American cities would deem it necessary to look to Europe for direction in aesthetics or technology.[195]

In her critique of the CB movement, American activist and writer Jane Jacobs referred to it as an "architectural design cult,"[196] and the White City architecture that ignited it, in particular, as a "retrogressive imitation [of] Renaissance style"[197] marked by "one heavy, grandiose monument after another . . . like frosted pastries on a tray."[198] Jacobs suggested American city schemes modeled on the White City had done nothing but separate one special (elite) part of the city from the socioeconomic realities of the rest, segregating it to remain pure and "decontaminated"[199] from the (colored or impure) residuals. As a result, remainder areas adjacent to these select "white enclaves" were severely neglected, often becoming the home of tenement buildings and slums, filled with an "incongruous rim of ratty tattoo parlors and secondhand clothing stores" (though arguably many of these areas have now been gentrified).[200] In short, color in the so-called democratic American city has time and again been subject to violent exclusions and marginalization because it has not been a part of the unspoken power and politics of the white city.[201] In the end, both sides of the Atlantic have invoked their own form of whitewashing: in the former it has been the American drive for power and capital, while in the latter, it has been a rehashing of European whiteness through the rhetoric of aesthetic and moral superiority.

Due to its intense polychromatism and diverse audiences, Times Square at first seems orthogonal to these narratives but closer inspection reveals it to be just as integral to the development of America's white imaginary, rooted in the unfettered pursuit of monolithic power and capital. Historian David C. Hammack posits a fourfold rationale as to how and why Times Square assumed this status at the center of American culture and consciousness in the twentieth century. First, there was the national shift to a market economy in the last part of the nineteenth century, when the growth of industry engendered a relocation of manufacturing plants to major metropoles on the Eastern Seaboard to maintain proximity to raw materials in the Great Lakes region.[202] Second, there was New York City's size and location on the Eastern Seaboard: as the largest of these cities, New York was made a

major transportation nucleus by geographic circumstance alone.[203] Third, Midtown Manhattan had become a central transit hub within New York City, especially after the 1904 opening of the crosstown subway and Mayor George McClellan's renaming of Vanderbilt's horse exchange to "Times Square."[204]

The relocation of Grand Central Station a few blocks away (originally located between 26th and 27th Streets, bounded by Madison and Fourth Avenues [now Park]) in the 1840s aimed to mitigate congestion on the street that impeded efficient access to warehouses and the speedy transportation of shipments around the city.[205] Key here is the rationale to improve business, not to transform the infrastructure of the city to better the quality of life for people in it (also the primary argument waged against the work of Robert Moses).[206] Finally, private and public zoning laws in the city, alongside advertising reformers (also a group of Old World "economic elites"[207]) fought to designate this region of Midtown Manhattan as the most prominent commercial entertainment district in the country and, for some decades in the twentieth century, in the world.[208]

During this era, the Great White Way was born. The initiation of the Square in 1904, alongside the migration of the city's main attractions farther and farther uptown (eventually hitting 59th Street), were the key catalysts for growth. Its unique electrographic architecture was imbued with playfulness and a sense of democratic belonging, seemingly qualifying the greatness of the Great White Way as truly the "best" of all worldly ways.[209] As Stephen Chalmers put it in 1904, even the word *Broadway* was enough to "induce magic" and "cast a spell on a New Yorker no matter where they [we]re in the world."[210]

The following chapter continues my analysis of this new brand of electrographic Americana, rooted in unabashed commercialism sought by way of bright, white light and power.

Douglas Leigh's Times Square Spectaculars

1930–1960

People everywhere [are] making signs and outdoor advertis-
ing a part of their American way of life.
—Virginia Sebastian, 1947

By the end of the nineteenth century, advertising was a surmounting force in the United States, most evident in big cities like New York where dwindling faiths in Old World religion were rapidly supplemented by the New World's religiosity of commerce hailed by illuminated public marketing. As thousands of urban immigrants and working-class New Yorkers garnered jobs, wages, and access to leisure time, they sought to enjoy America's freedoms (shops, parks, movies, theaters, and restaurants), the vast majority of which were concentrated in Times Square.

This chapter analyzes a then-new genre of large-scale electric signs known as spectaculars, largely engineered for and in Times Square by American advertising executive Douglas Leigh and his colleagues Benjamin Strauss and Jacob Starr. The chapter addresses the ways their mass, polychromatic edifices bolstered American mythologies of a democratically accessible "good life" by way of increased visual and material consumption. After an exegesis of Leigh's classic American underdog origin story, the remaining two-thirds of the chapter offer a chronological catalog of highlights from his Times Square portfolio from the 1930s to the 1960s.[1] The extensive technical detail in this index is meant to offer a resource for media artists and historians of technology who wish to re-envision this work today or, as the author and her research assistant Jessica Huppalo have done to complement

this book's publication, digitally re-create some of his kinetic master-pieces.[2] The chapter's conclusion returns to my broader critique of con-sumer culture as an instantiation of America's white imaginary, positing that the majority of products Leigh "brought to life" in the Square—gasoline, tires, frozen food, cigarettes, chewing gum, whiskey, beer, and soda pop—collectively participated in a mass whitewashing of Ameri-can fantasies into a homogenous and sanitized, prepackaged "good life."[3]

RAINBOW RAVINE

In January 1928, the *Saturday Evening Post* declared the dawn of a "New Age of Color,"[4] a "chromatic revolution" that was "everywhere apparent" in American life, from architecture to clothing to kitchen appliances.[5] The announcement arrived one year after automobile mag-nate Henry Ford ceded to popular demand by introducing colorful cars on the market and mounting an equally chromatic national advertising campaign; sound recordings became a part of the cinematic experience; the American home befitted a new pallet of synthetic hues lining walls, "draperies, and floor coverings," and a "craze for colored glassware" brightened up the kitchen and pantry.[6] Meanwhile, Siegfried Kracauer, reflecting on the modern landscape in 1927, wrote, "The position that an epoch occupies in the historical process can be determined more strikingly from . . . its surface-level expressions than from [its] judg-ments about itself,"[7] an idea developed by Guy Debord in 1967 when he retroactively dated the launch of his theory of the "society of the spectacle" to 1927.[8]

As described in the previous chapter, New York City's Times Square was championed as the quintessence of this new age of color. Between 1918 and 1930, the population of the city expanded to over 1.5 million people.[9] The end of World War I led to a rejuvenation in cultural and economic growth that, by the late 1920s and 1930s, made Times Square a mecca for Jazz Age entertainment, hip fashions, posh new restaurants, nightlife, and of course, cutting-edge electrographic advertising.

Hollywood's growing successes further catalyzed changes in the Square. When the number of legitimate live theaters in the Square (and the country in general) declined between 1910 and 1925,[10] they were replaced by vaudeville and burlesque houses and, more notably, a slew of luxe movie palaces. By 1933, five of the ten remaining theaters in the area had relinquished live production and transitioned to

vaudeville, burlesque, or first- and second-run movies.[11] Lowe's State Theatre and Paramount Studios came to the area in 1926, followed by Roxy's Rialto, the Strand, and the Capitol. The Paramount's luxurious 3,600-seat venue with "frescoed and gilt ceilings" and a "grand lobby" set a new standard for the majestic movie palaces of the decade.[12] When these grand movie theaters offered first-run premieres of Hollywood productions, they attracted celebrities and, closely behind them, large crowds. This in turn gave national exposure to the Square once again, sustaining the neighborhood's reputation for cutting-edge glitz and glamour. Moreover, in contrast to expensive live theatrical productions, screening movie reels proved to be a much more cost-efficient method for capitalizing on the Square's foot traffic and limited real estate.

By this time, the sign maker's palette was flush with a new gamut of synthetic colors and lighting devices, including ticker tapes, gas and incandescent bulbs, motorized and automated systems, and neon. As early as 1921, the *Edison Monthly* reported not a square foot of skyline in the Square remained that did "not proclaim the virtues of something to eat or drink or wear."[13] The Square boasted the most expensive advertising space in the nation. Circa 1926, a company could pay up to $600,000 to rent a Broadway sign space for the year.[14] The Great White Way had morphed into a polychromatic "Color Canyon" and "Rainbow Ravine," as *New York Times* reporter Meyer Berger put it in 1944,[15] making it the world's most visually aggressive battleground for brand awareness. William Leach argues that it was during these years that Americans for the first time became comfortable defining themselves through the things they possessed.[16]

The stock market crash of October 29, 1929, put a temporary hold on the Jazz Age's fervent pursuit of fulfillment through individual possession.[17] Financial crisis and news of Wall Street's flailing stocks traveled uptown where, as of 1928, stock prices had begun to appear on the newly installed Times Square "Zipper,"[18] a ticker tape that wound around the corner of One Times Square. As the Square transitioned from the upscale elite fashions of the pre-Depression years into an informal mecca for migrants, vagabonds, and immigrants from non-English-speaking communities during the Depression years of the 1930s, it nonetheless remained the city's central gathering place, sustaining itself as the most lucrative site for a new genre of electric marketing, most successfully accomplished by American advertising executive Douglas Leigh.

DOUGLAS LEIGH AND THE AMERICAN DREAM

Born in Anniston, Alabama in 1907 to a well-to-do banker father,[19] from an early age Douglas Britton Leigh (1907–1999)[20] developed a lifelong obsession with display lighting as he witnessed new forms of illumination emerging in cities across the country and, in the most American of ways, recognized white light's capacity to accrue power and prestige.[21] One of his earliest jobs involved selling copies of the *Saturday Evening Post*,[22] after which he worked for the General Outdoor Advertising Co. Inc. (GOA) in Birmingham and Atlanta.[23] He completed his freshman year at the University of Florida in 1927,[24] but dropped out in his sophomore year after turning a $5,000 profit (equivalent to $79,000 today) flipping advertising space in the school yearbook.[25]

When Leigh arrived in New York City in 1930 with $8.25 in his pocket and a secondhand Ford, he sold the car for $150 and took a position at General Outdoor Advertising selling signs for $50 a week. When the company cut his salary to $30 a week in 1933 and refused to let him create signs for the much sought-after Times Square district, he quit. By 1941, he owned and operated a multimillion-dollar business designing "breathtaking signs"[26] for the Square and, by the age of thirty, had acquired the monikers "Sign Boy King" and "Lamplighter of Broadway" and was nationally celebrated as a sign wizard of the bourgeoning color canyon.[27]

Historians have noted Leigh's strong character, rife with self-determination, creativity, and professionalism. Robert Sellmer observes his "shy, low-pressure type of salesmanship,"[28] while Douglas Martin describes his "soft-spoken sales ability and a flair for the fabulous."[29] E. J. Kahn Jr., writing in 1941 for the *New Yorker*, compared Leigh's persona to a "Princeton freshman" who dressed in tweeds, bow ties (he confessed to owning more than sixty[30]), and a "fresh boutonniere of cornflowers."[31] At first glance, Leigh's life and work exemplify the myth of the American underdog, from Horatio Alger to Wall Street: the young professional from humble origins manifesting big dreams.[32]

Times Square was Leigh's canvas. It was here that his first, biggest, and most innovative (truly supreme) works debuted and consistently made national headlines between the 1930s and 1960s. Leigh built signs with "even more hyperbolic visual presence than any previous sign-maker," bringing "a heightened sense of spectacle to an already visually extravagant form."[33] According to Meyer Berger, on Broadway Leigh became the "master conductor of the world's greatest [street]

symphony."[34] Author Jerome Charyn concurs, noting Leigh's remarkable development of an entirely "new architecture" for the city, a fresh "body and bones of light."[35] In Leigh's work, we find the very definition of electrographic architecture wherein the word "architecture" no longer seems relevant (as a signifier of a single entity in space), because the built environment is always already taken as a broader, media ecology. Even if Leigh's signs did not generate direct sales, they generated "memory value,"[36] which, according to him and several generations of marketing experts after him, can do more for a city's and product's brand than direct sales ever could.

Yet Leigh and his colleagues have remained largely underrepresented figures in histories of technology, electronic advertising, and urbanism, while other figures—Carnegie, Le Corbusier, Edison, Rockefeller, and Zuckerberg—have circulated in household patois for decades.[37]

ARTKRAFT STRAUSS

American-born, German-Jewish craftsman Benjamin Strauss was known for his meticulous calligraphy, sign painting, and hand lettering. In 1897, he founded Strauss & Co. Signs, an outdoor advertising company located on the second floor of a gentleman's saloon at 1299 Broadway and 47th Street, in the north end of what would become Times Square in 1904.[38] Strauss & Co produced detailed hand-painted price tags for retail stores, menus, showcards, gilded signs for shops, and theater marquees.[39] Strauss also worked with gaslit signage, which involved banks of gas jets caged in metal frames of copper, tin, or bronze. The frames were painted, treated with enamel, had holes punched out to form the names of the production or performers, and then covered with colored glass lenses.[40] Strauss's main competitor at the time was sign developer Oscar J. Gude (chapter 3). The victor would be the one who succumbed to the new era of electric signage the quickest. For Strauss, this would be in 1909, when he joined forces with Jacob Starr.[41]

Russian-born Jacob Starr (1889–1976)[42] demonstrated a gift for "invention and a flair for mechanics."[43] At a young age, he began training as an apprentice metalworker and taught himself electric trade skills during his time off. At the age of fourteen, he ventured into his town's "best eatery" and negotiated a deal with the owner whereby Starr would build an electric sign for the business and, if the sign did not work in generating profit for the business, Starr would not get paid.[44]

The sign mainly consisted of German-made lightbulbs. To generate power, Starr harnessed the flow of a nearby river.[45] In essence, as Starr and Hayman explain it, he built not only an electric sign from scratch but also a fully operative electric generating plant to fuel it.[46] The sign was a success. It drew crowds to the restaurant, making it the "most popular night spot" in Ekaterinoslov (now Dnepropetrovsk), Ukraine, a city that, at the time, did not even have streetlights or domestic lighting.[47]

When Starr arrived in New York City in the early 1900s, he moved in with his uncle on the Lower East Side during a time when European and Russian Jewish immigrants dominated the neighborhood. He began scavenging old scrap metal, which led to the purchase of a pushcart and eventually a horse-drawn wagon, which became the location of his first business, collecting and reconstructing burnt-out light bulbs around the city. The business was successful enough to allow him to hire a "team of immigrant girls"[48] to work for him and, more notably, to catch the attention of the unruly Edison company, to which he sold his business in 1909, using the profit to emigrate his father to the United States.[49]

Less than a year after the sale, Starr presented himself to Benjamin Strauss at his 47th Street factory. According to Jacob's granddaughter Tama Starr, he pulled out all the bells and whistles to make a good impression on his possible future employer. His tactics worked. Strauss began working at Strauss & Co. Signs in 1909 and no sooner had he started than Strauss & Co. Signs segued into electric sign production.

Starr and Strauss's first electric sign was completed the same year Starr joined the company. The "Floradora Girls" sign for the eight-story Casino Theater at the corner of Broadway and 39th Street featured the famous Floradora Girls, "vaudeville cuties"[50] who predated and paved the way for Florenz Ziegfeld's better-known theatrical Broadway spectaculars (1907–31). The Floradora Girls "undulated from side to side, their palms coyly placed beside their roseate cheeks," brazenly displaying "their stuff."[51] Starr used pink gelled spotlights and animated bulbs with an interconnected set of electric motor–driven mechanisms to feature the Girls (painted by Strauss) wearing their signature feathered leghorn hats while riding their trademark pony cart.[52] As the wheels of the cart turned, the pony trotted, the wagon appeared to rock, and the dancers' feathers swayed as they grinned at viewers. The sign was prosperous, attracting a number of spectators each evening to watch its show.

In 1914, Strauss and Starr built their first advertising spectacular for Willys-Overland Motors, later known as Willys Jeep. At the time, Willys-Overland ranked as the second top automaker in the country,

struggling to overtake Henry Ford's company. Accordingly, the sign was located on a highly visible (and valuable) rooftop on the corner of Broadway and West 54th Street.[53] Strauss & Co. Signs rebuilt the Willys-Overland sign several times over the years, the last one in 1924. It was also this sign that was the first in Times Square to use neon color.[54]

In the early 1920s, Starr left Strauss to build his own consulting company, named Starr Engineering.[55] He traveled to Lima, Ohio, to make an agreement with the Artkraft Company,[56] which held the Claude Neon franchising rights for the country (for more on neon, see chapter 5). Artkraft began as a producer of porcelain enamel for bathtubs, stoves, and other appliances but transitioned to sign making in 1921.[57] After Starr returned to New York and formed Artkraft New York[58] as chief engineer and general manager, he held the most dominant neon franchise in the city. He began leasing rooftops from cash-strapped property owners and releasing the space (and signs) to national advertisers.[59] Starr and Strauss were in fierce competition until the Depression hit in 1929,[60] when they joined forces once again, this time with Starr in charge.[61]

In 1935, Starr and Strauss formed Artkraft Strauss[62] and moved to a new factory at 830 Twelfth Avenue, between 57th and 58th Streets.[63] They retained their centrally located office in the Palace Theater building, behind the Trimble Whiskey sign on 47th Street and Broadway, where their "control tower" allowed them to manage the central nervous system of Times Square.[64] Artkraft Strauss was by now a leading national and international manufacturer of signs. By September 1945, Starr and Strauss were leasing 75 percent of the viable building tops in New York and by 1948, manufacturing more than 90 percent of the large-scale electric spectaculars along Broadway. In one week in January 1946 alone, the company executed the debut of seven new spectaculars in the Square.[65]

Strauss retired in 1959, though he stayed on as general manager.[66] Jacob Starr, the full owner since 1937, handed the reins over to his son Mel Starr in 1976.[67] Mel was joined by his sister Tama in 1982, who became the sole owner in 1994. The grandchildren, Tama explains, embraced computerization, high-tech engineering, LED fabrication, and computational electronic controls required for success in the new millennium.[68] In 2004, the family sold its production plant at the ship docks, refurbished themselves as a design consultancy, and relocated to 1776 Broadway.[69]

LEIGH'S TIMES SQUARE PORTFOLIO

"I'm an idea man, a concept guy," Leigh explained to a journalist in 1998.[70] According to Times Square historian Darcy Tell, Leigh generated more than ten thousand ideas per year, many of which he passed off to his staff to file by subject: "babies, fog, magic, searchlights, sounds, sparks, etc."[71] He drew inspiration from a variety of sources, including World's Fairs, Fourth of July celebrations, Broadway theater, Hollywood, cartoons, party games, and toys.[72] A 1947 issue of *Hearst International* notes a Fourth of July fireworks celebration that Leigh witnessed in 1919, at the age of twelve, when the "sputtering Stars and Stripes"[73] amazed the audience with its "pyrotechnical Hocus Pocus"[74] but for Leigh, familiarized him with a host of "successful showman techniques."[75]

Leigh also garnered inspiration from Manhattan. He was known to walk around the city, survey rooftops, and scout leases about to expire for potential advertising sites.[76] He would snatch up these leases, sell his exuberant ideas to advertisers at exuberant costs, and then provide them with signs. A number of concepts went unsold or unbuilt. One example was his plan to include real animals inside signs, such as horses, camels, elephants, and cows.[77] In another example from 1942, Leigh picked up a kaleidoscope at an antique shop in Silvermine, Connecticut and, upon viewing the colored-glass fragments inside the toy, was inspired to create a Broadway sign with the same kind of rotating, colored sections of plastic (versus glass), each 20 to 30 feet long.[78] Pedestrians would be consistently awed by the sign's "unpredictable pattern changes," he argued.[79] Leigh even went so far as to pitch the concept to a garment manufacturer to advertise his store, but in the end, the plan did not come to fruition.

Other unbuilt design concepts include a translucent glass of orange juice and a helium-filled, dripping plastic orange to advertise Tropicana products, and a five-mile-high swinging searchlight for Eveready batteries.[80] For Two Times Square, Leigh envisioned transforming the entire building into the shape of a perfume bottle, puffing out branded scents into the street. He also projected the entirety of New York City be remade as a light show. Many of his unmade ideas foreshadow the mass electric spectacles in Times Square today. As Meyer Berger put it in 1944, Leigh's crazy ideas conjured up the most "delightful nightmares,"[81] a Times Square "bathed in narcotic pastels" and "Sin No. 5."[82] But Leigh was hardly the transcendental or trippy type; rather, in him we find a true creative visionary who merely tempered his wild

visions to capitulate to the demands of mechanized commerce and commodity capital.

As for the concepts that were put into production, Leigh relied on a team of skilled engineers who toiled behind the scenes to materialize his wild visions for public consumption. Key was his chief engineer and company vice-president, Fred Kerwer, possibly poached from Starr for his excellence as an engineer, draftsman, metalworker, electrician, mechanic, tube bender, carpenter, and overall sign man after Leigh left the company.[83] Leigh also worked with animator Otto Messmer (1892–1983), creator of the Felix the Cat cartoons; Otto Soglow (1900–1975), known for his comic strip *The Little King*; former Walt Disney animator "Hutch" Hutchison; and Australian inventor Kurt Rosenberg. He was also known to hire Hollywood stars to appear in his Epok animations, including Martha Raye, Joan McCracken, Rita Hayworth, Fred Astaire, and Bill "Bojangles" Robinson.[84] The remainder of this chapter (excluding the conclusion) offers a catalog of highlights from Leigh's exceptional Times Square portfolio, focusing more on the signs made to advertise products than on theatrical productions, with the exception of *High, Wide, and Handsome* (1937). As noted, each entry offers detailed technical specifications for digital re-creation purposes or simply for understanding the immensity and scale of Leigh's innovative output, otherwise inaccessible to contemporary readers.

A&P (1933), Douglas Leigh, Inc.

Leigh's first spectacular was produced during his tenure at the St. Moritz. He used his access to hotel stationery, in conjunction with a new "Douglas Leigh, Inc." stamp[85] to pitch a sign concept to the Great Atlantic and Pacific Tea Company (A&P) in 1933.[86] Within a few months, he had constructed an impressive 50-foot-high sign featuring an image of a young woman facing the street. In front of her was a giant, 25-by-15-foot steel coffee cup that puffed real clouds of steam onto the streets of Times Square.[87] Located at the corner of 47th Street and Seventh Avenue, just north of the iconic Palace Theater at 1564 Broadway and West 47th Street, in what used to be a vaudeville venue in the 1910s and 1920s, the advertising sign for A&P's Eight O'clock brand coffee garnered for Leigh base production costs plus a $2,000-per-month rental fee.

The innovative sign caught the attention of the press, including the *New York Times*, the *Daily Mirror*, and *Hearst's International*, the last of which lauded the endeavor for succeeding in "a [Depression] year

when salesmanship of almost supernatural order was required to sell anything except retrenching equipment."[88] Walter Winchell also sang the praises of the sign in his "Broadway Bulbs" gossip column for the *Daily Mirror*,[89] while the *Times* was slightly ambivalent. When the sign was switched on during opening night on March 4, 1933, "the steam condensed, drenching the gathering of notables in the street below."[90] The mishap was quickly amended, and for the following four decades, Leigh was vigilant about avoiding press coverage of accidents.

Shortly after the A&P sign went up, Leigh moved into a new office space in the International Building at Rockefeller Center where he diligently labored away assembling concepts, sign production schedules, and leases for the most prominent rooftops in the city and Square.[91] His main techniques—discussed in detail below—included neon, animation, color, smoke, water, and large-scale sculptures. While there were certainly spectacular billboards in the Square prior to Leigh's arrival (described in chapter 3), it was really through his work that we witness a resurgence of the Square as the capital of twentieth-century spectacle.

Prohibition (1920–1933)

More damaging to Leigh's business than one accidental waterfall was prohibition, which began on January 17, 1920 and did not end until December 5, 1933. Embodied in the Eighteenth Amendment to the US Constitution and the Volstead Act, prohibition forbade the manufacture and sale of alcoholic beverages.[92] As scholars have noted, one of the unforeseen consequences of prohibition was the proliferation of speakeasies and the admission of women into what were formerly all-male, semiunderground drinking clubs and parlors. Another consequence was a rise in crime, from prostitution to pickpocketing and bootlegging moonshine. In some locales, such activities were hardly concealed, such as the hip nightlife that still colored the Square, where drinking became fashionably chic, "invested with the allure of forbidden fruit."[93]

The end of prohibition was clearly presaged well before its actual arrival.[94] Advertisers began promoting alcohol in neon signs placed around the country as early as November 1932. The Anheuser-Busch sign, for example, appeared simultaneously in New York, Chicago, Philadelphia, New Orleans, St. Louis, and Kansas City on November 4—four days before the presidential election.[95] The New York version, located at Broadway and 46th Street, displayed the company's flying eagle logo with the name Budweiser underneath, spelled out in "strapping neon."

According to Starr and Hayman, the sign functioned as a not-so-covert message to presidential rivals Roosevelt and Hoover that they needed to read the writing on the wall.[96]

Once prohibition ended on December 5, 1933, alcohol manufacturers sprang back into action and, along with them, the spectacular signs that so successfully sold their products. Leigh's sign business jumped back on its upward trajectory and remained there through the 1960s, with only a second temporary setback during the brownout years of World War II.

Ballantine Beer (June 1936), Douglas Leigh, Inc.

The 1936 "Ballantine Beer" sign for P. Ballantine & Sons[97] marked the twentieth spectacular sign Leigh had assembled in New York since 1933. The four-story (68 by 40 foot) sign was located on the roof of the eleven-story Brill Building (Alan Lefcourt, 1931), located at 1619 Broadway and 49th Street.[98] Designed around the theme of a "three-ring show," the display employed 2,220 feet of 15- and 11-millimeter neon tubing in red, gold, and turquoise, complemented by 600 red and white incandescent bulbs.[99] Its 12-second animation consisted of a clown pitching three quoits in a row, each one expanding after release from the clown's grasp and moving across the space in fifteen spins before landing on its mark (a post) and then "interlocking" as it transformed into the three-ring Ballantine Beer logo in a double row of neon.[100]

After each flawless toss of a ring, the words "Purity," "Body," and "Flavor" appeared as the clown bent down to pick up another ring.[101] When the clown stood up, the lights forming his eyes flashed on and off "as if he was winking at the crowd below,"[102] and the "200–watt lamp blink[ed] on and off at the tip of his [red] nose."[103] After his third toss, a 40-foot bottle of beer in green tubing emerged, overlaid on a copper-colored beer can, and a goblet filled up with "electrically flowing beer" from a giant old-fashioned beer tap. The animation ran daily from sunset to 1 a.m. It cost approximately $68,400 to build, the equivalent of $1.25 million today, and consumed 3,275,000 watts per hour to run, costing an additional $300 per month.[104]

Coca-Cola (1938), Douglas Leigh, Inc.

In an attempt to provide New York City with its first large weather prediction sign and Coca-Cola spectacular, Leigh came up with the slo-

gan "Thirst knows no season."[105] The text appeared on the giant spectacular positioned just north of Times Square in Columbus Circle. In addition to advertising Coca-Cola, the sign forecast the weather on a 30-foot-wide dial with images of rain, sun, snow, clouds, and other weather effects appearing at appropriate times.[106] Leigh was able to secure a direct line to the head of the New York Weather Bureau, Dr. James H. Kimball. According to Leigh's publicity agent, Helen Cooke, Kimball would relay the local forecast to Leigh, who would turn the dial to the corresponding weather forecast icon on his desk, triggering the proper word and scene to flash on the sign.[107]

Gillette (June 1939), Douglas Leigh, Inc.

Accompanying the Coca-Cola weather spectacular was a large-scale clock for Gillette produced in June 1939, located at 47th Street and Broadway. Later additions included 25-foot neon red tubing in the form of a pendulum swinging at a rate of 80 feet per second with sound effects akin to Westminster chimes ringing out on the quarter hour from 10 a.m. to 10 p.m. daily. Both signs were operated by remote control from Leigh's offices in Rockefeller Center. According to Cooke, these offices housed the only radio line leased by the New York Telephone Company for a purpose other than radio.[108]

Wrigley's Gum (March 8, 1936–February 1942), Dorothy Shepard and General Outdoor Advertising Co. Inc.

We take brief leave of highlights from Leigh's work to discuss Dorothy Shepard's Wrigley's Gum aquarium sign, a unique creation by one of the few females working in this industry that also allows us to further analyze the genre's close-knit relationship between historically coded color palettes and early electric animation.

The "Wrigley's Gum" spectacular of 1936 was constructed by General Outdoor Advertising (GOA) on the roof of the two-story International Casino, the building that would later become known as the Bond Building (site of Leigh's famous Bond [1948–54] and Pepsi [1955–] signs), facing the Hotel Astor (1904–67) on Broadway between 44th and 45th Streets. It was designed by California-based interior designer Dorothy Shepard, known for her clean print-based advertisements.[109] For this mammoth edifice (Shepherd's second for the company), she designed

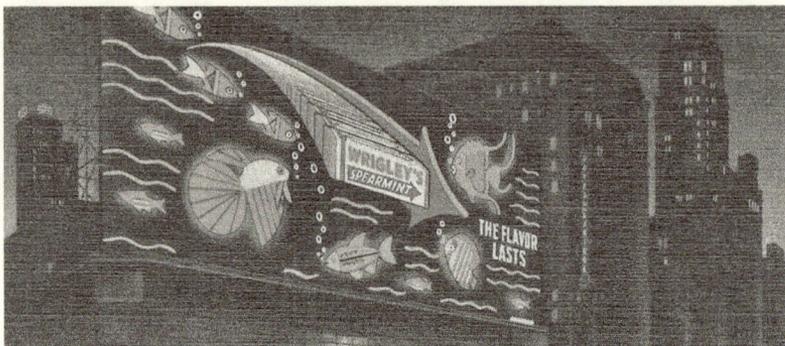

FIGURE 4.1. Poster depiction of *Wrigley's Gum* spectacular (March 8, 1936–February 1942). Designed by Dorothy Shepard and constructed by General Outdoor Advertising on the roof of the International Casino on Broadway between 44th and 45th Streets, the aquarium sign included hyperrealistic tropical fish adorned in stunning neon colors designed just for the sign. Author's collection.

an aquarium full of hyperrealistic tropical fish decked in stunning neon colors—vivid ultramarine blue, yellow, turquoise, sea green, an iridescent chartreuse, and vermilion—colors mixed just for the sign. She based her illustrations on real fish she observed at the California Aquarium, including a giant orange and blue angelfish, an "iridescent" veiltail fighting fish, a striped Amazonian pompadour, four minnows, a *Rasbora heteromorpha*, and an endangered bloodfin.[110] The final sign consisted of 1,084 feet of neon tubing to form a 23-by-39-foot spearman studded with 25-watt lamps; the 4 foot, 6 inch triple-rowed red letters in the "Spearmint" text; and a 35-foot spear. The package of gum (also created in a triple row of red neon tubing) was 14 feet wide by 48 feet long and studded with 15-watt lamps and 25-watt lamps at the edges.[111]

General Electric created 29,508 incandescent bulbs specifically for the sign, in new and off-kilter colors including vermilion, orange, yellow, and metallic green, mounted through a hidden, elaborate wiring system that required every circuit to be individually wired and connected to the timing mechanism that regulated the sequential flashing of the tubes and bulbs.[112] GE's efforts likely constituted a retroactive attempt to compensate for its failure to take advantage of neon in the mid-1920s.[113]

In Shepard's animation, the fish serenely made their rounds in the tank, creating a refreshingly hypnotic atmosphere that "conscious[ly] depart[ed] from the screwball pace of most contemporary spectaculars."[114] The 23-foot-high bright-green Spearman pulsed as the fish tails and fins swayed around him with bubbles emerging from their mouths and waft-

ing to the surface.[115] The unhurried pace of the animation complemented Wrigley's brand message at the time, reinforced through equally relaxing slogans appearing on the upper left and lower right of the space, including "Keeps the Taste in Tune" and "Steadies the Nerves," with alternating overlays "Quality and Flavor"; "Aids Digestion"; "After Every Meal"; and "The Flavor Lasts."[116] The intrinsically spellbinding quality of neon further underscored the sign's tranquility. As discussed in chapter 5, neon has a way of capturing and holding a viewer's attention, not through aggressive or accelerated flashes but through a gentle and soft absorption. Together, these elements created a brand atmosphere of leisure and relaxation, in contrast to one boosting energy for increased productivity, which is how Wrigley's had advertised the same product a few years prior.

The sign went up on March 28, 1936, and remained in place until February 1942 when it was shut off in accordance with World War II brownout regulations.[117] It cost GOA $1 million to build (comparable to $18.8 million today) and earned the title of world's largest display.[118] It weighed 110 tons, was 188 feet long—equivalent to one full city block[119]—and reached over eight stories (75 feet) high (or, as the *Signs of the Times* put it, exceeded in width the 151-foot-tall Statue of Liberty).[120]

THE EPOK ERA

According to a 1937 issue of the industry magazine *Tide*, the Epok system newly afforded animated signs with a cinematic flexibility akin to a Walt Disney short.[121] Invented and patented by Austrian inventor Kurt Rosenberg, the Epok system drew on the basic premises of cinematic animation by distilling each gesture into a simple cell animation that combined moving images with live-action data, cut for large-scale public advertising. Rosenberg experimented with the technology for eight years and established headquarters in Stockholm, but European sign men were not interested in pushing the system to the extent that Douglas Leigh would after purchasing it from Rosenberg (and the world rights from Karl Ullstein) in 1936, securing for himself a seventeen-year monopoly.[122]

American sign developers (aside from Leigh) were uninterested in Rosenberg's system. They feared its high maintenance costs and suspected it would not secure profitable returns. Leigh, however, being more amenable to risk, openly embraced the system and, once in his domain, worked with engineer Fred Kerwer to make key improvements and acquire additional patent protection, eventually setting up American Epok Inc. and renaming the system the Leigh-Epok Control System.[123]

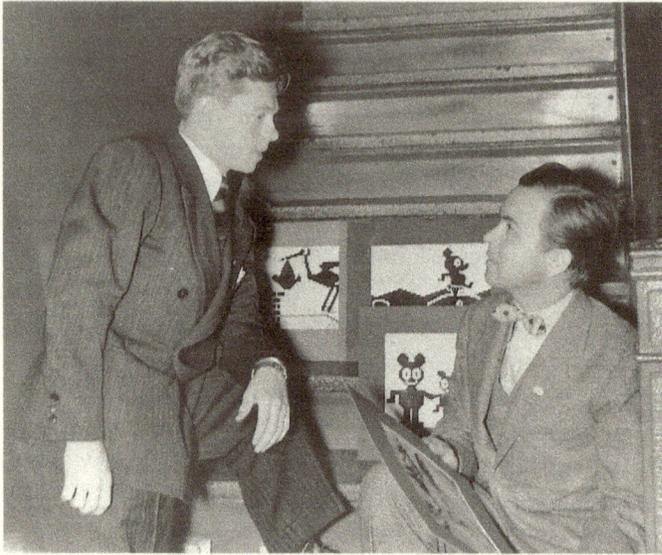

FIGURE 4.2. Douglas Leigh with Mickey Rooney in front of Leigh's early
Epok signs. Black-and-white photograph, 22 × 31 cm, as published in
Archives of American Art Journal 40, nos. 1–2 (2000):32. Photograph by
Ted F. Leigh. Douglas Leigh Papers, 1903–1999, Archives of American
Art, Smithsonian Institution.

Over the following three years, Leigh's Epok signs generated over
$500,000 in revenue in the midtown area alone.[124]

The Epok technical process was intricate, involving principles from
mixed-media platforms and turning on three fundamental steps:

1. *Illustrations.* First, a black-and-white story sequence was laid out
 in squares on nonshrinking paper. As with traditional storyboards,
 a new drawing is created for any significant shift in movement.[125]
 Up to twenty drawings could be used for a single gesture or
 motion, though in principle a story or sequence could go on
 indefinitely.[126] Epok animations typically lasted five minutes,
 requiring approximately 2,000 separate pictures.[127]

2. *Filming.* Each drawing was then photographed onto one frame of
 16 mm motion picture film (later, when the film was projected at
 twenty to twenty-four frames per second, the figures appeared to
 move at a slightly slower pace).

3. *Transferring to photoelectric cells.* Where steps one and two
 followed traditional animation techniques,[128] the third step

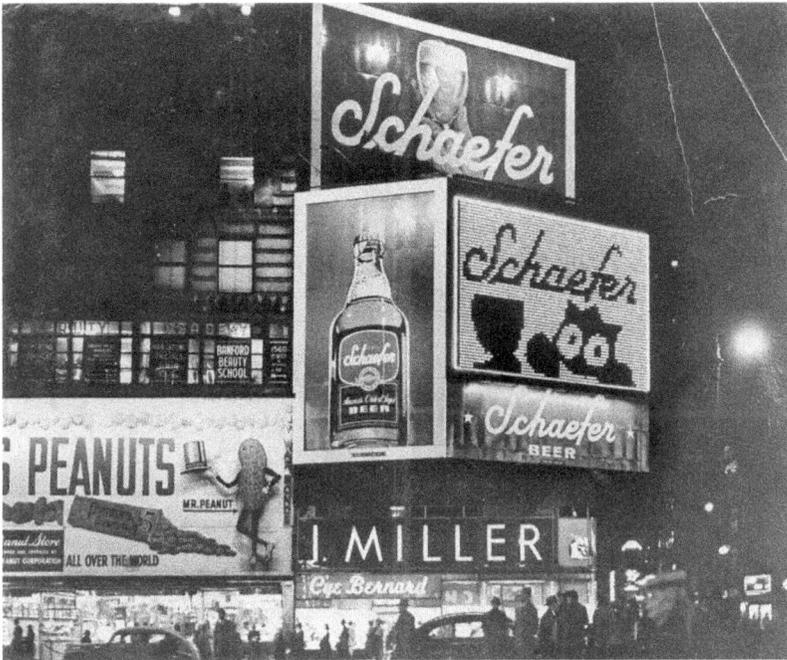

FIGURE 4.3. Schaefer Beer spectacular and billboards, Times Square, New York City, 1950s. Leigh worked with Otto Messmer, creator of the Felix the Cat cartoons, to produce animations for his Epok sign system. Douglas Leigh Papers, 1903–1999, Archives of American Art, Smithsonian Institution.

involved something more akin to computer graphics programming (both systems are in fact derivatives of technologies developed for warfare).[129]

The transfer to photoelectric cells involved running the film through a motion picture projector and "throwing" the image onto a bank of 4,104 tiny photoelectric cells (versus a screen).[130] The cells were connected to another, external-facing board of Mazda bulbs by way of mercury tubes that used up to 200,000 miles of wiring, and 15,122 soldered joints.[131] As light or dark squares from the film were projected onto the light-sensitive control grid, corresponding bulbs lit up or turned off on the externally connected sign. When no light was cast onto the grid, the corresponding space on the exterior sign would remain dark. For this reason, only a positive print of the film could be used for projection, allowing the background to appear in lights and the unloaded parts to make up the picture.[132]

Early Epok signs used a 1:4 correspondence—that is, one photocell for every four bulbs on the external screen (later developments would allow for a 1:1 ratio[133])—and were typically shown in continuous loops from 6 p.m. through to 1 or 2 a.m.[134] The 1,026–photoelectric cell grid was located in a projection room where the operator could view a miniature version of the outside screen.[135] Each bulb was capable of flashing on and off twenty times a second. The technology may seem similar to television, but recall that television needs to fit only in a small screen area—in the 1940s about 5 by 7 inches—while an Epok external screen totaled 93,000 square inches.

Leigh further exploited the live-action component of the signs by inviting famous actors and Hollywood stars to appear for a sign's public debut. Celebrities such as Walt Disney, Joan Crawford, Mickey Rooney, Al Jolson, Eddie Cantor, Martha Raye, Bert Lahr, Ethel Merman, and Elizabeth Taylor attended opening nights for his various signs, making the event no different than a traditional movie premiere.[136] Other celebrities (Bill Robinson, Fred and Adele Astaire, and Anne Miller) and the work of famous artists (Walt Disney and Max Fleischer) appeared at times behind the scenes to draw in equally large crowds. In one instance, Leigh hired a stripper who performed her act in front of the photoelectric sensors. On the street, viewers saw a 20-foot-tall dancing nude woman, attracting crowds and causing a number of fender benders.[137]

To maintain the signs, Leigh employed a squad of men to patrol the Square area each night and note any burnt-out or flickering (near dead) bulbs that needed to be replaced the following day. The term "Small-pox" was used to refer to a situation in which too many bulbs were burning out at once, or at a pace faster than they could be replaced. On one occasion, Robert Rochlin notes, "Times Square had a chronic case of smallpox": a mere half-hour after a new set of bulbs was replaced in a sign, dark patches began to appear again. The disease was purged once Leigh's crew discovered the source: a Yale freshman. In town for the weekend, the student was hosting a cocktail party in a posh hotel across the street where he took the liberty of "astound[ing] his guests by shooting out the bulbs with an air rifle."[138]

From 1937 to 1941, Leigh generated sixteen Epok signs in Times Square alone, alongside a number of spectaculars for smaller cities along the East Coast from Boston to Atlantic City.[139] Signs were leased for a minimum of three years and cost anywhere from $15,000 to $51,000 a month to maintain.[140] Taken together, the Epok spectaculars are unequaled in the Square's history. Their striking animations and

ambitious dramaturgical presentations remain in the minds of many today.[141] The following index of Epok spectaculars underscores only a few from Leigh's astounding repertoire.

Wilson Whiskey (1937), Leigh-Epok for Wilson Whiskey

One of the earliest Epok signs in the Square was the 1937 "Wilson Whiskey" spectacular, located at 46th Street and Broadway at the south end of the Palace Theater (which extended northward on Broadway to 47th Street), beside the Bond clothing store and above the Miller shoe store that had been on the corner since the late 1920s (also across the street from the Astor Theater, then displaying Leigh's *High, Wide, and Handsome* sign).[142] Wilson Whiskey had secured a three-year contract for the ad space, at a cost of $3,000 a month. Its terms granted the distillery a new, five-to-ten-minute action sequence every six weeks.[143]

The capacity to swap out action sequences in the sign was one of Epok's selling points. For many years, the variations were created by Felix the Cat animator Otto Messmer, even though Messmer never owned the copyright to the Felix images or received royalties or screen credits for the 150 cartoon shorts that he directed.[144] Credit was instead issued to Australian film entrepreneur Pat Sullivan, who passed away in 1933. With Sullivan's passing, the Felix studio closed and Messmer was left jobless. When the Van Buren Studio purchased the Felix cartoon rights in 1936 to transform the cartoon into a series of Technicolor shorts, Messmer turned down the offer as he preferred the simple, silent, black-and-white drawings he was accustomed to,[145] a preference that made him the perfect match for the "silent visual gags" and then-still-black-and-white animations featured in Leigh's Epok spectaculars. Messmer joined Leigh's team in 1937 and remained an active member for thirty-seven years until he retired in 1973.

High, Wide, and Handsome (1937), Leigh-Epok for Paramount

The second Epok sign went up on the Astor board at Broadway and West 45th Street, across the street from the "Wilson Whiskey" sign as an advertisement for the musical film *High, Wide, and Handsome,* then playing at the Astor. Together the two spectaculars signified a new era of large-scale, live-action electrographic architecture that, it was now clear, would only mature through the remainder of the century, not only in New York but also in other major metropolises around the world.

The sign was commissioned by Paramount, which paid $21,000 for the seven weeks it would be up.[146] It measured 43 by 75 feet[147] and displayed a miniature condensed version of the film's narrative. To create it, Leigh employed scenes from the picture, transposed into cartoons, including a girl dancing, two men fighting, an Indian, elephants and camels, trees, trains, and an orchestra leader with a baton.[148] When the lease ended, Leigh retained the sign as his own property, which he rented out to other businesses on a three-year contract, including relocation costs and operation, upkeep, and regular animation changes.[149] Maintaining control over all aspects of sign production and installation allowed Leigh's monopoly to remain intact for several decades.

Four Roses (June 30, 1938–1942), Leigh-Epok for Frankfort Distilleries

Frankfort Distilleries was purchased by former Confederate soldier Paul Jones (b. 1840) in 1922. Paul was possibly related to Lawrence Jones, who acquired Four Roses bourbon whiskey in 1866 from his home base in Louisville, Kentucky.[150] Frankfort Distilleries was also one of the few companies granted a government permit to continue selling liquor for "medicinal purposes" during prohibition. Over the years, the Distilleries adopted various brand names for their products, including "Four Roses," "Jones Four Star," "Old Cabinet," "Old Cabinet Rye," and "Swastika." "Swastika" was used circa 1915—prior to the Third Reich—in allusion to a 3,000-year-old Native American sign for good luck.[151]

Located at the northern end of Times Square at 1600 Broadway, the display was erected by Marty Ottone & Bro. Pictures and reached over one hundred feet in height and one block in length.[152] Flanking the brand name were four tremendous 20-foot red roses that weighed nearly a ton apiece and required a twenty-five-man crew to hoist them 160 feet above the Broadway sidewalk.[153] The roses sat on long green stems, forming a bouquet that extended seven stories (74 feet) in height.[154] Between the roses was "FOUR ROSES" in gigantic capitals five stories high and set to flash on and off at the same time as the roses. The brand name alternated at short, regular intervals with a 42-foot numeral "4" and the 15-foot slogan "A Truly Great Whiskey."[155] The logo, roses, "4," and slogan overlay were lit with 4,000 feet of fluorescent tubing, 4,000 25-watt lamps, and 100,000 feet of wire. The sign remained lit for four years.[156]

Scantily clad live models were hired for press events to enhance brand cachet. The press photographs featured in a 1938 *Signs of the Times*

article, for example, explains to readers (i.e., sign industry men) that they could better understand the enormity of the sign being "erected" if they imagined it in "girl units."[157] The four rose bouquets that bloomed on either side of the sign equaled more than thirteen girls in height, and the overlaid "4" fluorescent tubing was equivalent to eight girls in height. The letters in the FOUR ROSES logo were each "about six girls tall."[158] Leigh was well aware of this psychosexual symbolism and deliberately (like Barnum, Gude, and most sign men before them) exploited it in his campaigns.

For the launch, the first flash occurred at 9:30 p.m. on June 30, performed by "Miss Alice Shaughnessy," one of four models from John Powers's modeling school and agency (another one of whom Leigh would soon marry), who pressed a remote-control button on the roof of the Hotel Astor.[159] The admen of Frankfort Distilleries and Douglas Leigh Inc. later assembled for dinner at the Astor, where they were graced by "a dozen other models, carrying baskets of roses," who expanded the campaign into the city afterward by touring the hotels and nightclubs in the Square, passing out the flowers. More than 16,000 roses were handed out that night, each with a little card attached that read, "Something old . . . Four Roses."[160]

Old Gold (July 8, 1938–1941), Leigh-Epok for P. Lorillard Company and Lennen & Mitchell

Circa 1938, Old Gold was the third-leading brand of cigarettes in the country, and it was seeking to further its brand recognition with a Times Square spectacular.[161] The sign was commissioned by Lennen & Mitchell, P. Lorillard Company's advertising company, and stood at the corner of 43rd Street and Broadway until at least 1941. It cost $27,000 to build and had a yearly electric bill twice the amount of the entire city of Hackensack, New Jersey.[162] It reached half a block in length and two and a half stories in height and employed 4,000 feet of luminous tubing, 300,000 feet of wire, and 17,112 soldered joints.[163] To the right of the 30-by-24-foot Epok screen, the words "Old Gold" appeared in 11-foot-high fluorescent tubing, flashing thirty times a second.[164] Just above the Epok animation, the text "America's Double-Mellow Cigarette" appeared.[165]

For the Old Gold Epok animation, Leigh worked closely with animator Otto Soglow and electrician Robert Donovan to produce a short featuring "Old Goldie" and his girlfriend as they made love, smoked cigarettes, and blew smoke rings to the crowds.[166] As described in *Signs of the Times*,

Goldie "walks into a tobacco shop, where he buys a package of cigarettes. He then strides along smoking and makes his way to his sweetheart's home. While he stands in front of the door blowing smoke rings, his girl comes to the balcony window. There she catches whiffs of the smoke, is delighted by it, and steps onto one of the smoke clouds to ride gently to the ground. She takes the cigarette from Goldie, smokes it, and the two go off together to be married."[167] The animation ran on a five-minute loop, with transitions between cycles signaled by blending geometric shapes. It was changed up six times a year, all with variations focusing on the romantic adventures of Goldie and his nameless girlfriend.[168]

The Epok spectacular was celebrated by industry and the public alike. An estimated 1 million viewers saw the cartoon every day. The *Signs of the Times* described it as a "free show presenting a movie of romance and smoking pleasure,"[169] and even the Broadway Association (chapter 3) welcomed it, along with Leigh's other spectaculars, given the association's current goal to "whiten up" Broadway for the upcoming 1939 World's Fair, when an additional 40 million viewers were expected in the city.[170]

Whiteness has not been explicit in my discussion of the above-noted signs, but arguably, it continued to inundate the Square through this new genre of electrographic architecture, not as a literal, material whiteness—as it had a few decades prior—but instead through the brazen color and newfound ethos of entrepreneurial capital. The unfettered pursuit of power, property, and prestige was the prerequisite for the Square, and the nation's, claims to global hegemony during this era. To be the best and brightest was to be authentic to American capital supreme.

In addition (and it seems possible to make this claim only retrospectively) the cheap, mass-produced products featured in these spectaculars—cigarettes, alcohol, synthetic fabrics (nylons, garters, petticoats), sugary soda drinks, Wonder Bread, and chewing gum (with plastic in it)—also bolstered fantasies of American whiteness by engendering a socially progressive imaginary ripe with "freedom" to pursue the "good life" by way of ruinous commodity consumption. The same logic of excessive commodity choice today continues to obfuscate our increasingly limited capacity to think and see "choice" beyond commodity markets.

To be clear, this is not to suggest that the admen, the engineers who worked on signs, or Gude or Leigh themselves were deliberately aiming to create a nation of "false consciousness," but rather that "America" and its mythologies of freedom, liberty, and individualism were already so deeply imbricated in the culture that, in order to "succeed," one had

to capitulate to these invisible yet pervasive models of collective homogenization (Echeverría's *blanquearse*).[171] Colorful, flashing, mass-produced objects became, as they remain today, the primary vehicle for perusing and attaining America's white imaginary, whether by production or consumption.

The "Old Gold" sign embodied these values in spades. Its minimovie—a story of "romance and smoking pleasure"[172]—was lauded by the press and advertising industries as serving "the mentally alert who formulate the potential buyers' market." Humor, the article concludes, "loosens the purse strings of the 'grumpies' by accentuating the brighter side of life."[173] But who are these "grumpies" and what lessons of the "good life" are gleaned by way of smoking cigarettes? What modern girl is so "delighted" by the smell of cigarette smoke that she is catapulted into love and marriage?

The 1939 World's Fair

The 1939 World's Fair ran from April 30, 1939 to October 27, 1940 in Corona Park in Flushing Meadows, Queens (formerly the site of an ash dump), with hopes of boosting wartime morale and the nation's consumer culture through such products as television, introduced at the fair by Radio Corporation of America (RCA) president David Sarnoff. The numerous other innovations and advertising endeavors at the fair are beyond the scope of this book, save for the Lagoon of Nations, which Douglas Leigh visited on several occasions.[174]

The Lagoon of Nations was located in the "Government Zone" fairgrounds on the eastern end of the park near the Flushing River. The Lagoon was the fair's most popular pavilion, inspiring both Leigh and what would become the Carnival de Lumiere at Disney's EPCOT Center forty-four years later. After dark, the Lagoon was illuminated from below by "multicolored beams of light" supported by a "thousand water nozzles, capable of throwing twenty tons of water into the air at a time."[175] The Lagoon's 400 gas jets, 350 fireworks guns, and 3 million watts of light were accompanied by a live band that performed during the light show each evening, harmonizing with the pace and rhythm of the animated Lagoon lights as they ran through the spectrum of available colors, "building up to a maximum crescendo of brilliant white light,"[176] reminiscent of Chicago's White City (chapter 3).

Leigh drew so much inspiration from the Lagoon that, according to Tell, he visited the exhibition at least ten times, carefully jotting down

his observations after each trip.[177] Not surprisingly, shortly after the fair, the Lagoon of Nations reappeared as the blueprint for two of his most noteworthy Times Square spectaculars for Bond clothing (1948) and Pepsi-Cola (1956), discussed below, both replete with colored lights, fountains, and massive statues alluding to Greco-Roman antiquity, albeit in proper American style and form.[178]

Wilson Whiskey (September 6, 1941), Leigh-Epok for Browne Vintners and Wilson

As noted above, the original 1937 "Wilson Whiskey" sign at 46th Street and Broadway was remade in color in 1941. In creating the world's first color Epok sign, the changeover involved replacing 75 percent of the white bulbs with evenly distributed green, red, and yellow ones. When inking in the squared drawings in step one, animators needed to identify the precise location of each corresponding bulb and specify its color. Rochlin explained it as follows: "If green grass [was] desired, the squares for red, white, and yellow bulbs [were] blacked out. For the black colored characters themselves, all four colors [were] blacked out on the drawing."[179] Thirty-five-millimeter film was used for the color Epoks to achieve greater detail,[180] but at much greater costs. In 35 mm, animations were no longer limited by blocky shapes but could now generate enough detail to include rounded edges. The trade-off was the tremendous cost of acquiring and processing 35 mm film at professional laboratories. Otherwise, the same technical attributes of the 1937 Epok screen remained intact (54 cells by 27 cells per vertical and horizontal rows, respectively), but the new color system now permitted a 1:1 correspondence between cell and lamp (versus 4:1), bringing the total up to 10,000 lamps per board, 4,104 of which were in the animation.[181] The new sign's 4,000-square-foot board contained a movie screen comparable to the one at Radio City, while the "Four Roses" spectacular down the street seemed even larger, as it was positioned closer to viewers on the ground.[182]

For Wilson Whiskey's opening night, Leigh sold tickets, placed tables on the sidewalk across the street from the sign, and arranged for movie star Joan Crawford to flip the final "on" switch. Al Jolson, Eddie Cantor, Martha Raye, and dancer Vera Zorina also participated by dancing behind the Epok screen to generate silhouette animations for the live camera.[183] Celebrities Bert Lahr, Bill Robinson, Fred and Adele Astaire, Anne Miller, and Ethel Merman were also in attendance, many of whom

would later take their turn dancing behind the scenes for Broadway's new large-scale silhouette.[184]

Leigh considered the 1941 "Wilson Whiskey" sign his life's master-piece, a platform through which he could execute ideas he had been percolating since 1934,[185] including an "open air theater" that emulated a sprawling World's Fair environment.[186] Due to their creative ingenuity and technical superiority, the new genre of spectacular signage was more attractive and popular with the public than traditional buildings in the city, and the signs were widely known for their capacity to halt and freeze pedestrians.[187] Unfortunately, these spectaculars are still not accepted as a valid part of architectural history—even the more eccentric and experimental ones that embraced "architecture" as always already involving the environment and ecology it existed in.

POSTWAR SPECTACULARS

With war orders in effect, advertisers in Times Square were severely limited. During the war years, the government mandated citizens and businesses to turn off all nighttime illuminants, save for the barest necessities. Nonetheless, Leigh never ceased pumping out creative solutions for large-scale spectaculars that could remain on display within the wartime restrictions. This section of the chapter addresses two such signs, followed by a brief index of key postwar spectaculars, no less remarkable than earlier ones in their ascension to bigger and brighter urban illumination.

During the brownout years (April 1942–1946), New Yorkers were required to turn off lights at night. In contrast to the brownouts mandated during World War I, those during World War II were instituted not to save fuel but to avoid unsuspecting attacks from enemy bombers and prevent reflective light from showing at sea and endangering American ships.[188] Wartime restrictions also required exterior advertising signs and electric light above the fifteenth floor to be turned off from sunset to sunrise and light permitted below the fifteenth floor was heavily regulated.[189] One 1946 amendment made entrance lighting permissible at no more than 60 watts per entrance, the minimum required for public health and safety.[190] Some exceptions were made for signs with lights that shone downward but for the most part the adjective *brown* was an apt descriptor of the low light conditions that produced an atmosphere of grays, browns, and washed-out concrete. Accordingly, wartime advertising focused on national brands, many of which

supported wartime efforts like machine production or selling war bonds.

While many of the sign companies in Times Square worked to support the war effort (Leigh joined the navy in 1942 to become a lieutenant in the Special Devices Division, where he worked on training gadgets[191]), others remained dedicated to commercial endeavors. The Federal Sign Company manufactured signaling equipment and YESCO (discussed in chapter 5) developed specialty sheet metal fabrication. Artkraft-Strauss built metal containers used on aircraft and custombuilt airplane wings while the government compensated the company with financial payments or extra equipment to work with.

During the war, New York became one of the most popular ports in the world and many who arrived in the city traveled through Times Square.[192] Between 1943 and 1944, the city's railroad stations saw 50 percent more passengers. As a result, in July 1944, the War Department (renamed the Department of Defense in 1949) threatened to ration travel to encourage people to stay at home.[193] Sign companies not dedicated to the war effort saw the increased foot traffic as an opportunity to develop new techniques that would speak to these audiences while still complying with the brownout regulations. One such strategy developed by Jacob Starr was to create a mosaic from broken mirror pieces clustered on one-inch squares in varying shades and colors of gold, blue, green, red, and yellow. Others developed fluorescent paint and black lights to attract more light, drawing what they could from the cars occupying the area at night.

During these years, the Square's target market remained the working-class masses. No longer the posh clientele of the Jazz Age, the sailors and military men on leave looking for fun and frills bolstered the area's shift to a "cheap carnival"[194] atmosphere. In his attempts to attract this now primarily male clientele, Leigh, not surprisingly outdid them all (again).[195]

"Camel Cigarettes" (December 12, 1941–January 3, 1966), Douglas Leigh and Artkraft-Strauss

Unlike the priests of pop art, Leigh [was] deadly serious. There was no kitsch to the Camels sign. He was selling products with a tight, surrealistic dream.

—Jerome Charyn

Almost all sign companies suffered during World War II, including Leigh's, which temporarily plummeted into disaster until his first

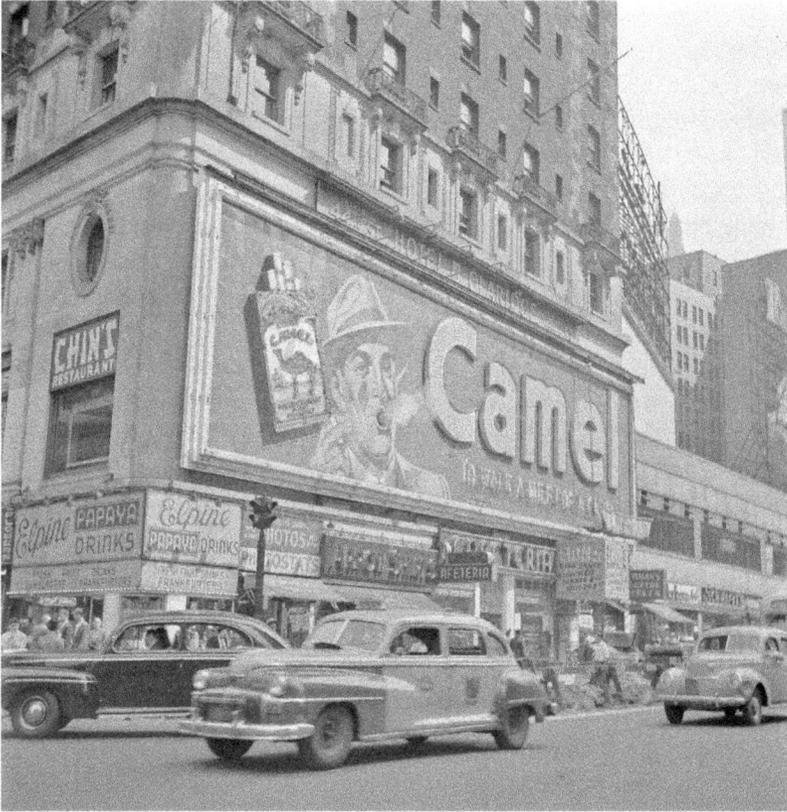

FIGURE 4.4. "Camel Cigarettes" (December 12, 1941–January 3, 1966), Douglas Leigh, built by Artkraft-Strauss. Mounted on one side of the Hotel Claridge (1911), on the southeast corner of Broadway and 44th Street, the Camel sign debuted on December 12, 1941. Because the sign used no lights but only steam to simulate the effect of cigarette smoke, it remained a popular city spectacle throughout the war years. Photography by Willem van de Poll. Image courtesy of Smithsonian Institution.

wartime solution was produced, also his most famous and longest-running Times Square spectacular. This was the Camel sign, debuted on December 12, 1941, just five days after the December 7 attack on Pearl Harbor and a few months before the US government ordered Times Square to dim the lights. The Camel sign was in this regard prescient. It was not an over-the-top, extravagant illumination but, originally, a simple yet elegant image of a soldier painted on a red background blowing perfectly paced smoke rings into the middle of Broadway. The further the rings traveled across the street, the larger they became.[196]

The Camel sign was mounted on the second and third floors of the Hotel Claridge (completed, 1911), a sixteen-story building on the southeast corner of Broadway and 44th Street in Times Square. Leigh drew inspiration for the sign from a series of parlor tricks he witnessed, including a gentleman blowing smoke into a cellophane wrapper, causing smoke rings to emerge as he tapped the package.[197] The idea was simple but the engineering involved in translating the idea into a mass sign was complex. Chief engineer Fred Kerwer built a giant bellows mechanism to sequentially emit rings of smoke (steam) onto the street. His network of contraptions began by gathering actual steam from Con Edison's underground utility pipes and sending them through a cone shaped reservoir. The steam was next forced through a piston-driven diaphragm that pulled it back through a series of electric-driven levers so that, once a metal rod pulled the diaphragm to its farthest point, a spring could force the metal rod to snap forward, pushing the diaphragm into the cone and forcing steam out of the gentleman's mouth, creating the illusion of smoke rings.[198] The sign was programmed to exhale a ring of smoke every four seconds, for 18 hours a day, from 7 a.m. to 1 a.m.[199]

There were several variations of the Camel sign over the years. The original sign depicted a painted soldier, who was replaced by a businessman after the war with a streamlined neon frame and cigarette package.[200] For the first version, Leigh contacted a modeling agency and asked for a photograph of an all-American smoker in action. The "Jimmy Stewart type" that they sent him was named Lyman Clardy and he posed for the original sign for $5.[201] The first twelve of the twenty-two cities where the sign was duplicated (Baltimore, Boston, Buffalo, Chicago, Cleveland, Detroit, Los Angeles, Milwaukee, New Orleans, Philadelphia, Pittsburgh, and San Francisco) used this same original "all-American smoker" model. These cities were all heavy war production centers, which, Leigh reasoned, would be more likely to have cigarette consumers.[202]

Tuesday, May 8, 1945, was named V-E (Victory in Europe) Day, marking the end of World War II in Europe. For V-E night celebrations, the Statue of Liberty torch was set to an "increased brilliance," and its floodlit base and incandescent bulbs were replaced with 400-watt high-intensity mercury vapor lamps.[203] Thousands gathered in Times Square, and many photographed the event with Leigh's Camel sign smiling above them. The postwar climate lent a renewed spirit of optimism to the country and the brazenness of the prewar American imaginary was back on track.

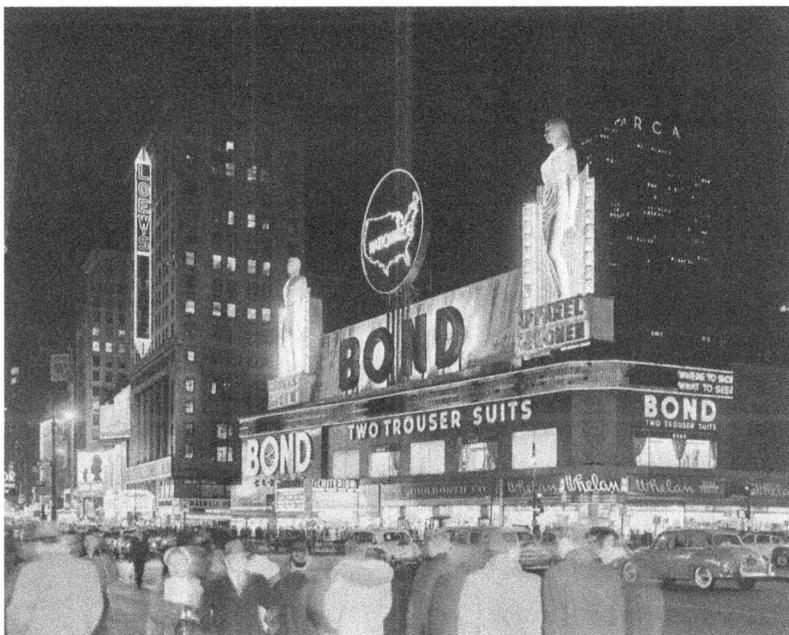

FIGURE 4.5. Bond Clothing spectacular, New York City (June 1948–1954). Black-and-white photograph, 19 × 25 cm. Douglas Leigh and Jacob Starr, with animation by the Sign Animation Corporation. The sign cost $500,000 to build, reached 85 feet above the store, and ran 225 feet in length, across the whole block from 44th to 45th Streets. Douglas Leigh Papers, 1903–1999, Archives of American Art, Smithsonian Institution.

Bond Clothing (June 1948–1954), Douglas Leigh, Jacob Starr, and Sign Animation Corporation

In 1948, Leigh persuaded the president of the then-popular Bond clothing brand, Barney Ruben, to commission what would become his notorious Bond spectacular on the roof of the "cathedral of clothing" (the former site of Shepard's chewing gum spectacular), on the east side of Broadway between 44th and 45th Streets.[204]

Costing $500,000 ($5.5 million in 2022 currency),[205] the sign reached 85 feet above the store and ran 225 feet long, all the way down the block from 44th to 45th Streets.[206] Its contents featured two, twin 70-foot-high figures, one male of a size 40 suit and one female of a size 14-long dress, respectively.[207] The statues were not clothed, however, but instead graced with strands of electric light that lit up at night.[208] Underneath the male figure on the right, the sign's text read, "Clothes for the Man" and under the female on the left, the sign declared,

"Apparel for the Woman."[209] The sculptures were made by the New York–based sculpture, stone-carving, and modeling firm Rochette and Parzini out of crushed lava, which has the strength of cast stone but weighs only about a tenth as much. Both statues weighed about six and a half tons each and were completed in three months.[210]

The statues were flanked by a 50,000-gallon waterfall 120 feet wide and 27 feet tall (the first sign to successfully employ a live waterfall as its central motif).[211] The water from the fall tumbled into a 10,000-gallon trough from which, behind the scenes, it was pumped back up to the top of the fall. It was also engineered to never overflow, held in place from behind by a giant vacuum.[212] In the winter months, the water was spiked with 300 gallons of antifreeze to prevent icing. The waterfall structure itself was constructed of expanded metal and engineered to produce the effect of elaborate ripples and the illusion of turbulence. A series of "hidden pockets" were built into the system to create the effect of rushing water.[213] The sign employed 2,310-horsepower pumps that recirculated water over the falls at 800 gallons per minute, reaching 1,140,000 gallons per hour.[214]

The background of the sign was painted by Bob Everhart, then one of the highest-salaried artists in the sign business.[215] At the top-center of the sign, a large Bond logo appeared with a circular clock that read, "Every Hour 3,490 People Buy at Bond."[216] At its base was a 6-foot-high-by-278-foot-long Trans-Lux Adcast news zipper that ran ads across the bottom—space sold to national advertisers in the entertainment, hotel, and resort fields.[217] Both components were driven by flasher systems made up of 23,000 incandescent lamps and nearly two miles of neon that, when turned on, appeared to be rotating, fluttering, and flickering.[218]

The $500,000 sign consumed 400 million watts of electricity per hour to run (the equipment was housed in a special bungalow on the roof of the Bond building) and, according to Artkraft-Strauss, was its finest achievement to date.[219] Some 75,000 spectators came out to witness the spectacle's launch, including Deputy Mayor John J. Bennett, borough president of Manhattan Hugo Rogers; and actresses Lucille Ball and Anne Brock Pemberton.[220]

Marshall Berman observed the sign's hypnotic effect. Standing before it, he felt as if "Niagara had not only surrendered its energy to Times Square but had also handed off its power to inspire awe."[221] Others were offended. A few "prudish guests" of the Hotel Astor across the street complained of the statue's nudity, after which they were clothed in neon tubes.[222]

Pepsi-Cola (June 14, 1956–), Douglas Leigh and Artkraft-Strauss

In 1955, the 225 feet, block-long Pepsi-Cola sign replaced the Bond sign.[223] The new sign reached upward of 100 feet in height and demonstrated a three-dimensional concept that made it visible from 42nd to 47th Street.[224] The waterfall from the Bond sign remained largely intact, but the statues were replaced with five-story porcelain enamel Pepsi-Cola bottles (the largest ever made, "anywhere in the world"). At the back of each bottle a series of bubbles were animated by electric lights, symbolizing the effervescence of the carbonated beverage inside.[225]

The Bond clock was replaced with a 50-foot Pepsi-Cola bottle cap, paved with 15,000 twinkling red, white, and blue light bulbs to form the Pepsi logo.[226] Its sum total of 35,000 lightbulbs and waterfall system consumed 1 million watts of power per hour.[227] Like the Bond sign, the Pepsi waterfall cascaded continuously night and day, reaching a flow rate of 50,000 gallons per minute.[228] After the waterfall's animation sequence cycled through a series of colors and reached its final epiphany in bright white light, the crown reached full illumination, and the 200-foot-long words appeared: "The Light Refreshment."[229] According to *Signs of the Times* columnist Virginia Sebastian, after dark the multicolored beams of light would function as a cooling site for the millions of persons passing by it each day.[230]

BLIMP CASTING

For a number of years, Leigh entertained a fantasy of transmitting omniscient, illuminated messages from the sky.[231] His visions manifested once the navy made its surplus war-era blimps available for purchase in 1945, several of which Leigh instantly purchased at a fraction of the cost.

Formally known as dirigible balloons, blimps are helium-inflated flying machines ("Flying Spectaculars," "whaleships,"[232] or "sign boards of the air"[233]) that surfaced in the United States in the late 1940s. While the dirigible technology had existed since the mid-nineteenth century, the surplus of postwar technology paved the way for a new genre of dirigibles transformed for commercial applications. After setting up his New York–based Douglas Leigh Sky Advertising Corporation at 630 Fifth Avenue,[234] Leigh modified, commissioned, and sailed several of these blimps throughout the late 1940s and 1950s, manned by ex-navy and postwar servicemen trained in flying the airships. His blimps

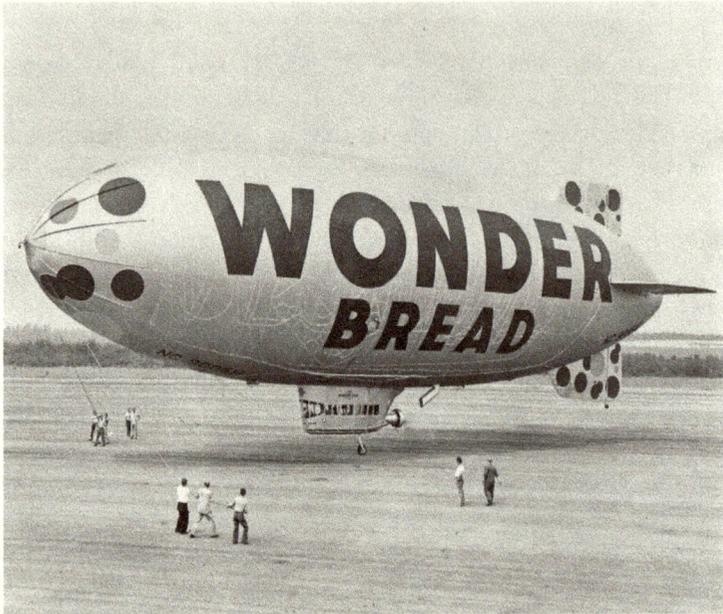

FIGURE 4.6. The Wonder Bread blimp (1945–1955). Black-and-white photographic print, 20 × 24 cm. After the war, Douglas Leigh bought surplus war blimps from the navy and transformed them into a squad of sky-based advertising machines equipped with neon animations. Douglas Leigh Papers, 1903–1999, Archives of American Art, Smithsonian Institution.

advertised products ranging from cars and gasoline (Mobil and Tydol were his two main clients) to Wonder Bread and Hollywood movie studios (MGM studios),[235] products all in line with the collective midcentury whitewashing of the American imaginary by way of homogenized consumer products promising to rapidly emulsify fantasies of a prêt-à-porter American Dream. I here expand on only two of these commissions, one for Goodyear (February 1, 1947–April 1948) and the other for Tydol (1947–).

In 1947, the Akron-based Goodyear Tire and Rubber Company purchased and revamped the 425,000-foot blimp known as *Puritan*, originally built in 1944 by the Goodyear Aircraft Corporation for the K-28 fleet of the US Navy. The *Puritan* was Goodyear's sole K-type (nonrigid) airship and also held the title of the largest commercial advertising blimp at the time. After numerous modifications, the *Puritan* set sail as a civilian ship on February 1, 1947. It contained a base generator and two portable generators with a fuel capacity of 700 gallons and a flying

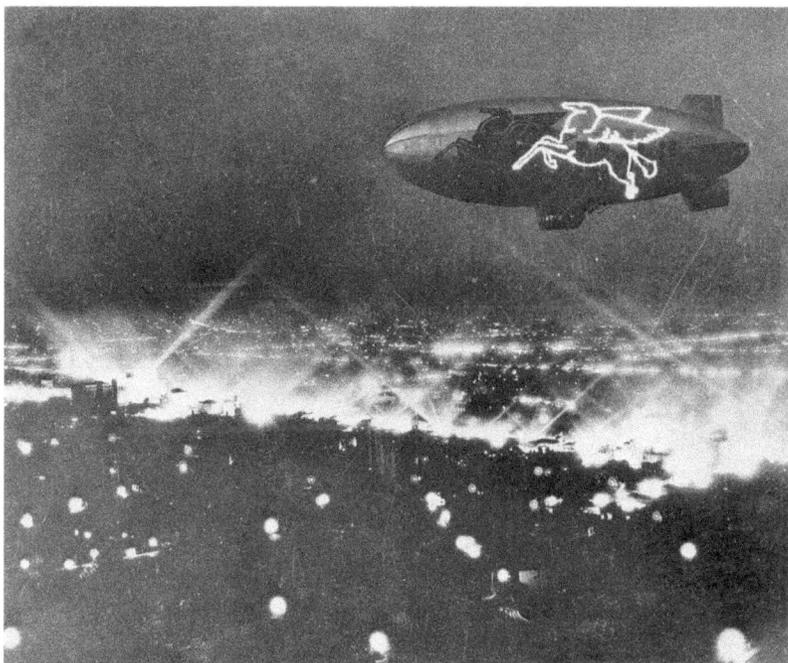

FIGURE 4.7. The Chevron Flying Spectacular over Los Angeles (1945–1955). Black-and-white photographic print, 20 × 24 cm. A blimp with Goodyear's Chevron logo is animated in neon lights. Douglas Leigh Papers, 1903–1999, Archives of American Art, Smithsonian Institution.

range of 1,400 miles without refueling.[236] Over 22 miles of wire transmitted power from the generator to the engine, allowing it to reach a top speed of 80 miles per hour and a cruising speed of 65 at 1,000 feet above the ground.[237] The ship required a crew of four men, with one alternate in case one of the essential crewmembers needed to be relieved of his duties.[238]

The *Puritan* displayed a series of news headlines in the sky or, as one 1947 *Signs of the Times* article described it, "aggressive advertising messages."[239] Because each message could only be seen one line at a time, it was broken into brief sentences that appeared one after the other in rapid succession. The device's primary commercial value was its portability, functioning as a miniature version of Times Square capable of carrying its electrically illuminated messages "to cities and towns all over the country."[240]

The blimp's Trans-Lux electric sign system was similar to the one used on many of the Square's spectaculars, but bigger.[241] The control

mechanism employed the same standard telegraphic tape, punching the code with a mechanical perforator to send a signal indicating which lights needed to be turned off or on in sequence. The Trans-Lux system permitted 18-foot-tall letters to travel all the way from right to left across the 190-foot length of the sign, on both sides, simultaneously.[242] Goodyear's Wingfoot trademark sign appeared above the text, also on both sides. When viewed at night, the illuminated text seemed to crawl across the sky.[243] For the year it was in flight, the blimp circled the night skies from Miami Beach northward, shining its neon letters from 6:30 p.m. to 10 p.m., four nights a week.[244]

In the same month that Leigh's Goodyear blimp set sail, so did his Tydol gasoline blimp, sponsored by Tidewater Associated Oil Company on the Atlantic coast (Leigh's third in the region). The Tydol dirigible was a former combat ship (with an "impressive combat record," Sebastian reports) from World War II, now manned day and night by an expert crew of ex-navy blimp operators, headed by navy veteran Captain Ramen Tyler.[245] It was 53 feet high by 118 feet wide.[246] Tydol letters on each side were 37 feet high, spanning 176 feet in length. For nighttime illuminations, letters on the starboard side would flash on any desired copy, while the port side featured a variety of electric overlays with a 27-foot-high "Flying A Gasoline" sign equipped with a large red letter *A* and illuminated signage to make the wings appear as if they were flying off into space.[247] Leigh was once again celebrated in the pages of *Signs of the Times* for putting one of the largest electrical letters ever produced several hundred feet up in the sky.[248]

. . .

In addition to the spectaculars noted in this chapter, Leigh also created spectaculars for Gruen watches (1946), Schaefer's Beer (1945), Super Suds detergent (1946), Chevrolet automobiles (1948), Philco (1949), Canada Club Whiskey/Hiram Walker (1952), Admiral Appliance (1952), Kleenex (1955), Miss Youth Form (1947–52), Chesterfield cigarettes (1948), Flamingo Frozen orange juice (1950), the Mutual Life Weather Star Tower (1950), Johnnie Walker (1951–55), Grand Union (1953), Scripto Pencil (1953–55), Bayer Aspirin (1954), and Gordon's Gin (1966). He was also a largely successful real estate owner and business developer. By 1953, Leigh headed up four other corporations in addition to Douglas Leigh Spectaculars, Inc. (est. 1933). These included the above-noted Douglas Leigh Skyway Advertising Corporation (1946); Douglas Leigh Poster Advertising, Inc.; Lee Foods, Inc., manu-

facturer of Flamingo Frozen products; and a fifth corporation involved in three-dimensional work for film.[249]

In 1961, Leigh purchased the famous Times Tower at One Times Square for an undisclosed amount and converted it into a hybrid exhibition hall and office building.[250] Just two years later, he sold the Tower to the Allied Chemical Corporation, a manufacturer of industrial chemicals, plastics, and synthetic fibers and agreed that the outer terra-cotta surface of the building could be replaced with white marble and glass, then standard for new office towers.[251] Allied Chemical envisioned the newly renovated building serving as a popular showcase for the latest chemistry, but its plan failed. In 1972, the company sold the Tower for a dramatic loss.[252]

During all of this, Leigh was simultaneously building valuable relationships with important city politicians and regulatory bodies, many of which came to be useful in 1962 when he was elected president of the Broadway Association (he was reelected for a second term in 1964).[253] During his tenure, he took on several heritage and development projects in the Square, including the Claridge Hotel (built 1909 by Daniel Burnham), and the Heidelberg Building (which had now become the Crossroads Building), both in 1964. The plan for the latter, developed by architect William S. Sherry, involved a seven-story automobile showroom with glass walls. The interior would bear a giant, revolving conveyor belt with the newest models of cars on display; however, due to a lack of financial backing, the dealership never advanced beyond the design stage.[254] Although neither of these projects succeeded, Leigh continued to donate large sums of money to the city and supported efforts to introduce greenery, such as the green space that now runs up the center of Fifth Avenue.

In sum, Leigh's spectaculars consistently challenged the glass box modernism of the 1950s, until the 1970s when he ceased creating over-the-top spectaculars and turned to more "tasteful" and subtler lighting effects for such noteworthy Manhattan edifices as the Waldorf-Astoria, the 14th Street Con Edison Tower, the Citicorp Building at Lexington Avenue and 53rd Street, and Donald Trump's 40 Wall Street, all of which inspired Empire State Building owner Harry Helmsley to commission Leigh to light all four sides of the skyscraper in what is now its iconic red, white, and blue design for the 1976 US bicentennial.[255]

In 1979, when Leigh was eighty years old, he sold his remaining fourteen Times Square locations to the Van Wagner Company and transitioned to designing lighting plans for entire cities, including Atlanta and Cincinnati (though, in 1984, he accepted a commission to install a

3,000-bulb, two-and-a-half-story snowflake on Fifth Avenue at 57th Street).[256] By 1998, Leigh was dividing his time between Oyster Bay, Palm Beach, and his apartment on East 52nd Street, where he died in 1999.[257] His truly innovative, iconoclastic Times Square spectaculars are typically only remembered in archives and those few published works that honor them. As for the city itself, Leigh's signs began vanishing as a new generation of computer-automated signage swept through the Square in the 1980s (discussed in chapter 6).

. . .

This chapter charts the innovative new genre of Times Square spectaculars, pioneered largely by American entrepreneur Douglas Leigh from the 1930s through the 1960s. It maps his career alongside what was for many a postwar landscape of entrepreneurial freedom, prosperity, and growth and, in the broader context of this book, the progressive development of a unique brand of polychromatic consumer America, ushered in through the auspices of postwar redevelopment. By the 1950s, the new materialisms of American consumer culture appeared nightly in Time Square. The former generation's protest against bright and bold illuminants as symptoms of a degenerative culture (chapter 3) gave way, at least in the Square, to a new era of synthetic, color-crazed Americana.

Leigh's astounding spectaculars augmented this shift, not only by way of over-the-top presentations and feats of new technologies, colors, and innovative engineering, but also by using these platforms as a wheelhouse for the most banal (whitewashed), mass-produced commodities, from beer and liquor to cigarettes, gasoline, caffeinated beverages, soda pop, chewing gum, synthetic nylons, and underwear. By the 1940s, the Square had once again become an informal mecca for migrants, vagabonds, and immigrants from non-English-speaking communities. Advertising in the Square no longer spoke to the posh elite of the 1920s (chapter 2) but instead to a new generation of middle-class, consumer-primed Americans taught to believe that the attainment of the good life was first and foremost gleaned through the frenzy of consumption.

The Young Electric Sign Company and Las Vegas Neon

1920–1970

What, in the end, makes advertisements so superior to
criticism? Not what the moving neon red sign says—but the
fiery pool reflecting it in the asphalt.

—Walter Benjamin, 1925

The development of electric grids in American cities in the late nine-
teenth century increased the range of available activities, from transpor-
tation into and out of the suburbs to longer work hours and a host of
leisure activities. Neon's debut in America in the 1920s bolstered these
developments by radicalizing the nascent nocturnal landscape with the
sizzling rainbow hues of the Jazz Age and Art Deco, with its bobbed
haircuts, short skirts, gangsters, prohibition violations, and riotous
spending. Neon was upstaged by the late 1950s, however, by newer and
more efficient light media—backlit and molded plastics, synthetic fluo-
rescent lighting—and by the 1980s by solid-state LED systems. In a half
century, neon transitioned from a signifier of 1920s optimism to one of
alienation and loss, largely forgotten from histories of electric lighting,
art, architecture, and media alike.[1] But how could something that was
once so central to America and the development of its urban aesthetic
be so readily excluded from so many disciplinary histories and cultural
narratives?

To answer this question, the chapter analyzes the historical and tech-
nological development of neon through a variety of genres to unveil
how it operates as a complex symbol of America's deep-seated dreams
of utopia and excess on one hand, and fears of loss and obsolescence on

the other, inversely reflecting America's white imaginary through a rainbow of electrographic hues. By including accounts of neon from the New Journalism, cinema, and television (*Leaving Las Vegas*, *Casino*, *Blade Runner*, and *Maniac*), in addition to technical material from the scientific history of neon, the transitions in the history of the palette are captured through both symbolic and material registers. The fictive imagery communicates the same social and technological tensions at the heart of the medium's history in American visual culture, but, because they take creative license to exploit metaphor in a way that scientific and historical fact cannot, these fictions help to bring real cultural fears and technological optimisms to a heightened pitch.

The chapter temporarily steps away from Times Square to focus on neon in Las Vegas, not only as an international epicenter of polychromatic phantasmagoria but also for its role as the country's winning contender in the 1940s and '50s for producing the most supreme illuminated spectaculars (by 1999, Las Vegas had exceeded Mecca as the most visited place on earth).[2] Like the previous chapter, this one includes a middle section, "Postwar Icons of the Glitter Gulch Golden Era," which attends primarily to technical specificities that some readers may find useful (for purposes of digital re-creation or archiving), while others may be more concerned with the chapter's analytic trajectory. The sections are structured chronologically, from early neon developments in the 1910s, through its transatlantic migrations and early implementation in North America in the 1920s, to the nocturnal urban aesthetic that now defines cities like Las Vegas, Tokyo's Ginza, New York's Times Square, and London's Piccadilly Circus. The chapter ends with neon's declension in an era of postwar white flight, returning us to Times Square, the setting of the previous and following chapters.

NEON HISTORY

Neon (Ne) appeared out of thin air circa 1898, for the benefits of modern science.[3] As the fifth-most abundant element in the universe after hydrogen, helium, oxygen, and carbon, neon in its natural, "noble gas"[4] state is inert, invisible, and unremarkable, which makes efforts to render it visible extremely challenging. When these efforts finally succeeded, the reward was a sensational, cynosure aesthetic that, unlike any light seen before it—from fire through incandescent lighting—enchanted witnesses with its smooth texture and cool mesmerizing glow, physiologically akin to a visual trance or low-level psychedelic hallucination.

Much of neon's magic is explained through its physical and chemical processing. While neon is related to fluorescent lighting in that both involve a phosphor coating inside a glass tube designed to give off light when excited by high voltages, in neon tubes, by contrast, light is produced by the excitation of the gas itself.[5] Many mistake fluorescent lights or "black lights" as neon, even though the latter employ mercury vapor, not noble gases. Neon is thus a gas light but, because it is concocted through an electric apparatus, it is also electric and thus a truly liminal, hybrid light and color system.

Scientists have been aware of processes for generating light by electrifying gas trapped in a vacuum tube since the seventeenth century. The first such luminous tube was produced in 1745 by University of Leipzig physics professor Joann Heinrich Winkler, who bent glass tubes to spell out the name of a wealthy patron, sealed the ends, and lit it up inside a lead jar. In the nineteenth century, experimenter Heinrich Geisler developed a method to sustain the tubed-illumination method by adding platinum electrodes to the ends; in 1891, Tesla "dazzled" audiences in London, Paris, and New York by bombarding gas-filled Geisler tubes with upward of 1 million volts of his AC current.[6] Around the same time, both the United States and Britain granted patents to improve the Geisler tube for use in sign advertising. The Moore tube (1892) was the first such commercial development, engineered by General Electric's Daniel McFarlan Moore to pump supplementary gas into glass tubes at higher pressures, thereby increasing their longevity and brightness.

Capturing synthetic neon light as we know it today was finalized in the 1890s, after English scientist Sir William Ramsay and assistant Morris William Travers conducted a series of experiments using the above methods in conjunction with the fractional distillation of liquid air.[7] In 1897, they unearthed a successful method for extracting four of the six noble gases.[8] When they first witnessed neon's fantastical red glow, they were "spellbound,"[9] as reflected in the name they chose for the light: *neo*, from the Latin root for new.[10] Ramsay and Travers demonstrated their findings during the 1897 commemoration of Queen Victoria's Diamond Jubilee, for which they created a large sign in neon (orange-red), argon (blue), and krypton (orchid) that spelled out "Victoria Regina" in capital letters.[11]

In addition to being a hybrid electric and gas illuminant, neon's otherworldly color palette embodies a unique tension between the handmade and the mechanized—yet another attribute that makes it one of the most eccentric color systems in the history of science. The production process

FIGURE 5.1. The so-called "Neon Palette," 2022. Neon and related noble gases are transformed into a series of brilliant colors through a lengthy process of tube bending, bombardment, heat processing, electrical wiring, blocking, and coating. Only orange-red contains actual neon. Image licensed under the Creative Commons "Attribution-NonCommercial-NonDerivative 3.0 (US)." Courtesy of Wictionary.

has largely remained the same since its inception in 1897 and requires a series of preindustrial, labor-intensive skills from tube bending and bombardment to heat processing, wiring, blocking, and coating. One begins by forming a thin glass tube through an extremely cumbersome process of glass blowing: a preindustrial process that requires great expertise (many neon benders train for decades in apprenticeships before becoming masters). The process allows very little room for error. Even the slightest deficiency or impurity such as dirt, grease, or the presence of other gases results in failure.[12] Once the tubes are precisely formed, heat is added to mold them at both ends with a metal terminal serving as an electrode, one as a positive anode and the other as a negative cathode.[13] Next, through the fractional distillation processes, a small amount of the rare gas (neon in this case) is placed inside the glass tube through the small tip. This is done for each segment of glass, after which the tubes are cleaned for impurities again, connected to a "manifold," and "bombarded" with a vacuum pump.[14] They are ready to illuminate their specified color (i.e., the specific gas that has been placed inside them) once the electric charge is ignited to run through it.[15] As noted, more than a century later, this process remains the same, save for the fact that glass tubes can now be ordered in bulk.[16]

Neon's color gamut ranges from a natural crimson to a low-level green, which is to say, only about 20 percent of the colors we conventionally identify as neon are actually neon. Instead, each gas used in the so-called neon palette (seen in figure 5.1) derives from a different rare gas or from a combination of a rare gas with another substance as follows:[17]

Neon: fiery orange-red (the only rare gas capable of illumination "unadulterated" by other gases)

Argon: soft blue or lavender

Argon mixed with mercury (sometimes coated with ultraviolet phosphors): brilliant blue

Krypton: silvery-white, yellow-white, pale orchid

Xenon (mixed with argon or other gases): pale blue or bright lavender

Helium (with argon): pinkish red

Using different ratios determines what the color will be. Neon gas tends to a warm red, which, as it happens, is ideal for public signage because red light can travel longer distances than any other visible color: up to 70 lumens per foot, versus blues and greens, which can travel only half that amount. As red light travels, it excels penetrating air and translucent substances like glass, plastic, rain, and fog, also making it ideal for visual detection in various weather conditions (in fact, the ideal condition for the maximal light transmission of neon red is rainy weather, when it hits a wavelength of 635 millimicrons).[18] Finally, because human vision is most receptive to yellow-green light, the orange-red region of neon's peak light emissions offers yet another reason why it has been so popular in a host of applications from the military to roadside advertising. These factors together contributed to the palette's dominance in early- to mid-twentieth-century American cities.

CLAUDE'S NEON MONOPOLY

Neon advertising was not French scientist Georges Claude's first-choice application for his chemistry experiments with oxyacetylene welding, a process of cutting metals with gas. He initially aspired to produce oxygen systems for hospital use (in great demand at the time), but his efforts accidentally yielded a brilliant red gas after he filled a Moore tube with

FIGURE 5.2. Georges Claude with neon light (1926). Claude is here demonstrating an ocean thermal energy conversion at the Institut de France in 1926.

neon and charged it with electricity.[19] When he used argon instead of neon, the light turned a beautiful grayish blue.[20] His results were stunning and could be more so, he determined, if he coated the interior walls of the glass tubes with porcelain enamel or ultraviolet-sensitive phosphors, intensifying the naturally cool luminosity of the gases during electrification.[21] Claude anticipated his new lighting systems would compete with Edison's incandescent lighting for interiors, but this did not pan out. Fortunately, his then colleague Jacques Fonseque recognized his illuminants' propensity for public advertising and encouraged Claude to pursue this direction instead.[22] Claude took Fonseque's advice and, with his newly formed company, Claude Air Liquide, S.A., he grew a neon empire.

On March 7, 1910, Claude received his first patent, named the Claude Method, and, on December 11, 1910, in collaboration with Moore, he demonstrated this method at the Grand Palais auto show in France. This first public display of neon consisted of 114-foot Moore tubes.[23] (During Moore's visit to France, Ramsay had given him a quart of neon for experimental use back home, a token of industry collegiality that would not last long.) But Claude quickly found serious limits with Moore tubes. To maintain the light's crispness and intensity, the neon needed to be used in larger concentrations than the tubes permitted.[24] After making necessary amendments, he began producing industrial quantities of it, which he sold for use in advertising signs, including the sign for the Palais Coiffeur, a small barbershop on Boulevard Montmartre, now recognized as having exhibited the world's first neon sign in 1912.[25] By 1914, Claude had a fully functional neon plant in operation, and on January 19, 1915, he was granted a second patent for an electrode attachment process to aid in resistance against corrosion.

News of Claude's successes traveled swiftly. As public demand for neon grew, factories were overwhelmed with orders for signs. By the late 1920s, "Claude Neon" had become a household phrase,[26] and franchises popped up around the world in Vienna, Shanghai, Mexico City, Casablanca, and the United States (in New York, Los Angeles, San Francisco, Detroit, Pittsburgh, Boston, and Chicago). Each franchise sold for up to $100,000.[27] In Paris alone, neon advertisements grew from 160 signs in 1914 to more than 6,000 by 1927.[28]

According to some accounts, neon first came to the United States in 1923, when two large neon signs were bought in by Earle C. Anthony for his Los Angeles–based Packard auto dealership.[29] Recent scholarship counters this, however, indicating that while Earle bought the two signs in Paris from the Claude Neon factory and paid $1,200 for each, they did not appear at the Los Angeles Packard location until 1926.[30] Either way, neon signs proved extremely effective in American cities, maybe even too much so. The Los Angeles Police Department contended the Packard signs were causing traffic jams as locals traveled across town to catch a glimpse of them or complained of their brashness. But, alas, this cynosure effect was precisely the attribute that, for others, led to neon becoming the new medium of choice for outdoor advertising.[31] By 1927, there were a total of 750 neon signs in New York City, and 611 of them were made by Claude Neon. By 1928, Claude Neon had subsidiaries in Dallas, Duluth, Houston, Indianapolis, Lexington, Kansas City, Louisville, Memphis, Milwaukee, Minneapolis, New Orleans, Los Angeles,

Denver, Seattle, Salt Lake City, and Shreveport and dominated 80 percent of the sign market in the country, reporting annual sales of $19 million, equivalent to $290 million in today's currency.[32] Even in 1929, the year of the stock market crash, Claude Neon reported annual sales of $9 million out of a total market for illuminated signage of $11 million, a 40 percent increase over the previous year.[33]

Not surprisingly, Claude's monopoly prompted the formation of rival companies in the United States, resulting in a seemingly endless chain of patent litigations that would, in the end, do Claude in. Already by 1930 Claude Neon was wearing thin, exhausted after almost a decade of battling patent suits for a precious six core patents.[34] Unlike General Electric, which zealously armed itself with a team of aggressive lawyers and battled every patent to the bitter end, the endless litigations for Claude Neon became too costly. His company's lawsuit against Rainbow Luminous Products Co., in particular, for operating Machlett patents that appeared too close to its own, was especially costly, and the *New York Times* never seemed to tire of reporting on it and various other accusations of false advertising and malfeasance in the late 1920s through the early 1930s.[35] One clear victory against a field of losses still "drained the treasury,"[36] and by 1936, Claude had spent more than $400,000 in legal fees and filed more than six dozen federal suits against alleged infringers.[37]

The company's expiration date was further foreshadowed as its patents began to expire. The key patent for its durable, corrosion-resistant electrode expired in 1932, at which point the monopoly dissolved. Prior to the expiration date, competing American entrepreneurs had been preparing, acquainting themselves with the technology required to make neon signs and opening up their own "bootleg" schools, ignoring Claude's patent rights to produce well-crafted knockoffs. The 1932 expiration legitimated their activities, and neon sign production finally entered the open market.

Independent neon shops exploded across the country, complemented by an unrestrained growth in neon trade journals, manuals, and legal neon schools. In 1934, nearly 20,000 neon advertisements went up in Manhattan and Brooklyn alone. By 1936, New York City had spent $6 million on what had become a $30 million neon sign industry, with each sign estimated to cost between $1,250 and $15,000.[38] Even the Edison Company produced a short film in 1930 called "Selling with Electricity" to help salespeople "hone their skills as promoters of neon" and incandescent lighting.[39] In 1938, Claude finally surrendered. He with-

drew all of his investments from the United States, sold his remaining rights to General Electric, and turned to non-neon-related experiments.[40]

With or without Claude, American neon was destined to grow supreme. The end of prohibition in 1933 catalyzed uses of neon advertisements for bars, pubs, and related venues. Just as neon had once denoted scientific progress and optimism in Paris circa 1910, in American cities in the late 1920s and 1930s, it came to signify the nation's spectacular growth and rise to power. In urban centers, neon attracted pedestrians to businesses, while elsewhere, on highways or the new interstate system, neon beaconed drivers from afar. Either way, it had become a vernacular facet of public space, the truest expansion of the definition of *architecture*, beyond any singular structure to the media ecology it persisted in and through. If any single location could be singled out as exemplary of this development, it was indisputably midcentury Las Vegas.

MORMONS AND GANGSTERS

Las Vegas is located in southern Nevada, flanked by Death Valley on the west and the Grand Canyon on the east. In prehistoric times, the area was covered in sea waters as a remnant of the Ice Age (2.4 million to 11,500 years ago). Subsequent warming allowed for habitation by the Southern Paiute people and Paleo–North American hunter-gatherers between 11,000 and 9,000 BC[41] and by Columbian mammoths 8,000 to 15,000 years ago.[42] The Native American peoples lived off the land in small, shallow, open-air pit dwellings "scratched out of the soil,"[43] proto-architectural habitats (discussed in chapter 1 as forms of precolonial whitewash). By 300 BC, the descendants of the Paleo–North Americans were raising corn, hunting wild game, potting clay vessels, and weaving baskets as their settlements expanded along the Moapa Valley, 65 miles northeast of Las Vegas Springs. The arrival of Spanish colonists in 1540 marked the beginning of the decline of the Pueblo cultures. Formal "explorations" commissioned by wealthy European kings and queens crossed the Southwest.[44]

Jumping ahead several centuries, modern Las Vegas played a fundamental role in the development of the country's neon landscape, originating with Mormons and continuing with gangsters in the 1930s, followed by a second growth spurt in the 1950s, and ending with the cosmopolitan explosion of world-class corporate spectacle that Las Vegas continues to host today. Las Vegas is the only major American

city, Tom Wolfe argued in 1964, not built by "East Coast aristocrats or politicians" but instead by "gangsters."[45] This is partially accurate. Mormons arrived in the region circa 1855. Led by William Bringhurst, they arrived in wagons and established modest homes and farmlands in what they called "The Meadows" (translated from the Spanish, "las vegas"), filled with fresh artesian water and some vegetation, and seemed to live peacefully amid the gamblers and criminals who arrived from the American west in 1901. By 1931, gambling was legalized in Las Vegas, while advertising it remained outlawed and thus added value to the visually spectacular signs used to entice customers inside the hotel lounge bars that also happened to be casinos. As this occurred, the Young Electric Sign Company (YESCO), the oldest and largest Mormon-owned neon manufacturer in the region, was poised to meet the demand.

The company was founded by English-born Thomas Young (1895–1971), a Mormon who moved his family from Montreal to Utah in the 1910s and again to Nevada in the 1930s. Young founded the Thomas Young Sign Company (TYSC), which eventually became YESCO, in the late 1920s. At first, TYSC manufactured coffin plates, gold leaf window lettering, lighted signs, and painted advertisements. The company's renaming inaugurated a permanent transition to neon tube manufacturing and sign production serving Utah, Idaho, Wyoming, and eventually Nevada in the 1930s. In Reno, Young encountered stiff competition for neon sign work, most notably from San Francisco sign man Dewey Laughlin. The competitors "concluded that Reno wasn't big enough for the two of them," Charles Barnard writes, so they "flipped a coin to see who would stay and who would leave."[46] Young lost and headed south of Reno to Las Vegas. When he arrived in March 1932, he took a room at the New Apache Hotel and swiftly began soliciting sign work in town as the "exclusive licensee and manufacturer of Q.R.S. neon signs."[47]

Following the completion of Boulder Dam in 1935 (renamed Hoover Dam in 1947), many of the construction workers temporarily located in the area dispersed, taking much of the business with them and making a number of the clubs they frequented along Fremont Street vulnerable to out-of-state financing, in particular the "the illegal gambling kingpins of Southern California."[48] With no other option, businesses accepted the trade, and the city henceforth gained its reputation as a gangster-backed metropolis, a reputation the city of Las Vegas has worked strenuously to shed in exchange for a public image as a legitimate tourist destination. As both efforts ensued, the famous "Glitter Gulch" was born in the 1930s and 1940s,[49] temporarily surpassing Times Square's white light

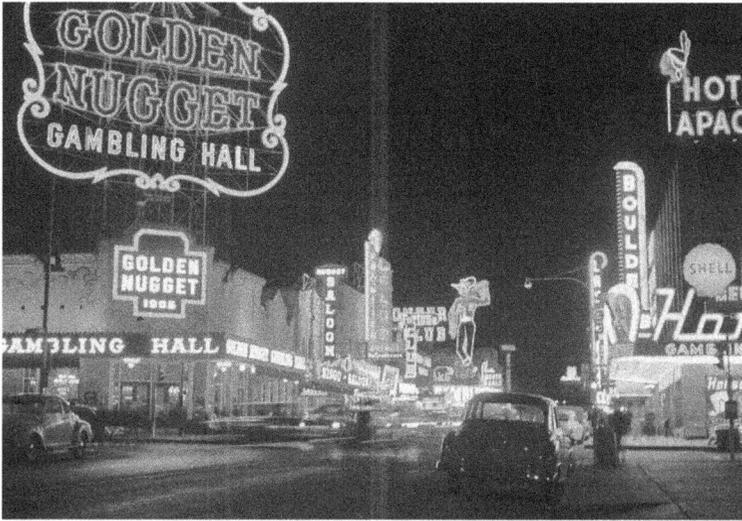

FIGURE 5.3. Edward Edstrom, *Fremont Street* (Las Vegas, 1952). By the 1940s, Fremont Street was saturated with vibrant neon signs and related electrographic architecture, epitomizing the city's golden era as the "Glitter Gulch." On the left is Boernge's 1950 "Golden Nugget" sign. Image courtesy of Edward Edstrom.

hegemony.[50] According to Starr and Hayman, before the end of the 1950s, Las Vegas contained more miles of neon and square footage of spectacular signs than "anywhere else on earth."[51]

The growth spurt began in the late 1930s with the progressive elaboration of prosperous clubs and their increasingly larger illuminated sign displays.[52] Bolstered by the state's socioeconomic liberties (legalized gambling and cockfighting, easy divorce, open prostitution)[53] and equally relaxed zoning laws that allowed for large, free-standing neon signs, the competition to produce the biggest and most visibly astonishing electrographic sign architecture seemed indigenous to the landscape of the city.[54] Large numbers of people began traveling greater and greater distances to see the new Vegas spectacles. President Franklin Roosevelt visited on September 20, 1935, for the opening of Boulder Dam, followed by a number of glamorous Hollywood stars who began to appear in the city, including famous "It girl," Clara Bow, who purchased property there in the 1930s.[55] Strip clubs, gas stations, banks, fast food joints, motels, and casinos all conveniently emerged on Route 91 to Los Angeles (soon named "the Strip") to serve the new clientele, rapidly becoming a central facet of Las Vegas culture.

Also by this time, five new sign companies had popped up in the area: the Las Vegas Neon Electric Sign Co. (which completed the installation of neon signs at the Gateway Hotel, Northern Club, Beckley's, and the Mission Cigar Store), AD-ART Inc., Federal Sign (formerly Sign Systems Inc., or SSI), Heath and Co., and Larsen Sign. The competitors joined the ranks of YESCO, and rivalries predictably emerged between all six companies as they competed to win bids for the same projects.[56] According to Barnard, a former staff member in AD-ART's design department, the business of selling Las Vegas spectaculars "require[d] an aggressive entrepreneurial flair."[57] Each company diligently worked to maintain a roster of high-end clients and, once a project was announced, competed with one another again to produce innovative designs using detailed scale models and, in some cases, color films to accurately represent the project they could build. Even after a bid was won, there were still cumbersome negotiations for the contracts, not to mention the challenges of sign production and implementation. In the end, YESCO established itself as the prevailing but still-edgy startup in town, capturing top commissions early on and sustaining them for the longest period. A series of acquisitions throughout the Southwest furthered its growth and maintained its dominance, beginning with its purchase of the Rainbow Sign Company of southern Utah in the 1950s, followed by the acquisition of Sierra Neon and Western Neon in the 1960s and the Royal Sign Company and Federal Sign's offices in Phoenix, Las Vegas, and Reno in the 1970s.

WORLD WAR II INTERLUDE

World War II presented mass fears and uncertainties, especially around the use of bright lights during curfews and blackouts. Like Times Square, Las Vegas encountered a temporary lull in the growth of its landscape of spectacle, especially as many of the sign workers there joined the war effort, temporarily diverting production away from commercial applications to producing military supplies. At the insistence of the armed forces, prostitution was terminated in Las Vegas in 1942,[58] just as rationing and other shortages curtailed most—but not all—other leisure activity there.

In the spring of 1942, Tom Hull's motor hotel, El Rancho Vegas was born, followed by the Last Frontier, supplementing the official birth of the now-acclaimed Las Vegas Strip.[59] By capitalizing on traffic from Southern California, businesses found novel ways to sustain themselves during these difficult times. Between 1942 and 1945, New York City ad

man J. Walter Thompson was employed by the Las Vegas Chamber of Commerce to help boost tourism in the city. Thompson's agency introduced the Western-themed "Vegas Vic" cowboy logo, soon seen on postcards around the world. After the war, the money started streaming back in and Vegas Vic's "Howdy, Podner" greeting was a welcoming beacon for "war-weary" Americans looking for some "fun in the sun."[60] The real money, however, would not arrive until Bugsy Siegel's luxe materialism befell the nascent Strip.

BUGSY SIEGEL

Hailing from a well-known New York crime family, Benjamin "Bugsy" Siegel (1906–1947) moved to California in 1936 to work as a hitman after his early career bootlegging and gambling in New York City. In California, he was charged and acquitted for murder in 1941, during which time he began visiting Las Vegas to scout prospective investments. For several reasons, his arrival was apparent to all who cared to look. First, he had "several million dollars at his disposal," later traced back to mob-related financing.[61] Second, he sponsored the construction of a new luxury hotel, the first of its kind in the area, designed in 1945 by well-known California-based architect George Vernon Russell and backed by *Hollywood Reporter* owner Billy Wilkerson, who had a track record of building successful Hollywood restaurants and nightclubs like the Cafe Trocadero, Ciro's, the Vendome, Sunset House, LaRue, and L'Aiglon. When Wilkerson ran out of funding in Las Vegas, however, possibly due to the return of his unfortunate gambling habit, Siegel stepped in with the new aim of introducing the luxury and excesses of Hollywood glamour and sophistication to the modest desert resort. Moreover, the new luxury hotel was not located on popular downtown Fremont Street but instead a surprising seven miles away, on 30 acres of empty land adjacent to the Los Angeles Highway, near what was becoming "the Strip."

Once completed in 1946, the Flamingo Hotel stood as the third resort built on Highway 91 but no less a force to reckon with. Siegel ensured the hotel paid record-high fees to draw in such big-name entertainers as Jimmy Durante, the Andrew Sisters, and Lena Horne.[62] Unlike the other Cowboy-themed dens on the Strip, the Flamingo offered star entertainment and cosmopolitan designs to attract wealthy customers from Southern California and Miami. Its overall aesthetic was "Miami-Modern," as Wolfe called it, with "curvilinear shapes, cantilever roofs,

and scalloped swimming pool outfitted in the electrochemical pastels of Florida littoral" hues ranging from "tangerine, broiling magenta, livid pink, Congo ruby . . . [to] methyl green . . . incandescent orange, scarlet-fever purple, cyanic blue, tessellated bronze" and "hospital-fruit-basket orange."[63] The hotel's roadside signage featured an eight-story cylindrical tower covered from top to bottom in neon rings shaped like bubbles. Unfortunately, Siegel was not around to see the results, having been gunned down in Beverly Hills on June 20, 1947, less than a year after the Flamingo's opening.[64] The hotel nonetheless brought a new flair of upscale glamor to Las Vegas, and with it emerged a new age of luxe materialism and unprecedented financial growth that continues to attract seasoned gaming operators, entertainers, and patrons from around the world.

POSTWAR ICONS OF THE GLITTER GULCH GOLDEN ERA

As urban growth boomed in Las Vegas in the postwar years (as it did elsewhere in the country), the city's efforts to promote "clean" tourism paid off. In 1948, the new McCarran Airport began operating at the south end of the city, handling twelve flights a day to a burgeoning community of 20,000.[65] Nineteen fifty was the first year the city saw no material shortages for sign making, while the US military relocated a number of bases to the region, including Nellis Air Force Base, a test site for Thunderbirds, stealth fighters, and bombers located 50 miles north of the city (extending the Las Vegas Army Airfield). The military relocation was complemented by the nuclear test sites built at Frenchman and Yucca Flats in the early 1950s, 100 miles from downtown.[66] These changes furthered the city's population boom while serving a more perverse function of promoting military-commissioned spectacles. Hotel and casino owners capitalized on the explosions by offering visitors the "added thrill of atom bomb–viewing breakfasts,"[67] while others enjoyed the spectacle freely from the sidewalk. Either way, all seemed to agree at the time that the nuclear detonations "proved a boon, rather than a dampener"[68] to the city's tourism industry.

By this time, YESCO was hiring commercial artists with backgrounds in the movie industry, poster design and display, and animation. These multitalented artists "formed a new rank of sign designers," Barnard explains, that shifted the quality and caliber of Las Vegas signage[69] in accordance with postwar prosperity. Unfortunately, the names and

colorful histories of the vast majority of these sign designers and tube benders have been excluded from mainstream art, design, media, and architectural histories—even from histories of Las Vegas itself. This section restores only a small fraction of these attributions, mainly by way of technical specificities (i.e., metrics). Although these descriptions may be of less interest to some readers, for those engaged in histories of technology and digital re-creation efforts (such as the kinetic simulations offered for chapters 3 and 4), the details offer insight into these actors' incredibly imaginative endeavors and innovative solutions.

Two of the city's first "designer-sculptor geniuses,"[70] as Tom Wolfe characterized them in 1969, were YESCO workers Aloysius McDonald, cofounder of the Nevada State Board of Architecture (1949) and designer of the neon display for Club Bingo on the Strip, and California-born Herman Boernge (1915–1966), who started working for YESCO in 1948 and remained with the company for twenty years, eventually becoming the first art director of the Las Vegas branch. Boernge hailed from Los Angeles, where he had worked as a commercial sign artist and designed the diorama for the 1939 San Francisco World's Fair.[71] During his tenure at YESCO, Boernge achieved national recognition for his work, including his sign for the Las Vegas Club, a towering 120-foot vertical display near the corner of Fremont and Main Streets (the tallest electric sign in downtown Las Vegas until the Lucky Casino sign surpassed it twelve years later);[72] the original sign for the iconic Golden Nugget in 1950; and subsequent signs for the original Flamingo, the Sands and Desert Inn, the Lucky Strike, the Mint, and the Horseshoe.[73]

Glitter Gulch signage materialized by the minute. In 1951, the Pioneer Club (1942) contracted YESCO to build a neon replica of the original "Vic," created by J. Walter Thompson Advertising in 1945.[74] The new, 50-foot-tall Vegas Vic stood on Fremont Street atop the entry canopy of the Pioneer Club, smiling and waving in neon light.[75] In 1952, the Sahara opened on the site of the former Club Bingo and, in 1953, the Flamingo installed a new sign (then the tallest freestanding sign beacon on the Strip), an 80-foot cylindrical "Champagne Tower" designed by the architectural firm Pereira and Luckman and constructed by YESCO. In 1955, YESCO's Ben Mitchem designed the signs for the newly constructed Dunes, a 30-foot-high steel and fiberglass sultan rendered in sparkling white and gold neon attire, floodlit from below, mounted on the building's roof, and flanked with matching sets of illuminated letters that spelled out "Dunes" in yellow light.[76] By the end of

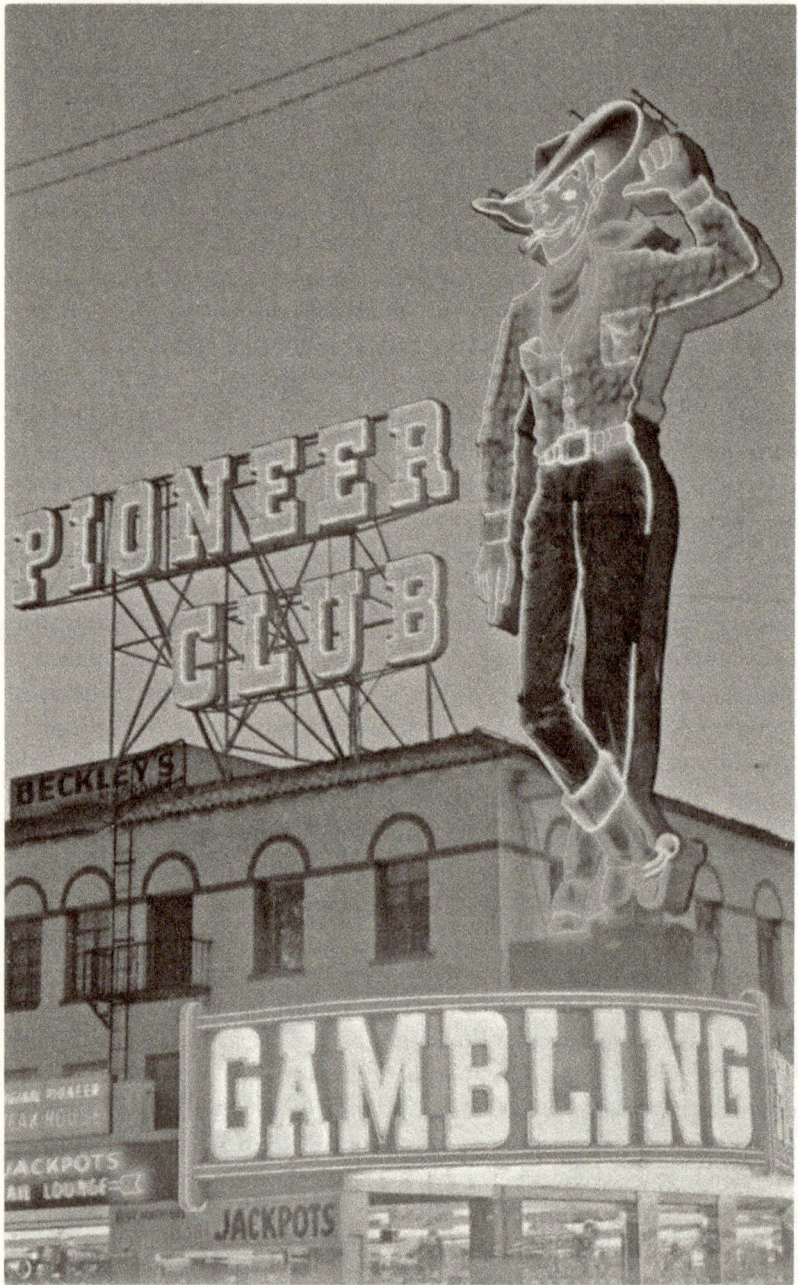

FIGURE 5.4. In 1951, the Pioneer Club (opened in 1942) commissioned YESCO to build a neon replica of the original 1945 "Vic," created by J. Walter Thompson Advertising. This postcard shows the new "Vegas Vic," standing on Fremont Street atop the entry canopy of the Pioneer Club, smiling and waving in 50 feet of neon light. Author's collection.

the year, three other establishments appeared on the Strip: the Riviera, the Royal Nevada, and the Moulin Rouge (one of the few establishments that permitted multiracial gaming).[77] As ever-more-spectacular signage popped up along Fremont Street and the Strip, Las Vegas officially overtook New York City for the boldest and most impressive electrographic architecture.

In 1956, Chicago-born YESCO designer Kermit Wayne introduced a wrapping sign concept for the Golden Nugget by positioning streams of animated neon lamps that collectively receded from the giant bullnose corner.[78] Shortly thereafter, YESCO collaborated with architects McAllister and Wagner in redesigning Benny Binion's classic Horseshoe outside the Horseshoe Casino (originally the Eldorado Club and Hotel Apache) on Fremont Street (kitty-corner to the Golden Nugget)[79] to produce a 31-by-24-foot concave panel of interlocking yellow-gold neon "H" logos that served as a backdrop for the 13-foot illuminated horseshoe in the foreground, positioned above a 7-foot-high "H" and below that the word "GAMBLING."[80] Thirty years after its debut, it still held the title of the world's largest neon sign.[81]

In July 1958, the Stardust Hotel and Casino gained the title of third-largest spectacular on the Strip. The hotel chose a Space Age theme, coinciding with the era's fascination with space travel and the recent news of the Russian satellite *Sputnik II*. Wayne created a horizontally oriented sign of red and white letters in "Elektra Jag," or "Atomic" font set against a sky-blue background that ran 217 feet long and reached 27 feet high with a large globe and stars decorating the backdrop.[82] Mounted on twelve steel columns detached from the actual building (like many of the Leigh and Gude signs in New York; see chapters 3 and 4), the display required more than 30,000 feet of wiring to light its nearly 11,000 electric lamps and 7,000 feet of neon.[83]

In 1964, the Los Angeles Division of Federal Signs (LADFS) challenged YESCO's world title when it produced a taller freestanding sign at the Dunes, located on the Strip. LADFS built the new Dunes sign on a steel structure filled with 267 cubic yards of concrete weighing 1.5 million pounds. Its feet were buried deep in the desert sands to withstand winds that could exceed 100 miles per hour, and one of the sign's support legs came with its own service elevator. For a publicity event in 1964, a chorus girl posed on a mound of 7,200 electric lamps, echoing the enormity of bright lights used in the sign itself while delicately pointing to the top of the $500,000 spectacle, which displayed the resort name, "DUNES," in 20-foot gold letters on a blue background with red

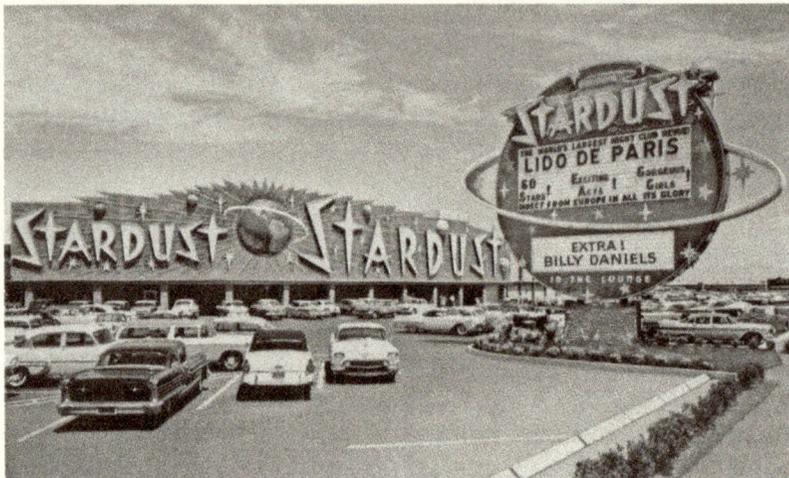

FIGURE 5.5. This postcard for the Stardust Hotel and Casino shows the sign by Kermit Wayne for YESCO (early 1960s). The hotel's Space Age theme reflected the era's fascination with the Soviet Union's recent launching of its *Sputnik II* satellite. The display, mounted on twelve steel columns detached from the actual building, required more than 30,000 feet of wiring to light its nearly 11,000 electric lamps and 7,000 feet of neon. Author's collection.

arabesque framing.[84] LADFS was proud of its achievement, as were those who wished to publicize it, but to others, its aggressive red neon was the cause for numerous complaints, especially from neighboring hotel guests who eventually saw their hotel rooms lined in thick drapes.[85] The new Dunes spectacular also caught the attention of Denise Scott Brown, Robert Venturi, and Steven Izenour as one of the first in a series of formative new designs that shaped their 1972 postmodern theory of "duck and shed" architecture (expanded on below).[86]

Las Vegas could now lay claim to the three tallest electric signs in the world: the Dunes (180 feet), the Frontier (184 feet), and the Stardust (188 feet), the last gaining a listing in the *Guinness Book of World Records*.[87] While the language of sovereignty or omnipotence was not explicit in Glitter Gulch rhetoric, there was nonetheless an unswerving drive to achieve national (and eventually international) preeminence through the signs' spectacular electrographic architecture. In this way, the history of Las Vegas neon evidences the same mythic American drive to be the brightest, tallest, and most financially lucrative, even if by way of brazen polychromatic lights and novel animations.

Although the American drive for spectacular sovereignty has been equally operative (if not more so) in Las Vegas since the Glitter Gulch's

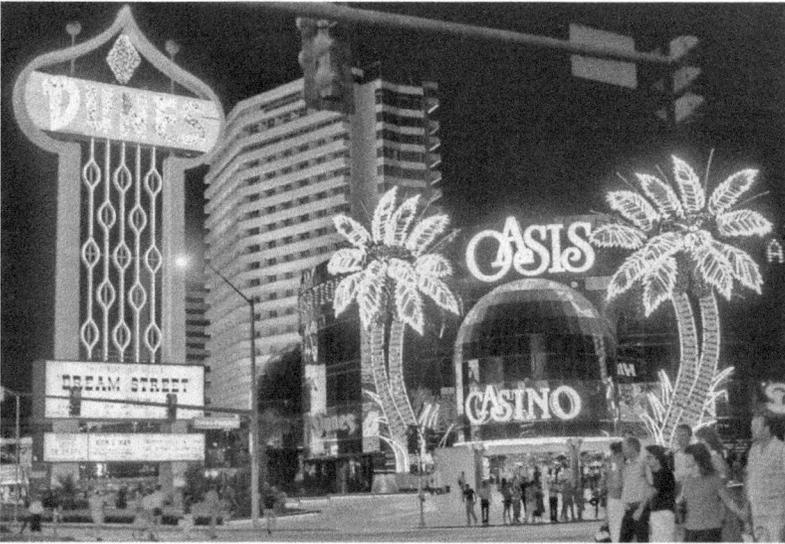

FIGURE 5.6. The Dunes Hotel and Casino (1955–1993). The Dunes sign seen here in 1983 was built in 1965 by the Los Angeles Division of Federal Signs (LADFS). It used nearly three miles of neon tubing and 7,200 General Electric lamps. The 180-foot sign garnered for LADFS the new title of "World's Tallest Freestanding Sign."

golden era, in this chapter's analysis, we see only the beginnings of these tendencies. For example, such events as American millionaire Howard Hughes's (1905–1976) purchase of the Desert Inn, the Sands, Castaways, the Frontier, the Silver Slipper, and the Landmark in 1967 all foreshadowed an era of intensified capital and control by any means necessary. It was not just that Hughes purchased six hotels in one fell swoop; it was also the way he simultaneously swayed Governor Paul Laxalt in 1968 to modify the state's laws regarding who could be granted a gaming license to operate there.[88] Prior to Hughes's purchases, corporations were not permitted to operate gaming institutions in the state. After his acquisitions, the doors swung wide open for foreign investments and international corporate interests.

After 1967, there was also a widespread turning away from free-standing pylon signs toward more immersive porte cocheres that invited luxury cars in off the street. For example, Raul Rodriguez (1944–2015)[89] of Heath and Co. (by this time a division of Federal Sign) elegantly redesigned the Flamingo Hotel and Casino sign in 1976–77. Rodriguez designed a porte cochere and freestanding vertical pylon in line with the sign fashions of the decade, but unlike them, his graceful curvature

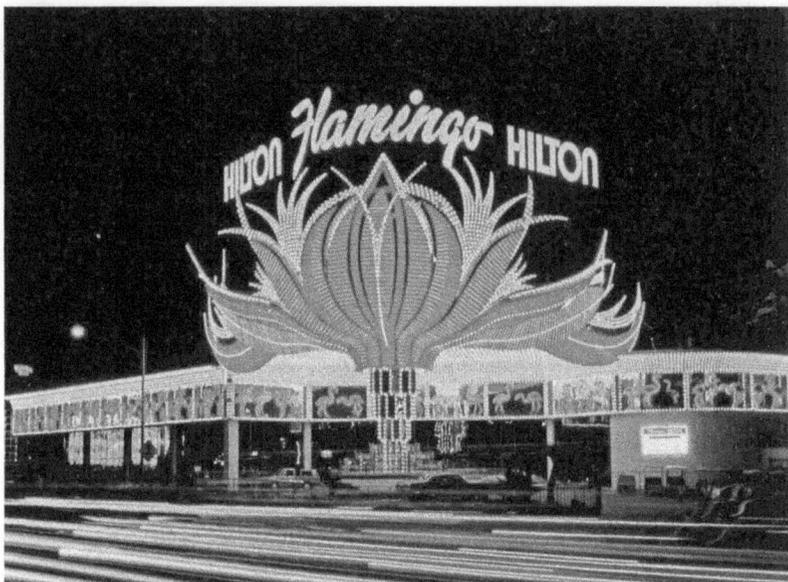

FIGURE 5.7. Postcard of the Flamingo Hilton (1946–), circa 1978. The Flamingo was built on the Strip with an upscale Art Deco style that aimed to introduce Hollywood luxury and sophistication to the desert. It was completed in 1946 by mobster Bugsy Siegel, who was assassinated in 1947. In 1968, Raul Rodriguez of YESCO gave the Flamingo a facelift by designing this unique and elegant, freestanding sign. Author's collection.

broke with the aesthetic convention of angles and corners that still dominated the electrographic architectural styles of "Googie" LA diners and mid-century modern obsessions with the space age. Rodriguez's sign consisted instead of elegant, organically shaped, neon-lit flamingos in rich pinks and fuchsias, a truly original contribution that cannot be forgotten, despite the more monolithic, techno-capitalist imperatives that saw it to fruition.

On the whole, late 1970s Las Vegas architectural facades saw a widespread transition toward glamour and glitz, mirrors, and backlit illumination, accurately reflecting the new decade's focus on money and excess, retroactively depicted in films like Martin Scorsese's *Casino* (1994). Neon had by this time slipped out of fashion and companies like YESCO had had to make a number of changes. As early as the late 1940s, it began transitioning to hybrid plastic signs and, by the end of the 1970s, had fully adopted newer and more efficient four-color, computerized electronic message systems. In 1980, the company installed

the world's tallest freestanding sign (222.5 feet) at the Sahara Hotel and Casino, was commissioned by Disney to produce Epcot Center signage,[90] and pursued related projects at the McCarran International Airport, the World of Coca-Cola landmark sign in Atlanta, Caesars Palace, and Ford Motors on the West Coast. By the mid-1990s, the company had 806 employees. In the 2010s, the renamed YESCO Franchising was awarded the annual Top Franchise Satisfaction Award, and in 2015, it was acquired by Samsung International,[91] marking the end of its history. The many renowned, hand-crafted immersive light experiences YESCO pioneered are now automated in cities around the world, with little concern for innovation or originality. It is possible that the first and second generation of Las Vegas sign creations would have been entirely lost to media and architectural historians if it had not been for a coterie of open-minded Yale University professors circa 1968.

YALE LEARNS FROM LAS VEGAS

Yale University architecture professors Robert Venturi and Denise Scott Brown, along with graduate student Steven Izenour undertook what is considered the first scholarly effort to bring serious theoretical attention to Las Vegas architecture. Their 1968 studio visit, "Learning from Las Vegas, or Form Analysis as Design Research," was most likely inspired by American journalist Tom Wolfe's essay "Las Vegas (What?), Las Vegas (Can't Hear You! Too Noisy), Las Vegas!!!" (*Esquire*, 1964), followed by his 1969 *Architectural Design* essay "Electrographic Architecture," from which this book takes its title. The Yale professors published their findings as "A Significance for A&P Parking Lots, or Learning from Las Vegas" (*Architectural Forum*, 1968), followed by a book of the same name (1972) with Izenour as the third author. The book remains a foundational text in architecture, communications, and design studies. It has inspired a wealth of secondary scholarship, which I circumvent here, save for a brief exegesis on the way the text validated neon as a "serious" component of what would eventually be called "postmodern architecture," in itself a much-needed expansion of the implied singularity of "architecture" to include immersion in a broader media ecology (and thus the word *architecture* begins to seem anachronistic, relative to terms like *urban landscape, ecology,* and *mediated environment*).

In his two above-noted essays from the 1960s, Tom Wolfe foreshadowed this postmodern turn in architecture by identifying a new genre of "Electrographic Architecture," rooted in pastiche, commercialism, and

eye-popping hues. Born in Richmond, Virginia in 1930, Wolfe was awarded a PhD in American studies at Yale University in 1956 and has since been recognized as a progenitor of the New Journalism style. In his still–relatively unknown but pivotal 1964 and 1969 articles, he defended the merit of commercial signage over the pretenses of "stuffy" artworld neon. He takes stabs at all the major players, including Jack Burnham, author of the avant-garde cult classic *Beyond Modern Sculpture* (1968), who hailed neon sculpture as the "future" of techno-aesthetic fashions, led by a "technological elite" of Euro-American art stars.[92] This artworld stardom was a joke to Wolfe. Where Burnham claimed "[Billy] Apple [was] a lyrical user of neon, with a very personal sense of color,"[93] Wolfe countered by declaring Apple's neon colors "curiously pallid for neon—everything [wa]s a 'sick apricot . . . limp . . . Frankly, I'm embarrassed for the guy!'"[94] Wolfe suggested that the then-popular neon art stars travel to Las Vegas, where neon was a "serious architectural subject" and feat of technology, able to "revolve, oscillate, and soar," inevitably rendering helpless "the existing vocabulary of art history."[95]

Wolfe's provocative prose offered a critical and progressive response to the conservate sentiments of aesthetic modernism and a postwar cultural milieu of blind consumption.[96] He closed his 1969 essay by declaring that someone "must write [a] new book, now, fast, on the most lavish coated stock [at] $18.50 a copy, called *Beyond Modern Architecture*"[97]—taking yet another stab at Burnham while advocating an expansion of the then–de rigueur modernist style of architecture beyond the consideration of an isolated "monument" built by a singular genius to include the contextual landscape (people, politics) that architecture's material constructs were connected to. The Yale architects answered his call.

Learning from Las Vegas follows Wolfe's work by lauding the material and psychological presence of large-scale neon signs rapidly outstripping the "nondescript Las Vegas buildings" that stood behind them. Contrary to modernist theories of architecture that, as noted, privileged clean (white), single, monumental structures over generic facades (let alone sign, color, or decor), *Learning from Las Vegas* returned critical attention to the seemingly inconsequential colors of surface and ornament that had played an important role in the entire history of architecture *prior* to modernism.[98]

Upon returning from Las Vegas, the Yale scholars contoured a new genre of postmodern architecture defined by "duck" and "shed" motifs. A so-called *duck* edifice indicated an affiliation with modernist architec-

ture, insofar as form and volume remained its core attributes. In contrast, a *decorated shed* signified the use of large-scale signage (color, décor, and ornamentation) relative to what was typically a simple shed-like body that lay behind it. The above-noted neon signs all serve as strong examples of decorated sheds and, for this reason, were formative in the development of postmodern aesthetics.

So-called decorated-shed signage functioned along both religious and aesthetic lines, Venturi and colleagues argued. Like giant hieroglyphs, electrographic architecture beaconed consumers into their temples of glory, proclaiming supremacy—not of God but of American capital, materialized in blazing neon color. That visual spectacle attains a theological status in advanced capitalism is hardly news. What was news, however, was the validation of prosaic phenomena as a meaningful site of cultural production. Finally, the commercial colors of Las Vegas's electrographic architecture could join the pantheon of America's (not so) "pure" white imaginary, alongside Chicago's White City and New York City's Great White Way.

Unfortunately, the Yale intellectuals were both too early and too late. By the time of their trip, the neon palette was already under threat by cheaper and more efficient backlit plastics, first introduced in 1938 by Bakelite, followed by molded plastics in the 1940s and 1950s, including Flexglass, Lucite, Melamine, Vinylite, Magicast, and Fluorex, combined with equally new synthetic materials developed during the war such as plywood, fiberglass, nylon stenciled cloth, and of course variations of synthetic phosphorescent, fluorescent, Mercury, Glo-Let, and Day-Glo lighting.[99] Plastic not only dramatically lowered the costs of production, upkeep, and maintenance but, as reported by the *New York Times* in 1950, promised to "solve all the problems traditionally associated with neon."[100] By the late 1940s, even companies like YESCO were shifting from neon to plastics, while the Ohio-based Neon Products Inc. would by the end of the decade convert 90 percent of its production to the patented "Plastilux 500." By 1955, Neon Products had become the world's largest producer of plastic signs.[101]

WHITE FLIGHT, DARK NEON

As cheaper plastics took over, neon was abandoned to the inner city, coinciding with the country's mass exodus, or postwar "white flight." This mainly Caucasian repudiation of numerous inner cities in the United States for the safer, sanitized, and more materially expansive suburbs led

to the formation of inner-city ghettos and decrepitation of tenement buildings. As whites moved out, estranged immigrants and disenfranchised peoples moved in, alongside the abandoned neon signs, many no longer working, others half-lit at best—much like the tenement buildings themselves—left to those without resources or real power.

As these mass demographic shifts ensued, they "sanctioned the formation of a new racial geography,"[102] Eric Avila writes, whereby "black" became synonymous with "urban"[103] and the suburbs became synonymous with a new "white" identity, reinforced by blockbusting, restrictive covenants, municipal incorporation, price-fixing, redlining, and outright violence. The 1934 Federal Housing Act (FHA), for one, made home ownership accessible to millions of "white" citizens by using "confidential" government city surveys and appraisers' manuals to funnel the majority of loan funds exclusively to them and not to colored Others.[104] By the 1960s, many white-flight suburbs had incorporated themselves as independent municipalities, thereby gaining access to greater amounts of federal funding by qualifying for preallocated "urban aid."[105] Neon's material declensions paled in comparison to the mass racist practices bolstering white flight, amplified by the mass migration of African Americans to the nation's northern cities as they fled a legacy of poverty and racism in the South, where, in the now-neglected inner cities, both landscape and its lighting were half-lit, flickering signifiers of social and economic decline.

Just outside the city limits, cookie-cutter layouts and template designs were promoted to "white people" as signposts of upward mobility, Dianne Harris argues, as a stepping stone in the acquisition of the "good life."[106] Home advertisers and real estate agents played off real and imagined stereotypes, emphasizing the "privacy," "freedom," and "spaciousness" of the new "safe" and "sanitized" suburban housing (versus what had become the "dirty conditions" of the [colored] inner city). Accordingly, white-flight suburban aesthetics capitalized (once again) on a puritanical, whitewashed color palette. Far from the militant white of Le Corbusier's architectural modernism discussed in chapter 2, this was a palette of pastels and watered-down hues deemed "safe" by way of synthetic chemistry and its commercial discourses of "hygiene, novelty," and "sophistication."[107]

US Commissions on Civil Rights have more recently brought to light a number of ways by which FHA officials collaborated with the Department of Housing and Urban Development, property owners, and real estate developers to "aid and abet"[108] segregation in US residential

neighborhoods by financing the movement of low-income whites away from inner-city neighborhoods and into the suburbs. Between 1934 and 1962, the FHA and Veterans Administration financed more than $120 billion of new housing, less than 2 percent of which was available to nonwhite families.[109] Meanwhile, inflated costs and price fixing of "substandard" urban real estate resulted in a 200 percent increase of housing costs in the city between 1968 and 1972. Profits went to "lenders (almost all of them white)," while bankers foreclosed on the "mortgages of thousands of uninspected and substandard homes," where nonwhites lived, ruining the property value of many inner-city neighborhoods for decades to come.[110] Between the 1930s and the 1970s, so-called urban renewal projects demolished more than 1,600 Black neighborhoods in American cities,[111] while the FHA and federally sponsored loans built up thousands of new little white houses in the "safe" and sanitized suburbs. Although such practices are far from obsolete today, their potency during these years reinforces the links between light, color, and power imbalances at the foundation of American culture.

In sum, white flight illustrates how America's white imaginary, buttressed by the "safety" and "comforts" of homogeneity, containment, and predictability, inversely ensure ongoing racial segregation for nonwhites and their capacity to access housing, resources, and opportunities for upward mobility.[112] Granted that the polychromatic hues of Las Vegas and the largely heterosocial, unpredictable hues of Times Square hardly seem synonymous with the pastel niceties of the genteel suburbs, all of these colors, when taken in social and historical context, fall under the common denominator of servicing the American dream, for a few and by a few, sold by promising it to all.

X-RATED NEON

When white flight took hold of Midtown Manhattan, Times Square signage transitioned to the dark side. In the 1970s, the Square's few blocks of pre-Giuliani Manhattan sported neon that now communicated a lurid baseness rather than glamour or posh. This was far from the neon of the 1920s and '30s that signaled optimistic freedom and celebratory excess, or even the progressive neon of the productive postwar years; instead, this was the neon of sex shops, porn theaters, and peep shows. Urban-renewal legislation affecting the Square in the 1970s is discussed in the following chapter; suffice it to note here that the area declined to sex capital of the country, elegantly articulated in Samuel R.

Delany's *Times Square Red, Times Square Blue* (1999). Delany outlines these two colors' dual role in reinforcing the Square's seediness while simultaneously celebrating the otherwise taboo social, racial, and sexual relations that the dark side of neon remained tied to.

As inner-city neon grew dirty, the once "clean" and "optimistic" neon elsewhere in the United States began to disappear. Some cities like Los Angeles and Pasadena took measures to protect their historic 1920s-era neon signs from decay. The former encouraged the restoration of neon signs on top of historic apartment buildings along Wilshire Boulevard, while the latter began historical designation. Cities like San Diego required sullen neon signs to be removed unless they were "designated historic,"[113] in which case they required cleaning and maintenance, while in San Jose, repairs were permitted only for preexistent signs. Other American cities developed neon preservation institutions to house what was becoming a rapid accumulation of unwanted artifacts. For example, the infamous "Neon Boneyard" in Las Vegas; the Neon Museum in Los Angeles; and the now-closed Neon Museum of Philadelphia, founded by Len Davidson in 1985. But whether it was preserved or not, an inactive neon sign viewed in daylight was just as the name Boneyard suggested: dead and void of the transcendent optimism of its yonder years.

CHIC NOIRE

Beginning in the 1970s, Hollywood began marketing the chic, dark side of urban decline as a spectacle for those with the luxury of being safely removed from it. Whether set amid "littered streets, dark alleys, and decaying buildings of a downtown"[114] or the existential horrors of excessive materialism gone wrong, postwar film noir genres capitalized on the fears that fueled white flight and the resultant inner city left behind. This penultimate section considers only a few such examples.

Precursors to neon noire can be identified in fiction, in Nelson Algren's short story collection, *The Neon Wilderness* (1947) and John McDonald's novel *The Neon Jungle* (1953), which responded to the degradation of inner-city life and the new role of neon as a metaphor for it. McDonald's novel in particular focused on the less fortunate facets of urban life (death, crime, and cruel women), paving the way for a slew of literary journalists after him, from Tom Wolfe to Hunter S. Thompson and Joan Didion.[115] Christoph Ribbat recounts Didion's take on Las Vegas neon in *Play It as It Lays* (1970), in which hypersensitive protagonist Maria Wyeth is an actor undergoing a series of "personal and psychological

crises" while living in the city, described by Didion's Wyeth as "waves of voices" in "colors and light."[116] Unlike the other—primarily male—journalists who wrote about Vegas during this time, Didion's protagonist moves through space differently, with her perception highly attuned to subtleties in movement. Even if she was "blindfolded and confronted with the neon advertisements of the Thunderbird, Flamingo or other well-known Vegas casinos," Didion writes, "her sensitivity was so acute, she would be able to identify which casino she was standing in front of."[117] Didion's Wyeth offers an alternative to still-dominant accounts of sensory and psychological overload in the face of chaotic urban spectacle, taking instead to embracing them as part of what we may describe as a new electrographic phenomenology.

Neon's status as a signifier of urban and moral decline also drew support from postmodern intellectual circles. French scholar Guy Debord published his infamous *Society of the Spectacle* in 1967, affiliated with his 1973 Situationist film critiquing the hegemony of images in modern culture by claiming that the conditions of production today, in the spirit of Marx, supplanted authentic social relations. "All that once was directly lived," he wrote, "has become mere representation."[118] While it would be a mistake to accept this overarching technological determinism at face value, it would also be remiss not to substantiate these insights as part of the aggressive diminishment of human voices and bodies in public space, a subject I return to in the book's concluding discussion of twenty-first-century algorithmic-driven spectacles.

If neon was not explicit in Debord's work, it was a focus in the writings of iconic French intellectual Jean Baudrillard, who provocatively argued that Las Vegas's bright colors and signs marked a total evacuation of meaning as such. For Baudrillard, unlike Debord, images and simulations were more accurate forms of reality than unmediated ones. American historian Todd Gitlin concurs in his discussion of the late 1960s, implying that spectacles like Las Vegas and the mediated Vietnam War were equally untethered to truth, because in both, "reality appears illusionary and illusions take on lives of their own."[119] Nothing is sacred, not color, spectacle, or its absence. While these sentiments epitomize a postmodern ethos, they also align with the actual, material fate of neon in the late 1970s and '80s, as reflected in Hollywood noir.

The full roster of color films featuring neon is too vast to index here and thus I highlight only three examples from the 1980s–90s, chosen for their capacity to remap neon as a visual signifier of post-1960s cultural decline. The first example is Ridley Scott's *Blade Runner*

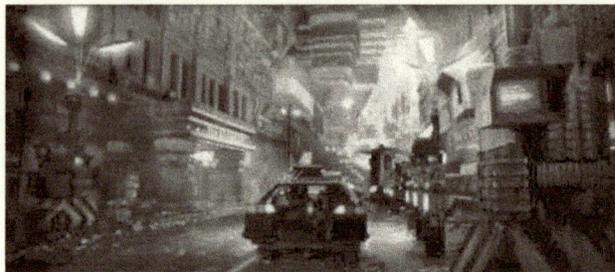

FIGURE 5.8. Still from *Blade Runner* (1982), directed by Ridley Scott. Postmodern aesthetic theories have drawn on the mise-en-scène of this film. The prevalence of neon supports the remapping of visual culture in post-1960s decline.

FIGURE 5.9. Still from *Blade Runner* (1982), directed by Ridley Scott. Throughout the film, chaotic and aggressive neon decorates the backdrop and, in some scenes, comes directly into the foreground of the action.

(1982). Because a wealth of scholarship has accumulated on the futuristic mise-en-scène of the film, I jump directly to the way the film chaotically employs neon to decorate its transhistorical backdrops or, in a few cases, drives neon into the foreground of the action.

Produced at the Warner Brothers' "New York Street scene" studio in Hollywood, where 1930s gangster-era films were shot, *Blade Runner* opens with giant screens hovering over an oddly futuristic and seemingly ancient city, with advertisements for commercial products projected amid a mélange of neon lights and signs illuminated from below. The film's simulation of advertising's visual cultures mixes older products with newer ones (in classic postmodern garb), as the film's historical setting offers a pastiche of London in the eighteenth century, busy markets in New York's Lower East Side circa 1910, and Times Square in the 1980s.[120] Neon appears again in the sign for Los Angeles's Yukon Hotel, alluding to the California gold rush, since

replaced by a T-Mobile outlet at South Broadway and Third Street in the city itself. *Blade Runner*'s cityscape is also unlike many actual contemporary cities in that its use of illuminated signage is void of sex industry advertising, popularized through urban red-light districts. Rather, Ribbat notes, the film's invocation of the neon palette has more to do with a dismal and "heady" take on a postmodern dystopia than with the actual sex den that was Times Square during the film's release.[121]

As the 1990s dovetailed with the end of the Thatcher and Reagan years, Hollywood films continued to deploy neon to address the dark side of material excess. Mike Figgis's *Leaving Las Vegas* (1995), for instance, featured protagonist Ben (played by Nicolas Cage), who travels to Las Vegas to drink himself to death. He meets Sarah (played by Elisabeth Shue), a prostitute who is equally down and out, and they fall in love in a sad and shared broken world. Despite being praised for its glorious iconography, neither neon signs nor neon facades are ever featured directly in the film. Only indirect reflections of distorted neon signs and colorful lights are seen falling on the actors' bodies, reflecting in the windshields of their cars, or filling in the backdrop's mise-en-scène. By "leaving," the film's title implies a departure from the material world, whether by overindulgence or the delusions of mass image effects, which is exactly what happens to Cage by the end of the film: he dies and thereby "successfully" leaves Las Vegas.

Casino (1995; directed by Martin Scorsese) likewise caters to the psychological dark side of Las Vegas hedonism by recounting the epic demise of crime and gambling on the neon-clad Strip. Less a story of glamor and conventional American entrepreneurial success—though there are moments of monetary ecstasy—we see instead the dark side of Sin City through excessively bright lights and scintillating glitz. A number of scenes feature well-known neon signs on the Strip. There is no attempt to conceal their identity, just as Scorsese felt little need to conceal the film's critique of the city's corruption.[122]

An equally thoughtful use of neon is found in *Casino*'s title sequence, designed by the gifted Saul Bass and Elaine Bass. Made in 1995, one year before Saul's death,[123] the sequence features an array of elegant neon colors with a silhouette of a man falling across the screen until an explosion occurs and he begins to float upward in the other direction. The Basses wanted to create a series of images that functioned as a metaphor for the city's "twisted morality, greed, hubris, and in the end, self-destruction."[124] They drew inspiration from Dante's *Inferno*, Hier-

FIGURE 5.10. Elaine and Saul Bass, title sequence for *Casino* (1995), directed by Martin Scorsese. Designed one year before Saul's death.

onymus Bosch, and Bach's oratorio *St. Matthew Passion* (1727).[125] Film theorist Jan-Christopher Horak suggests the Inferno-like flames of the title sequence also allude to "medieval paintings of souls being sucked into hell's fire, as in Hans Memling's triptych *The Last Judgment* (1467), the Limbourg brothers' illustration of Hell (circa 1412), or their illustrations for Duc de Berry's *Book of Hours*."[126] Either way, the abstract luminous colors do not symbolize the uplifting hues of optimism that neon had stood for in this same city only a few decades prior.

From the 1960s through the 1990s, images of neon in Hollywood and American media more broadly served as metonyms for social alienation, desolation, and politically motivated self-interest. Many of these signifiers remain intact today, even as neon is itself increasingly rare.[127] A final example from the single-season television series *Maniac* (2018; directed by Cary Fukunaga) illustrates this point while also providing a different set of neon signifiers apropos of the twenty-first century. In one scene, a cool neon blue is seen against a dark background outside the window of protagonist Owen (played by Jonah Hill). The image is faintly reminiscent of the *Blade Runner* set and, in this way, connotes the film's neonoir setting, even if only by allusion. In some scenes in *Maniac*, the neon sign alternates from the blue neon in the shape of the Oral-B brand logo to an orange-red and yellow neon sign advertising Jolly Ranchers. Gone are the nostalgic associations to the past, as with *Blade Runner*'s stylistic use of advertising signs from defunct companies, the palette's once-optimistic origins, and of course, the names and roles of the persons who diligently worked on the signs and in the studios—then and now—to make this dark side of neon shine. Instead,

we have only neon as product placements, a reflection of a reflection in a 24/7 barrage of products we never knew we needed.[128]

CULTURE FOR RENT

In his 1925 essay, "This Space for Rent," German philosopher Walter Benjamin offers a nuanced take on the powerful neon colors then on debut in Berlin. Like Didion and Wolfe after him, Benjamin reflected on neon imagery as a productive symbol of modern experience: "The most real, mercantile gaze into the heart of things is the advertisement."[129] By reversing the postmodern decree to dismiss mass images as deceptive forms of "false consciousness" (namely, Debord, writing in the spirit of Marx), Benjamin esteems them on their own terms (much like Wolfe, albeit void of the irony). "What, in the end, makes advertisements so superior to criticism?" he asks. It is "not what the moving neon red sign says—but the fiery pool reflecting it in the asphalt."[130] But how could a shadow be "superior" to intellectual critique, let alone the original object?

Throughout his work, Benjamin argued, as Baudrillard, Debord, and Jameson would later do, that moments of self-reflective contemplation, fundamental to modernist literary critique, had been eviscerated (in alignment with postmodernism). Changes in mass culture and media involved a move away from the literary world of books, hermeneutics, and critical distance into a new, faster-paced world of automated images, advertisements, and commodity displays. In the new visual regime, Benjamin suggested, meaning was more readily available in the seemingly "mystical" commodity forms that offered only their own excess and abstractions. Put differently, advertisements had become immune to critique precisely because they carried their reflections outside themselves—in a puddle. At the same time, things have changed since Benjamin wrote this essay. Advertising has become more sophisticated and in many cases self-reflective in precisely the ways hermeneutic critique once was.

. . .

This chapter has charted the material and aesthetic history of neon from its early utopian optimisms to its inner-city abandonments and associations with postwar white flight and Hollywood noir, in tandem with the major socioeconomic downturns in the United States at the time, and in Las Vegas and Times Square in particular. Even though cheaper LEDs and backlit plastic signs have replaced neon, retaining this history

ensures that the link between material color and the historical development and decline of urban space in America remains with us, even if only as an absent signifier and trace.

The following chapter picks up with this still-dark side of Times Square illumination in the 1970s, where the work of American artist Jenny Holzer offers a unique critique of America's popular imaginary by reappropriating the channels of its own light-based communication.

Jenny Holzer's Light Art as Urban Critique

1970–1990

For his men's 2018 spring-summer runway show in Florence, Virgil Abloh wanted "a female voice," one that worked against the "white noise of rhetoric."

THE INFORMATION AGE

As the United States underwent an economic boom and extended season of prosperity in the first few decades of the postwar era, for many this meant an influx of foreign expertise and inflated budgets at think tanks once devoted to wartime development. For others, ensuing advances in postwar electronics and information management systems resulted in the opposite: an incessant deskilling of the labor process and corresponding fears of human obsolescence. Nonengineers and workers without PhDs (the majority of America's labor force) faced job markets with unending displacements, temporary employment, and dwindling union strongholds.[1] In 1973, Daniel Bell defined these collective conditions as the new postindustrial economic model (also known as the post-Fordist model of economic production), in which the management and manufacturing of information took precedence over the production of objects and goods paramount to the former, industrial model.[2]

Fears of machine takeover were exacerbated by geographical fragmentation. As factories relocated outside city centers, they pressured working classes to commute long distances or migrate to them in the suburbs.[3] Moving to the suburbs, as chapter 5 illustrates, was very much rooted in white privilege,[4] and the failure to move often meant being without viable employment or housing and being abandoned in what were rapidly

deteriorating inner-city ghettos. New York City from the late 1960s through the early 1980s provides one of the strongest illustrations of this transformation and, as such, establishes the setting for this chapter's analysis of American artist Jenny Holzer's (b. 1950) Times Square projects in the late 1970s and early 1980s. As noted in the introduction, her work is selected as the sole critical, artistic practice analyzed in the book because of its contextual and thematic relationship to New York City and Times Square, compounded by her pioneering use of electrographic architecture.

After fleshing out the social and political background of the United States in the 1970s, and in New York City in particular, the chapter turns to Holzer's life and work, analyzing how her creative pursuits paved the way for broader practices in public art as political interventions into public space, actively cutting through the "white noise of rhetoric,"[5] as American fashion designer, architect, and entrepreneur Virgil Abloh put it. The chapter then returns to Times Square redevelopment efforts in the 1980s through the 1990s to show how both the Square and Holzer's artwork, several decades after their mainstream appropriation, have been whitewashed of any edgy or unsavory color. In the case of Holzer, this whitewashing has meant the appropriation of her work on the red-carpet, fashion runway, and on T-shirts and mugs, while for Times Square, it has meant the capitulation of any eccentric-colored Other to a never-ending stream of informatic homogeneity.

THE END OF THE POSTWAR BOOM

In addition to factory relocations and postindustrial shifts in the labor market, urban decline in New York City (and elsewhere in the United States) was intensified by a series of global economic issues in the 1960s and early 1970s that officially demarcated the end of the postwar boom. Most significant was the termination of the Bretton Woods system in March 1973 (ending a decline that began in 1971). According to the Bretton Woods agreement (1945), gold was the basis for the US dollar, which a number of developed countries around the world agreed to tie their currency to in order to maintain the stability of their own currency. Central to the Bretton Woods system were globally agreed-upon exchange rates that ensured and controlled fluctuations in the value of the US dollar, and therefore also in the currencies in the countries tied to it. Once these restrictions were lifted in 1973, the gold standard became free-floating or "abstract," marking the advent of what David Harvey refers to as the age of "flexible accumulation," an era when

labor, production, and currency were all subject to flux and vulnerable to rapid change.[6] For Harvey, this single gesture marked a complete dissipation of the most concrete material contingency in the history of twentieth-century economics.

Meanwhile, a seemingly endless chain of dreary events was developing: in October 1973, the Organization of Arab Petroleum Exporting Countries (OAPEC) launched an embargo protesting the United States' ongoing support of Israel during the Yom Kippur War, catalyzing the 1973–74 stock market crash, which dovetailed with real and perceived oil shortages in the United States (and in much of Europe).[7] The United States was for many the most powerful and economically prosperous nation in the world, until a series of public humiliations challenged this hegemony, beginning with the Watergate scandal and the 1974 resignation of President Richard Nixon (1969–1974),[8] followed by the rise of laissez-faire economic policy and neoliberalism in the Margaret Thatcher (1979–90) and Ronald Reagan years (1981–89). When Jimmy Carter took office in 1976, he inherited the fallout, compounded by the endless escalations of the Vietnam War (loosely dated from 1955 to 1975); the tail end of Cold War paranoia; the ongoing militarization of civilian life; the violence of civil rights struggles; explosions and bombings worldwide; the rise of celebrity scandal, drug addiction, and suicide (e.g., the horrors of the Altamont Speedway Festival); widespread environmental disaster; social and political disenfranchisement; wage stagnation; a second oil crisis in 1979;[9] the beginnings of the AIDS epidemic; the near meltdown of the Three Mile Island nuclear power plant; the 1979 Soviet invasion of Afghanistan, which exacerbated the ideological stakes of the Cold War; the commodification of culture in general, also known as "postmodernism," or the third and purest form of capitalism, as Fredric Jameson suggests;[10] and an overall decline in funding for the arts and humanities.

As all of these stresses came crashing down, President Carter bequeathed to America his well-known "Crisis of Confidence" speech, proclaiming "symptoms" of the "crisis of the American spirit" were "all around us."[11] For the first time in the history of the country, the sitting president declared in 1979, "The next 5 years will be worse than the past 5 years."[12] And after that? All Carter could offer was "faith": "We simply must have faith in each other, faith in our ability to govern ourselves, and faith in the future of this Nation. Restoring that faith and that confidence to America is now the most important task we face."[13] The "American right" to be happy and free had been "deferred," but it would return, he submitted, once faith in America was revitalized.

Whose America was Carter alluding to? And whose "right" and which "we"? Such questions could not be more apposite to a legacy of exclusion and privilege, on the cusp of the neoliberal era, which is to say, when even more so-called advantaged persons have lost power and privilege, save for the narrowing "1 percent." David Breslin suggests Carter's grasp at "faith" harkens back to the biblical story of Job, where suffering in the present would, in the end, bring about a righteous reclamation of the kingdom of God (in this case "America"). But such visions are equally delusionary. It is now obvious that the social and economic hardships of the late 1960s and early 1970s only foreshadowed what has become the lasting death of the American dream for the vast majority.

TIMES SQUARE IN THE 1970S

The end of America's monolithic global supremacy was prescient in New York City's Times Square in the 1970s, epitomized by its descent into an unparalleled fiscal nadir. On October 30, 1975, Frank Van Riper's article "Ford to New York: Drop Dead" appeared on the front page of the *New York Daily News*, alongside similar articles from the *New York Post* and *New York Times*, all alluding to President Gerald Ford's (1974–77) refusal to bail out New York City from its devastating state of financial distress and high unemployment rates by denying federal loans and debt reformation.[14] The city was as near to bankruptcy as it has ever come, having sunk to such a state that even basic civil services like garbage removal and street cleaning were severely limited. Crime, political scandal, drug addiction, homelessness, and white flight were all on the rise.[15]

Located at the center of the city, Times Square was saturated with massage parlors, adult bookshops, peep show arcades, grindhouses, brothels, and porn theaters[16] and had become a national symbol of the era's deteriorations. The grand movie palaces of the 1930s were "demolished or converted to grind house cinemas showing kung-fu, exploitation, and pornographic films," Zach Melzer writes, while "dance halls were converted to strip clubs."[17] The squalid culture of the Square (and much of the metropolis surrounding it) is depicted in gritty films like John Schlesinger's *Midnight Cowboy* (1969), characterizing the city as a "squalid subculture of sex-for-hire"[18] and Martin Scorsese's *Taxi Driver* (1976), in which ex-marine and Vietnam vet Travis Bickle (Robert De Niro) works day and night as a taxi driver on the seedy streets of 1970s Manhattan.

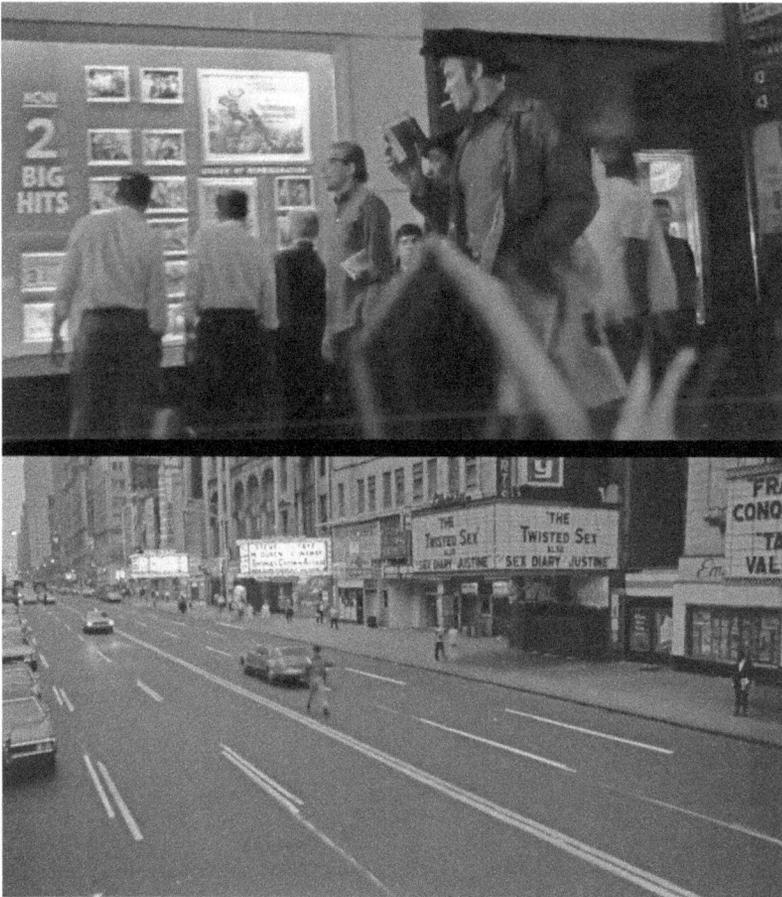

FIGURE 6.1. Two stills from *Midnight Cowboy* (1969), directed by John Schlesinger. Actor Jon Voight walks down the street and sidewalk surrounded by a landscape of commercial sex and pornography.

Laurence Senelick suggests the "rapid sleazification" of Times Square dates back to the 1919 Volstead Act and alcohol prohibition, when posh rooftop gardens and fashionable drinking holes (chapter 3) diminished due to a lack of business and were replaced by nonalcoholic cabarets with illegitimate after-hours entertainment favored by managers eager to bring the sleaze on stage in order to raise admission fees. By the 1960s, the Square had become an open market for sex and drugs which, not surprisingly, attracted the mob. By 1968, the mob had secured a monopoly over the rapid successes of the porn and drug industries there and, working in tandem with corrupt members of the Development Council, secured sky-high

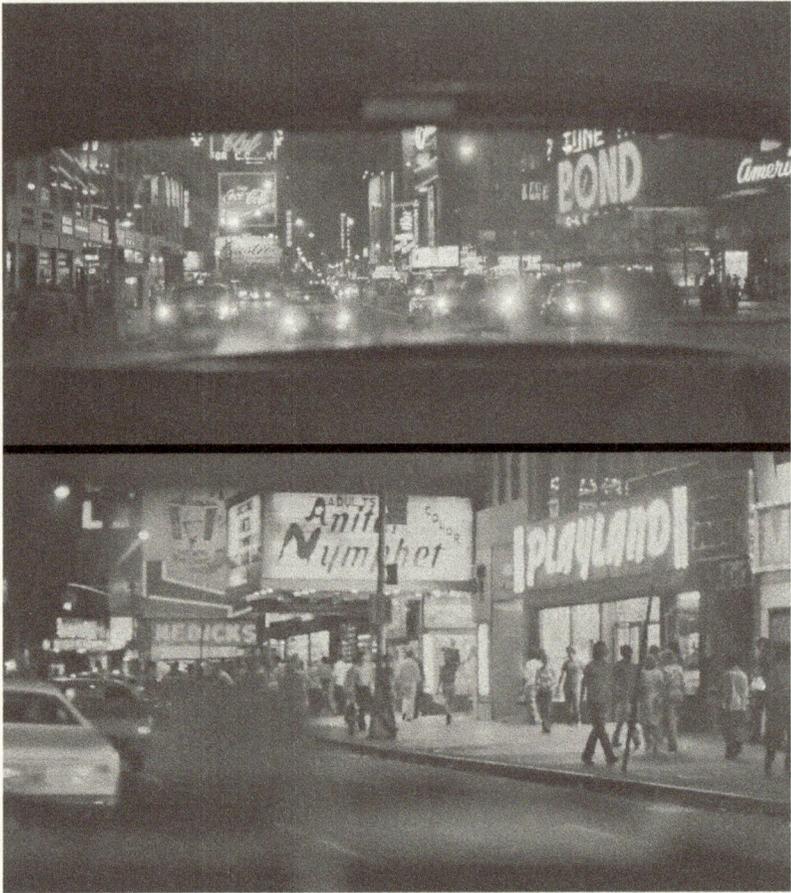

FIGURE 6.2. Two stills from *Taxi Driver* (1976), directed by Martin Scorsese. Ex-marine and Vietnam vet Travis Bickle (Robert De Niro) works day and night as a taxi driver in 1970s Manhattan, witnessing drugs, prostitution, and the "animals" that "come out at night."

leases and expensive advertising spaces.[19] An arrest could easily be bought off, especially if the organization charged with the offense was backed by the mob in the first place.[20] Many police were in on the deal, and those who were not faced scrutiny for not going along with the majority.[21] It is perhaps less shocking to learn that politicians were bankrolling illegal prostitution rings, crime, and corrupt lending practices than it is to discover that, yet again, fraudulent agreements between the criminal underground and some of the city's most powerful elite were the driving force behind keeping the area in its sad and unprotected state for several decades.

The peep shows grew increasingly explicit. In the early 1970s, a typical live peep show in the Square was conducted behind glass barriers, but by 1978, "the glass partitions were removed" so a customer could "touch, feel, [and] taste the far-from-obscure object of his desire"[22] and the women performing the shows were left to negotiate boundaries and prices for themselves.[23] The era of the "window free peep show" was short-lived, however, ending on January 20, 1980 when, for so-called legal reasons, managers deemed they were not securing enough profit from the performers who were likely engaging in prostitution to yield additional revenue for themselves.[24]

The height of sleaze in the Square marked a new chapter in its history, the beginning of a new subculture of sorts, rooted in the embrace of previously marginalized social types (perverts, homosexuals, fetishists, etc.), otherwise excluded from the mainstream, now given quasi-acceptance and a public meeting place. Some scholars refer to this era as the "golden years" of exploitation cinema in the Square. In his book *Times Square Red, Times Square Blue* (1999), Samuel R. Delany, for instance, celebrates this period in the Square as opening an emancipatory space for gay, queer, and otherwise taboo social, racial, and sexual relations.[25] Zach Melzer adds to this notion, describing how the Square managed to generate its own kind of sex tourism by attracting people from around the country who felt safe in the area or simply wanted to witness the "supposed smut and vulgarity firsthand."[26] What was once an "Arcadian playground for all white New Yorkers"[27] was now its inverse.

Second-wave feminists added to the mix, arriving in the Square to ardently oppose the pornography, aggressive sexual solicitations, and objectification of women's bodies. Senelick recounts the fascinating tale of Elisabeth B,[28] a German woman around twenty years of age who, while pursuing a degree in sociology in 1982, began to participate in the Times Square sex industry as a performer in one of the "no contact" peep shows.[29] By using a hidden camera in her cubicle, she photographed her customers masturbating, reporting their "absolute mediocrity."[30] The vast majority of them were "white and white-collar," thirty to forty years old, arriving during their lunch hours or after work with "briefcases, shined shoes, and the *New York Times* under their arms."[31] On occasion she would encounter a grandfather type or a "youngster in jeans," but "no blacks, [just] a great many exceedingly polite Asians." Elisabeth B was also frequently asked to assume the position of a gynecological exam. She suggests this seemingly odd but popular request

made perfect sense in a puritanical society that shuns natural drives for "public nudity, topless sunbathing, and compulsory sex education."[32]

While much has been written on "the female voice" and agency in sex work, it is also important to note, as Elisabeth B did, the total and pervasive need for masculine control during these encounters. Pleasure was hoarded by the client, a dynamic that is still a de facto part of prostitution exchanges (even in so-called domination work, where, at the end of the day, the client still calls the shots), and profits still run up the ladder from worker to employer.[33] The voices of the first wave of organized feminism (also referred to as second-wave feminism)[34] set the stage for Holzer's work and the ways it, too, confronted this now-invisible power elite, using their own channels of communication to do so.

RISD DOESN'T WANT JENNY HOLZER

While enrolled in the Rhode Island School of Design's (RISD) MFA program in painting in the late 1970s, American artist Jenny Holzer had "an unstated agreement" with the institution whereby, if she agreed to "stay away" from the school, it would "still let me graduate."[35] In a 2001 interview with Joan Simon, Holzer expanded: "I was in trouble with the RISD painting faculty. One of my videos was about alcoholism, which was in my family, and in the faculty. Someone asked me, 'You would expose your alcoholic aunt?'[36] Another painting professor on the faculty said to her, 'You would do anything. That is what is wrong with the twentieth century.' I considered suicide."[37]

A half-century later, the tables have turned. Art schools and a cultural landscape of self-help now depend on personal narratives of trauma and addiction. What was it about Holzer's invocation of alcoholism that elicited such condemnation?

Even as a young student, Holzer brazenly positioned contentious social and political issues at the heart of her work. The seeds were sewn in the above-noted RISD project, where, by holding a mirror up to the unconscious homogeneity of academic modernism and demanding its accountability, she made her viewers uncomfortable to the point of attack. This same boldness persisted in her later—now internationally renowned—urban light art.

Since the 1980s, two general approaches to Holzer's work have been in circulation: one focused on the word and linguistic communication, and the other focused on visual context and its role in site-specific spaces, including a contextualization in the United States and New York

City in the 1970s. Building on both, I argue in the following four sections that Holzer's work, alongside that of other artists of her generation, paved the way from modern to postmodern urban aesthetics in the last quarter of the twentieth century, foreshadowing a nascent aesthetic of urban critique in the twenty-first-century city.

JENNY HOLZER

Jenny Holzer was born in Gallipolis, Ohio, in 1950 to Richard and Virginia Holzer. Her father and maternal grandfather were Ford dealers;[38] her paternal grandfather was a doctor and her paternal grandmother was a nurse, who together founded the hospital Holzer was born in.[39] Retaining the family's joint interests in sales and health, as a young adult Holzer visited the Metropolitan Museum of Art in New York "for an hour" and encountered a Rembrandt behind a rope. More than the image itself, she recollects the $1 million price tag displayed beside it, resembling the way her "father used to . . . sell Fords."[40]

In 1968, Holzer applied for and received early enrollment in the liberal arts program at Duke University in North Carolina.[41] Soon after she commenced her studies there, she "became dissatisfied with the program"[42] and transferred to the University of Chicago in 1970, where she took painting, printmaking, and other art courses. But after only one year she left there too, completing her undergraduate degree at Ohio University in 1972 and, two years later, attending summer school at RISD, where she began graduate courses in painting in 1975.

One year after commencing studies at RISD, the above-noted critiques ensued. The "very conservative"[43] painting department consisted only of "apple and orange and nude painting,"[44] Holzer explains, and was eager to reject anything "non-conventional,"[45] which included politics and hybrid genres. For Holzer, this narrow-minded atmosphere catalyzed her decision to seek an alternative, which she found in New York City in 1976.

THE ISP AND THE *TRUISMS*

Just before her final year of study at RISD, Holzer was awarded a position in the Whitney Museum of Art's prestigious Independent Study Program (ISP), which she participated in from 1976 to 1977. The state of art and theory in New York City circa 1976 was significantly more progressive than at RISD. The ISP in particular had a transformative

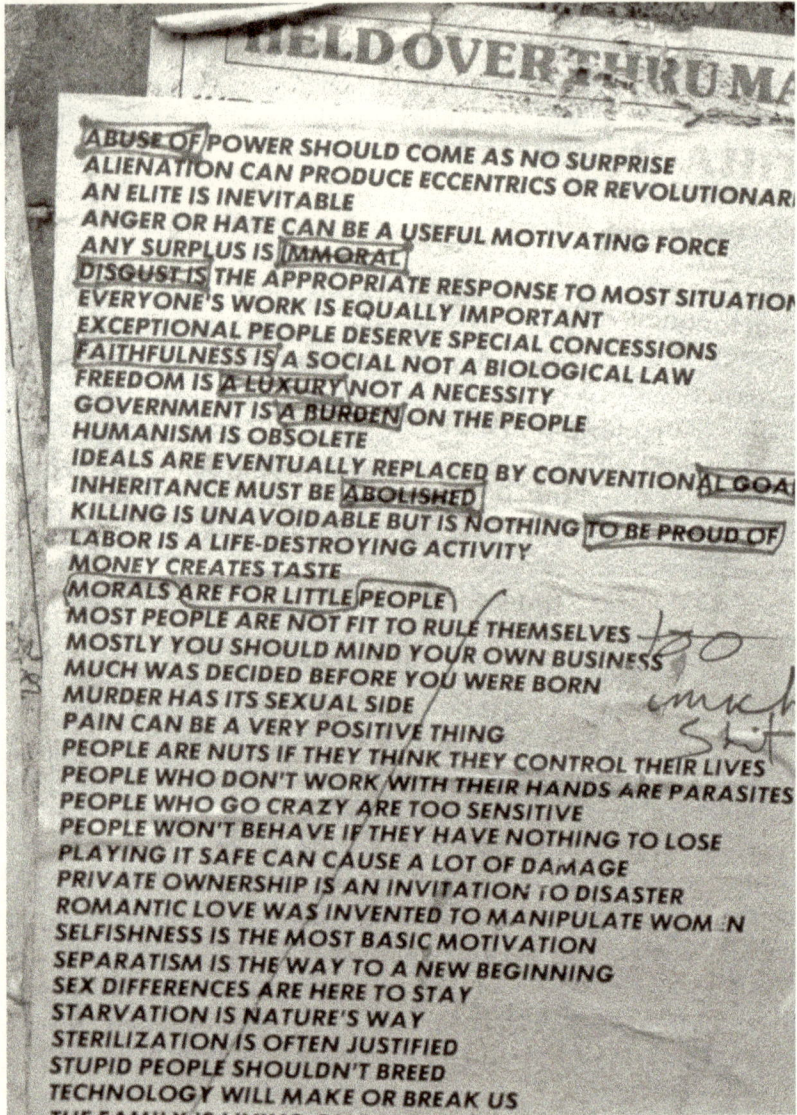

ABUSE OF POWER SHOULD COME AS NO SURPRISE
ALIENATION CAN PRODUCE ECCENTRICS OR REVOLUTIONAR[
AN ELITE IS INEVITABLE
ANGER OR HATE CAN BE A USEFUL MOTIVATING FORCE
ANY SURPLUS IS IMMORAL
DISGUST IS THE APPROPRIATE RESPONSE TO MOST SITUATION[
EVERYONE'S WORK IS EQUALLY IMPORTANT
EXCEPTIONAL PEOPLE DESERVE SPECIAL CONCESSIONS
FAITHFULNESS IS A SOCIAL NOT A BIOLOGICAL LAW
FREEDOM IS A LUXURY NOT A NECESSITY
GOVERNMENT IS A BURDEN ON THE PEOPLE
HUMANISM IS OBSOLETE
IDEALS ARE EVENTUALLY REPLACED BY CONVENTIONAL GOA[
INHERITANCE MUST BE ABOLISHED
KILLING IS UNAVOIDABLE BUT IS NOTHING TO BE PROUD OF
LABOR IS A LIFE-DESTROYING ACTIVITY
MONEY CREATES TASTE
MORALS ARE FOR LITTLE PEOPLE
MOST PEOPLE ARE NOT FIT TO RULE THEMSELVES
MOSTLY YOU SHOULD MIND YOUR OWN BUSINESS
MUCH WAS DECIDED BEFORE YOU WERE BORN
MURDER HAS ITS SEXUAL SIDE
PAIN CAN BE A VERY POSITIVE THING
PEOPLE ARE NUTS IF THEY THINK THEY CONTROL THEIR LIVES
PEOPLE WHO DON'T WORK WITH THEIR HANDS ARE PARASITES
PEOPLE WHO GO CRAZY ARE TOO SENSITIVE
PEOPLE WON'T BEHAVE IF THEY HAVE NOTHING TO LOSE
PLAYING IT SAFE CAN CAUSE A LOT OF DAMAGE
PRIVATE OWNERSHIP IS AN INVITATION TO DISASTER
ROMANTIC LOVE WAS INVENTED TO MANIPULATE WOM[]N
SELFISHNESS IS THE MOST BASIC MOTIVATION
SEPARATISM IS THE WAY TO A NEW BEGINNING
SEX DIFFERENCES ARE HERE TO STAY
STARVATION IS NATURE'S WAY
STERILIZATION IS OFTEN JUSTIFIED
STUPID PEOPLE SHOULDN'T BREED
TECHNOLOGY WILL MAKE OR BREAK US

FIGURE 6.3. Jenny Holzer, *Truisms*, 1978. Holzer's first installation of the *Truisms* took place on the streets of downtown Manhattan. Image courtesy of Jenny Holzer / Artists Rights Society (ARS), New York.

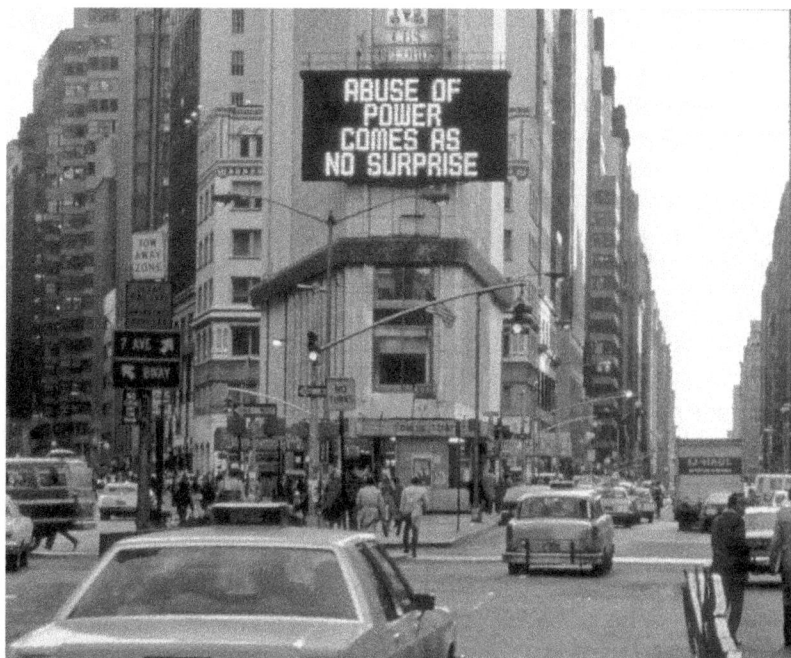

FIGURE 6.4. Jenny Holzer, *Truisms*, 1982. The second installation of the *Truisms* occurred on the Spectacolor board at One Times Square, as a part of the *Messages to the Public* series, organized by Public Art Fund. The image speaks on multiple levels to the abuse of power in the city and the corrupt sex and drug industry in the Square, in conjunction with broader socioeconomic decline. Image courtesy of Jenny Holzer / Artists Rights Society (ARS), New York.

effect on Holzer's work, validating her practice to date and pushing her further by exposing her to radical readings from the likes of Mao Zedong, Vladimir Lenin, Emma Goldman, Adolf Hitler, Leon Trotsky, Gilles Deleuze, and Claude Levi-Strauss, and to weekly guest speakers like Vito Acconci and Dan Graham. It was also while she was in residence at the ISP that one of Holzer's most infamous works took form.

As Holzer absorbed the dense roster of materials at the ISP, she began to reformulate the elaborate theories into terse statements accessible to wider audiences (in order, as she later put it, to make "the big issues in culture intelligible as public art"[46]). The *Truisms* was the result, a series of "manufactured one-liners" engineered to "resemble clichés or common 'wisdom' and assembled in typeset alphabetical lists on posters."[47] Examples include:

A lot of professionals are crackpots

Abuse of power comes as no surprise

Bad intentions can yield good results

Categorizing fear is calming

Holzer refers to the *Truisms* as "mock clichés,"[48] which she alphabetized, printed on 8.5-by-10 pieces of paper, and wheat-pasted to the walls of buildings and construction scaffolding in the Lower East Side, SoHo, and parts of Tribeca in 1978.

The *Truisms'* simple, direct tone and snappy brevity was complemented by a clear and uncluttered visual presentation. Written in all-caps Government Style typeface, developed by the War Department in the 1930s and still used by the Veterans' Administration on headstones and markers, the sans-serif font conveys a direct and authorial tone.[49] The text appeared on a plain background, centered in the middle of the page to draw direct attention to it and nowhere else. Together, content and form emulated the voice of authority, yet also somehow seemed askew, speaking with an alternative voice of contemplation. As Holzer puts it, the aim of the *Truisms* (and later the *Inflammatory Essays*) was to "evoke the persuasive and not the didactic power of language,"[50] that is, to simulate *the way* in which advertising and politics draw from the ancient art of sophistry, drawing a listener-viewer into its public space by discursively manipulating facts and truths but, in Holzer's work at least, stopping short of prescribing any single one as objective or immutable.

Louis Althusser's notion of interpellation is useful for analyzing the *Truisms* as it captures how Holzer's linguistic operations foreshadow broader systems of (nonvisual and algorithmic) power and control in large-scale, commercial spectacle. In his 1970 "Ideology and Ideological State Apparatuses," Althusser argued that certain uses of language effectively inculcate or "interpellate" a subject into a dominant ideology.[51] Interpellation takes place in the "most commonplace every day" occurrences, such as a police officer hailing a subject by saying, "'Hey, you there!'"[52] In religion, interpellation works by way of the invisible voice of God: "God addresses himself to you through my voice."[53] The unseen, unknown, yet omniscient and omnipresent voice of God "calls" on presumably "free" subjects to either "obey or disobey the call."[54] Put differently, by answering "the call," one retroactively avows the abstract entity—"the voice of God"—as omniscient and omnipresent.

Ideology operates by disguising the terms of exchange to appear as the reverse, as if one *chose* to stop or respond to the call of God or to

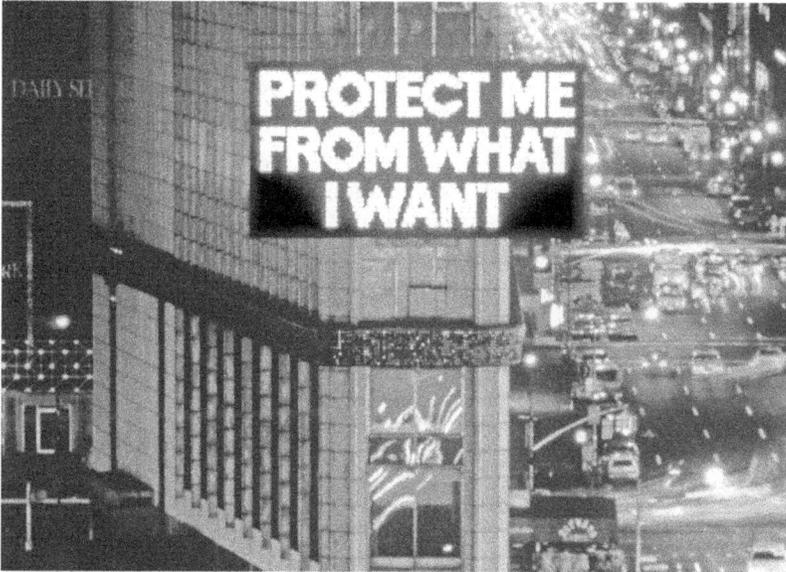

FIGURE 6.5. Jenny Holzer, *Survival* (1983–1985). This excerpt from Holzer's *Survival* series is featured here on the Jumbotron in Times Square circa 1985. The image simultaneously alludes to a legacy of patriarchal possession and "protection" of women, the Square's dangerous and scandalous sex industry, and the rise of sexually transmitted diseases in the city. Image courtesy of Jenny Holzer / Art Resource New York (ARS). Photograph by John Marchael.

the law. In Holzer's work, we find a similar set of rhetorical devices at work. For example, "Raise boys and girls the same way," "Abuse of power comes as no surprise," and "Fathers often use too much force" (all from the *Truisms*) are statements that structurally emulate the way interpellation filters ideology through language, albeit without de facto reproducing ideology but rather as a critical mimesis of the structure itself, speaking from a subaltern position. In so doing, the otherwise invisible link connecting power to its mode of address is rendered visible. The resultant conceptual disorientation (a lack of clear or effective interpellation) is what allows her work to open a new space of political unrest, to "cut through the white noise of rhetoric," even if only by prompting a question: Should boys and girls be raised the same way, or are they intrinsically different? Should *all* power be neutralized, or is there a form that is fair and just?

After the *Truisms*, Holzer created several aphorism-based works, including the above-noted *Inflammatory Essays* (1979–82), an

installation of nine color-coded texts consisting of equally terse, alpha-betized statements, later published in manuscripts entitled *the black book* (1979), *Living* (1980–82), *Survival* (1983–85), *Under a Rock* (1986), *Laments* (1987–89), and *Mother and Child* (1990). In these projects, she continued to use tight wording, clear language, and a simple layout and design, even as her communication platform evolved through time, from paper printouts to Times Square's LED Spectacolor board and Italian runways. By the end of the 1980s, Holzer had achieved international notoriety as a cutting-edge media artist who, in 1989, was given a solo exhibition at New York's Guggenheim Museum and, in 1990, submitted her winning contribution as the first female artist to represent the United States at the Venice Biennale.

HOLZER AND THE CITY

Holzer's relationship to New York City began with a community of artists she lived and worked with in the Lower East Side in the late 1970s. When she first moved to the city in 1976, she worked as a typesetter and lived in a loft on Eldridge Street, upstairs from experimental writer Kathy Acker.[55] She quickly became a part of the now-well-documented downtown arts scene, joining up with Collaborative Projects (Colab), a group of fifty "indigent maverick artists"[56] who organized a number of artist-run exhibitions in nonofficial art spaces.[57] In 1980, Colab, in collaboration with Bronx-based Fashion Moda, held its best-known event, the "Times Square Show," at an abandoned massage parlor at 41st Street and Seventh Avenue, declared by the *Village Voice* as "the first radical art show of the 1980s."[58] For the event, the collective chose a salon-style format and deliberately "overstuffed and engorged" the space with works from artists and nonartists alike.[59] Instead of spending money on rentals, real estate, and other administrative costs, Colab generated funding—in a truly radical fashion—that went directly to the artists.

Holzer next joined forces with Group Material (GM), a similar downtown artist-run collective that also opposed the commercial and minimalist setup of most galleries and museums. GM also disliked the term "alternative space." As they put it, "It was clear to us that most prominent alternative spaces are, in appearance, policy and social function, the children of the dominant commercial galleries in New York." As result, GM (and Holzer) turned away from both so-called alternative spaces and the gallery system to consider the city itself as the most fruitful platform for their work.

Holzer was already drawing inspiration from the city for her work. The tone and presentation of the *Truisms* pulled from and gave back to the streets of Manhattan,[60] while inspiration for the *Inflammatory Essays* (1979) came from Times Square, from a man who "went around plastering Times Square with posters that warned other men to stay away from the area, warning them that they would get leprosy and tuberculosis if they crossed [the] imaginary circle ... he'd ... put around it"[61] (an invisible coat of sanitizing whitewash already too colorful to assume any real power). Holzer's engagements with GM reaffirmed her insights about the city as an aesthetic medium and encouraged her to push them further. From them, she learned about the legitimacy of placing her "[art]work in front of the general public"[62] as long as she thought "hard about what subject matter would be appropriate"[63] there and took responsibility for her words and actions.

After Colab and GM, Holzer got involved with The Offices of Fend, Fitzgibbon, Holzer, Nadin, Prince, and Winters, which had an "office" at 305 Broadway in downtown Manhattan.[64] The Offices, like Colab and GM, were concerned with unorthodox modes of creating and exhibiting art. They held lengthy meetings with lawyers and investors and engaged in public media events, in effect, miming professionalism through a critical mirror that allowed them to highlight what they deemed to be the absurdities of postindustrial office culture. Their business cards read: "Practical esthetic services adaptable to client situation."[65] The Offices spoke to the new culture of "immaterial labor" and information management that privileged services over object-based commodities.[66]

These collective interests fostered Holzer's aesthetic, including her nuanced use of language to invoke its persuasive, *not* didactic power; her invocation of the language of authority and advertising under the guise of critique; and most important, her political engagements with public space.[67] New York's city streets appeared to be the ideal canvases for these endeavors: compared to the gallery and museum system, it seemed void of exclusionary white walls dictating what kind of (safe, sanitized, watered-down) colors could enter and under which conditions.

MESSAGES TO THE PUBLIC

Conversations for the redevelopment and gentrification of Midtown Manhattan had been under way since 1962, when the Broadway

Association (BA)—which elected Douglas Leigh (chapter 4) as its president in November 1962[68]—was planning a restoration of 42nd Street between Seventh and Eighth Avenues.[69] Redevelopment plans came to a halt in 1973–74 when New York City underwent its most dramatic financial crisis to date. As noted, businesses tanked, white flight escalated, and the area found itself with a surplus of retail and office space.[70] Some advertising continued in the area, but nowhere near the level or the popular demand as the spectaculars of previous decades.

A number of city factions joined together to seek a solution, all claiming the common goal to "develop" the area while, behind the scenes, each entity retained vested interests in what successful redevelopment should look like. In 1976 the Broadway Association joined forces with the 42nd Street Development Corporation (DC) and the Office of Midtown Enforcement (OME), both formed in the same year with the aim of raising private equity to fund the area's redevelopment into a viable zone for "good commercial uses."[71] In cahoots with politicians and policymakers, the BA, DC, and OME introduced new zoning laws and began cracking down on violations of health department ordinances with heavy fines. Massage parlors, pinball arcades, topless bars, and peep shows were banned, and a police station was placed in the center of the Square, in the location of a former peep show.[72]

After many American advertisers deserted the Square, a number of Japanese companies stepped in to advertise on its large-scale screens.[73] When the head of Minolta's US subsidiary, Sam Kusumoto, arrived in the Square in 1969, he remarked that it had "gone dark,"[74] but the Japanese, like the Yale architects who visited Las Vegas one year prior (chapter 5), admired the deterioration and half-lit neon for its patina, considering it "an important vernacular art form"[75] still full of glamour and prestige.[76] A number of Japanese companies thus agreed to finance the Square, in hopes that it would promote their products to American consumers.[77] The foreign investments were greatly needed and made it possible for the large screens to remain active during difficult times. Moreover, the Japanese enthusiasm for neon lights was transported back to Asia, where the technology developed further in Hong Kong, Singapore, and, most notoriously, in Tokyo's Ginza district.[78]

Another result of foreign fiscal support was the infamous Spectacolor screen board erected in Times Square in 1976. This large-scale, computer-generated message board was set on a nonstop electronic schedule that ran 24 hours a day, seven days a week. Positioned on the north facade of 1475 Broadway, on the site of the twenty-five-story, 363-foot-

high skyscraper built by Cyrus L. W. Eidlitz in 1904 for the relocation of the *New York Times* (though the paper had moved to 229 West 43rd Street by 1913), the board faced crowds moving northbound on Seventh Avenue and Broadway while remaining visually accessible to crosstown traffic on 42nd Street. Already by the early 1980s, a few large-scale computerized, electronic screens began to appear with the capacity to display preprogrammed moving images and text, marking the cusp of mass changes in large-scale electric signs and imagery.[79]

Circa 1976, the 800-square-foot Spectacolor board was the most prominent screen in the Square, "defining the standards of high quality electronic signage" for the times.[80] It necessitated more than 92 miles of wiring to connect a computer on the fourth floor of the building to the back of the Spectacolor board.[81] Its interface consisted of 8,942 red, green, blue, and white programmable bulbs. By combining bulbs in coordinated patterns, the display could exhibit up to twenty-four colors at a time at a rate of eight frames per second.[82] The board worked on a binary programming system, so each bulb could be turned either on or off but could not be dimmed to create color variations or color mixing.[83] As a result, the most effective use of its "extremely low resolution," 2,048 pixels, was to display images or text with simple, bold lines.[84]

To usher people toward visual spectacles in public space (versus the inside of an X-rated movie house), the Spectacolor developers agreed with the city in 1982 to include artist-created projects in support of its revitalization efforts. Prior to this agreement, all of the content on the board was either news updates or paid advertisements.[85] Between January 1982 and August 1990, New York City's nonprofit Public Art Fund (PAF), with support from the National Endowment for the Arts' Inter-Arts Program,[86] was apportioned 25 percent of the Spectacolor screen time for public service announcements. Over the nine years that the *Messages to the Public* program ran, the PAF commissioned seventy-eight artists to create visual and text-based works for the light board.[87]

Messages to the Public was the brainchild of Rebecca Robertson, former president of the 42nd Street Development Project (1994–97), in conjunction with artist Jane Dickson, then a computer programmer for Spectacolor Inc. and an active member of the exhibitions committee at the Public Art Fund and Colab. On one hand, the goal of the project was to create a public platform for artists who were already members of Colab. On the other hand, it was designed to fulfill a facet of the city's broader plan to reshape the culture of Times Square by actively dissuading sex trafficking and other illicit activities and attracting (the right

kind of) tourists by bringing the (right kind of) "color back into the Square."[88] The unspecified nature of this "color" was precisely the point. The only color that counted for the Development Council was safe and sanitized color, whitewashed in advance by committees and planning boards.[89]

Working in accordance with these technical limitations, the selected *Messages to the Public* artists worked with Spectacolor programmers to create work that would look good, despite the display's technological limitations. Collaborations were laborious and could take several weeks from conception to completion. Each of their 30-second "messages" could be either 4 by 8 feet or 5 by 10 feet, correlating with the board's dimensions.[90] Once the artist drafted a storyboard of images they wished to project, they would work with a computer programmer who created the final text or image animations.[91] After the initial designs were in place, the images would be subject to coloration or effects-based manipulation, or both, albeit in a restricted capacity (e.g., they could choose from just four different typefaces). Each 30-second spot was then aired fifty times a day between 8 a.m. and 11 p.m.,[92] as "filler material, sandwiched between standard commercial advertising spots."[93]

Holzer's simple style and clear use of language was perfectly suited for the board. Not surprisingly, she was selected as the first artist to participate in the series. Her 1982 contribution involved a selection from *Truisms*, including the following aphorisms:

"Men don't protect you anymore"

"A man can't know what it's like to be a mother"

"Romantic love was invented to manipulate women"

"Mothers shouldn't make too many sacrifices"

"Your oldest fears are the worst ones"

"Raise boys and girls the same way"

"You are so complex you don't always respond to danger"

"What urge will save us now that sex won't"

"Abuse of power comes as no surprise"[94]

In the context of the Square, the statements took on new meanings. Some statements directly addressed the neighborhood's calamitous sex industry and its problematic gender politics, while others appeared to speak in support of it, and others still, to the rise of neoliberal markets in the Reagan-Thatcher era. All readings were valid, in part due to

Holzer's nuanced linguistic techniques and brazen resistance to assuming any singular, objective voice of power or authority.

Messages to the Public was also Holzer's first opportunity to use large-format electronic sign systems. The new platform marked a shift in her professional trajectory. "The L.E.D. signboard," Holzer explains, is the "medium par excellence of contemporary information society."[95] Its main attribute is the capacity to program messages and store them in the computer's memory, an important supplement to print-based writing that, for her, opened up the image to alternatives in the mutability and impermanence of text in time and space.[96] Second, the large-scale electronic screen was an established channel for mass communication and the (singular, official, monolithic) system of power connected to it. Speaking through this "medium of authority," Holzer explains in 1986, infused her "messages" with a greater power and effectivity, letting them appear to "come from on high" while being heard from the side and below.[97]

No longer working with or on the septic colors of the yet-to-be-gentrified Manhattan streets, Holzer now spoke through the official channels of mass communication. Did access to this new mass medium mean her messages also attained the same weight and authority? Did it mean that her DIY voice suddenly lost its "authentic" political edge? These questions are crucial, especially given the way her work has since been appropriated on social media, fashion runways, and the red carpet, from musician Lorde donning excerpts of Holzer's *Inflammatory Essays* on the back of her red Valentino dress at the 2018 Grammy's, to Virgil Abloh's 2017 solicitation of Holzer's work on war and immigration for his men's 2018 spring–summer Off White runway show at the Pitti Palace in Florence.[98]

In short, there is a tendency to pluck her words from their original context and import them into an alternate one, often beyond her making. In some cases they retain *a* political layer—as, for example, Lorde's allusion to the then-active #MeToo movement[99] and Abloh's allusions to the international refugee crisis[100]—but these connections are far from the direct and multitiered questioning of the original instantiations and sites for her work. Put differently, a mere reference to "politics" is not synonymous with a work's capacity to do political work. Rather, it simply extracts a signified value from a prior context and retroactively attaches it (as an abstract signifier) onto what is (likely) already a dead object or "safe" space of consumption (perhaps the best example of this phenomenon is the appropriation of Barbara Kruger's bold red and white feminist aesthetic in the Supreme logo, a so-called streetwear

label with international blue-chip investors). Once the context of one's words change (i.e., platform, history, culture, and politics) beyond one's doing or control, an audience is by default severed from the original questions and climate that drove the work, seeing instead only the surface or immediate topic it might pertain to. Such is the fate of creative innovation in commodity capitalism.

Before moving to the chapter's conclusion, I consider two final pieces from Holzer's work that illustrate this, both of which move south of Times Square to Chelsea and, for one last time, to Las Vegas.

LAMENTS

From the mid-1980s onward, Holzer created a number of memorial sites integrating electronic screens, one of which was *Laments*, realized at the first exhibition for the Dia Art Foundation in Chelsea.[101] The project dealt with the then-dire AIDS epidemic.

Between 1987 and 1989, AIDS was having its most dismal effects in the country. The number of officially reported cases in the United States reached 32,000, in part as a result of the federal government's failure to address, let alone support, those suffering from the epidemic.[102] The uncertainty and newness of the illness at the time incited mass fear and avoidance (President Reagan avoided the word *AIDS* for six years, between 1981 and 1987), and, "given the prolong[ed] incubation period of the virus," Breslin notes, it was often the case that, once positively diagnosed, one lived with a looming death sentence.[103]

ACT UP (AIDS Coalition to Unleash Power) was founded in May 1987, just two months after the anti-HIV antiviral drug Zidovudine (AZT) was approved by the US Food and Drug Administration.[104] In New York City, Chelsea sat at the center of the epidemic and a functional extension of the gay and lesbian neighborhoods whose residents were moving northward from the West Village to afford cheaper housing.[105] While Holzer's *Laments* was created for an indoor gallery, it nonetheless served as a template for the much-needed public mourning in the neighborhood by speaking to local issues of death and loss and the lack of public recognition thereof.[106]

Laments included thirteen stone sarcophagi of various sizes, each one carved out of green or red marble, onyx, and black granite, with corresponding computer-animated LED panels (the same kind used on the New York Stock Exchange light board and for the ticker at One Times Square). Each platform was programmed or engraved with the

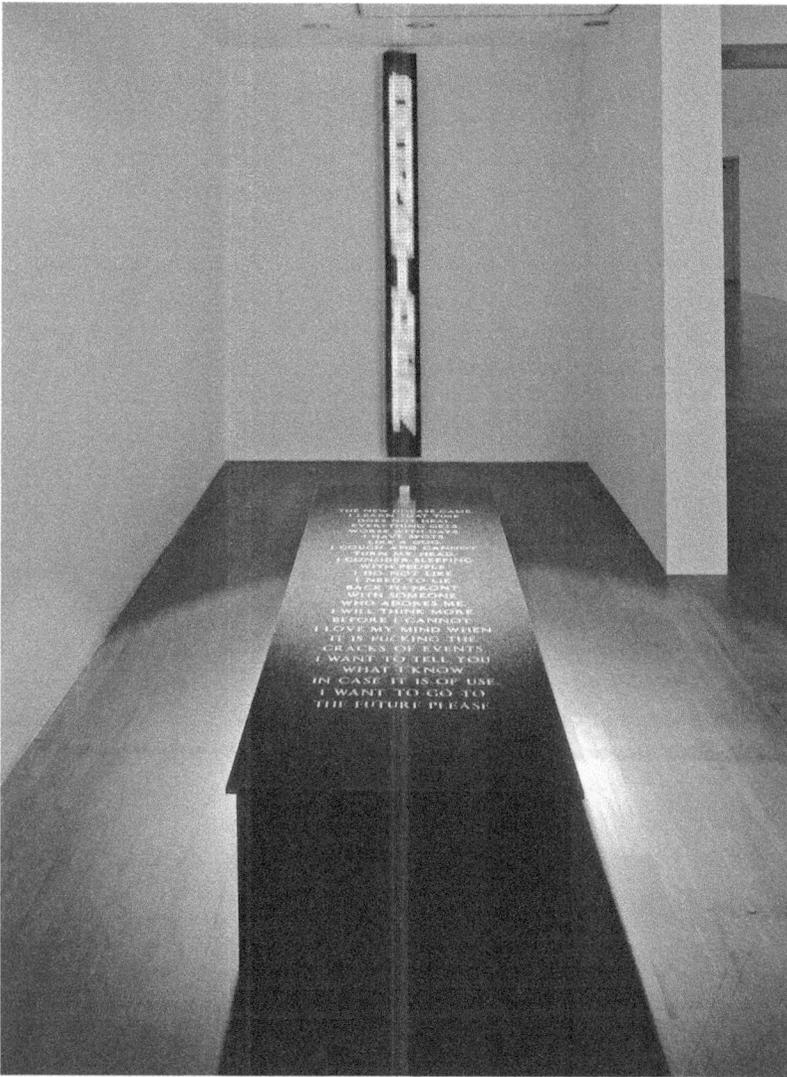

FIGURE 6.6. "The new disease came . . . ," in Jenny Holzer, *Laments*, 1989. Nubian black granite sarcophagus and electronic sign with red and green diodes. Installation: Contemporary Art Center, Mito, Japan, 1994. Photo by Shigeo Anzai. The original installation took place at the Dia Chelsea. © 2022 Jenny Holzer, member Artists Rights Society (ARS), New York, and Art Resource.

same text, addressing themes of death, violence, and disease from thirteen diverse subject positions.[107] Both platforms also conveyed messages of death that could hardly be considered clean or sanitized for prêt-à-porter consumption. Rather, each platform's colors, messages, and media together conveyed an incommensurable ecosystem of political abandonment and heartfelt compassion; a state of mourning suspended between life and death.[108] In short, *Laments* did not offer a quiet or polite mourning space but instead an upset one, chock-full of aggressive colors void of resolution. Holzer's use of vibrant, flashing colored lights—as with her Times Square work—functioned here to offset the tone and tenor of conventional graveyard ceremonies by bringing unrestrained color into the sanitized spaces of the white cube and the popular political imaginary.

Holzer used a similar strategy in *Benches* (1986–90), the AIDS Memorial NYC (2016), and related public mourning pieces, all with terse and direct text inconspicuously engraved in the stone or granite, calling public values and memorialization practices into question. Together, this body of work evidences how public mourning can "tarry with grief" by remaining exposed to its untenability, as Judith Butler suggested just after the September 11 attacks on the World Trade Center.[109] Instead of striving for retaliation or rhetorical resolution through fixed monuments and quiet ceremonies, the works suggest a need to understand dislocations of "first-world privilege" as part of an ongoing and collective wound that we must accept global responsibility for.[110] How can we see past the so-called grandeur of loud and bright spectacle or monuments in order to identify the collective value of coming together?

BACK IN VEGAS

One last example before turning to my concluding thoughts is Holzer's 1986 screen-based public installation in Las Vegas. Commissioned by the Nevada Institute of Contemporary Art in Las Vegas, Holzer was authorized to install LED signs and excerpts from the *Truisms* in a number of sites in and around the city, including the Fashion Show Mall, the University of Nevada's sports center, the large-scale electric signboard located outside Caesars Palace (featuring the *Truism* "Protect me from what I want"), and the baggage carousel at McCarran International Airport (featuring "Money Creates Taste").[111]

While neither the Times Square board nor the Las Vegas venues were the original locations of the *Truisms*, they both presented occasions and

FIGURE 6.7. Jenny Holzer, selection from *Truisms*, 1986. Installation: baggage carousel, McCarran International Airport, Las Vegas. Image courtesy of the Nevada Institute of Contemporary Art, University of Nevada. Image courtesy of Jenny Holzer / Artists Rights Society (ARS), New York.

contexts selected and adapted by Holzer for their very specific ties to local religion, commercial advertising, and consumer culture. For example, "Money Creates Taste," installed on the LED screen above one of the baggage carousels at McCarran International, speaks in the above-noted pseudo-official voice of authority, normatively found in such public spaces as airports, but turns the *content* of such messages inside out, reanimating the space with a questioning consciousness. Circa 1984, the airport audience likely comprised privileged middle- and upper-middle-class Americans traveling to Las Vegas for entertainment and fun, already indoctrinated into an American ethos of individualism and fulfillment through the accumulation of material riches. That "money creates taste" is both obvious and suspect.

. . .

Unlike the advertising signs analyzed in the previous pages of this book, Holzer's work offers a refreshing critical alternative insofar as it speaks with and through an array of voices, equally true and untrue simultaneously, collapsing the possibility of a singular, invisible (masculine) voice

that speaks from nowhere and no place but nonetheless establishes taste (and value) "for everyone."[112] By emptying the possibility of any singular and immutably "true" position of authority, Holzer introduces a fundamental rupture in *all* speaking voices. Yes, monolithic authority is undermined, but so is *any* capacity to speak and claim a position or value *over* another. By always already starting from a position of fragmentation and the impossibility of singularity or subjective transcendence to a universal state of omniscient objectivity, her work undermines the presumed cohesiveness of *the* invisible voice of "authority," as such, speaking instead as a series of voices that are marked by particularity and flux. "Yes," Holzer says, "it's a woman's voice" that speaks in her work, which is also to say always already Othered, colored, and from a "heterogeneous," groundless division that is a priori split from *the* "masculine, classical will to unify and . . . drive out difference."[113] The book's conclusion does not offer analogous creative projects from the twenty-first century, so it is here, I submit, that creative practitioners may return for ideas and inspiration to fuel future critical engagements with the electrographic city.

TIMES SQUARE REDEVELOPMENT

Extreme light . . . by overcoming the organs of sight, obliterates all objects, so as in its effect exactly to resemble darkness.

—Edmund Burke, 1757

Redevelopment proposals to "clean up" the Square and the city beyond it had been streaming into City Hall for several years, through several mayoral administrations, from the tail end of Robert Wagner's tenure (1954–65), through John Lindsey's (1966–73), Abraham Beame's (1974–77), Ed Koch's (1978–89), David Dinkins (1990–93), and Rudy Giuliani's (1994–2001). As early as 1955, the exterior of the Times Tower was demolished in anticipation of redevelopment efforts, but no such projects were realized, and the stone cut from the exterior of the building ended up "unceremoniously dumped in a New Jersey landfill."[114]

Serious efforts began to materialize only in the early 1980s.[115] The advent of LED, back-lit plastic, and related cheap and mass-produced illuminated signs and screens (like the Spectacolor board) helped, ushering spectacle and the people following it into the new, hygienic space of the public square. In 1977, there were ninety-six sex-related businesses in Times Square, but by 1987, they had dwindled to thirty-five.[116] There was also a natural decline in X-rated movie houses and peep shows with the development of color television in the mid-1960s, followed by the

introduction of the VCR and home video industry in the 1980s, which drew larger numbers to viewing pornography at home and renting videotapes from neighborhood stores.[117]

Author Jerome Charyn suggests that Douglas Leigh's 1976 illumination of the Empire State Building was pivotal to the city's redevelopment efforts. "No one had ever thought of theatrical gel for the sides of the building until Douglas Leigh," Charyn writes. "His engineers removed the old fluorescent lamps and replaced them with metal halides housed in Lexan sheets (the strongest possible plastic)."[118] The effect was lighting four times as bright as before, with no leak in electrical power. In essence, a pure, clean whiteness in cool, commercially viable color—a template for the polychromatic yet homogenous fairground of computerized screen colors that would come to characterize late-twentieth-century Midtown Manhattan.

In 1980, city, state, and private developers launched the "City and 42nd Street" project[119] in conjunction with the City Planning Commission and the Office of Midtown Planning to rebuild preexisting theaters and related sites. Because the project was estimated to cost $600 million, most of which would be financed through private development (namely the Ford Foundation),[120] it incited mounting controversies. To secure funding, the city would need to exert authority over land acquisitions and allocate urban renewal status to devalued properties in the area to allow for their condemnation.[121] In exchange, private developers would be guaranteed tax abatements and the transfer of the old theaters' air rights (vertical development rights).[122] Then mayor Ed Koch promptly shot down the proposal, calling it "Disneyland at 42nd St,"[123] rejecting it on grounds of its theme park style, "lack of competitive bidding[,] and likely destruction of the Times Tower."[124]

In the fall of 1980, Koch returned to the table with a regeneration project of his own, the infamous and soon to be even more controversial "42nd Street Development Project" (DP).[125] Koch's project also sought to "clean up" 42nd Street and it's "sordid spillover into Times Square,"[126] but now, big business and four mammoth office towers sat at the center of the plan. The towers would "offer construction opportunities"[127] to developers, and it would "cost [the city] nothing."[128] By trading more tax abatements, zoning exceptions, and extra rentable floors on the development properties, he swore to lure in big business and bring the city and Square out of its fiscal crisis.[129]

Koch worked closely with the New York State Urban Development Corporation, which had prior experience with large renewal projects

and, unlike the City, had the power to condemn privately owned land and reassemble it as eminent domain without having to go through the city's local reviews.[130] The DP passed its first set of redevelopment guidelines in 1981 and again in 1982, delineating the maximum height permitted for walls, the amount of space it needed to be set back from the street in order to reduce a skyscrapers' bulk and let in light, and the kind of lighting and reflexive materials permitted on electric signs in the Square.[131] The guidelines were prepared by planner-architect firm Cooper Eckstut Associates, which had worked on the master plan for Battery Park City; in both cases, the firm emphasized a traditional look and atmosphere, as well as (ostensibly) integrated space for visual spectacle and densely moving crowds.

The four "drab modernist skyscrapers"[132] at the heart of the DP were first presented to the public in 1983 by architects Philip Johnson (1906–2005) and John Burgee (1933–), with prospective development sponsored by Park Tower Realty and the Prudential Insurance Company of America.[133] Johnson and Burgee proposed four large red-granite towers and a merchandise mart, each one positioned at a corner of the Square.[134] Not only did their program ignore the prescribed guidelines for glass and metal, which would reflect light and allow for city vistas, but also all of the neoclassical detailing they were required to include were placed in unusual locations not visible from the street level. The plan also ignored zoning delineations for building setbacks and the implementation of large-scale signs, and the astoundingly tall height of the four bulky towers—at 29, 37, 49, and 56 stories—was "unthinkably large" for the 1960s and previously unknown to that part of the city (at the time, the tallest skyscrapers were located downtown).[135] Finally, there was the fact that the four towers would inevitably dwarf nearby theaters and related neighborhood venues, now prized as icons in the city's historical culture. In short, the so-called cleanup plan "for the public" was a sham for the accumulation of private profit, corralled through public office. That is, business as usual.

Even though the 42nd Street Development Project was never realized, its sheer pomp generated waves of controversy and real estate prices in Midtown Manhattan skyrocketed.[136] What was once "the worst section" of the Square, on 42nd Street between Seventh and Eighth Avenues,[137] now became some of the most expensive real estate in the city. The Chandler Building, for instance, a skyscraper built in 1914 at 209–213 West 42nd Street, was purchased in January 1980 for $1.3 million and resold in 1984 for $14.75 million. The price and

number of spectacular signage also ballooned. Circa 1983, there were some twenty-four spectacular signs in the Square, but by 1995, there were around sixty, with annual rental fees ranging from $180,000 to $1.2 million, beyond what many independent businesses could afford.[138] The city's recovery from financial despair had clearly commenced, but not without damage to those (Others) who normally get damaged in such gentrification processes.

Oppositional voices were first heard from the Municipal Art Society (MAS), which had led and supported redevelopment efforts in the past (and the banning of advertising entirely, as noted in chapter 3), but by 1984 had changed its tune. It now acknowledged the new zoning laws were "a threat to Times Square's look, atmosphere, and traditional businesses"[139] and thus joined forces with the Landmarks Preservation Commission (founded in 1831), charged with administering the Landmarks Preservation Law throughout the city, in attempting to grant landmark status to forty-four historic theaters in the area, all in danger of being demolished.[140] A local chapter of the American Institute of Architects,[141] along with local residents and businesses spoke out against impending gentrification, claiming "class bias and discrimination in favor of business interests."[142] Tama Starr (daughter of Jacob Starr, introduced in chapter 3) recalls one especially salient protest during the height of the opposition to Johnson and Burgee's high-rise redevelopment proposal. At a designated time in the evening, all the major signs were shut down in the Square, all within a few minutes of one another, except for one sign on the Tower (slotted for demolition) that read "Help Keep the Bright Lights in Times Square."[143] The demonstration lasted half an hour, after which all lights and signs were turned back on. Two days later, after hearing testimonies from architects, academics, and organizational leaders,[144] the city introduced new legislation endorsing large-scale illuminated signage on new developments between 43rd and 50th Streets, facing Broadway or Seventh Avenue.[145]

Additional voices of opposition were heard from feminists who, on one hand, spoke out against the selling of sex and objectification of women's bodies in many of the sex shops in the Square, seen by many as a polymorphous drug den, and, on the other hand, were proponents of sexual freedom who defended the sex shops' right to remain in the Square and joined the MAS in opposing the big business redevelopment. In October 1985, the Office of Midtown Enforcement "launched a major drive to eliminate juvenile prostitution from Times Square entirely,"[146] while Trudee Able-Peterson's "Street Work Project" aimed

to find underage prostitutes in the Square and provide them with alternative options.[147] Neither group saw eye to eye with the redevelopment plans, however, even though they all ostensibly supported some sort of transformation in the area.

As previously mentioned, a key revision of the 1982 zoning decree, introduced in 1986, required all new buildings in the Times Square District (running from 43rd to 50th Street between Seventh Avenue and Broadway) to carry animated electric signs with a designated size and brightness value. Additional requirements specified each sign's ratio, placement, and sizing and mandated that every business maintain "lively ground-floor uses on the street"[148] and a certain amount of space on the storefront for the signs.[149] A later amendment indicated a certain quantity of square footage must also be used for new buildings with entertainment-related activities.[150] The Board of Estimate approved and ratified these zoning changes in February 1987.

Meanwhile, the "bulldozer revolution" was under way. By 1989, One Times Square, once the Square's visual and cultural center, had been demolished into a piece of "junk architecture."[151] A number of the iconic hotels and one- and two-story turn-of-the-century entertainment venues in the Square were also destroyed, one after another, even though no official redevelopment plan had been agreed on.[152] The defeated 42nd Street Development Project was forced to seek out private equity to set up an interim plan to bring provisional white light to the now-even-darker condemned district between Seventh and Eighth Avenues. It renegotiated deals with Times Square Center Associates, which agreed to temporarily support retail and entertainment in the area and postpone construction in order to receive fiscal returns and more "extended tax breaks."[153] By 1992, the owners of One Times Square filed for bankruptcy.[154]

DISNEYFICATION

That popular architectural styles were moving away from glass-box modernism, as seen in the Johnson and Burgee program, was a happy coincidence for Times Square preservationists.[155] City planners were showing a greater appreciation for vernacular architecture, commercial decor, and prosaic forms of city life scorned by modernists. They turned to the work of urban theorist Jane Jacobs (chapter 3) and architects like Robert Venturi, Denise Scott Brown, Steven Izenour (chapter 5), and Rem Koolhaas to preserve the integrity and visual character of Times

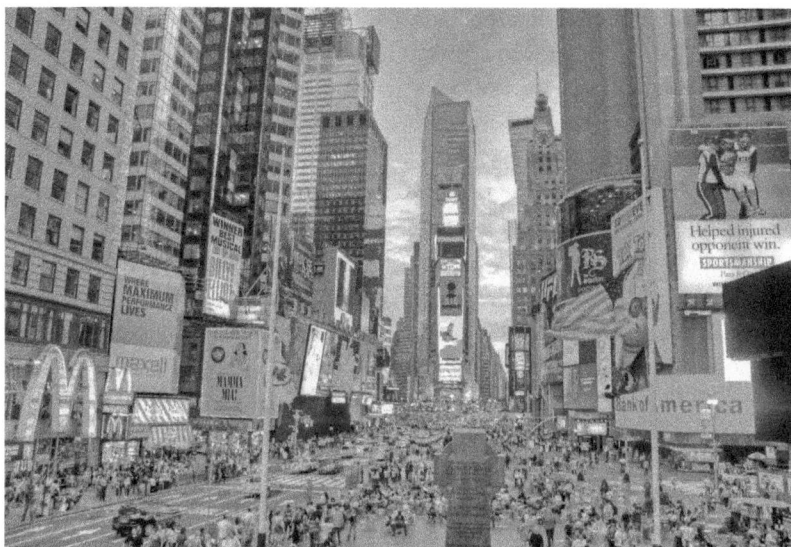

FIGURE 6.8. Times Square facing south. By 2009, redevelopment efforts returned supreme spectacles to the Square. Photograph by Terabass, September 13, 2009. CC BY-SA 3.0.

Square.[156] Neighborhood advocates appreciated this and the related concessions they now received in new redevelopment plans, especially those regarding the restoration of the Square's old movie theaters.

In particular, the new redevelopment plan, entitled "42nd Street Now!" (aka the Disneyfication of Time Square) was presented to the public in 1993, in uncanny anticipation of Mayor Rudolph Giuliani's tenure (1994–2001), which would see the plan to fruition. When the Walt Disney Company arrived in Times Square in 1993, it took on the task of renovating the New Amsterdam Theater (formerly the Ziegfeld Follies home) on the west side of Seventh Avenue at 42nd Street, following the lead of the 42nd Street Development Corporation, which, in 1992, signed a ninety-nine-year lease with the city and New York State to assume responsibility and oversight for the Liberty, Victory, Selwyn, Apollo, Lyric, and Empire theaters. From the start, Disney demanded all remaining pornography businesses on 42nd Street be immediately condemned and closed.[157] They also insisted AMC Entertainment and Madame Tussaud join forces with them in the Square, which they did, in 1995.[158] The mega–corporate triumvirate inspired other entertainment and commercial companies to follow suit, setting up a domino

effect that finally knocked the Square into its current state as an international tourist and entertainment capital.[159]

When Giuliani came into the mayor's office on January 1, 1994, he made it clear he supported and endorsed Disney's plans. The Disneyfication of the region would ensure "a bright, clean, lively district," he declared, "where families feel safe."[160] But Giuliani went above and beyond what Disney asked, setting out to make the Square the brightest and whitest yet, which is also to say the most financially lucrative. He negotiated new, strict regulations for "adult-use" establishments, "prohibiting them within 500 feet of a house of worship, a school, a residential zone, or another adult-use establishment."[161] Much of Giuliani's whitewashing was further accomplished through "81-732: Special Times Square Signage Requirements," obliging developers to create public signage at least as large and as bright as any of the previously existing signage in the Square. According to policy 81-732, new signs must be located on the "ground floor establishment" of each zoned lot, expanding the "full length of the [zoning lot] frontage or the first 100 feet from Seventh Avenue or Broadway," and be illuminated at 1.5 LUTS[162] for a minimum of 25 percent of the sign, with the remainder falling at a minimum of 0.2 LUTS of incident illumination.[163]

Policy 81-732 also specified that the sign must be turned on *all* the time, generating intense 24/7 illumination or, rather, an effervescent coat of brightness that guaranteed the obliteration of any remaining street "color" threatening cleanup efforts.[164] That the policy required nonstop, physiologically intense illumination speaks to yet another use of white light to monitor behavior in space, an extension of both the ancient night watch (chapter 2) and the lessons learned from the White City (chapter 3) whereby the effective control of bodies in space is packaged to the American public as desirable entertainment, while the real work of indoctrination into a global space of psychological individuation and possession goes unchecked.

By 1995, new office buildings sitting kitty-corner from the Times Tower, along with electronic signs sponsored by NASDAQ, Coca-Cola, and Sony, recharged the neighborhood with a corporate energy and ethos, in many ways resembling the Square's posh commercial neighborhood a century prior, albeit pandering to global markets and international audiences.[165] In 1997, the Empire Theatre (completed in 1893), at 1430 Broadway between 40th and 41st Streets, built a five-story entertainment complex, including a twenty-five-screen cineplex, while Lehman Brothers sold the Times Tower to Jamestown LP for $117 million,

turning an $89.5 million profit in two years.[166] The billboards on the Tower alone generated a net revenue of $7 million a year, yielding a 300 percent profit. Money-making Manhattan once again sat supreme.[167]

By September 1997, Giuliani proudly declared that "over 80 percent of the adult establishments in the Times Square area have closed."[168] Less than twelve years later, in 2009, then mayor of the city of New York Michael Bloomberg (January 1, 2002–December 31, 2013) was arranging lawn chairs and lunch tables on Broadway between 42nd and 47th Streets in an effort to slow down foot and vehicular traffic to prevent tourist injuries through the Midtown crossing.[169] By this time, as I discuss in the book's conclusion, a new generation of electrographic architecture had outpaced those from the past. Characteristic of this new breed were LED, HDTV, Plasma, and liquid-crystal displays, all with a homogenizing flatness that bid adieu not only to the voluminous "hot" qualities of gas, hand-bent neon, and features of other early signage (consider, for example, some of Leigh's signs that, even though they did not use cutting-edge technology, evinced unique craftsmanship and presence) but also the individual creatives who innovated with them. The new age of computerized chips, microcontrollers, and semiconductor diodes meant generic "content" could be programmed from afar, from another city, or possibly another country, and then transmitted on screen in the same way it could be transmitted on several hundred other screens exactly like it around the country and world. The increasingly sensational yet completely homogenous and mass-produced spectacles of corporate information marked a new era in the Square and many other urban centers around the world, guaranteed by law to produce a nonstop hypnotic stream of electrographic imagery in quick, cheap, whitewashed color.

. . .

Using the history of late-twentieth-century Times Square, this chapter has illustrated how American artist Jenny Holzer's work from the late 1970s and early 1980s emerged during a time of social and economic crisis in the city and, as it did, spoke directly to and from them. Unlike the previous chapters, which focus on relatively permanent and non-critical electrographic architecture, this chapter concentrated on ephemeral work habitually classified under the heading of *installation art* or *public multimedia work* (including the work of Shimon Attie, Krzysztof Wodiczko, Pipilotti Rist, Jeremy Couillard, David Hockney, Zina Saro-Wiwa, and the many other artists who have participated in Times

Square's Midnight Moment over the years).[170] Doing so allowed me to analyze creative and critical work that emerged in lockstep with the inversely proportionate, rapidly changing culture of the Square itself, now reproduced in many metropolises around the world. The book's conclusion considers Times Square's next and most recent progression in whitewashed corporate spectacle by way of artificial intelligence.

Chromophobia in the Smart City

1992–2022

The concepts of "environment" and "ambiance" have
undoubtedly become fashionable only since we have come to
live in less proximity to other human beings . . . and more
under the silent gaze of deceptive and obedient objects which
continuously repeat the same discourse . . . of our absence
from one another.

—Jean Baudrillard, 1970

Electrographic Architecture has illustrated how something as seemingly
innocuous as a lightbulb or a steaming coffee cup is always a question
of power and privilege. Born from the joint contexts of capitalism and
chromophobia, all of the works discussed in these pages operate as
technologies of illumination, striving to amass new color and ground
under unchecked terrain. The book's focus on the ideological and imag-
inary musings of American whiteness also offered a sustained attempt
to allegorize whiteness in America's polychromatic, electrographic sur-
round and the way it operates in less obvious, nonvisible ways.

In the new millennium, we face a new world order of smart algo-
rithms and network exchanges where no single country or identity rules
the roost. All colors (including white) seem suspect, even as visual spec-
tacles remain prevalent, channeled through smart data and algorithms
that align themselves with increasingly obfuscated notions of power
and control. Today it is artificial intelligence (AI) that orders the world
into a series of ranked cultures, populations, and data sets by subscrib-
ing to and perpetuating mythologies of a totalizing and universal intel-
ligence.[1] Like whiteness in the twentieth century, informatic-era white-
ness and AI dominate today insofar as both determine what (or who)

counts as legitimate and valuable, and who or what is a dangerous, foreign threat. Both AI and whiteness also depend on constantly shifting boundaries, strategically deployed as advantages in shapeshifting cultural edifices to suit their respective needs—which may, in the end, be one and the same.

This concluding chapter considers artificial intelligence and its new uses in large-scale public spectacle in Times Square in the early twenty-first century. I reflect on this new genre of informatic visual encoding to question how it might also engender a fresh paradigm of informatic whiteness rooted in fantastically elastic models of abstract data amassed as a precarious form of New Age cultural intelligence. Before jumping to the algorithm, however, I briefly highlight key issues from the previous chapters to act as a series of counterpoints for understanding the uniqueness of algorithmically encoded spectacle in the smart city.

CHROMOPHOBIA

It is no secret that architects disdain color. Progenitor of the International Style Le Corbusier confirmed as much in 1923 when he wrote, "Colour is suited to simple races, peasants and savages."[2] "Let's have done with it," he continued in 1925; "it is time to crusade for white-wash and Diogenes."[3] As chapter 1 shows, Le Corbusier was not alone. The annals of architecture are chock-full of like-minded connoisseurs with grand visions, crippled by a fear and distrust color of any kind. Nor is Western architecture's long history of chromophobia unique, as the preceding pages illustrate in respect to media, public art, advertising, neon, and cinema. Color in the West has always been a threat to structure and form, subject to a militant system of exclusion that treats it as some indeterminate "foreign body . . . usually the feminine, the oriental, the primitive, the infantile, the vulgar, the queer or the pathological."[4] By default, Western chromophobia births an ethos of white-washed fear intent on maintaining delusions of universality and sanitized objectivity while scapegoating colored Others for the world's problems. Both whiteness and Western chromophobia, as we have seen, also hide in plain sight, safeguarded from the visual field until a misstep, at which point whiteness becomes so intoxicated with itself, it cannot resist claiming the sacrosanctity of its own spectacle.

As noted in chapter 3, in May 1893, the White City opened as the centerpiece of the World's Columbian Exposition in Chicago, drawing in over 10 percent of the US population.[5] Its chief architect and planner,

Daniel Burnham, oversaw production of the City's flat, white, neoclassical arches and canals filled with sixty imported gondolas from Italy, lit by 200,000 incandescent bulbs. The City's allusions to Greco-Roman antiquity invoked the aspirational nature of both classical idealism and America's nascent white imaginary that would, over the course of the twentieth century, inform the nation's cities and citizens as "superior" in multiple respects.

But whiteness in the White City, like whiteness elsewhere, was not limited to visible surfaces. Consider its inaccurate allusions to Greco-Roman antiquity. It is by now common knowledge that polychromatic profusions of paint, jewels, and colored lights decorated the art and architecture of classical antiquity, even as this information was suppressed for ages due to vested interests in upholding the sanctity of classical European "taste" as pristinely white and morally righteous. Placing color(ed) Others under historical erasure is, as we have now seen several times over, the most cliché form of whitewash. Insofar as any person or thing challenges whiteness's invisible axioms of truth and normalcy, it poses a threat that must be sanitized or expunged, or both. This is the real matter of whiteness—not its color but its insipid capacity to eviscerate all that diverges from it. Le Corbusier's call for compulsory whiteness; the white walls of the White City; the white light of the Great White Way; and the progeny of architectural whiteness that have followed in their wake were all easy targets. The real challenge, as I insist from chapter 4 onward, has been to unearth how America's white imaginary confers through the brazen colors of modern capital.

WHITE SPACE

During the long eighteenth century of the European Enlightenment (roughly 1685–1815), fresh coats of whitewash defined new ways of organizing visual space according to the logic of a grid. By equating the logos of the (white, male) eye and mind to truth, knowledge, and the "right" to judge, Cartesian space embedded itself in the worldview of Western modernity. Media, neoclassical architecture, and imaging technologies followed suit. From painting to photography and cinema, the spatial order of whiteness fixed time and objects in space through each new representational platform now comprising the so-called history of technology. For instance (and as noted in chapter 3), the entirety of the White City was structured *for* easy photographing (visitors were encouraged to "snap pictures without thinking too deeply about frame and

composition"[6]), catalyzing notions of the American city as a series of clean, white surfaces for individual, visual consumption,[7] which is to say, possession and control.

Over a century later, pure white spaces and surfaces are a rarity in the American city, reserved for small areas neatly cordoned off from cultural life for the purposes of government. Nonetheless, as chapters 4 through 6 illustrate, whiteness continues to thrive in the less obvious, polychromatic spaces of commercialized urban spectacle in Las Vegas, Times Square, and beyond. In this conclusion, I turn to philosophical notions of spectacle as they were constructed in the last century, followed by a consideration of twenty-first-century spectacle as it intersects with AI and public space, highlighting how the now-AI-infused electrographic architecture in Times Square (and by extension beyond) intensifies these same tried and true regimes of whiteness, no longer by flashing lights or white paint alone but now through interactive advertising and algorithmically "correct" branding campaigns.

ALL THAT GLITTERS

Following orthodox Marxist tendencies, French intellectual Guy Debord argued in the 1950s that the mechanically reproduced image (a photograph or film, for instance) was a form of false consciousness, a fantasy generated by a culture machine encouraging its inhabitants to escape the material conditions of reality. The spectacle's annihilation of historical and material knowledge, Debord argued, was replaced by an incessant stream of simulations: representations, images, and displays exhibiting a perpetual present without finitude.[8] Structuring experience through a perpetual present is of course key to the successful marketing of commodities in consumer culture. Whether a shiny new facade or a pack of bubblegum or cigarettes on display, the surface *must* obfuscate past ills in order to compel current desires to assume its possession for a perceived-to-be-more-rewarding future.

Debord's work derives from a host of related critiques of life in the modern city that emerged in tandem with the rise of Edison's white light empire, the Great White Way, the White City, and Las Vegas and Times Square spectaculars. Most of these accounts surfaced first in Europe, just prior to the formation of America's White Ways, when fin-de-siècle Europe saw radical changes in modern life, from the advent of photography and cinema to automobiles, railroads, and electric lighting in public and private space. As modernity remade the world as an endless series of

spectacular surface re-presentations, European intellectuals challenged its seductive surface-shine. German theorist Siegfried Kracauer proposed that modern life had become a "mass ornament" in which individuals in the city functioned like the architecture and objects around them, comprising a "theoretical totality of surface level expressions,"[9] while Martin Heidegger contended in 1938 that the world itself had become an ontological picture of itself.[10] Walter Benjamin argued that the new media of cinema and photography functioned as perceptual training grounds for a new generation of factory workers, and Lewis Mumford, Charles Baudelaire, Edgar Allan Poe, Sigmund Freud, Georg Simmel, and later in America, Miriam Hansen, Anne Friedberg, Jonathan Crary, and Tom Gunning all followed suit, identifying the ways in which modernity corresponded with sweeping changes in the human sensorium and the experience of life itself.[11] As more and more people packed themselves into the modern metropolis and stunning external stimuli and mechanized vehicles increased their speed and pace, people lost touch with their empathetic and emotional sides, Simmel argued in 1903, and hence, a new "metropolitan type" emerged, mirroring the cold logic of calculation that ran the money economy.[12] It is not by accident that such axioms of calculated reason match those of white possession that, together, form the core tenets of artificial intelligence, the newest new media to shape the American imaginary.

ARTIFICIAL "INTELLIGENCE"

The term *artificial intelligence* was coined by American mathematician John McCarthy at a 1956 meeting of all-male attendees at Dartmouth College during a time when the Pentagon's dedication to postwar computer intelligence was a top priority in order to maintain US global supremacy. So long as AI research and development agendas molded themselves to the military framework of enemy detection (image and satellite analysis), speech recognition for "surveillance and voice-controlled air craft," and robotics for autonomous weaponry, the Pentagon shoveled millions of unrestricted funding its way.[13] The million-dollar drip began with the Eisenhower administration. Funds were sent to exclusive labs like the Stanford Research Institute (SRI) and MIT's Artificial Intelligence Lab, which in the 1970s, received more than 70 percent of the Pentagon's AI budget.[14]

The 1980s saw the height of the Cold War and Ronald Reagan's Strategic Defensive Initiative as yet another justification for bloating AI budgets

under the guise of national security.[15] By the 1990s, around the same time that computers introduced 3D modeling environments, AI faded from academic fashions, until its resurgence in the 2010s as a global phenomenon newly equipped with a hip rhetoric of social awareness. In the twenty-first century, phenomena like big data and smart algorithms promise support for cultural projects ranging from fashion to labor, education, and human rights organizations. Rebranding AI in the service of social and political issues helped, as it continues to, detract attention from recently past attacks on AI surveillance in Silicon Valley. In the wake of Edward Snowden's leaks, Yarden Katz observes, AI-reliant companies faced mass criticism for their neoliberal world governance strategies, executed through the deployment of centralized data collection to spy on citizens.[16] As one coat of whitewash was stripped from AI's history, another, so-called socially conscious one was ready and waiting.[17]

AI SPECTACLE

The first generation of so-called socially attuned smart-tech, spectacle-based advertising in Times Square began in the early 2000s, serving American society by way of cellphones, flavors of candy, and Coke. "Hershey's World" (Clear Channel Spectacolor, 2002), located at Broadway and 48th Street at the base of the Crowne Plaza Hotel, launched this genre with an interactive screen display encouraging customers to have a "family-friendly" personal message displayed on the giant LED strip for 15 minutes, at $4.95 a pop.[18]

In 2014, Google leased Clear Channel's billboard at 1535 Broadway for its Android campaign "Be together. Not the same,"[19] during which time a participant could "Androidify" themselves by walking up an elevated platform to play one of four motion-sensing games as their personalized avatar appeared on the big screen. The results of each play—personal data pertaining to race, gender, and so forth and content "freely" offered over by consumer-citizens—were then used as advertisements in a series of animated shorts depicting Androidified New Yorkers as they went about their day. The phrase "Be together. Not the same" appeared in bold letters, illustrating the campaign's perfectly parsed distribution of colored bodies in an algorithmic representation of the city's ethnic rainbow.

In 2015, Coca-Cola's #WhatsInAName launched a three-week "smart" campaign on the Clear Channel screen at 1552 Broadway. Consumers were encouraged to Tweet their first name with #CokeMyName to see a "fun fact" about their name broadcast on Clear

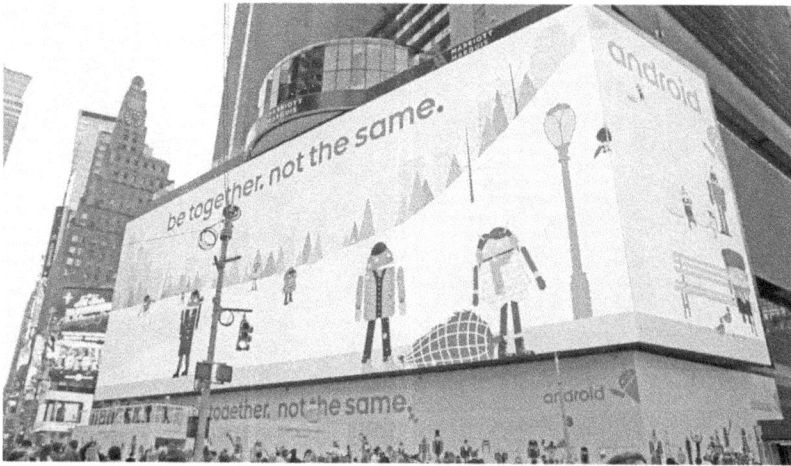

FIGURE 7.1. Google/Clear Channel's Android, 2014. Google leased Clear Channel's billboard at 1535 Broadway for its Android campaign "Be together. Not the Same." The campaign shows a perfect (algorithmically) diverse array of "Androidified" New Yorkers.

FIGURE 7.2. Coca-Cola's #WhatsInAName Campaign (2015, Clear Channel Outdoor/ Posterscope/Google). Here, "Andrea" appears to have tweeted her name with #CokeMyName in order to see a fun fact about herself displayed on the big screen for 15 seconds.

FIGURE 7.3. Still from "M&M's Caramel Taste Test." In 2017, M&M's launched its caramel flavor. For the event, the company transformed billboards in Times Square into augmented reality "ARcade" game sequences for participant-customers.

Channel's digital screen for 15 seconds,[20] after which a photo was taken of the name, Tweeted back to the consumer, and entered into the "Share a Coke" API, where it was matched with 160,000 other names sent to Clear Channel's server, along with other data crowdsourced from Google.[21] Lastly, the launch of M&M's Caramel candy in 2017 transformed billboards in the Square into augmented reality "ARcade" games in which participants could download the free "Blippar" app and scan featured billboards to unlock the games on their smartphones.[22]

But alas, all these "fun" candy colors and diverse bodies could not matter less to the algorithm. The real stakes of AI, as with whiteness, is the *what* and the *who* lost during algorithmic capture. That is, the actually diversity of the city space and the really nuanced bodies and colors excluded from participation in the smart city (which is to say, the white city): those who chose not (or were excluded from choosing) to have their private lives and bodies classified, tracked, and displayed through mass media.

CONTROL ARCHITECTURE

Technologies of surveillance, like whiteness and whitewashed architecture, are always already color-coded. Which bodies feel "safe" in sanitized environments of control, and which bodies do not? To allow one's

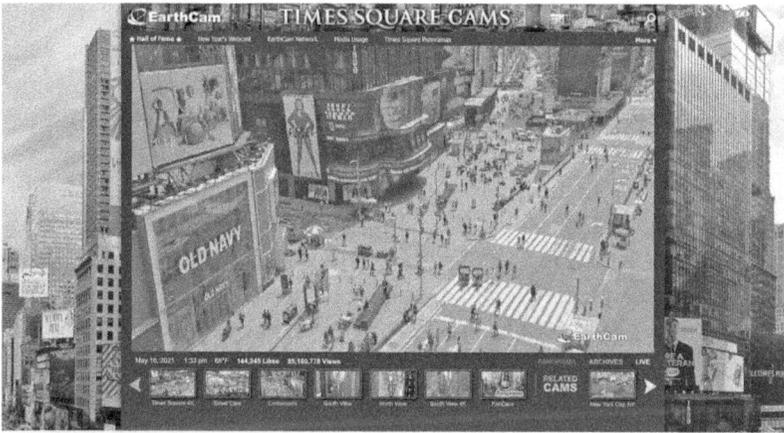

FIGURE 7.4. "Times Square Cams" on EarthCam USA. A sample 24/7, publicly accessible live feed in Times Square on May 16, 2021. Note the availability of different perspectives and the capacity to zoom in; navigate north, west, east, or south; listen to live sound; and post images to linked websites. Image courtesy of EarthCam.

flesh to be measured and tracked, to be "social" with media, is to become a sanitized subject in the aseptic new world order, an informatic node lodged in a new architecture of high-tech whitewashing that colors the twenty-first-century landscape with its numerically encoded, abstract cyber-citizens. The above-noted "smart" urban spectacles merely sweeten the deal, presenting themselves as "intelligent" affirmations of modern selfhood, but, as Lida Zeitlin-Wu argues, they are in fact "designed [as] . . . part of an attention economy that turns sensory pleasure into data by existing in two places simultaneously."[23] Quantifying a body through algorithmic vision and outsourcing sociality to media feeds have not only become the singular means by which one can "participate" in the game— gain access to novel social goods and "fun"—but also the unequivocally dominant mode of financial capture and possession. To belong in (white, dominant) culture today, to "succeed" and play for what might be left of the great American dream, one no longer pays a fixed ticket price ("taking" a picture *for* oneself) but instead offers (or is forced to offer) mind and flesh for epidermal quantification and laboring through the informatic eyes of an (unseen) apparatus.[24]

Let us not forget that the goal of whiteness has always been to hide behind the surface of colored Others. Whiteness (like AI) was never meant to merely function in the service of society but rather to "act as a form of policing in its own right," as an automated "technology of surveillance" that puts into motion its own "ever-expanding culture of self-policing."[25] Silicon Valley and the Pentagon have ensured this. With streets full of closed-circuit television, smart lighting, and cops-with-cameras, all life in public space is subject to a deadening coat of algorithmic whitewash insofar as it enters into view, which, in the eyes of the machine, is synonymous with existence. This is the "sincere truth," as Le Corbusier said of urban whitewash a century ago, of visual spectacle in the twenty-first-century city.[26] In this new age, our "questions concerning technology" must continue to ask, Whose imaginary is this? Whose dreams and desires fuel such rigid control spaces?

In the end, AI's alleged concerns with race and culture are exposed as a foil, one more invisible coat of paint covering up decades of political agendas to manage and track aberrant colors and bodies in space, inadvertently morphing the true greatness of America—the freedom and independence to pursue one's dreams and innovate in unforeseen directions (from Thomas Edison through Oscar J. Gude, Douglas Leigh, YESCO, and Jenny Holzer)—into the surreptitious control of millions, eclipsing all things free and democratic.

Is it possible to alter this course—to retrain algorithms to embrace and understand *all* color and to detect the nuances in human life, context, and politics? Who has the incentive (or capacity) to try? The history of whiteness, AI, and urban architecture in the global Northwest, whether electrographic or just plain brick and mortar, collectively reveals dismal prospects for the future of "color blind" algorithms if architects and creatives do not rise to this challenge. At least one thing is clear: far from radicality, AI thus far evidences only the most tried and true strategies of whiteness that—like the variations of whitewashing that came before it—eviscerate the nuances of its own history, all of those essential, shape-shifting forms that color life with value and meaning.[27]

Acknowledgments

Research for this book began in 2012, in the Cooper Union Library. Only in the past few years have I been able to return to this research, thanks to the generous support of the Social Sciences and Humanities Research Council of Canada (SSHRC). I am also beholden to the dedicated research assistants who helped me along the way: Rachel Rammal at McGill University; Alice Yao and Jessica Hupalo at Toronto Metropolitan University; and Sydney Mullins at the University of Kentucky, who acted as an archival life-saver during the COVID-19 lockdown. Toronto Metropolitan University's interlibrary loan system was equally fantastic, and Donna Kewley, Denise Matchett, and Natalie Briggs consistently hunted down hard-to-find materials. Toronto Metropolitan University's communications subject specialist Naomi Eichenlaub came to my rescue on numerous occasions, magically retrieving articles and archives from obscure databases and collections. Without Nirva Saatjian's stellar organization and accounting skills, I would have had no headspace remaining to conduct this research; my eternal gratitude to her. I also wish to acknowledge Tod Swormstedt from the American Sign Museum; the holdings at the Smithsonian; Cooper Hewitt, Smithsonian Design Museum; the Museum of Modern Art Library and Archives; and the New York Public Library. Last but not least, I am thankful to Raina Polivka, Sam Warren, Jeff Anderson, and Steven B. Baker at the University of California Press, and to Thomas Stubblefield and Sabine Doran for their generous feedback on the manuscript.

Opportunities to speak on this work at Cambridge University, Northwestern University, Rice University's School of Architecture, the Southern California Institute of Architecture, the Harvard Graduate School of Design, Stanford University, Penn State University, and Michigan University's School of Architecture and Digital Studies Institute (DSI) all helped me to sus out the topics and perspectives that would work best in these pages. The book also benefited from

conference participation at the Society for the History of Technology, the History of Science Society, the Society for Cinema and Media Studies, the International Communication Association, and the Toronto Film and Media Seminar at the TIFF Bell Lightbox.

A draft of the conclusion, "Chromophobia in the Smart City," appeared in *Architectural Design* in 2022—remarkably, the same periodical that published Tom Wolfe's inspiring and original 1969 essay, "Electrographic Architecture." A very early version of chapter 5 and excerpts from chapter 6 appeared in *Visual Communication* (2020) as "Neon Visions: From Techno-optimism to Urban Vice," and in the *Harvard Design Magazine* 51 (2023), respectively. Brief excerpts of chapter 1 are forthcoming in the Royal Institute of British Architects publication *Full Spectrum: Colour in Architecture.*

Notes

1. Jenkins's 1911 article "The 'Signs' of the Times" invokes the term *perfection* no fewer than three times in his short piece, while Jones's 1911 article, "The Most Wonderful Electric Sign in the World," employs the word no fewer than eight times.

2. Chalmers, "How Broadway's Magic," SM5.

3. The subhead for this section is an allusion to Walter Benjamin's essay "Paris—Capital of the Nineteenth Century" (1935), in which "capital" refers to both money and the city itself.

4. Le Corbusier, *When the Cathedrals Were White*, 48.

5. Elliott, "In Lightest New York," 187.

6. Elliott, 187–88.

7. Leach, "Commercial Aesthetics," in Taylor, *Inventing Times Square*, 239.

8. Cited in Leach, 240.

9. I am consciously playing off Tocqueville's discussion of "American exceptionalism." For that discussion, see Tocqueville, *Democracy in America*, vol. 1, ch. 2.

10. This book's main title, *Electrographic Architecture*, is adopted from Tom Wolfe's essay by the same name, published in a 1969 issue of *Architectural Design*.

11. Nor does the book analyze the harmful ecological effects of light; appositional darkness; shadows study; or socioeconomic injustice in relation to light and surveillance, which are all valid subjects but beyond the scope of this single project.

12. Portions of this and the following section have been adapted from Kane, "Color as Signal/Noise," 69–88, in *High-Tech Trash*; and Kane, "Colors Sacred and Synthetic," in *Chromatic Algorithms*, 22–69.

13. Albers, *Interaction of Color*, 3.

14. Wiggs, "Color Vision," 9.

15. Wittgenstein, *Remarks on Colour*, 3.

16. Wittgenstein, 9.

17. This is also the argument used in racist theories of classification based on skin color. My implication here, however, is to note that, in order to use color in creative work, one has to be conscious of the color one is selecting and how and why it is not another.

18. Because color studies is interdisciplinary, each subheading cites titles that likely belong to at least one or two other fields, formally separated for the purpose of this review.

19. It is also possible that Plato followed Heraclitus's notion that "fire is a regulatory principle that is present in the outside world and in our souls." For a more detailed and nuanced history of pre-Socratic and classical theories of color and vision, see Zemplén, *History of Vision*.

20. Plato, *The Collected Dialogues*, 45b–c, 54c (my italics). Color perception was for Plato a hybrid affair, even as my emphasis here clearly falls to his articulation of it as internal and subjective.

21. Plato, *The Republic*, 599d.

22. Plato as cited in Lichtenstein, *Eloquence of Color*, 54. See also Detienne and Vernant, *Les Ruses de L'Intelligence*, 47–48.

23. Kant continues: "The colours which give brilliancy to the sketch are part of the charm. They may no doubt, in their own way, enliven the object for sensation, but make it really worth looking at and beautiful they cannot." *Critique of Judgement*, 55–56.

24. In another example, Melville writes that colors "are subtle deceits, not actually inherent in substances, but only laid on from without." "The Whiteness of the Whale," in Melville, *Moby Dick*, 186.

25. David Batchelor further argues that color is related to "the primitive, the infantile, the vulgar, the queer or the pathological." *Chromophobia*, 53.

26. Aristotle, *Aristotle's* On the Soul, 419a. At the same time, he elsewhere argues that seeing color belongs to *aisthesis* (sense-perception), a mediated activity contingent on other bodies in the transparent medium of the air and atmosphere. "For in fact no object of perception is easy to define; and such questions of degree depend on particular circumstances, and the decision lies with perception [*aisthesis*]." Aristotle, *Nicomachean Ethics*, ix, 8.

27. Aristotle, *Minor Works*, 437b–438a.

28. For example, Aristotle also suggested that color emerged *between* black and white, lending itself to the subjective approach.

29. Goethe, *Theory of Colours*, 7, 9, 297.

30. Alcoff, *Future of Whiteness*, 99 (my italics).

31. While Newton made significant discoveries about light and color before and after this date, his 1704 *Opticks* is his most comprehensive and readily accessible work on the subject.

32. Alcoff, *Future of Whiteness*, 99–100.

33. Alcoff, 99.

34. Alcoff, 99.

35. Crary, "Your Colour Memory," 20.

36. Alcoff, *Future of Whiteness*, 99.

37. Critical whiteness studies (CWS) has been addressed in a range of disciplines, including but not limited to history, social science, education, psychology, studies in sexuality, and law. For a comprehensive bibliography of this field, see Engles, "Towards a Bibliography"; and for an account of BLM and the George Floyd murder relative to "white power," see Mirzoeff, *White Sight*.

38. Nissim-Sabat, "Revisioning 'White Privilege,'" 43.

39. Cited in Yancy, "Whiteness as Insidious," 113.

40. Morrison, *Playing in the Dark*, 90.

41. Morisson; Bell, "Whiteness Interrupted," 2.

42. Bell, "Whiteness Interrupted," 265.

43. Bell, 265.

44. Bell, 23.

45. Gordon, "White Privilege," 25.

46. Du Bois introduced the notion of "personal whiteness" in 1920. Bell, "Whiteness Interrupted," 37.

47. Decolonization can be achieved, Fanon argued, only by destroying these segregated and compartmentalized facets of society.

48. McIntosh, *White Privilege*, n.p.

49. For additional sources in the social sciences, see Frankenberg, *White Women, Race Matters*; Irving, *Waking Up White*; McKinney, *Being White*; and Wildman and Davis, "Making Systems of Privilege Visible." In legal studies, see Harris, "Whiteness as Property."

50. Bell, "Whiteness Interrupted," 41.

51. Ahmed, "Phenomenology of Whiteness," 163–66.

52. The notion of "white fragility" can be identified alongside T. J. Jackson Lears's notion of a bourgeois "paralysis of the will" (Lears, *No Place of Grace*, 50), or Carter's *Heart of Whiteness*, which addresses the rise of nervous disorders among Anglo-Saxon American whites.

53. Cabrera and Corces-Zimmerman, "Beyond 'Privilege,'" 14.

54. Morrison, *Playing in the Dark*, x.

55. Roediger cited in Cabrera and Corces-Zimmerman, 14; Roediger, *Wages of Whiteness*, 13.

56. Lipsitz, *Possessive Investment*, vii.

57. DiAngelo, "White Fragility," 56.

58. Frankenberg, *White Women, Race Matters*, 1.

59. Wilkerson, *Caste*, 19.

60. Bergo and Nicholls, "Introduction," 7.

61. Cabrera and Corces-Zimmerman, "Beyond 'Privilege,'" 14.

62. Wigley, "Chronic Whiteness," n.p.

63. Bell, "Whiteness Interrupted," 7.

64. Echeverría and Ferreira, *Modernity and "Whiteness,"* 2.

65. Echeverría and Ferreira, 42.

66. Fuentes, cited in Echeverría and Ferreira, xiv.

67. Echeverría and Ferreira, xix.

68. Current debates in sociology discuss the use of *race* versus *ethnicity*. Some scholars argue that race and ethnicity are distinct categories, while others contend that race should be treated under *ethnicity*. This observation is apropos here, since cultural whiteness is defined by Echeverría using *ethnicity* rather than *race* (and the two are therefore used interchangeably in my discussion of his work).

69. Thompson cited in Engles, *Towards a Bibliography*, 20.

70. Jacobson, *Whiteness of a Different Color*, 4.

71. The United States is hardly alone. The French-speaking working classes of Quebec were "told to 'speak white'" (i.e., English) in order to participate in the dominant culture. Bergo and Nicholls, "Introduction," 7.

72. As Hale put it in 1998, "Central to the meaning of whiteness is a broad, collective American silence." *Making Whiteness*, xi.

73. Le Corbusier, *Towards a New Architecture*, 143.

74. Le Corbusier, *L'Art Décoratif*, 135.

75. Le Corbusier, cited in Janneau, "L'Exposition des arts techniques," 64.

76. See Solon, *Polychromy*; and a handful of articles and dissertations, including Solon, "Side-Lights," 83–84; and Summitt, *Greek Architectural Polychromy*.

77. For example: Gatz and Wallenfang, *Color in Architecture*; Lam, *Perception and Lighting*; Porter and Mikellides, *Color for Architecture*; Porter, *Architectural Color* and *Colour Outside*; Linton, *Color in Architecture*; Riley, *Color Codes*; Toy, *Colour in Architecture*; and McCown, *Colors*. One recent and excellent exception is Cheng, Davis, and Wilson, *Race and Modern Architecture*.

78. Wigley, "Chronic Whiteness." The essay's compatibility with media archaeology is extant, though not explicit.

79. Wigley. A 1996 issue of *ANY* (*Architecture New York*) entitled "Whiteness: White Forms, Forms of Whiteness" ostensibly interrogated whiteness in relation to architecture, but the majority of the issue's essays only tangentially linked western architecture to systemic whiteness. The first chapter of Batchelor's *Chromophobia*, "Whitescapes," 9–20, is also noteworthy, even as it dances around the theme of whiteness. And, as noted, another excellent exception, which does not focus on whiteness directly but works within this same critical spirit, is Cheng, Davis, and Wilson, *Race and Modern Architecture*.

80. Examples include Nye, *American Illuminations*; Nye, *American Technological Sublime*; Nye, *Electrifying America*; Eskilson, "America the Spectacle"; Neumann, *Architecture of the Night*; Major, Spiers, and Tischhauser, *Made of Light*; Petty, "Cultures of Light"; Edensor, *From Light to Dark*; Isenstadt, Petty, and Neumann, *Cities of Light*; and Isenstadt, *Electric Light*.

81. Examples include Neale, *Cinema and Technology*; Misek, *Chromatic Cinema*; Yumibe, *Moving Color*; Gunning et al., *Fantasia of Color in Early Cinema*; Fossati et al., *Colour Fantastic*; and Street and Yumibe, *Chromatic Modernity*.

82. One keystone essay is Roth, "Looking at Shirley, the Ultimate Norm." More recent work includes Yue, "The China Girl on the Margins of Film,"; Katz, *Artificial Whiteness*; and Menkman, "Behind the White Shadows."

83. Exceptions include Dyer, *White*; Berger, *White Lies*; Foster, *Performing Whiteness*; Alcoff, *Future of Whiteness*; and Mulvin, *Proxies*. At the same time, only the last-cited work addresses whiteness in conjunction with the history of light media.

84. This scholarship tends to focus on the subjugation of African Americans and corresponding works made by people of color. See, for example, Benjamin, *Captivating Technology*; Browne, *Dark Matters*; and Thompson, *Shine*. Roth's "Looking at Shirley" is also helpful here.

85. Lipsitz, *How Racism Takes Place*, 5.

86. Harris, "Whiteness as Property," is also helpful here.

87. See Bell, "Whiteness Interrupted"; Avila, *Popular Culture*.

88. Foucault, *Power/Knowledge*, 119.

89. Foucault, *Archaeology*, 62; Nietzsche, *On the Genealogy of Morals*, 45.

90. Nietzsche, *On the Genealogy of Morals*, 45. The flash, in his account, is also a pun on the Enlightenment conflation of visibility and knowledge.

91. In recent decades, the growth of media archaeology has been aided by the work of Friedrich Kittler, Siegfried Zielinski, Wolfgang Ernst, Lisa Gitelman, Wendy Hui Kyong Chun, Erkki Huhtamo, and Bernard Stiegler.

92. Zielinski, *Deep Time*, 1–4; Kittler, *Gramophone, Film, Typewriter*, 84–85.

93. Bhabha, "White Stuff," 21.

94. Echeverría and Ferreira, *Modernity and "Whiteness,"* 44.

95. See Kane, "Digital Infrared," in *Chromatic Algorithms*.

96. Suffice it to note that the overall picture of American (and global) illumination is complex, multiple, and diverse, and this book does not cover all or even a significant portion of them. There are numerous other places and contexts for white architecture around the world, some minoring and others majoring in white forms and fashions (for example, white West African architectures such as the Bobo Dioulasso mosque in Burkina Faso, much of Morocco, or the Mayan White Way). However, as noted at the outset, my focus in *Electrographic Architecture* lies with a singular and particular strain of whiteness in the context of the illuminated American city (New York and Las Vegas) over the course of the past century, which I in turn read as an allegory of the nation's white imaginary.

Why these particular cities were chosen as primary case studies (versus the countless, more modest examples of municipal and regional lighting in towns and cities across America) is because, as indicated at the outset, they offer the strongest illustrations of the essence of American electrographic architecture, with its pretensions for supreme spectacularity. This is of course not to say that all illumination in America is always supreme or spectacular but that a certain genre of it, which I am focusing on in this book, caters to and reinforces notions of totalizing, omnipresent whiteness. I thank the University of California Press reviewers for helping me to clarify these rationales.

97. The epitome of American "supremacy," Edward Said argues, is synonymous with global hegemony. Whether this took the form of "manifest destiny" in the nineteenth century or "world responsibility" in the twentieth, in discourses on American leadership "exceptionalism is never absent." Said, *Culture and Imperialism*, 285.

CHAPTER 1

Epigraphs: Kant, *Critique of Judgment* (1987), ¶7; Le Corbusier, *Decorative Art*, 188.

1. Farr cited in Engles, *Towards a Bibliography*, 9.
2. Wigley, "Chronic Whiteness," n.p. These two sections and another section further below draw their contours from Wigley's essay.
3. Ibáñez Estévez et al., "Emergence of the Neolithic"; Wigley, "Chronic Whiteness."
4. Wigley writes: "Architecture incubated infectious disease by hosting new infra- and inter-species intimacies. Domestic cohabitation between humans and non-humans acted as a medium for inventing and exchanging disease, as well as a reservoir for storing it." As a result of these sick-induced buildings, "humans [also] got shorter." "Chronic Whiteness."
5. Wigley (my italics).
6. Hippocrates, "On Airs, Waters, Places," part 20.
7. Hippocrates, parts 19–20.
8. Aristotle, "On Colour," 23.
9. Vitruvius, *Ten Books*, 26; also cited in Wigley, "Chronic Whiteness."
10. Vitruvius, 26.
11. Wigley, "Chronic Whiteness."
12. Le Corbusier, *Le Voyage d'Orient*.
13. Le Corbusier, *L'Art decoratif*, 189.
14. Le Corbusier, *L'Art decoratif*, 188.
15. Wigley, "Chronic Whiteness."
16. Le Corbusier, *Towards a New Architecture*, 143.
17. See Hammer, "White, Everything White?"
18. Jeanneret, "Quelques Impressions."
19. Jeanneret; Wigley, "Chronic Whiteness."
20. Jeanneret; Wigley.
21. Jeanneret; Wigley.
22. "I must have drunk too much resin wine. . . . Again today I imbibed too much resin wine." Resin wine was a precursor to absinthe, prohibited in France since 1930. Jeanneret, 235.
23. Jeanneret, 14.
24. Jeanneret, 14.
25. Le Corbusier, *Le Voyage d'Orient*, 82, 88, 93, 142.
26. "On the bedsheets" at his Turkish hotel, he writes, "the black of the bedbugs [were] easily equal to the weight of the unwashed linen." Le Corbusier, *Le Voyage d'Orient*, 82.
27. Le Corbusier, 235.
28. Wigley, "Chronic Whiteness."
29. Le Corbusier, *Le Voyage d'Orient*, 235.
30. Jeanneret, "Charles-Édouard Jenneret to William Ritter," 99.
31. "In the course of my travels . . . I found whitewash wherever the twentieth century had not yet arrived." That is, *pure* whitewash, *original* whitewash, as anything *but* modern. Le Corbusier, *L'Art Décoratif*, 189.

32. Le Corbusier and Ozenfant, "Purism," 62–64.

33. Scavuzzo, "Compositions for Chromatic Keyboards," 434.

34. Braham, *Modern Color/Modern Architecture*, 2; François Ducros, cited in Eliel, *L'Esprit Nouveau*, 12, 82.

35. Jeanneret and Ozenfant, *Après le Cubisme*, 27.

36. That these same industrial machines also produced the same gamut of industrial colors that they rejected was somehow lost to them.

37. Le Corbusier, *L'Art Décoratif*, 188.

38. The tenth color appears to be a lime green or a light emerald green; Batchelor, *Chromophobia*, 47.

39. Le Corbusier, "Notes a la suite," 49; also cited in Wigley, "Chronic Whiteness."

40. Wigley, "Chronic Whiteness"

41. Skelton, "A Colour Chemist's History," 44–45.

42. Skelton, 46.

43. Plato, *Republic*, 420c–d. "We were painting statues and someone came up and began to blame us, saying that we weren't putting the fairest colors on the fairest parts of the animal—for the eyes, which are fairest, had not been painted purple but black." It is possible that purple was understood as a kind of indigo or violet blue, but even so, the wild colors adorned on Greek statues confirms an imaginary at work. Plato, 420c–d.

44. Marconi and Steiner, *Oxford Handbook*, 269; Porter and Mikellides, *Color for Architecture*, 23.

45. Porter and Mikellides, *Color for Architecture*, 23; Talbot, "Myth of Whiteness," n.p.

46. Cremin, *Archaeologica*, 170; Freely, *Strolling through Athens*, 69; Wigley, "Chronic Whiteness."

47. Wigley, "Chronic Whiteness."

48. A founder of modern Turkey, Mustafa Kemal Atatürk in 1928 launched a state-sponsored campaign to amplify Turkish whiteness through the excavation of skulls, ancient blood types, and historical documents. Ergin, "Turkey's Hard White Turn."

49. Efendi cited in Fowden, "The Parthenon, Pericles and King Solomon," 269; Wigley, "Chronic Whiteness."

50. British Museum, "Lord Elgin and the Parthenon Sculptures"; Wigley, "Chronic Whiteness."

51. Hart, "Why Do People Believe in Hell?" n.p.

52. Winckelmann, *History of the Art of Antiquity*, 195; Hart, "Why Do People Believe in Hell?"

53. Classically trained William E. Gladstone also viewed antiquity as colorless, as exemplified in *Studies on Homer and the Homeric Age*, where he suggests that the few instances of color terms in Homer denote a deficiency in Greek color perception (later identified as colorblindness). Talbot, "Myth of Whiteness."

54. Winckelmann, *History of Ancient Art*, 13. Hodne suggests Winckelmann's aesthetic whiteness confused the whiteness of the stone surface with the complexion of the skin. Hodne, "Winckelmann's Depreciation of Colour," 192. Either way, in his 1756 *History of Ancient Art*, Winckelmann implicated the Greeks as

Indo-European in origin and, for this reason, superior in their accomplishments. His key move was to sever Greek culture from the Egyptians and Jews who arrived from Africa. However, as David Bernal and others have shown, the early Greeks did not belong to this Winckelmann-esque "Aryan model" of history but instead to an "Ancient model" that charts their migration from northern Africa (Egypt) and India. As a result, Winckelmann's *History of Ancient Art* produced a still-lingering notion that the psycho-geography of peoples could be used to assess the relative merit of their works of art, establishing a highly precarious yet nonetheless popular, biologically contingent notion of style. Bernal, *Black Athena*, 27; Bindman, *Ape to Apollo*, 15; Michaud, "Barbarian Invasions," 69).

55. "The whiter the body is," he argued, "the more beautiful it is." Winckelmann, *History of Ancient Art*, 13.

56. Bernal, *Black Athena*, 184, 379.

57. Ceram, *Gods, Graves, and Scholars*, 4.

58. McCown, *Colors*, 173.

59. Talbot, "Myth of Whiteness."

60. Talbot.

61. Talbot.

62. Fabio Barry cited in Talbot.

63. Talbot.

64. Batchelor, *Chromophobia*, 12.

65. Plato, *Republic*, 599d, as trans. in Lichtenstein, *Eloquence of Color*, 54.

66. Plato, 599d.

67. Analogies between light and whiteness in the Christian Bible can be found in Matthew, Luke, Nehemiah, and the Psalms.

68. Dyer, *White*, 66, 84. *White* as a signifier of race comes into common discourse only in the nineteenth century, after first appearing in the Oxford English Dictionary in 1604. Bernal, *Black Athena*, 201.

69. Dyer, *White*, 67.

70. These images show how a Black ruler "comes of his own volition to the white man's land and lays down his wealth and his power at the feet of the Christ child." Boime, *Art of Exclusion*, 3–4; also cited in Dyer, *White*, 66.

71. Dyer, *White*, 68.

72. Dyer, 23–24.

73. Xenophon, "Memorabilia," in *Memorabilia*, I. 2.1.21–2.1.23, p. 95.

74. Xenophon, "Memorabilia," I. 2.1.21–2.1.23, p. 95.

75. Xenophon, "Memorabilia," I. 2.1.21–2.1.23, p. 95.

76. Xenophon, "Memorabilia," I. 2.1.21–2.1.23, p. 95.

77. Xenophon, "Oeconomicus," in *Memorabilia*, IX, 18-x, p. 449.

78. Xenophon, "Oeconomicus," IX, 18-x, p. 447.

79. Xenophon, "Oeconomicus," IX, 18-x, p. 447.

80. Xenophon, "Oeconomicus," IX, 18-x, p. 449.

81. Alberti, *On the Art of Building*, 17; Wigley, "Chronic Whiteness."

82. Alberti, *On the Art of Building*, Book X, p. 226; Bulgarelli, "Bianco e colori," 48–57. Wigley cites Alberti's reconstruction of the ecclesiastical Temple in Rimini (1450) as the "first attempt to reconstitute" the "true" white of the classical architecture of Antiquity that never existed. "Chronic Whiteness."

83. Alberti, *On the Art of Building*, Book X, p. 240; Wigley, "Chronic Whiteness."

84. So-called white marble is never white alone. Marble always bears specks of multiple pigments, from ochres and yellows to blues and greens. Hammer, "White, Everything White?"; Wigley, "Chronic Whiteness"; Ibáñez Estévez et al., "Los primeros agricultores y ganaderos, 103–23.

85. Alberti writes: "Cicero, being guided by Plato's Opinion, thought it necessary that the People should be admonished by the Laws to lay aside all Manner of Delicacy in the Adorning their Temples, and take Care only to have them perfectly clean and white." The same militant tenets shaped his later theories of the genius artist, which he saw manifest in Leonardo da Vinci. *On the Art of Building*, Book VII, p. 149.

86. Vitruvius, *Ten Books on Architecture*, 26, cited in Wigley, "Chronic Whiteness."

87. Wigley, "Chronic Whiteness."

88. Alberti, Book VII, 134.

89. Alberti, *I Libri Della Famiglia*, 83–84.

90. Alberti, *I Libri Della Famiglia*, 83–84.

91. Alberti, 83–84.

92. Wives were "prohibited from whitening their faces with chalk." Wigley, "Chronic Whiteness."

93. Other colored women and slaves were excluded from this so-called natural white-light value pyramid. For example, while Alberti opposed slavery in principle, once the "barbarian nations" and "distant slave peoples" became "puffed up with boldness," ready to "burn the nest" and usurp the empire, they were deemed to be a "sickness of society," unequivocally linked to dirt and disease in tandem with his overall efforts to "naturalize hierarchy, servitude and property." Alberti, *I Libri Della Famiglia*, 17; Wigley, "Chronic Whiteness."

94. Alcoff, *Future of Whiteness*, 100.

95. Goethe, *Theory of Colours*, 7, 9, 297.

96. Crary, "Your Colour Memory," 20.

97. Goethe, *Theory of Colours*, 326–29.

98. Goethe, *Theory of Colours*, 326–29, also cited in Taussig, *What Color Is the Sacred?*, 55.

99. Alcoff, *Future of Whiteness*, 99–100. It was also during this time that former value hierarchies prioritizing the art, culture, and people of the more Latin-influenced, southern European cultures in the Ottoman Empire (then consisting mainly of Turks, Latin cultures, and Romans in southern Europe), which had been seen as "superior" since antiquity, were overturned as northern Germanic tribes became newly esteemed (primarily by virtue of the praises sung by the Romantics, such as Goethe) for their Gothic art and architecture, and positioned at the top of the food chain. Another commonly cited example is found in the above-noted, fraught work of Johann Joachim Winckelmann.

100. In the spirit of Heidegger and Nietzsche, Derrida offers a similar line of deconstructionist thinking he calls "White Mythology," a critique of the false origins in the history of Western metaphysics and rhetoric. He writes: "What is

metaphysics? A white mythology which assembles and reflects Western culture: the white man takes his own mythology . . . his logos—that is, the mythos of his idiom, for the universal form of that which it is still his inescapable desire to call Reason." Derrida and Moore, "White Mythology," 11.

101. Heidegger's affiliation with the Nazis introduces another set of questions. For more on this association, see his *Ponderings II–VI.*

102. Kant cited in Eze, "Color of Reason," 217–18.

103. Kant, *Beobachtungen über das Gefühl,* quoted in Eze, "The Color of Reason," 214; Kant, "On the Different Races of Man," 48.

104. Kant, *Critique of Judgment* (1987), ¶8, 45.

105. "The beautiful is that which, apart from concepts, is represented as the object of a *universal* delight." Kant, *Critique of Judgment* (1987), ¶6, 42; ¶8, 45. And in Pluhar's translation: "The Beautiful Is What Is Presented without Concepts as the Object of a Universal Liking" (¶6).

106. Kant, *Critique of Judgment* (1987), ¶7. "The judgment of taste itself does not *postulate* the agreement of everyone . . . it only *imputes* this agreement to everyone." Kant, ¶8.

107. Lloyd, "Race under Representation," 64.

108. Lloyd, 66.

109. Yancy, "Whiteness as Insidious," 109.

110. For a further critique of objectivity, see Daston and Galison, *Objectivity.*

111. Kant, *Critique of Judgment* (1987), ¶11, 52; ¶40, 160 (my italics).

112. Chrisman, "Theorising Race, Racism, and Culture," 129.

113. Lloyd, "Race under Representation," 70.

114. Dyer, *White,* 38.

115. Chrisman, "Theorising Race, Racism, and Culture," 128.

CHAPTER 2

1. Foucault, *Discipline and Punish,* 195–228.

2. Deleuze, "Postscript on the Societies of Control," 177–82.

3. Foucault, *Discipline and Punish,* 195–228.

4. Deleuze, "Postscript on the Societies of Control," 177–82.

5. Dyer, *White,* 52.

6. Browne, *Dark Matters,* 8.

7. Fiske, "Surveilling the City," 81, 85, cited in Browne, *Dark Matters,* 17.

8. Wilkerson, *Caste,* 17.

9. Brox, *Brilliant,* 15.

10. Schivelbusch, *Disenchanted Night,* 4.

11. Schivelbusch, 4.

12. Brox, *Brilliant,* 11.

13. Brox, 13.

14. In some cases, moonlight could be used for less detailed activities.

15. Wealthy classes were excluded from this rule. Brox, *Brilliant,* 21.

16. Even the word *curfew,* Brox notes, derives from the Old French *couvre-feu,* meaning to "cover fire." Brox, 21.

17. Brox, 21.

18. "The Value of Good Lighting," 319.

19. Nye, *American Illuminations*, 14.

20. Brox, *Brilliant*, 15.

21. Brox, 26–27.

22. Nye, *American Illuminations*, 15.

23. Nye, *American Illuminations*, 15; Brox, *Brilliant*, 28.

24. Isenstadt, *Electric Light*, 2.

25. Nye, *American Illuminations*, 15.

26. Brox, *Brilliant*, 33.

27. Brox, 55.

28. Brox, 35.

29. Brox, 33.

30. Oatman-Stanford, "Let There Be Light Bulbs," n.p.

31. Brox, *Brilliant*, 67.

32. Street lighting was installed in Baltimore in 1816. Kantack, "Study of Fine Lighting Today," 4.

33. Brox, *Brilliant*, 62. As noted in the introduction, no light source is ever purely white, always tending to one side of the blue or red spectrum. Nonetheless, there is a social tendency to describe public light sources as "neutral" or white, or both.

34. Schivelbusch, *Disenchanted Night*, 38–39.

35. Brox, *Brilliant*, 62, 80; Isenstadt, *Electric Light*, 2–3.

36. Schivelbusch, *Disenchanted Night*, 87.

37. Brox, *Brilliant*, 68.

38. Brox, *Brilliant*, 58; Schivelbusch, *Disenchanted Night*, 39.

39. Liberty, *The Centenary*, 7, 66, 188, cited in Schivelbusch, *Disenchanted Night*, 40.

40. "Triumphant Industries," 7.

41. "Triumphant Industries," 7.

42. Anderson, "Lighting the Pan-Pacific Exposition," 24.

43. Isenstadt, *Electric Light*, 5.

44. Brox, *Brilliant*, 104, 156; Oatman-Stanford, "Let There Be Light Bulbs."

45. Oatman-Stanford, "Let There Be Light Bulbs."

46. "Brush Electric Light," 211.

47. Isenstadt, *Electric Light*, 5.

48. "Brush Electric Light," 211.

49. Luckiesh, "A Half-Century of Artificial Lighting," 920.

50. "Brush Electric Light," 211; Noble, *America by Design*, 7; Rossell, "Compelling," 5, 138–39.

51. "Brush Electric Light," 211.

52. Oatman-Stanford, "Let There Be Light Bulbs," n/p.

53. Brox, *Brilliant*, 104.

54. "The Brush Electric Light," 211.

55. Oatman-Stanford, "Let There Be Light Bulbs."

56. "Brush Electric Light," 211–12.

57. Noble, *America by Design*, 8.

58. "Lighting a Revolution."

59. See, for example, see Freeburg, *Age of Edison*; Jonnes, *Empires of Light*; and Noble, *America by Design*.

60. Reich, "Lighting the Path."

61. "Inventing Entertainment."

62. Starr and Hayman, *Signs and Wonders*, 46. Starr and Hayman claim that this patent was Edison's first, but according to a number of other sources it was at least his second.

63. Noble, *America by Design*, 8.

64. Noble, 8.

65. Noble, 8.

66. He arrived in New York in 1884 with four cents, a sheaf of poems, and detailed plans for building a flying machine. Starr and Hayman, *Signs and Wonders*, 46.

67. Jonnes, *Empires of Light*, 111.

68. Luckiesh, "A Half-Century," 920; Tell, *Times Square Spectacular*, 25.

69. Starr and Hayman, *Signs and Wonders*, 47.

70. Starr and Hayman, 47.

71. Starr and Hayman, 47.

72. Starr and Hayman, 47.

73. Oatman-Stanford, "Let There Be Light Bulbs."

74. Jonnes, *Empires of Light*, 96; Carlson, *Tesla*, 3.

75. Starr and Hayman, *Signs and Wonders*, 44.

76. Starr and Hayman, *Signs and Wonders*, 48.

77. J.P. Morgan purchased the brownstone at 219 Madison Ave. (on the corner of 36th St.) in 1881 and, in 1903, the brownstone at 231 Madison Avenue for his son Jack Morgan.

78. Brox, *Brilliant*, 120.

79. Brox, 120.

80. Smithsonian Institute, "Lighting a Revolution."

81. Josephson, "Edison," 255.

82. Smithsonian Institute, "Lighting a Revolution."

83. Munson, *From Edison to Enron*, 53.

84. Munson, 53; Brox, *Brilliant*, 124; DiLaura, "History," n.p.

85. Smithsonian Institute, "Lighting a Revolution."

86. Isenstadt, *Electric Light*, 5.

87. Brox, *Brilliant*, 127.

88. Smithsonian Institute, "Lighting a Revolution."

89. Reich, "Lighting the Path," 307.

90. Reich, 307.

91. Reich, 307.

92. Reich, 307.

93. Reich, "Lighting the Path," 307.

94. Smithsonian Institute, "Lighting a Revolution."

95. Munson, *From Edison to Enron*, 55.

96. Isenstadt, *Electric Light*, 5.

97. Brox, *Brilliant*, 166.

98. DiLaura, "History."

99. Munson, *From Edison to Enron*, 54.

100. Munson, 54.

101. Munson, 54.

102. Munson, 51–52.

103. Isenstadt, *Electric Light*, 5.

104. Munson, *From Edison to Enron*, 52.

105. Munson, 52.

106. Munson, 51–52, 56.

107. Munson, 51–52, 56.

108. Reich, "Lighting the Path," 307.

109. Reich, 307.

110. Reich, 307.

111. Reich, 309.

112. Reich, 307.

113. Reich, 307.

114. Munson, *From Edison to Enron*, 52; Reich, "Lighting the Path," 307.

115. Reich, "Lighting the Path," 328.

116. Krajewski, "Great Lightbulb Conspiracy," n.p.

117. Krajewski.

118. Krajewski.

119. Munson, *From Edison to Enron*, 52; Krajewski, "Great Lightbulb Conspiracy." The slew of information about the Phoebus cartel came to light in the 1940s after a second government investigation into the company and its business partners.

120. Reich, "Lighting the Path," 305–6.

121. "A New Incandescent Light"; Schivelbusch, *Disenchanted Night*, 58.

122. Rossell, "Compelling Vision," 122.

123. In Britain, St. George Lane-Fox was also pursuing a viable form of incandescent lighting. Oatman-Stanford, "Let There Be Light Bulbs."

124. Oatman-Stanford.

125. Freeberg, *Age of Edison*; Oatman-Stanford, "Let There Be Light Bulbs." While some historians date the first electric sign to Edison's 1882 display in London, this 1881 Paris exhibition must also be seen as a key precursor in the transformation of fairs and exhibitions. Consider, for example, that the Paris Exposition of 1878 closed each day at dusk, whereas by 1881, the 1,300 arc lights of artificial illumination at the exposition drew nocturnal crowds by the hundreds, catalyzing a collective appetite for electric spectacle. Nye, *American Illuminations*, 176).

126. Tell, *Times Square*, 25.

127. Thompson, "Rainbow Ravine," 165; Tell, *Times Square Spectacular*, 35.

128. "Watts in a Name," 68.

129. Tell, *Times Square Spectacular*, 25.

130. Rossell, "Compelling Vision," 89.

131. Rossell, 89.

132. Rossell, 89.

133. Petty, "Cultures of Light," 46.

134. Rossell, "Compelling Vision," 90.

135. Broyles, "Vanderbilt Ball," n.p.
136. Rossell, "Compelling Vision," 90.
137. Reich, "Lighting the Path," 333.
138. Rossell, "Compelling Vision,"124; Nye, *Image Worlds*, 14.
139. Nye, *Image Worlds*, 14; Rossell, "Compelling Vision," 124.
140. Reich, "Lighting the Path," 330.

CHAPTER 3

Epigraphs: "Two Spectaculars in the Making," 29; Elliott, "In Lightest New York," 194 (my italics); Sebastian, "Along Broadway," *Signs of the Times* 133, no. 2 (1953): 93; Nye, *American Technological Sublime*, 188.

1. Schultze, "Legislating Morality," 41; Whiting, "The Minister Militant," 59.
2. Wood, cited in Whiting, 59.
3. Whiting, 60.
4. Whiting, 60; Schultze, "Legislating Morality,"41.
5. Schultze, 41.
6. This chapter draws heavily on the history of New York City. For more on this history see Taylor, *Inventing Times Square*; McKendry, *One Times Square*; Traub, *Devil's Playground*; and Sagalyn, *Times Square Roulette*.
7. Namely, the nearby Garfield Monument. Schultze, "Legislating Morality," 37–38.
8. Schultze, 38.
9. Schultze, 38.
10. "At the Sign of the Innerseal."
11. "A Persistent Purpose to Produce Perfect Biscuit."
12. Schultze, "Legislating Morality," 38.
13. Osdene, "American Neon," 31; Nye, *American Technological Sublime*, 173.
14. Kelley, "A Museum to Visit from an Armchair," B5.
15. Osdene, "American Neon," 31.
16. Starr and Hayman, *Signs and Wonders*, 23.
17. Saxon, "P. T. Barnum and the American Museum," 131.
18. Dennett, *Weird and Wonderful*, 17.
19. Starr and Hayman, *Signs and Wonders*, 25.
20. Starr and Hayman, 27.
21. Schultze, "Legislating Morality," 38.
22. McFarland, "Why Billboard Advertising as at Present Conducted Is Doomed," 38; Schultze, "Legislating Morality," 38.
23. In response, the Outdoor Advertising Association of America formed in 1870, and in 1884, B. W. Robbins launched the American Billposting Company, which eventually became the General Outdoor Advertising Company. These independent associations had much less political power. "Outdoor Advertising Timeline: 1850–1899."
24. Woodruff, "Billboard Nuisance," 5.
25. Woodruff, 12.

26. *New York Times*, cited in Starr and Hayman, *Signs and Wonders*, 25.

27. Starr and Hayman, *Signs and Wonders*, 26.

28. Woodruff, "Billboard Nuisance," 47; Woodruff, "Indictment Against the Billboard," 47.

29. Woodruff, "Billboard Nuisance," 50; Woodruff, "Indictment Against the Billboard," 50.

30. Woodruff, "Billboard Nuisance," 11.

31. Woodruff, "Billboard Nuisance," 12.

32. Schultze, "Legislating Morality," 42.

33. Erickson, "Birth of Zoning Codes."

34. Tell, *Times Square Spectacular*, 52.

35. Tell, 36.

36. Lears, *Fables of Abundance*, 3.

37. Lears, 3.

38. Lears, 3.

39. Schultze, "Legislating Morality," 42.

40. Tell, *Times Square Spectacular*, 58.

41. Hammack, cited in Taylor, *Inventing Times Square*, 44.

42. *New York Times* (February 12, 1928), sec. II, 5; Leach, *Land of Desire*, 343.

43. Hammack, cited in Taylor, *Inventing Times Square*, 44.

44. Tell, *Times Square Spectacular*, 55.

45. The first World's Fair, titled "Exhibition of Products of French Industry," was held in Paris in 1798 and ran until 1849. The infamous 1851 Great Exhibition at London's Crystal Palace followed, attracting 14,000 exhibitors and more than 6 million visitors. Isenstadt, "Spaces of Shopping," 14–15.

46. For more on World's Fairs, see Edensor, *From Light to Dark*; Isenstadt, "Spaces of Shopping"; Nye, *American Technological Sublime*; Rossell, "Compelling Vision"; and Schivelbusch, *Disenchanted Night*.

47. Tell, *Times Square Spectacular*, 31; Starr and Hayman, *Signs and Wonders*, 42.

48. For example, Richmond, Virginia; Washington, DC; Baltimore, Maryland; Columbus, Ohio; Madison, Wisconsin; Montreal, Canada; and specifically, the Benjamin Franklin Parkway in Philadelphia; the Civic Centers in St. Louis and San Francisco; the area of New York City occupied by the Manhattan Municipal Building; and the Louisiana Purchase Exposition in St. Louis in 1904.

49. Gordon, *Urban Spectator*, 22.

50. Gordon, 16.

51. Brox, *Brilliant*, 130.

52. Starr and Hayman, *Signs and Wonders*, 43.

53. Gordon, *Urban Spectator*, 22–23.

54. At first individual visitor photographs were not allowed, but the demand was so high that Burnham and the WC administration changed the policy midway through the event ("the new has come, and he will possess it"). Burnham, cited in Gordon, *Urban Spectator*, 16.

55. Gordon, 20.

56. Brox, *Brilliant*, 135. There was also the gaping absence of African American life and culture at the event—an event held in the south side of Chicago, no less—coupled with the fact that Black people had no representation on the planning committee.

57. From the Dutch "Grote Kil."

58. McKendry, *One*.

59. Bloom, *Routledge Guide to Broadway*, vii.

60. McKendry, *One*; Bloom, *Routledge Guide to Broadway*, vii.

61. Burrows and Wallace, *Gotham*, 419–22.

62. Bloom, *Routledge Guide to Broadway*, vii.

63. Minuit paid not cash but instead what he perceived to be the equivalent of sixty guilders in goods.

64. "A symbol of a new style of cosmopolitan, modern living." Gray, "Streetscapes/50th Street," 7.

65. McKendry, *One Times Square*; Tell, *Times Square Spectacular*, 20.

66. Blackmar, "Uptown Real Estate and the Creation of Times Square," cited in Taylor, *Inventing Times Square*, 52.

67. Blackmar, 55.

68. Blackmar, 56.

69. Blackmar, 56.

70. Huxtable, "Re-inventing Times Square, 1990," in Taylor, *Inventing Times Square*, 359.

71. The Olympia opened on November 25, 1895, and took up an entire block of Broadway between 44th and 45th Streets (Lampard, "Introductory Essay," in Taylor, *Inventing Times Square*, 17). Hammerstein had previously built two theaters in Harlem, both on 125th Street, and the Manhattan Opera House on 34th Street in 1893, but these two were his first in Longacre.

72. McKendry, *One Times Square*.

73. Lampard, "Introductory Essay," 17.

74. McKendry, *One Times Square*.

75. Lampard, "Introductory Essay," 17.

76. McKendry, *One Times Square*. Macy's also moved uptown from the "Ladies Mile" to Herald Square in 1900 (where it resides today).

77. Both hotels were demolished in the 1960s and '70s, respectively. Huxtable, "Re-inventing Times Square, 1990," 359.

78. An 1896 fire killed 60 of the AHE's 265 horses. The *New York Times* reported that "crazed animals could be seen [through the windows] dashing blindly about in their terror." In the immediate aftermath of the fire, escaped horses were found all across midtown. Gray, "Streetscapes/50th Street," 7.

79. Hammack, cited in Gordon, *Urban Spectator*, 77.

80. Blackmar, "Uptown Real Estate and the Creation of Times Square," 60.

81. Blackmar, 57.

82. By 1913 the *New York Times* had expanded to 43rd Street, though it retained ownership of the building and still used a small portion to house the advertising department.

83. McKendry, *One Times Square*.

84. Starr and Hayman, *Signs and Wonders*, 154.

85. Starr and Hayman suggest the structure was twenty-four stories. *Signs and Wonders*, 154.

86. McKendry, *One Times Square*.

87. McKendry.

88. Starr and Hayman, *Signs and Wonders*, 154.

89. McKendry, *One Times Square*.

90. The "ball dropping" concept was developed by *Times* owner Adolph Ochs and executed and engineered by Jacob Starr of Artkraft-Strauss, who continued in this role for several decades, until the early 1990s when Ochs and Starr had a falling out with the city.

91. Bloom, *Routledge Guide to Broadway*, x.

92. William Leach, "Introductory Essay," in Taylor, *Inventing Times Square*, 236.

93. Jenkins, "'Signs' of the Times," 157.

94. Blackmar, "Uptown Real Estate and the Creation of Times Square," 59.

95. Rossell, "Compelling Vision," 138–39.

96. In San Francisco in 1916, some 1 million people gathered to witness the installation of the first intensive White Way along Market Street. Starr and Hayman, *Signs and Wonders*, 51.

97. Isenstadt, *Electric Light*, 200; Hibben, "Growth of Ornamental Street Lighting," 83.

98. "New Designs for Street Lighting Units," 224; Kaempffert, *Ornamental Street-Lighting*, 5–6.

99. Rossell, "Compelling Vision," 37–38; Wood, "Ornamental Street Lighting," 208.

100. Rossell, "Compelling Vision," 37; "Value of Good Lighting," 319.

101. Prior to the early 1920s, most electric signs lacked color. This was due in large part to technological limitation but also to neon patent rights. Many sign makers adapted by using incandescent filters and colored glass. Moreover, given the off-white color of most so-called white lighting systems, the attribution of "whiteness" on the country's various White Ways is rendered precarious, especially when taken alongside the book's broader argument for the whitewashing of the American imaginary. See Leach, "Introductory Essay," 238.

102. Cook, "Great White Way," 142, 148.

103. Tell, *Times Square Spectacular*, 25.

104. Cook, "Great White Way," 142.

105. Cook, 148. A number of accounts credit O. J. Gude for coining the term "Great White Way," used to refer to sections of Broadway below Times Square. Isenstadt, *Electric Light*, 161.

106. "Moving Signs along Broadway," 225.

107. Chalmers, "How Broadway's Magic Affects the Stranger," SM5.

108. Jenkins, "'Signs' of the Times," 156.

109. Chalmers, "How Broadway's Magic Affects the Stranger," SM5.

110. "Our 'White Way.'"

111. Jenkins's 1911 article posits that mankind has achieved a state of "perfection" through electric lighting. He invokes the term no less than three times in his short piece, while Jones's 1911 article, "The Most Wonderful Electric Sign

in the World, and How It Is Worked," employs the word "perfection" no less than eight times. See Elliott, "In Lightest New York," n.p.

112. Melzer, "Chapter 2: Low Resolution," in "Screen Clusters," 68.

113. Isenstadt, *Electric Light*, 159; Tell, *Times Square Spectacular*, 25. The Brush Electric Illuminating Company of New York was then located at 133 and 135 W. 25th Street. Once again, contradicting sources suggest that the early lighting system was installed between 14th and 34th Streets. Most likely it was installed in stages, the latter of which was between 25th and 34th Streets.

114. Tell, *Times Square Spectacular*, 25.

115. Bloom, *Routledge Guide to Broadway*, ix.

116. Tell, *Times Square Spectacular*, 29.

117. In response to the vandalism of numerous billboards at the time, Gude deployed aggressive tactics (as Edison had), at times drawing on his "street fighting days." Tell, *Times Square Spectacular*, 52.

118. Tell, *Times Square Spectacular*, 52; Isenstadt, *Electric Light*, 159–61; Starr and Hayman, *Signs and Wonders*, 28–29. Once again, we find contradicting dates. His grandson suggests he started this company in 1878 with "$100 in capital." Gude, "O. J. Gude and Me," n.p.

119. Isenstadt, *Electric Light*, 163; Starr and Hayman, *Signs and Wonders*, 29.

120. The word *spectacular* was very much in vogue for describing large, colorful and attention grabbing, animated, electric signs. Some spectacular signs produced by Gude's company and *not* addressed here include the 1912 Corticelli Kitten, 1915 White Rock Table Water sign, Twins of Power (ca. 1919), Pure Oil Company (1924), Clicquot Club Ginger Ale ("Eskimo sign," 1925), Standard Plumbing (1927), and Dodge Brothers and General Motors (1928). By 1919, Gude had produced more than ten thousand billboards across the United States. Traub, *Devil's Playground*, 51; Gude, "O. J. Gude and Me," n.p.

121. Traub, *Devil's Playground*, 44.

122. Gude is incorrectly attributed with creating the first large-scale electric sign in the city. As Virginia Sebastian notes in her long-standing *Signs of the Times* column, the first large-scale spectacular in the city was Lawrence Jones's 14-foot-high "Paul Jones Pure Rye Has No Equal" sign. Sebastian, "Along Broadway," *Signs of the Times* 110, no. 1 (May 1945): 61.

123. David Nye argues it was a "six story" building. Other sources suggest it was seven (Osdene, "American Neon," 36–37). From what I gather from historical documentation, including black-and-white photographs, the building appears to have seven stories.

124. Prior to its migration to Times Square, the lower sections of Broadway from Midtown to 14th Street were known as the Great White Way. They were the first places where the city installed artificial illumination and large-scale spectacular signs using nondurable incandescent bulbs with colored filters or coatings.

125. "Best 'Ad' in the City."

126. "Best 'Ad' in the City"; Starr and Hayman, *Signs and Wonders*, 55.

127. "The Best 'Ad' in the City."

128. Weigel, "Commoditable Block Party," 36; Isenstadt, *Electric Light*, 163.

129. Starr and Hayman, *Signs and Wonders*, 56.

130. The text on the sign changed periodically. Starr and Hayman note that "Sousa's band soon edged out Gilmore's, Brock's eatery was replaced by Hagenbeck, and Pain's fireworks offered one of the nineteenth century's favorite spectacles." *Signs and Wonders*, 55.

131. As Dreiser's 1930 account describes the sign, "As one line was illuminated the others were made dark, until all had been flashed separately, when they would again be flashed simultaneously and held thus for a time." Dreiser, *Color of a Great City*, 119. See also Isenstadt, *Electric Light*, 163. A unique, historically accurate, digital re-creation of this animation is available at www.ucpress.edu/go/electrographic-architecture

132. "The Best 'Ad' in the City." Conflicting dates suggest the sign came alive in July 1892 (see Nye, *Electrifying America*; and Starr and Hayman, *Signs and Wonders*, 55), while Margaret Weigel suggests it came on in July of that year and was extinguished in 1895 ("Commoditable Block Party," 36), both in contradiction with sources that suggest it remained in place until 1895 (Isenstadt, *Electric Light*, 161); or 1898–1900 when it was replaced by the Heinz pickle sign (Tell, *Times Square Spectacular*, 40; Traub, *Devil's Playground*, 44; Thompson, "Rainbow Ravine," 165). Isenstadt notes that after Corbin's death in 1896, the *New York Times* took over the ad space. *Electric Light*, 163.

133. Weigel includes the color yellow, but Thompson does not. Weigel, "Commoditable Block," 36; Thompson, "Rainbow Ravine," 164.

134. Dreiser, *Color of a Great City*, 119; Isenstadt, *Electric Light*, 163.

135. "Watts in a Name," 68. The "talking sign" consisted of "any desired number of monograms or units in each of which any letter or figure can be formed by lighting certain combinations of incandescent lamps." Typically, this early system of electric sign could be manipulated to flash on and off different messages by forming the metal compartments in the body of the sign to give and receive signals to light up specific incandescent bulbs in sequence. In 1900, Egbert Reynolds Dull developed a method for using "bimetallic thermostats" with sign lamps to "create the first automatic flasher." "The Talking Sign," 140; Isenstadt, *Electric Light*, 163–65; "Electric Sign Flashers," 1210.

136. Gude, "Art and Advertising," 3; and Gude, "10 Minute Talk," 77; Leach, "Introductory Essay," 236.

137. Blank's Biscuits in particular led an especially contentious advertising campaign in the early twentieth century. The company's ads were so liberally posted around New York City that many residents began to protest. Eventually these protests spread to the electric advertisements, and Gude was at the forefront of defending them.

138. Tell, *Times Square Spectacular*, 44.

139. Tell, 44.

140. Tell, 46.

141. Traub, *Devil's Playground*, 44; Gude, "O.J. Gude and Me." Circa 1869, Henry John Heinz and L. Clarence Noble established the Heinz & Noble Company in Sharpsburg, Pennsylvania, for the purposes of bottling horseradish. In 1896, they introduced their "57 Varieties" slogan featured in this sign.

142. Osdene, "American Neon," 36–37; Holliday, "Through the Years," 20; Traub, *Devil's Playground*, 44. Traub's list includes "Sweet Pickles, Tomato Ketchup, India Relish, Tomato Soup, and Peach Butter," though the image (figure 3.7) uses "Tomato Chutney" instead and does not include the latter two items.

143. Starr and Hayman, *Signs and Wonders*, 57.

144. Starr and Hayman, 57. Thompson concurs: the sign was "widely decried as vulgar." "Rainbow Ravine," 165.

145. Starr and Hayman, *Signs and Wonders*, 57.

146. Traub, *Devil's Playground*, 45.

147. "Moving Signs along Broadway," 226. The rain and wind switched on and off every twenty seconds.

148. The text read, "Insist upon the Label." Tell, *Times Square Spectacular*, 46; Starr and Hayman, *Signs and Wonders*, 65.

149. Isenstadt, *Electric Light*, 167.

150. The rampant sex industry in Times Square is addressed in chapter 6.

151. Lears, *Fables of Abundance*, 10.

152. Lears continues, "Even the flagrantly sexual advertisements of recent years have presented erotic appeal as the product of disciplined conditioning." *Fables of Abundance*, 10.

153. Jones, "Most Wonderful Electric Sign," 544.

154. Jones, 541. The bulbs ranged from two to thirty-two candle power. Jenkins, "'Signs' of the Times," 157.

155. Jones, "The Most Wonderful Electric Sign," 542.

156. Jones, 541. Jones suggests that a tradesman coveted this interior space for his own, but, alas, the majority of these midtown Manhattan rooms were used for storing the various devices required to operate the sign. For more on this oddity, see Shannon Mattern's discussion of buildings constructed for electric wiring in Manhattan in the early twentieth century in *Code and Clay*.

157. Rossell, "Compelling Vision," 141; Isenstadt, *Electric Light*, 169.

158. These workers were tasked with scanning "the sign with as much care and anxiety as though he were a shipwrecked mariner 'looking for a sail.'" The office, Jones adds, was "some considerable distance from the sign, though in direct line of vision." "Most Wonderful Electric Sign," 541.

159. Jones, "Most Wonderful Electric Sign," 541.

160. The forty flashes per second were "faster than the eye can follow," rendering the movement, according to Jones, "visionally perfect" (542).

161. Nye, *Electrifying America*, 52–53.

162. Jones, "Most Wonderful Electric Sign," 544.

163. Jones, 544; Nye, *Electrifying America*, 52–53.

164. Jenkins, "'Signs' of the Times," 157. "When the current is turned on, this chariot actually seems to sway as the horses tear along. Although the near wheel does not actually turn, the flashing of the lights is so rapid that no observer could say with certainty that the wheel does not revolve." Jones, "Most Wonderful Electric Sign," 542.

165. Jones, "Most Wonderful Electric Sign," 540.

166. Jones, 544.

167. "The lights that decorate the arena seem to move in an opposite direction." Jones, 540.

168. Jones, 540; Nye, *Electrifying America*, 52–53.

169. Jenkins, "'Signs' of the Times," 157.

170. A second 20-foot-by-100-foot steel structure in the shape of a "curtain" bore the text "Leaders of the World." A cycle of 150 messages would repeat every forty minutes. In contrast, Nye suggests, "this portion of the sign operated on a ten-minute cycle, allowing up to ten different corporations to advertise." "The different announcements are shown on the curtain every few minutes and can be changed by cable or telegraph if necessary." Traub, *Devil's Playground*, 47; Nye, *Electrifying America*, 52–53; Jones, "Most Wonderful Electric Sign," 543.

171. Isenstadt, *Electric Light*, 169.

172. Jones, "Most Wonderful Electric Sign," 543.

173. Starr and Hayman, *Signs and Wonders*, 60.

174. Jones, "Most Wonderful Electric Sign," 539–40.

175. Jones, "Most Wonderful Electric Sign," 542. Readers may return to chapter 1 for a discussion of the links between Greco-Roman art and architecture and a legacy of Western whiteness.

176. Gude constructed his first sign for Wrigley's in 1911 in Herald Square. His initial display was for the "Wm. Wrigley, Junior Company," used a modest 4,100 lamps, and stood atop the Browning King & Co. building at 32nd Street and Broadway. For more on this sign, see the April 1912 issue of *Signs of the Times*.

177. Traub, *Devil's Playground*, 51.

178. This display dominated Broadway until 1924, when the Putnam Building was replaced by the Paramount Building. "The World's Largest Spectacular," 7; Traub, *Devil's Playground*, 51. McKendry argues that the sign was not positioned along Broadway but instead along Seventh Avenue. *One.*

179. Traub, *Devil's Playground*, 51. Starr and Hayman write that the "Chicago chewing gum magnate . . . was a pioneer in the aggressive use of national brand advertising." *Signs and Wonders*, 66.

180. Starr and Hayman, *Signs and Wonders*, 66.

181. Traub, *Devil's Playground*, 51.

182. Starr and Hayman, *Signs and Wonders*, 67; Traub, *Devil's Playground*, 51.

183. "The World's Largest Spectacular," 7.

184. Traub, *Devil's Playground*, 51.

185. "The World's Largest Spectacular," 7; Traub, *Devil's Playground*, 51.

186. Starr and Hayman, *Signs and Wonders*, 66.

187. Leach posits that the sign was only 80 feet high, and he and Starr and Hayman report 17,500 lamps, while Isenstadt claims "17,266 bulbs." Leach also says the sign cost only $9,000 a month to rent. Starr and Hayman, *Signs and Wonders*, 66; Leach, *Land of Desire*, 67, 341; Isenstadt, *Electric Light*, 167.

188. Wrigley's boasted hundreds of thousands of people coming to the Square each day to see "the largest electric sign in the world." Wrigley's Chewing Gum, 6.

189. Starr and Hayman claim that the sign marks the pinnacle of Gude's career. *Signs and Wonders*, 66.

190. Traub, *Devil's Playground*, 51; Gude, "O.J. Gude and Me"; Starr and Hayman, *Signs and Wonders*, 66.

191. Tell, *Times Square Spectacular*, 52.

192. Tell, *Times Square Spectacular*, 33.

193. Moralist reformer Jacob Riis took photographs in the late 1800s that he used to support the CB movement.

194. Tell, *Times Square Spectacular*, 33.

195. Tell, 48. European cities had been undergoing their own variation of advertising reform. For more, see Nye, *American Technological Sublime*, 190.

196. Jacobs, *Death and Life of Great American Cities*, 375.

197. Jacobs, 14.

198. Jacobs, 14.

199. Jacobs, 14.

200. Jacobs, 14–15.

201. In the post-COVID-19 era the concept of whitewashing the city carries a new force. If cities are indeed landscapes of "sick architecture," as Beatriz Colomina suggests, full of death and disease as breathing entities that need "clean" (white) light and air, then the post-COVID-19 landscape could not be sicker, with urban encampments, social neglect, and business collapse. What seems to be emerging from the pandemic is a demand for more whitewashing (order, control, and social surveillance).

202. The city's market was established in the mid-1860s, when it functioned as a hub for the exchange and circulation of information. By 1870, approximately 57 percent of all imported and exported goods passed through the port of New York. By 1900, this number had fallen to just below 50 percent. Hammack, cited in Taylor, *Inventing Times Square*, 37.

203. Hammack, 37.

204. Hammack, 38.

205. Hammack, 39.

206. The Holland Tunnel was developed in 1927, the George Washington Bridge in 1931, the Triborough Bridge in 1936, and the West Side Highway in 1903. The Lincoln Tunnel opened to the public in 1937, and the Queens-Midtown Tunnel in 1940, all contributing to increased traffic in and out of the city center.

207. Hammack, 39.

208. Hammack, 36.

209. Gordon, *Urban Spectator*, 84.

210. Chalmers, "How Broadway's Magic Affects the Stranger," SM5.

CHAPTER 4

Epigraphs: Sebastian, "Along Broadway," 117, no. 3 (November 1947): 119; Charyn, *Metropolis*, 95.

1. This catalog is assembled from primary and secondary sources, such as the industry standard magazine *Signs of the Times* and Virginia Sebastian's monthly column for it, "Along Broadway," written from the mid-1940s through

the late 1950s. Sebastian worked in the *Signs of the Times* office in the Flatiron Building and was appointed secretary of the New York Electric Sign Association in 1945. It is also worth noting her role as a female journalist in a field largely dominated by Euro-American men. In one issue, Sebastian calls attention to "some prominent women actively engaged in sign manufacturing," noting Violette Baldwin and Frances Kufahl. Sebastian, "Along Broadway," *Signs of the Times* 110, no. 3 (July 1945): 61; 111, no. 2 (October 1945): 61; 127, no. 3 (March 1951): 94.

2. See www.ucpress.edu/go/electrographic-architecture.

3. Berlant, *Cruel Optimism*, 3, 229, 262–63.

4. "New Age of Color," 22. See also Eskilson, "America the Spectacle," 1.

5. "New Age of Color," 22.

6. "New Age of Color," 22.

7. Kracauer, *Mass Ornament*, 75.

8. *La Société du spectacle* (Society of the Spectacle) is a 1973 film by Situationist Guy Debord based on the 1967 book of the same title. See also Crary, "Spectacle, Attention, Counter-Memory"; and Eskilson, "America the Spectacle," 3.

9. Gordon, *Urban Spectator*, 85.

10. Hammack, "Developing for Commercial Culture," in Taylor, *Inventing Times Square*, 48.

11. Knapp, "Introductory Essay," in Taylor, *Inventing Times Square*, 179.

12. McKendry, *One Times Square*, n.p.

13. "Watts in a Name," 68.

14. Nye, *American Technological Sublime*, 187.

15. Berger, "From White Way to Color Canyon," 34–36; Tell, *Times Square Spectacular*, 99.

16. Leach, *Land of Desire*.

17. McKendry, *One Times Square*.

18. McKendry.

19. Anniston was at this time an "important manufacturing center for the cast iron lamp posts" that were being used across the country's White Ways, typically bought and sold by General Electric between 1900 and 1930. Tell, *Times Square Spectacular*, 108; Sellmer, "Douglas Leigh," 49.

20. "Douglas Leigh Weds Model," 29.

21. Blake, *God's Own Junkyard*, 12–13; Osdene, "American Neon Signs," 144; Tell, *Times Square Spectacular*, 108.

22. Sellmer, "Douglas Leigh," 49.

23. After leaving the Brooklyn branch of General Outdoor Advertising in 1933, Leigh conducted his first on-foot survey of the existing signage in Times Square. He concluded that there were 90,500 lightbulbs on signs and approximately "73,500 feet of neon burning in excess of 2 million watts an hour." If the average sign had 2 miles of wiring, he reasoned, with "signed rental rates totaling 355,000 per year," this amount "exceeded interior rentals by two or three times." Profit was his for the taking. He used his statistics to persuade the posh St. Moritz Hotel at 50 Central Park South (currently the site of the Ritz-Carlton) to hire him to advertise its $4-a-night rooms on a billboard at the

intersection of Fordham Road and Crotona Avenue in the Bronx. In exchange, the St. Moritz offered Leigh a meal plan at its restaurant and a hotel room for a year, which also served as the home for his new business, Douglas Leigh Inc. Martin, "Douglas Leigh," B1; Spielvogel, "Takes 'White Way' to Reach the Top," 3; Charyn, *Metropolis*, 92.

24. Charyn, *Metropolis*, 92.

25. At the University of Florida, Leigh "bought all the advertising space in the yearbook for $2,000 on credit and then resold the space for over $7,000. He dropped out after his sophomore year. Martin, "Douglas Leigh," B1; Sellmer, "Douglas Leigh," 49–50.

26. By 1941, his company had earned $1.5 million. Martin, "Douglas Leigh," B1.

27. Charyn, *Metropolis*, 92. Martin claims this{{lt}}?{{gt}} was $9.00. Martin, "Douglas Leigh," B1; Tell, *Times Square Spectacular*, 103; Starr and Hayman, *Signs and Wonders*, 105; Canemaker, "Electric Felix Man," n.p.

28. Sellmer, "Douglas Leigh," 49.

29. Martin, "Douglas Leigh," B1.

30. Starr and Hayman, *Signs and Wonders*, 104.

31. Martin, "Douglas Leigh," B1; Kahn, "Lights, Lights, Lights," 24–25.

32. And while this mythology certainly rang true on a professional level, on a personal one, Leigh experienced several losses. For example, in 1937, he married Patricia De Brun. They lived together at 7 Beekman Place in Midtown East until 1941, when De Brun died at the age of twenty-two after an operation at Roosevelt Hospital. In 1943, Leigh married former John Powers model Ann Rush of St. Joseph, Montana. By 1949 they had divorced, and on July 18, 1949, Leigh married a third time, to New York model Betty ("Elsie") Patricia Chamberlain. Together they birthed and raised two daughters, Lucinda (whose name, they discovered after the fact, means "light" in Latin) and Heidi. Leigh continued to reside in his luxurious Beekman Place apartment (in a privileged neighborhood in Manhattan where "advertising signs of any sort are forbidden") until his retirement. "Mrs. Douglas Leigh," 23; Sellmer, "Douglas Leigh," 51; "Douglas Leigh Weds Model," 29; Martin, "Douglas Leigh," B1.

33. Blake, *God's Own Junkyard*, 12–13; Osdene, "American Neon Signs," 144.

34. Berger, "From White Way to Color Canyon," 34. Isenstadt concurs: "By all accounts, Douglas Leigh was the master." *Electric Light*, 169.

35. Charyn, *Metropolis*, 91.

36. Tell, *Times Square Spectacular*, 103.

37. This fact also underscores Tom Wolfe's point about the downgrading of commercial art. See the present book's introductory discussion of its title, *Electrographic Architecture*.

38. Gilbert, "Living Legend in Lights," n.p.

39. Conner, "Good Enough Never Really Is," 90.

40. Starr and Hayman, *Signs and Wonders*, 18.

41. Starr and Hayman, 19.

42. Jacob Starr died in 1976 at eighty-seven years old at the Doctors Hospital in Manhattan. He lived at 1095 Park Avenue. During his life he was a trustee

of the Park Avenue Synagogue and the founder of the Albert Einstein College of Medicine and the Hebrew University of Jerusalem. "Jacob Starr," 31.

43. Starr and Hayman, *Signs and Wonders*, 33.

44. Starr and Hayman, 33.

45. Starr and Hayman, 33.

46. Starr and Hayman, 33. A number of elements in this discussion draw from Starr and Hayman's *Signs and Wonders*, cowritten by Jacob Starr's granddaughter, Tama Starr. Another, anonymous historian of the sign industry pointed out to me that Starr and Hayman's text offers unwarranted praise of Jacob and his company.

47. The nearest power station was 250 miles away, in Kiev, and did not gain electricity until the early years of the following century. In the mid-1880s, the Edison Company built more than three hundred electric generating plants in Europe and Russia, but most were located in larger cities such as Kiev. Starr and Hayman, *Signs and Wonders*, 33, 18.

48. Starr and Hayman, *Signs and Wonders*, 34–35.

49. Starr and Hayman, 35.

50. Starr and Hayman, 36.

51. Starr and Hayman, 36.

52. Starr and Hayman, 36.

53. Conner, "Good Enough Never Really Is," 90; Chance, "Bright Lights," 22.

54. Conner, "Good Enough Never Really Is," 90; Chance, "Bright Lights," 22; Starr and Hayman, *Signs and Wonders*, 63.

55. Starr and Hayman, *Signs and Wonders*, 102.

56. Chance, "Bright Lights," 21.

57. Starr and Hayman, *Signs and Wonders*, 87.

58. Tell, *Times Square Spectacular*, 101.

59. Conner, "Good Enough Never Really Is," 91.

60. Conner, 91.

61. Chance, "Bright Lights," 21. Starr and Hayman's contrasting dates suggest that "in 1934 [Starr] renewed his association with Strauss." *Signs and Wonders*, 103.

62. Conner, "Good Enough Never Really Is," 91.

63. Starr and Hayman, *Signs and Wonders*, 103.

64. Gilbert, "Living Legend in Lights."

65. "Bond Adds New Note," 28; Sebastian, "Along Broadway," *Signs of the Times* 112, no. 1 (January 1946): 95.

66. Conner, "Good Enough Never Really Is," 91.

67. By 1932, Starr had accumulated enough capital to buy half of New York Artkraft, and by 1933, he bought out his partners entirely and set up his own fabrication plant. Conner, 91.

68. Conner, 91.

69. Conner, 91.

70. Martin, "Douglas Leigh," B1.

71. Tell, *Times Square Spectacular*, 108.

72. Tell, 104.

73. "Douglas Leigh," *Hearst's International*, 8.

74. "Douglas Leigh," *Hearst's International*, 8.

75. "Douglas Leigh," *Hearst's International*, 8.

76. Sellmer, "Douglas Leigh," 50.

77. Berger, "From White Way to Color Canyon," 35.

78. Berger, 36.

79. Berger, 36.

80. Gray, "Man behind Times Square's Smoke Rings," 5; Isenstadt, *Electric Light*, 169.

81. Berger, "From White Way to Color Canyon," 35.

82. Berger, 36.

83. Starr and Hayman, *Signs and Wonders*, 106.

84. Thompson, "Rainbow Ravine," 172.

85. Martin, "Douglas Leigh," B1.

86. Tell, *Times Square Spectacular*, 103.

87. Spielvogel, "Takes 'White Way' to Reach the Top," 3; Martin, "Douglas Leigh," B1; Tell, *Times Square Spectacular*, 101; Isenstadt, *Electric Light*, 161. While the sign was indisputably original, it should also be noted that a precursor was a 1909 painted representation of a steaming coffee cup created by lighting designer Mortimer Norden, who had worked with General Outdoor Advertising since the 1920s. Norden also used real smoke and sound in one of his movie theater sign designs from the period and was responsible for the 1932 neon lighting effects on the streamlined marquee at Radio City.

88. "Douglas Leigh," *Hearst's International*, 8.

89. Tell, *Times Square Spectacular*, 104; Winchell, "On Broadway," 1935, n.p.

90. Spielvogel, "Takes 'White Way' to Reach the Top," 3.

91. Isenstadt, *Electric Light*, 161.

92. Starr and Hayman, *Signs and Wonders*, 108.

93. Starr and Hayman, 108.

94. Starr and Hayman, 109.

95. Starr and Hayman, 109.

96. Roosevelt was already planning on repealing prohibition in order to generate taxes for the cash-strapped, Depression-era nation, and not surprisingly, he was elected into office. Starr and Hayman, *Signs and Wonders*, 109.

97. "Ballantine Display on Broadway," 38; Starr and Hayman, *Signs and Wonders*, 110.

98. Starr and Hayman, as well as Tell, claim the Brill Building was located at 48th Street, but there is no indication that it moved from the place of its original construction in 1931, at 1619 Broadway, near 49th Street. Tell, *Times Square Spectacular*, 104; Starr and Hayman, *Signs and Wonders*, 110; "Ballantine Display on Broadway," 36, 39.

99. "Ballantine Display on Broadway," 36; Tell, *Times Square Spectacular*, 106.

100. As each ring moved, it took two seconds to expand from 3 to 10 feet to create the visual effect that it was moving forward in space. "Ballantine Display on Broadway," 36–37; Tell, *Times Square Spectacular*, 106.

101. "Ballantine Display on Broadway," 36–37.

102. "Ballantine Display on Broadway," 36.

103. "Ballantine Display on Broadway," 36; Starr and Hayman, *Signs and Wonders*, 110.

104. "Ballantine Display on Broadway," 36.

105. "Tomorrow's Weather," 84.

106. Gray, "Man behind Times Square's Smoke Rings," 5.

107. "Tomorrow's Weather," 84.

108. "Add Pendulum and Chimes," *Signs of the Times* 92, no. 2 (June 1939): 55–56. Eventually, neighbors complained of the incessant noise, and as a result, the sound effects were removed.

109. "World's Largest Spectacular," 7.

110. Starr and Hayman, *Signs and Wonders*, 130.

111. "World's Largest Spectacular," 8.

112. Nye, *American Technological Sublime*, 186.

113. Starr and Hayman, *Signs and Wonders*, 85. Claude brought neon to the United States in 1922 and almost immediately made an offer to sell the exclusive rights to use his technology to General Electric for $5 million. General Electric refused, remaining "stubbornly wedded" to its incandescent bulb.

114. Tell, *Times Square Spectacular*, 115.

115. "World's Largest Spectacular," 8.

116. "World's Largest Spectacular," 8; Tell, *Times Square Spectacular*, 115.

117. Starr and Hayman, *Signs and Wonders*, 128–30; McKendry, *One Times Square*; Tell, *Times Square Spectacular*, 115.

118. "World's Largest Spectacular," 7.

119. "World's Largest Spectacular," 7.

120. "World's Largest Spectacular," 7.

121. "Leigh-Epok," 28.

122. Leigh to U.S. Consulate, September 6, 1940, 1–2, in Douglas Leigh Papers; Spielvogel, "Takes 'White Way' to Reach the Top," 3; "Leigh-Epok," 29.

123. "Leigh-Epok," 28–29. Kerwer also eventually attained the title of vice-president. Sellmer, "Douglas Leigh," 51.

124. "Leigh's Biggest," 10.

125. Rochlin, "Bringing Advertising to Life," 10.

126. The illustrations were possibly the most challenging part of the sequence, as everything needed to be drawn in black-and-white on graph paper. Registering facial expressions was especially difficult. For example, an animation of a fisherman drawing his line from a river might involve up to twenty separate illustrations to make the gesture believable to a viewer. Leigh himself stated in a 1938 article that the Epok animations could last anywhere from "five minutes to an hour." Rochlin, "Bringing Advertising to Life," 10; "Illuminated Sign That Stopped Broadway in Its Tracks," 4; Leigh, cited in "Leigh-Epok," 28.

127. Rochlin, "Bringing Advertising to Life," 10.

128. "The film is made same as a movie [or] cartoon, frame by frame photographing of innumerable still drawings." "Leigh-Epok," 28; Rochlin, "Bringing Advertising to Life," 10.

129. Rochlin, "Bringing Advertising to Life," 11.

130. "Leigh-Epok," 28; Rochlin, "Bringing Advertising to Life," 10.

131. "Leigh's Biggest," 10; Thompson, "Rainbow Ravine," 172.

132. Rochlin, "Bringing Advertising to Life," 10.

133. Early Epok signs used one photocell for each of the four bulbs on the screen outside.

134. "Leigh-Epok," 28; Thompson, "Rainbow Ravine," 172–73.

135. "Leigh's Biggest," 10.

136. Thompson, "Rainbow Ravine," 173.

137. Starr and Hayman, *Signs and Wonders*, 118.

138. Rochlin, "Bringing Advertising to Life," 22.

139. Tell, *Times Square Spectacular*, 113.

140. Rochlin, "Bringing Advertising to Life," 22.

141. Tell, *Times Square Spectacular*, 113.

142. In 1941, alterations to the "Wilson Whiskey" spectacular distinguished it as the first color Epok, discussed below. "Leigh-Epok," 28; Tell, *Times Square Spectacular*, 114.

143. "Leigh-Epok," 29.

144. Canemaker, "Electric Felix Man."

145. Canemaker.

146. "Leigh-Epok," 29; "Leigh's Biggest," 10.

147. "Leigh's Biggest," 10.

148. "Leigh's Biggest," 10.

149. "Leigh-Epok," 29.

150. "Two Spectaculars in the Making," 28–30.

151. Apparently, the Coca-Cola company, the Boy Scouts of America, and *Ladies Home Journal* also used the swastika symbol.

152. "More Promotion—More Business," 12; "Two Spectaculars in the Making," 28.

153. "Each rose weighs nearly a ton, and a sign erecting crew of 25 was needed to hoist them the 160 feet from the sidewalk of Broadway." "Two Spectaculars in the Making," 28.

154. "More Promotion—More Business," 12.

155. "More Promotion—More Business," 12.

156. "Two Spectaculars in the Making," 28–29; "More Promotion—More Business," 11.

157. "More Promotion—More Business," 12.

158. "More Promotion—More Business," 12.

159. "More Promotion—More Business," 11.

160. Frankfort Distilleries declared that the launch of "Four Roses" would last a week. Salesmen from the company positioned miniature displays of the spectacular in local restaurants and bars, emphasizing the sign's enormous size relative to the island of Manhattan. "More Promotion—More Business," 11.

161. "Old Gold Spectacular," 13. Thompson claims the first was Epok, but the two other sources cited above suggest otherwise. Thompson, "Rainbow Ravine," 173.

162. Rochlin, "Bringing Advertising to Life," 11; "Old Gold Spectacular," 13; "Two Spectaculars in the Making," 29.

163. "Two Spectaculars in the Making," 29; "Old Gold Spectacular," 14.

164. "Old Gold Spectacular," 14; undated press clippings, Douglas Leigh Papers, 1903–1999.

165. In the scale model, the text read "America's Smoothest Cigarette." "Two Spectaculars in the Making," 29; "Old Gold Spectacular," 14.

166. Thompson, "Rainbow Ravine," 173; "Old Gold Spectacular," 13–15.

167. "Two Spectaculars in the Making," 29.

168. Starr and Hayman, *Signs and Wonders*, 117; "Two Spectaculars in the Making," 29.

169. "Old Gold Spectacular," 13–14.

170. "Two Spectaculars in the Making," 29.

171. Diana Fuentes, quoted in Echeverría, *Modernity and "Whiteness,"* xvi.

172. "Old Gold Spectacular," 13.

173. "Old Gold Spectacular," 14.

174. For more on the fair, see Gelernter, *1939*.

175. Gelernter, *1939*, 344.

176. "Biggest 3-D Spectacular," 23; Gelernter, *1939*, 344.

177. Tell, *Times Square Spectacular*, 115.

178. Sellmer, "Douglas Leigh," 48; "Biggest 3-D Spectacular," 23.

179. Rochlin, "Bringing Advertising to Life," 22.

180. Rochlin, "Bringing Advertising to Life," 22; Tell, *Times Square Spectacular*, 113; Rochlin, "Bringing Advertising to Life," 22; Thompson, "Rainbow Ravine," 172–73.

181. Rochlin, "Bringing Advertising to Life," 11.

182. Tell, *Times Square Spectacular*, 114.

183. Tell, 115.

184. Tell, 115.

185. Tell, 114.

186. Tell, 115.

187. In the case of the 1941 Epok, police were needed to continually monitor the area in order to keep people moving rather than standing and "gawking" at the spectacle overhead. In most cases, people were gently ushered along, save for one case when African American performer Bill Robinson was arrested for watching his own tap dance performance in *The Hot Mikado* on the giant screen. As Thompson recounts it, Robinson was "arrested for refusing to move" because he was preoccupied watching his own performance, doing "my own tap dance" in the Hot Mikado. Thompson, "Rainbow Ravine," 173.

188. Tell, *Times Square*, 120.

189. Tell, 120.

190. Sebastian, "Along Broadway," *Signs of the Times* 109, no. 4 (April 1945): 65.

191. Sellmer, "Douglas Leigh," 47.

192. Tell, *Times Square Spectacular*, 121.

193. Tell, 122.

194. Tell, 121.

195. Tell, 121.

196. Tell, 119.

197. Spielvogel, "Takes 'White Way' to Reach the Top," 3. Duplications quickly popped up in twenty-two other US cities from Detroit to Los Angeles. Sellmer, "Douglas Leigh," 47. Sellmer, writing his article for *Life* Magazine in 1946, reported the replication of the Camel sign in only nine cities to date.

198. McKendry, *One Times Square*.

199. Starr and Hayman, *Signs and Wonders*, 141.

200. Tell, *Times Square Spectacular*, 119.

201. Starr and Hayman, *Signs and Wonders*, 141.

202. Starr and Hayman, 142.

203. Sebastian, "Along Broadway," *Signs of the Times* 119, no. 2 (June 1948): 81.

204. Sebastian, 81.

205. Spielvogel, "Takes 'White Way' to Reach the Top," 3.

206. Starr and Hayman, *Signs and Wonders*, 147–48.

207. Martin, "Douglas Leigh," B1.

208. Martin.

209. Starr and Hayman, *Signs and Wonders*, 147–48.

210. "Bond Adds New Note," 29; Sebastian, "Along Broadway," *Signs of the Times* 118, no. 4 (April 1948): 122.

211. Sebastian, "Along Broadway" (June 1948). Starr and Hayman suggest the falls were 132 feet wide. *Signs and Wonders*, 148.

212. "Biggest 3-D Spectacular," 23.

213. McKendry, *One Times Square*; Spielvogel, "Takes 'White Way' to Reach the Top," 3; Starr and Hayman, *Signs and Wonders*, 148.

214. Sebastian, "Along Broadway" (April 1948).

215. "Bond Adds New Note," 91.

216. Starr and Hayman, *Signs and Wonders*, 147.

217. As amended in the *Signs of the Times*, the zipper is not the longest but only bears the longest surface. The longest one was built by F. E. J. Wilde for the *New York Times* building and is 380 feet. Sebastian "Along Broadway," *Signs of the Times* 119, no. 1 (May 1948): 166; Martin, "Douglas Leigh," B1; Starr and Hayman, *Signs and Wonders*, 147–48.

218. Starr and Hayman, *Signs and Wonders*, 148.

219. "Bond Adds New Note," 91, 28.

220. Sebastian, "Along Broadway," *Signs of the Times* 119, no. 3 (July 1948): 89.

221. Berman, cited in Isenstadt, *Electric Light*, 199.

222. McKendry, *One Times Square*.

223. "Biggest 3-D Spectacular," 23.

224. "Biggest 3-D Spectacular," 23.

225. According to *Signs of the Times*, it would take about 1 million 8-ounce bottles of Pepsi to fill both of these bottles to capacity. "Biggest 3-D Spectacular," 23.

226. Starr and Hayman, *Signs and Wonders*, 149; "Biggest 3-D Spectacular," 23.

227. "Biggest 3-D Spectacular," 23.

228. "Biggest 3-D Spectacular," 23; "Artist's Preview of New Spectacular," 56.

229. "Biggest 3-D Spectacular," 23.

230. Sebastian, "Along Broadway," *Signs of the Times* 140, no. 2 (June 1955): 96.

231. "Goodyear Blimp Goes Neon," 106.

232. Sebastian, "Along Broadway," *Signs of the Times* 120, no. 1 (September 1948): 121.

233. "Goodyear Blimp Comes Home as Salesman," 40; "Greatest Event in the History of Outdoor Advertising," 127.

234. "Greatest Event in the History of Outdoor Advertising," 127; "Tydol Now Using Leigh Blimp," 123; "Goodyear Blimp Comes Home as Salesman," 40.

235. Thompson, "Rainbow Ravine," 172.

236. "Goodyear Blimp Comes Home as Salesman," 40.

237. "Goodyear Blimp Comes Home as Salesman," 40.

238. "Goodyear Blimp Comes Home as Salesman," 40.

239. "Goodyear Blimp Goes Neon," 106.

240. "Goodyear Blimp Comes Home as Salesman," 40.

241. "Goodyear Blimp Comes Home as Salesman," 40.

242. "Goodyear Blimp Comes Home as Salesman," 40.

243. "Goodyear Blimp Comes Home as Salesman," 40.

244. By late 1947, Leigh had expanded his flight routes from the East Coast to the West Coast, including one from Canada to Mexico. "Goodyear Blimp Goes Neon," 106.

245. Sebastian, "Along Broadway," *Signs of the Times* 115, no. 2 (February 1947): 126; "Tydol Now Using Leigh Blimp," 123.

246. "Tydol Now Using Leigh Blimp," 123.

247. Sebastian, "Along Broadway," *Signs of the Times* 115, no. 4 (April 1947): 119; "Tydol Now Using Leigh Blimp," 123.

248. Sebastian, "Along Broadway" (April 1947), 119.

249. Sebastian, "Along Broadway," *Signs of the Times* 113, no. 3 (July 1946): 104; Spielvogel, "Takes 'White Way' to Reach the Top," 3.

250. "Times Tower Sold," 1.

251. The Crow Construction Company was hired to "strip the tower of its masonry and replace it with marble and glass." "Times Sq. Will Get Malls of Flowers," 70; "Allied Tower," 19.

252. Tell, *Times Square Spectacular*, 142.

253. "Leigh Is Re-elected," 26. Also in 1964, Leigh contributed between $38,000 and $40,000 for flowers and landscaping in the center islands of Times Square and purchased the Claridge Hotel (a fourteen-story French Renaissance structure built in the early 1900s and the site of his famous Camel spectacular [1941–66]). "Times Sq. Will Get Miles of Flowers," 70.

254. Tell, *Times Square Spectacular*, 143.

255. Martin, "Douglas Leigh," B1; Gray, "Man behind Times Square's Smoke Rings" 5; Tell, *Times Square Spectacular*, 166. Leigh was also appointed official decorator for the Democratic Party's presidential nominating convention.

256. Martin, "Douglas Leigh," B1; Tell, *Times Square Spectacular*, 147.

257. Gray, "Man behind Times Square's Smoke Rings," 5.

CHAPTER 5

Epigraph: Benjamin, "This Space for Rent," 476.

1. Noteworthy exceptions include Barnard, *Magic Sign*; Rinaldi, *New York Neon*; Ribbat, *Flickering Light*; Osdene, "American Neon Signs"; Stern, *Let There Be Neon*; and DeLyser and Greenstein, *Neon*.

2. Al, "The Strip," 8.

3. Prior to its identification in chemistry, neon was recognized in the "neon tetra" (*Paracheirodon innesi*), a freshwater fish native to the upper Amazon.

4. Starr and Hayman, *Signs and Wonders*, 84.

5. Starr and Hayman, 82.

6. Starr and Hayman, 82.

7. This is the process of sending gas through pressurized glass tubes to isolate their constituents.

8. Starr and Hayman, *Signs and Wonders*, 84.

9. Knight, *Ideas in Chemistry*, 7; Rinaldi, *New York Neon*, 19.

10. Ribbat, *Flickering Light*, 7, 23.

11. Starr and Hayman, *Signs and Wonders*, 84.

12. Miller, *Neon Techniques*, 14.

13. Crowe, "Neon Signs," 30; Miller, *Neon Techniques*, 63.

14. Miller, 134; Osdene, "American Neon Signs," 64.

15. *Signs of the Times*, 17.

16. Jeff Friedman, 2016, interview with author.

17. Miller, *Neon Techniques*, 38.

18. Miller, 24–25, 29.

19. Crowe, "Neon Signs," 31; Osdene, "American Neon Signs," 56.

20. Miller, *Neon Techniques*, 5.

21. Early on, porcelain enamel backing was used to coat neon signs.

22. Stern, *Let There Be Neon*, 34.

23. Osdene, "American Neon Signs," 72, 80; Ulmer and Plaichinger, *Les Escritures De La Nuit*, 21–22. Arguably, Ramsay and Travers's display was the first public exhibition, though it is possible that the Queen's Jubilee would not be considered public or that the second public display was more rigorous and systematically repeatable.

24. Osdene, "American Neon Signs," 69.

25. Stern, *Let There Be Neon*, 34.

26. "Bright Lights," 38; Ribbat, *Flickering Light*, 34.

27. Crowe, "Neon Signs," 31; Stern, *Let There Be Neon*, 34.

28. Ribbat, *Flickering Light*, 34.

29. Former European manager for Westinghouse Electric W. T. Hollingsworth had met Georges Claude in France at the turn of the century, after which he traveled to the United States to organize and distribute neon tubing for Claude Neon, hoping to form Claude Neon Lights, Inc. Hollingsworth was later arrested in "his suite in the Hotel Savoy-Plaza on a charge of having made

false representations in recent newspaper advertising." "Bright Lights," 38; "Financier Arrested," 1, 28.

30. DeLyser and Greenstein persuasively argue that the sign did not appear until 1926, contrary to standing accounts that date the sign to 1923. *Neon.*

31. Stern, *Let There Be Neon*, 34; Starr and Hayman, *Signs and Wonders*, 85, 95.

32. "Bright Lights," 38. In Starr and Hayman's account, Claude offered to sell the exclusive rights to use his technology to General Electric for $5 million, but it mistakenly refused as it remained "stubbornly wedded" to the incandescent bulb. *Signs and Wonders*, 85. As a result, Claude formed a franchise agreement with Jacob Strauss, and in 1924, they sold the first American neon spectacular to Willys-Knight Overland Motors, at 45th Street and Broadway. Ibid., 86, 90.

33. Stern, *Let There Be Neon*, 24.

34. By 1925, Claude had acquired six patents on his neon process and equipment, granted by the US Patent Office, in order to establish a national network of neon franchises. Starr and Hayman, *Signs and Wonders*, 81.

35. "Bright Lights," 38.

36. "Bright Lights," 38.

37. Starr and Hayman, *Signs and Wonders*, 96.

38. "Bright Lights," 38.

39. Osdene, "American Neon Signs," 141.

40. Starr and Hayman, *Signs and Wonders*, 96.

41. Barnard, *Magic Sign*, 23.

42. Chase, *Glitter Stucco*, 118.

43. Barnard, *Magic Sign*, 23.

44. Barnard, 24. While the violence and horrors of this era of colonization cannot be overstated, they are also beyond the scope of this discussion. For more on this see, for example, the Maine Wabanaki-State Child Welfare Truth and Reconciliation Commission (https://www.wabanakireach.org /maine_wabanaki_state_child_welfare_truth_and_reconciliation_commission) and the Greensboro Truth and Reconciliation Commission (https://greensboro-trc.org).

45. Wolfe, "Electrographic Architecture," 380–82. Al compellingly argues that the city was formed more by policymakers than gangsters. Al, "The Strip," 3.

46. Barnard, *Magic Sign*, 65.

47. Q.R.S. Neon ("Quick Reliable Service") was a sign business then manufacturing licenses to select installers. Barnard, 64–66. Downtown Fremont Street was also already exhibiting signs made in neon. Two general areas in the city are associated with fantastic electric signs: Fremont Street, located downtown with a number of walk-in entrances and foot traffic, and the Strip, located on Las Vegas Boulevard, South, the former original Los Angeles Highway.

48. Barnard, 38.

49. Barnard, 38.

50. Starr and Hayman, *Signs and Wonders*, 119, 121.

51. Starr and Hayman, 119.

52. Barnard, *Magic Sign*, 67–68.

53. Al, "The Strip," 29.

54. Osdene, "American Neon Signs," 159.

55. Barnard, *Magic Sign*, 38.

56. Barnard, 19.

57. Barnard, 19.

58. Barnard, 42.

59. Barnard, 43.

60. Barnard, 43. Possibly a play on "Howdy, pardner."

61. Wolfe, "Las Vegas (What?)."

62. Barnard, *Magic Sign*, 43.

63. Wolfe, "Las Vegas (What?)."

64. Wolfe, "Las Vegas (What?)"; Barnard, *Magic Sign*, 45. Scorsese's protagonist in *Casino* is likely based on Bugsy Siegel.

65. Barnard, *Magic Sign*, 45.

66. Barnard, *Magic Sign*, 48–49.

67. Chase, *Glitter Stucco*, 119; Barnard, *Magic Sign*, 49. Since 1962, all tests have been carried out underground.

68. Barnard, *Magic Sign*, 49.

69. Barnard, 69.

70. Wolfe, "Las Vegas (What?)"; Barnard, *Magic Sign*, 93.

71. Barnard, *Magic Sign*, 276.

72. Barnard, 70.

73. Barnard, 276.

74. Barnard, 48.

75. In 1994, Vegas Vic "married" the 75-foot Vegas Vickie (originally named Sassy Sally), a sign also made by YESCO for the Girls of Glitter Gulch strip club, which remained on Fremont Street until 2017, when it was replaced with an upscale resort. Ribbat, *Flickering Light*, 87.

76. Barnard, *Magic Sign*, 87–89.

77. Barnard, 49–50.

78. Wayne studied at the Chicago Art Institute and, after working as a theater artist for the Balaban theater chain in Chicago and serving in the armed forces in 1942, he collaborated with art director George Gibson of Metro-Goldwyn-Mayer in Southern California and then moved to Las Vegas to work with YESCO. In addition to revamping Boernge's 1950 Golden Nugget sign, Wayne's noteworthy projects included the Mint, the Horseshoe, the Sahara, Fremont Hotel, Lucky Casino, and the 1958 illuminated facade of the Stardust. Barnard, 73, 280–82.

79. Barnard, 93.

80. Barnard, 93.

81. Barnard, 93.

82. Osdene, "American Neon Signs," 171; Barnard, *Magic Sign*, 87.

83. Osdene, "American Neon Signs," 171; Barnard, *Magic Sign*, 87–88. The sign stood until 1991.

84. Barnard, *Magic Sign*, 94.

85. Barnard, 94.

86. Venturi, Brown, and Izenour, *Learning from Las Vegas*.

87. Barnard, *Magic Sign*, 52.

88. Barnard, 53.

89. Rodriguez was a second-generation Angeleno who, at age fifteen, won a design contest for a Rose Parade float in Whittier, California. After achieving international notoriety for his exotic flower creations at the annual Pasadena Tournament of Roses Parade and accruing art degrees from Cerritos College and California State University, Long Beach, and a scholarship from the Art Center in Los Angeles, he began working as a designer for Walt Disney Productions. After the Flamingo, he went on to design the Silverbird pylon, portico church, and facade, and the sign for the Tropicana, and in 1981, contributed preliminary designs for the concept of the Dunes, "Oasis." Barnard, 301.

90. Completed in 1985 and hosting 15 million travelers a year by 1986.

91. "Samsung Electronics"; YESCO, *Legacy of Light.*

92. Burnham, *Beyond Modern Sculpture*; 367, 122–23; Wolfe, "Electrographic Architecture," 380. Other noteworthy neon artists include Chryssa (Chryssa Vardea-Mavromichali), Keith Sonnier, Stephen Antonakos, Bruce Nauman, and Joseph Kosuth.

93. Burnham, *Beyond Modern Sculpture*, 307.

94. Wolfe, "Electrographic Architecture," 380, 382.

95. Wolfe, 380, 382; Wolfe, quoted in Farquharson, *Magic Hour*, 47.

96. His first essay also appeared in the same year as conservative environmental writer Peter Blake's tirade against industrial culture in America, *God's Own Junkyard: The Planned Deterioration of America's Landscape*, and one year after Blake's related essay, "The Suburbs Are a Mess," which appeared in the *Saturday Evening Post* on October 5, 1963.

97. Wolfe, "Electrographic Architecture," 382.

98. For Brown and Venturi, the Las Vegas aesthetic consisted of two core factors rooted in the automobile and the Information Age. Farquharson, *Magic Hour*, 47.

99. Glo-Let is a multicolored neon sign with interchangeable letters and colors. Virginia Sebastian, "Along Broadway," *Signs of the Times* 137, no. 2 (June 1954): 119; 123, no. 3 (November 1949): 94; 110, no. 1 (May 1945): 61.

100. "Neon Converts to 'Plastilux 500.'"

101. "Neon Converts to 'Plastilux 500.'"

102. Avila, *Popular Culture*, 4. Avila focusses on Los Angeles, but the same practices were used in other cities in the Northeast (New York City in particular), Midwest, and Far West.

103. Avila, 5.

104. Additional mortgage insurance programs used similar techniques, supplemented by the routine concentration of federal and state tax funds to the suburbs throughout the 1940s and 1950s to construct and improve water lines, federal highways, and sewage facilities while neglecting derelict buildings and sewage systems in inner-city neighborhoods. Lipsitz, *Possessive Investment in Whiteness*, 5–6n21.

105. Lipsitz, 5–6n21.

106. Lipsitz, 6–7; Harris, *Little White Houses*, 99.

107. Harris, *Little White Houses*, 96, 117. One may also recall Malvina Reynolds's song about "little boxes." Her lyrics address the homogeneity of postwar white suburbia even as the houses were painted different colors.

108. Lipsitz, *Possessive Investment in Whiteness*, 5.

109. Lipsitz, 6.

110. Lipsitz, 77–78.

111. Lipsitz, 6.

112. Lipsitz, 7.

113. Crowe, "Neon Signs," 37.

114. Avila, *Popular Culture*, 8.

115. Even Hunter Thompson believed Las Vegas was "too twisted" for "psychedelic drugs." *Fear and Loathing*, 4; Ribbat, *Flickering Light*, 96.

116. Didion, *Slouching Towards Bethlehem*, 171.

117. Didion, 171; Ribbat, *Flickering Light*, 96.

118. Debord, *Society of the Spectacle*, 4–5.

119. Gitlin, *The Sixties*, 235.

120. Ribbat, *Flickering Light*, 118.

121. Ribbat, 118.

122. Horak, *Saul Bass*, 256.

123. Bass is known for creating introductory sequences to Otto Preminger's *The Man with the Golden Arm* (1955) and Hitchcock's *North by Northwest* (1959); *Vertigo* (1958), where he collaborated with filmmaker John Whitney; and *Psycho* (1960).

124. Haskin, "'Saul, Can You Make Me a Title?,'" 12–13.

125. Haskin, 11; Horak, *Saul Bass*, 256; Kirkham, "Bright Lights, Big City," 12–13.

126. Horak, *Saul Bass*, 256.

127. LED technology has improved significantly over the past two decades, to the point that it can simulate neon tubing with great efficiency, though, in my view, it lacks the nuance and heterogeneity of "dirty" neon tubes.

128. Although some contemporary uses of neon and LED are nostalgic, the examples I have chosen here are not.

129. Benjamin, "This Space for Rent," 476.

130. Benjamin, 476.

CHAPTER 6

Epigraphs: Author statement quoting Solway and Abloh, in Solway, "Story behind Virgil Abloh and Jenny Holzer's Potent, Political Off-White Show," n.p.; Burke, *A Philosophical Inquiry*, vol. 24, part 2.

1. Kalaidjian, "Mainlining Postmodernism," n.p. See also the work of Ernest Mandel and Fredric Jameson.

2. Bell, *Coming of Post-industrial Society*; Breslin, "I Want to Go to the Future," 116.

3. Kalaidjian, "Mainlining Postmodernism."

4. For more on the postwar movement to the suburbs as a predominantly white phenomenon, see Harris, *Little White Houses*.

5. Porter, "Next Fashion Collaboration"; Solway, "Story behind Virgil Abloh and Jenny Holzer's Potent, Political Off-White Show."

6. Harvey, *Condition of Postmodernity*, 141–60. In August 1971, Richard Nixon announced a "temporary" suspension of the US dollar's convertibility, a decoupling made permanent in 1973.

7. Breslin, "I Want to Go to the Future," 102.

8. Breslin, 104.

9. In 1980, the price of oil peaked again, reaching $35 a barrel, equivalent to $118 today.

10. Jameson, *Postmodernism*, 56.

11. Carter, "Crisis of Confidence."

12. Carter, "Crisis of Confidence"; Breslin, "I Want to Go to the Future," 106.

13. Carter; Breslin, 106.

14. Breslin, 53; Van Riper, "Ford to New York."

15. Breslin, "I Want to Go to the Future," 53.

16. Melzer, "Screen Clusters," 73.

17. Melzer.

18. Senelick, "Private Parts," in Taylor, *Inventing Times Square*, 329.

19. Senelick, 329, 341.

20. Senelick, 344.

21. Senelick, 345.

22. Senelick, 342.

23. Senelick, 342.

24. Senelick, 342.

25. For more on this emancipation, see Sconce, "Trashing the Academy," 371–93; Long, *The Forbidden Apple*; Bianco, *Ghosts of 42nd Street*; Friedman, *Tales of Times Square*; and Landis and Clifford, *Sleazoid Express*.

26. Melzer, "Screen Clusters," 75.

27. Senelick, "Private Parts," 329.

28. Elisabeth B maintained anonymity to protect herself from lawsuits or legal retribution.

29. Senelick, "Private Parts," 342.

30. Senelick, 342.

31. Senelick, 342.

32. Elisabeth B, *Das ist ja zum Peepen*, 93, quoted and translated by Senelick in "Private Parts," 342.

33. Senelick, "Private Parts," 342.

34. Senelick, 345.

35. Ferguson, "Wordsmith," 75.

36. Holzer, cited in Joselit et al., *Jenny Holzer*, 21; Breslin, "I Want to Go to the Future," 20.

37. Holzer, cited in Joselit et al., 21; Breslin, 20.

38. Simon interview, quoted in Joselit et al., *Jenny Holzer*, 14.

39. There were no hospitals in the area at the time, Holzer explains, so "they made one." Pavia, "How Could I Be on Twitter?" 8.

40. The Met had "just bought [the Rembrandt], and [they] had it out," Holzer explains. "I think they even had the price by it." Simon interview, quoted in Joselit et al., *Jenny Holzer*, 14, 16.

41. Waldman, *Jenny Holzer*, 9.

42. Waldman, 9.

43. Simon interview, quoted in Joselit et al., *Jenny Holzer*, 75; also cited in Breslin, "I Want to Go to the Future," 19.

44. Simon interview, quoted in Joselit et al., *Jenny Holzer*, 75; also cited in Breslin, "I Want to Go to the Future," 19.

45. Breslin, "I Want to Go to the Future," 20.

46. Holzer, quoted in Waldman, *Jenny Holzer*, 10; Steiner, "Framing Words," 98.

47. The technique was foreshadowed in a student project for which Holzer collected diagrams from books in the Brown University library and meticulously redrew them with new captions, which she found more intriguing than the drawings themselves (similar to the price tag on the Rembrandt painting). "The captions told you everything in a clean, pure way," she explains. "This was the beginning—or one of the beginnings—of my writing." Jones, "Being Alone," 426. See also Breslin, "I Want to Go to the Future," 8.

48. Waldman, *Jenny Holzer*, 10.

49. Waldman, 11.

50. Rogers-Lafferty, *Jenny Holzer and Cindy Sherman*, 7.

51. Althusser, "Ideology and the Ideological State Apparatuses," 264.

52. Althusser, 264.

53. Althusser, 308.

54. Althusser, 266.

55. Breslin, "I Want to Go to the Future," 53, 84.

56. Colab's fifty members included Tom Otterness, Kiki Smith, Robin Winters, Becky Howland, Coleen (or Colen) Fitzgibbon, Jane Dickson, John and Charlie Ahearn, and Mike Glier. Little, "Colab Takes a Piece," 63, 58.

57. The collective thrived in similar enclaves of like-minded artists in the city—P.S. 1, Creative Time, Group Material, The Kitchen, Fluxus, and Artists Space—that fostered bohemian ideals opposed to mainstream and commercial art galleries. Madoff, "Jenny Holzer Talks to Steven Henry Madoff," 82; Little, "Colab Takes a Piece," 63, 58.

58. Breslin, "I Want to Go to the Future," 57.

59. Breslin, 58.

60. In many cases, city residents would add comments to the lists. Sometimes they would cross things out; at other times they would highlight items. The feedback was informative to Holzer as, in essence, a true renouncement of artistic authority.

61. She continues, "I was amazed at how the word 'leprosy' on a poster could stop you short, and at how effective these posters were." Ferguson, "Wordsmith," 75. The sign read:

DEADLY DISEASE / LEPROSY DISEASE / EATS AWAY TERRIBLY / STAY AWAY FROM / THESE
TRAMPS / THEY HAVE LEPROSY / DISEASE AND TUBERCULOSIS / MEN CAUGHT / LEPROSY
AND TUBERCULOSIS / FROM THESE TRAMPS / STAY AWAY FROM / THESE TRAMPS / OR
YOU WILL BE IN A BAD WARD / AND SUFFER TERRIBLE / THE REST OF YOUR LIFE / WITH
TUBERCULOSIS AND LEPROSY. (*Novakov, "Artist as Social Commentator,"* 47.)

62. Madoff, "Jenny Holzer Talks to Steven Henry Madoff," 82.

63. Madoff, 82.

64. Breslin, "I Want to Go to the Future," 89.

65. Breslin, 89.

66. Breslin, 116.

67. Rogers-Lafferty, *Jenny Holzer and Cindy Sherman*, 7.

68. In the 1960s, Leigh took on several urban development projects in
the square, including two in 1964 alone: Daniel Burnham's Claridge Hotel
(completed in 1909) and the Crossroads Building (formerly the Heidelberg
Building), at the time open to the public as the Crossroads Café. Tell, *Times
Square*, 143.

69. Tell, 140.

70. Tell, 144.

71. Senelick, "Private Parts," 345.

72. Senelick, 345.

73. Tell, *Times Square*, 148.

74. Tell, 148.

75. Tell, 148.

76. Tell, 148.

77. Tell, 148.

78. Tell, 148.

79. These changes eventually led to LED signage, high-resolution digital
graphics, plasma screens, and HDTV. LED technology was introduced in 1962,
primarily for use in "indicator lamps." They were not commonly used for pub-
lic signage until much later, along with other uses such as remote controls, game
consuls, and "automotive lighting." Breslin, "I Want to Go to the Future," 133.

80. Melzer, "Screen Clusters," 93.

81. Melzer, 92.

82. Novakov, "The Artist as Social Commentator," 2; Melzer, "Screen Clus-
ters," 92. Compare this to the Spectacolor screen placed in Times Square in
2014, which was "77 feet tall by 323 feet wide." Its "4K LED screen feature[d]
2.3 million pixels . . . [amounting to] 93 pixels for every square foot," roughly
"36 times sharper" than the original screen.

83. Novakov, "Artist as Social Commentator," 2–3.

84. Equal to about 2.5 pixels per square foot. Melzer, "Screen Clusters," 92;
Novakov, "Artist as Social Commentator," 2–3.

85. Novakov, "Artist as Social Commentator," 2; Melzer, "Screen Clusters," 92.

86. Novakov, "Artist as Social Commentator," 2.

87. The artists included Keith Haring, Barbara Kruger, Vitto Acconci, Mar-
tha Rosler, Richard Prince, Nancy Dwyer, the Guerrilla Girls, Alfredo Jaar,
Crash, and Linda Montano.

88. Dougherty, "Broadway Lights," 39.

89. For example, one of the series' final messages, by Nancy Spero, was censored by Spectacolor owner George Stonbely, an ardent Catholic who opposed the artist's proposed pro-choice message. McNearney, "Times Square Pro-Choice."

90. Novakov, "Artist as Social Commentator," 2–3.

91. Novakov, 2–3.

92. Novakov, 2.

93. Novakov, 2–3.

94. Melzer, "Screen Clusters," 95; Breslin, "I Want to Go to the Future," 133.

95. Ferguson, "Wordsmith," 113 (my italics).

96. Simon, quoted in Joselit et al., *Jenny Holzer*, 26.

97. Ferguson, "Wordsmith," 113 (my italics).

98. She also engaged in a fashion collaboration with Helmut Lang in 1996 on the installation "I Smell You on My Clothes" for the Florence Biennale. The installation addressed the ways smells and scents left in a room summon the person who once wore them. For the exhibit, Holzer made two LED installations that hung from the ceiling, pulsing such messages as: YOU ARE THE ONE WHO DID THIS TO ME. She explains: "We did things that weren't strictly [typical, including a] funny adventure with the perfume . . . that smelled like sperm, sweat, and starch." Solway, "Story."

99. Excerpts from the piece of paper stitched on the back of her dress read: "Rejoice! Our times are intolerable. Take courage, for the worst is a harbinger of the best. Only dire circumstance can precipitate the overthrow of oppressors. The old & corrupt must be laid to waste before the . . . can triumph."

100. Holzer's poems scrolled upward on either side of the entrance of the piazza, after which Abloh's models came down the runway. Porter, "Next Fashion Collaboration"; Solway, "Story behind Virgil Abloh and Jenny Holzer's Potent, Political Off-White Show."

101. The Dia was established in 1974 by heiresses Heiner Friedrich and Philippa de Menil to support artistic and creative projects that fell beyond the purvey of normative gallery or museum collecting practices. Glueck, "To Get His Museum's Opening in '92"; Breslin, "I Want to Go to the Future," 134.

102. Today, there are more than 1.1 million people living with HIV, and more than 700,000 people with AIDS have died since the beginning of the epidemic, first reported in the United States in June 1981. "The HIV/AIDS Epidemic."

103. Breslin, "I Want to Go to the Future," 127.

104. Breslin, 127.

105. Breslin, 149.

106. Breslin, iii.

107. Breslin, 10; Kalaidjian, "Mainlining Postmodernism."

108. What struck viewers was the fusion of two "seemingly incommensurable forms." For Breslin, the stones and rock sarcophagi suggest a permanence contrary to the ephemerality of LED signs. "I Want to Go to the Future," 128, 10.

109. Butler, *Precarious Life*, 30; Breslin, "I Want to Go to the Future," 193.

110. Butler, *Precarious Life*, 30.

111. Joselit, "Voices, Bodies, and Spaces," in Joselit et al., *Jenny Holzer*, 57.

112. As noted in chapter 1, Kant wrote in 1790, "He judges not merely for himself, but for everyone." *Judgment*, ¶7.

113. Holzer, cited in Hughes, "Power's Script," 439. This being said, we must not forget Holzer's privilege. While she is first and foremost marked as a *female* artist before simply an artist, she has also been given access to these channels of power and authority in the first place. The Las Vegas installations, for instance, required high-level negotiations through a "network of business-people, university managers, and political officials" that she would not have had access to or the leverage to negotiate with if she was not already an internationally esteemed art star. Levy, "Las Vegas as Public Art," 30.

114. McKendry, *One*. In 1974, investor Alex Parker purchased One Times Square for $6.25 million; he then sold it to Lawrence I. Linksman in 1982.

115. City of New York Office of Midtown Enforcement, *Annual Report, 1987*, cited in Senelick, "Private Parts," 347; Knapp, "Introductory Essay," in Taylor, *Inventing Times Square*, 131.

116. Senelick, "Private Parts," 347.

117. Melzer, "Screen Clusters," 79.

118. Charyn, *Metropolis*, 90.

119. A nonprofit endeavor funded by the Ford Foundation and other local donors.

120. Tell, *Times Square*, 151.

121. Tell, 150.

122. Tell, 151. In Manhattan, air rights are restricted due to overcrowding and density concerns. Air rights to adjacent properties are thus sought-after for high-rise buildings. Charles Bagley, writing for the *New York Times* in 2005, observed that, in November of the same year, the Christ Church at Park Avenue and East 60th Street (on the historically wealthy Upper East Side) sold its air space or "vertical development rights at a record-breaking value of $430 per square foot, making over $30 million in profit." Bagli, "$430 a Square Foot."

123. Tell, *Times Square*, 151.

124. Tell, 151.

125. Tell, 151.

126. Huxtable, "Re-inventing," 363.

127. Huxtable, 363.

128. Huxtable, 363.

129. Tell, *Times Square*, 151.

130. Huxtable, "Re-inventing," 363.

131. A rezoning policy implemented in 1982 (N-820253-ZRM) gave developers permission to "construct taller and bulkier office towers in what was considered by many to be prime, though underused and neglected, real-estate location." Melzer, "Screen Clusters," 79.

132. Huxtable, "Re-inventing," 364.

133. Huxtable suggests that the 42nd Street Development Project was presented to the public in November 1984. Huxtable, 363.

134. Knapp, "Introductory Essay," 131.

135. Huxtable, "Re-inventing," 357; Tell, *Times Square*, 153.

136. By 1992, Mayor Koch's plan was stalling and eventually came to a halt as the four proposed large office towers failed to meet the deadline to have their foundations in place by 1988, as required by the 1982 zoning resolution. Tell, *Times Square*, 156.

137. Tell, 150.

138. City of New York Office of Midtown Enforcement, *Annual Report*, 1987; also cited in Senelick "Private parts," 347.

139. Tell, *Times Square*, 156.

140. Tell, 156.

141. Tell, 153.

142. Tell, 156.

143. Starr explains that her family's business controlled most signs in the Square at the time, so it was relatively simple for them to coordinate the blackout. Wong, "Sign Makers of the Starrs," 75.

144. Wong, 75.

145. Wong, 75.

146. Senelick "Private Parts," 348.

147. Senelick suggests that the juvenile sex trade resulted in part from the 1960s counterculture. "Private Parts," 348.

148. Senelick, 363.

149. Tell, *Times Square*, 157.

150. Huxtable, "Re-inventing," 363.

151. Taylor, *Inventing Times Square*, xxvi.

152. Taylor, xxvi.

153. Tell, *Times Square*, 159.

154. Gelder, "Lights Out for Times Square News Sign?" In March 1995, Lehman Brothers purchased the Tower for $27.5 million.

155. Tell, *Times Square*, 156.

156. Tell, 156.

157. Tell, 159–60.

158. Tell, 160.

159. McKendry, *One*.

160. In 1997, Disney's New Amsterdam Theater represented only a fraction of the billion dollars in private investment committed to 42nd Street revitalization. Giuliani, "New York's on Top Again"; Hughes, "Power's Script," 433.

161. Giuliani, "New York," 433.

162. Light Unit Times Square, or LUTS, are standard illumination units measured with "a 35 millimeter single lens reflex camera." A number of other detailed requirements can be found in the 81-732 policy document, including specifications for sign placement and size requirements. NYC Planning Zoning Resolution, "81-732: Special Times Square Signage Requirements," item 3.iii.

163. NYC Planning Zoning Resolution, item 3.iii.

164. NYC Planning Zoning Resolution, item 1. Resolution 81-732 outlined the minimum luminosity, placement, and size requirements necessary for signage in the bowtie.

165. Tell, *Times Square*, 160.

166. Hughes, "Power's Script," 432–33.

167. In 1998, the city finally acquiesced to advocates like the MAS and updated the subdistrict zoning policy for the Square to permit district-wide air rights transfers in order to preserve the neighborhood's low-rise historic theaters (ideally, if the companies supporting the preservation of the theaters purchased their air rights, they could prevent development). "History," Municipal Art Society of New York, accessed December 19, 2022, https://www.mas.org/about-us/history/.

168. Giuliani, "New York."

169. McKendry, *One*.

170. Presented by the Times Square Advertising Coalition and curated by Times Square Arts, "Midnight Moment" is "the world's largest, longest-running digital art exhibition, synchronized on electronic billboards throughout Times Square nightly from 11:57 pm to midnight," in place since 2012. Elsewhere in the city, Wodiczko created a series of projections, such as those for the AT&T building in Tribeca. One might also consider Shimon Attie's visually evocative work and the way it engages with the layers of history, memory, and politics in urban space.

CONCLUSION

Epigraph: Baudrillard, "Consumer Society," 33.

1. In AI, the idea of universality is gleaned from the increasingly large data sets that algorithms are trained on, once again sidelining issues of history, difference, and context. Katz, *Artificial Whiteness*, 94–95, 107.

2. Le Corbusier, *Towards a New Architecture*, 143.

3. Le Corbusier, *L'Art Décoratif*, 135.

4. Batchelor, *Chromophobia*, 22.

5. Gordon, *Urban Spectator*, 22.

6. Gordon, 40.

7. Gordon, 20.

8. Debord, *Society of the Spectacle*, 4.

9. Gordon, *Urban Spectator*, 20.

10. See Heidegger, "Age of the World Picture."

11. "Film serves to train people in those sorts of perceptions and reactions which are necessary for any interaction with apparatuses—apparatuses whose role in the lives of such people are increasing almost daily." Benjamin, "Work of Art," 359–360.

12. "Instead of reacting emotionally, the Metropolitan type reacts primarily in a rational manner." Simmel, "Metropolis and Mental Life," 9.

13. Katz, *Artificial Whiteness*, 3, 22–24, 35, 43.

14. Katz, 3, 25.

15. Katz, 43.

16. Katz, 12.

17. Some scholars may glean more complex readings from the following advertising situations, or wish to focus on so-called alternative creative practices in the twenty-first-century Square. I tend to be skeptical of the ways twenty-first-century algorithms are taking control of (visual, public, social) experience, however, and I view the rise of informatic media spectacles and control spaces in the modern city as increasingly aggressive, psychologically and physiologically.

18. Brill, "Hershey's."

19. "Clear Channel Spectacolor Selected."

20. "Coca-Cola: 'What's in a Name?'"

21. "Coca-Cola: 'What's in a Name?'"

22. "M&M's Caramel Launch Celebrated."

23. Wu, "Fabricating Images at the Color Factory."

24. Mandatory contact tracing in a COVID-19 landscape offers a case in point.

25. Wigley, "Chronic Whiteness."

26. Janneau, "L'Exposition des arts," 64.

27. Katz, *Artificial Whiteness*, 112.

Bibliography

Adams, Mildred. "In Their Lights the Cities Are Revealed." *New York Times*, December 11, 1932. SM12, 19.

Ahmed, Sara. "A Phenomenology of Whiteness." *Feminist Theory* 8, no. 2 (2007): 149–68.

Al, Stefan Johannes. "The Strip: Las Vegas and the Symbolic Destruction of Spectacle." PhD dissertation, University of California, Berkeley, 2010.

Albers, Josef. (1963) 2013. *Interaction of Color*. 50th Anniversary Edition. New Haven, CT: Yale University Press.

Alberti, Leon Battista. *I Libri Della Famiglia*. Translated by René Neu Watkins as *The Family in Renaissance Florence: Book Three*. Long Grove, IL: Waveland Press, 1994.

———. *On the Art of Building in Ten Books*. Translated by Joseph Rywert, Neil Leach, and Robert Tavernor. Cambridge, MA: MIT Press, 1999.

———. *The Ten Books on Architecture: The 1755 Leoni Edition*. Translated by Cosimo Bartoli and Giacomo Leoni. New York: Dover Publications, 1986.

Alcoff, Linda. *The Future of Whiteness*. Cambridge: Polity Press, 2016.

"Allied Tower Makes False Start on Facade." *New York Times*, August 4, 1964, p. 19.

Althusser, Louis. "Ideology and the Ideological State Apparatuses." *On the Reproduction of Capitalism*. Translated by G.M. Goshgarian. London, 232–72: Verso, 2014. Originally published as *Sur la Reproduction*, 269–314. Paris: PUF, 1996.

Anderson, J.M. "Lighting the Pan-Pacific Exposition: Origins of Illuminating Engineering." *IEEE Power Engineering Review* 18, no. 2 (1998): 24–25.

"Animated Antics Make 'Em Glad." *Signs of the Times*, 86, no. 3 (June 1937): 13.

"A Persistent Purpose to Produce Perfect Biscuit." *Saturday Evening Post*, November 2, 1912.

"A Plan for a White Way." *Dry Goods Reporter* 46, no. 11 (March 20, 1915): 9, 21, 38.

Applebaum, Barbara. *Being White, Being Good: White Complicity, White Moral Responsibility, and Social Justice Pedagogy*. Lanham: Lexington Books, 2010.

Aristotle. *Aristotle's* On the Soul. Translated by Hippocrates G. Apostle. Grinnell, IA: Peripatetic Press, 1981.

———. *Minor Works*. Translated by W.S. Hett. Loeb Classical Library 307. Cambridge, MA: Harvard University Press, 1936.

———. *Nicomachean Ethics*. Translated and edited by Roger Crisp. Cambridge: Cambridge University Press, 2000.

———. "On Colour." In *Minor Works*, translated by W.S. Hett, 3–48. Loeb Classical Library 307. Cambridge, MA: Harvard University Press, 1936.

"Artist's Preview of New Spectacular on Great White Way." *Signs of the Times* 139, no. 3 (March 1955): 56, 82.

"The Art of Lighting." *New York Daily Tribune*, February 15, 1906, 6.

"At the Sign of the Innerseal." Advertising Campaign, National Biscuit Company, 1901.

Avila, Eric. *Popular Culture in the Age of White Flight: Fear and Fantasy in Suburban Los Angeles*. Berkeley: University of California Press, 2006.

Bagli, Charles V. "$430 a Square Foot, for Air? Only in New York Real Estate." *New York Times*, November 30, 2005. https://www.nytimes.com/2005/11/30/nyregion/430-a-square-foot-for-air-only-in-new-york-real-estate.html.

Bailey, Alison. "Philosophy and Whiteness." In "Towards a Bibliography of Critical Whiteness Studies," edited by Tim Engles, 9–19. *Faculty Research and Creative Activity* (November 2006).

"Ballantine Display on Broadway." *Signs of the Times* 83, no. 3 (July 1936): 36–38.

Barnard, Charles F. *The Magic Sign: The Electric Art/Architecture of Las Vegas*. Cincinnati: ST Publications, 1993.

Bassett, Thomas J. "Cartography and Empire Building in Nineteenth-Century West Africa." *Geographical Review* 84 (1994): 316–35.

Batchelor, David. *Chromophobia*. London: Reaktion, 2000.

Baudrillard, Jean. *The Consumer Society: Myths and Structures*. 1970. Reprinted, London: Sage, 1998.

Bell, Daniel. *The Coming of Post-industrial Society: A Venture in Social Forecasting*. New York: Basic Books, 1973.

Bell, Marcus. "Whiteness Interrupted: Examining the Impact of Racialized Space on White Racial Identity." PhD dissertation, Syracuse University, August 2017.

Benjamin, Ruha, ed. *Captivating Technology: Race, Carceral Technoscience, and Liberatory Imagination in Everyday Life*. Durham, NC: Duke University Press, 2019.

Benjamin, Walter. "Paris—Capital of the Nineteenth Century" (1938). In *Walter Benjamin: Selected Writings, Volume 3: 1935–1938*, edited by Edmund Jephcott, Howard Eiland, and Michael William Jennings, 32-49. Cambridge, MA: Harvard University Press, 2002.

———. "This Space for Rent." In *One-Way Street*, in *Walter Benjamin: Selected Writings, Volume 1: 1913–1926*, edited by Marcus Bullock and Michael W. Jennings, 476. Cambridge, MA: Harvard University Press, 1996.

———. "The Work of Art in the Age of Its Technological Reproducibility: Second Version." In Vol. 7 of *Gesammelte Schriften*, edited by Rolf Tiedemann and Hermann Schweppenhäuser. Frankfurt: Suhrkamp, 1989.

Bentham, Jeremy, and Charles Kay. *Theory of Legislation*. Edited with an introduction by C.K. Ogden. Translated by Richard Hildreth. London: Kegan Paul, Trench Trübner & Co. Ltd., 1931.

Berger, Martin A. *Sight Unseen: Whiteness and American Visual Culture*. Berkeley: University of California Press, 2005.

Berger, Maurice. *White Lies: Race and the Myths of Whiteness*. New York: Farrar, Straus & Giroux, 1999.

Berger, Meyer. "From White Way to Color Canyon." *New York Times*, June 4, 1944. 34–36.

Bergo, Bettina, and Tracey Nicholls. "Introduction: A Focus on White Privilege through Personal Narratives." In *I Don't See Color: Personal and Critical Perspectives on White Privilege*, edited by Bergo and Nicholls, 1–11. University Park: Pennsylvania State University Press, 2015.

Berlant, Lauren Gail. *Cruel Optimism*. Durham, NC: Duke University Press, 2011.

Berman, Marshall. *On the Town: 100 Years of Spectacle in Times Square*. New York: Random House, 2006.

Bernal, Martin. *Black Athena: The Afroasiatic Roots of Classical Civilization—The Linguistic Evidence*. New Brunswick, NJ: Rutgers University Press, 2006.

"The Best 'Ad' in the City." *New York Times*, October 4, 1896. 8.

Bhabha, Homi K. "The White Stuff." *Artforum* 36, no. 9 (1998): 21–23.

Bianco, Anthony. *Ghosts of 42nd Street: A History of America's Most Infamous Block*. New York: Harper Perennial, 2005.

"Bickley Motograph." *Electrical Record* 12, no. 1 (July 1912): 50–51.

"Bickley Motograph or Continuous Talking Sign." *Electrical Review and Western Electrician* 61, no. 23 (December 7, 1912): 1094.

"Biggest 3-D Spectacular Unveiled on Broadway." *Signs of the Times* 140, no. 3 (July 1955): 23.

Bindman, David. *Ape to Apollo: Aesthetics and the Idea of Race in the 18th Century*. Ithaca, NY: Cornell University Press, 2002.

Blake, Peter. *God's Own Junkyard: The Planned Deterioration of America's Landscape*. New York: Holt, Rinehart & Winston, 1979.

Bloom, Ken. *The Routledge Guide to Broadway*. New York: Routledge, 2007.

Boime, Albert. *The Art of Exclusion: Representing Blacks in the Nineteenth Century*. Washington, DC: Smithsonian Institution Press, 1990.

"Bond Adds New Note to Broadway Glamour." *Signs of the Times* 119, no. 2 (June 1948): 28–29, 91.

Braham, William W. *Modern Color/Modern Architecture: Amédée Ozenfant and the Genealogy of Color in Modern Architecture*. London: Ashgate Pub. Co, 2002.

Breslin, David Conrad. "I Want to Go to the Future Please: Jenny Holzer and the End of a Century." PhD dissertation, Harvard University, 2013.

"Bright Lights: Neon Company's Earnings Rise; Signs Illumine Recovery in Nation." *Literary Digest* 122, no. 26 (December 26, 1936): 37–38.

Brill, Louis M. "At the Crossroads of the World (and Sign History)." *Signs of the Times* (June 2006): 72–78.

———. "Hershey's: How Sweet It Is—The Eye-Candy of Times Square." *Sign Industry.* Accessed April 5, 2021. http://www.signindustry.com/dimensional/articles/2008-04-15-LB-Hersheys_How_Sweet_it_Is_Signage_Spectacular_Times_Square.php3.

Brinkmann, Vinzenz and Ulrike Koch-Brinkmann. *Persian Rider.* (490 BC) 2007/2019. Experimental color reconstruction of the Persian Rider from the Athenian Acropolis, 160 cm. Liebieghaus Skulpturensammlung.

British Museum. "Lord Elgin and the Parthenon Sculptures." Internet Archive WayBack Machine. Accessed May 26, 2020. https://web.archive.org/web/20130203024816/https://www.britishmuseum.org/explore/highlights/article_index/l/lord_elgin_and_the_parthenon_s.aspx.

Browne, Simone. *Dark Matters: On the Surveillance of Blackness.* Durham, NC: Duke University Press, 2015.

Brox, Jane. *Brilliant: The Evolution of Artificial Light.* London: Souvenir Press, 2012.

Broyles, Susannah. "Vanderbilt Ball: How a Costume Ball Changed New York Elite Society." City Museum of New York, August 6, 2013. https://blog.mcny.org/2013/08/06/vanderbilt-ball-how-a-costume-ball-changed-new-york-elite-society/.

"The Brush Electric Light." *Scientific American* 44, no. 14 (April 2, 1881): 211–12.

Bulgarelli, Massimo. "Bianco e colori. Sigismondo Malatesta, Alberti, e l'architettura del Tempio Malatestiano." *Opus Incertum* 2 (January 2017): 48–57.

Burke, Edmund. *A Philosophical Inquiry into the Origin of Our Ideas of the Sublime and Beautiful.* 1757. Reprinted, New York: P. F. Collier & Son Company, 1909–14.

Burnham, Jack. *Beyond Modern Sculpture: The Effects of Science and Technology on the Sculpture of This Century.* New York: George Braziller, 1968.

Burrows, Edwin G., and Mike Wallace. *Gotham: A History of New York City to 1898.* New York: Oxford University Press, 1999.

Butler, Judith. *Precarious Life: The Powers of Mourning and Violence.* London: Verso, 2006.

Cabrera, Nolan, L. and Chris Corces-Zimmerman. "Beyond 'Privilege': Whiteness as the Center of Racial Marginalization." In *Marginality in the Urban Center: The Costs and Challenges of Continued Whiteness in the Americas and Beyond,* edited by Peary Brug, Zachary S. Ritter, and Kenneth R. Roth, 13–29. Cham, Germany: Palgrave Macmillan, 2019.

Canemaker, John. "The Electric Felix Man." *Animation World,* November 1, 1996. https://www.awn.com/print/animationworld/electric-felix-man.

Carlson, W. Bernard. *Tesla: Inventor of the Electrical Age.* Princeton, NJ: Princeton University Press, 2013.

Carter, Jimmy. "Crisis of Confidence" (speech delivered July 15, 1979). *American Experience.* Accessed January 7, 2023. https://www.pbs.org/wgbh/americanexperience/features/carter-crisis/.

Carter, Julian B. *The Heart of Whiteness: Normal Sexuality and Race in America, 1880–1940.* Durham, NC: Duke University Press, 2007.

Ceram, C. W. *Gods, Graves, and Scholars: The Story of Archaeology.* New York: Alfred A. Knopf, 1952.

Chalmers, Gordon. "The Lodestone and the Understanding of Matter in Seventeenth Century England." *Philosophy of Science* 4, no. 1 (January 1937): 75–95.

Chalmers, Stephen. "How Broadway's Magic Affects the Stranger: Impressions of a Scotsman." *New York Times,* December 11, 1904. SM5.

Chance, Terry. "Bright Lights, Big City." *Sign Business* (October 2002): 19–24.

Charyn, Jerome. *Metropolis: New York as Myth, Marketplace, and Magical Land.* London: Abacus, 1988.

Chase, John. *Glitter Stucco and Dumpster Diving: Reflections on Building Production in the Vernacular City.* New York: Verso, 2000.

Cheng, Irene, Charles L. Davis II, and Mabel O. Wilson, eds. *Race and Modern Architecture: A Critical History from the Enlightenment to the Present.* Pittsburgh: University of Pittsburgh Press, 2020.

Chrisman, Laura. "Theorising Race, Racism, and Culture: David Lloyd's Work." In *Postcolonial Contraventions: Cultural Readings of Race, Imperialism, and Transnationalism.* Manchester University Press, 2018.

City of New York, Office of Midtown Enforcement. *Annual Report, 1987.* New York: Mayor's Office of Correspondence Services, 1988.

"Clear Channel Spectacolor Selected." Clear Channel Outdoor, November 17, 2014, https://company.clearchanneloutdoor.com/clear-channel-spectacolor-selected-as-sales-agent-for-worlds-largest-most-technically-advanced-digital-billboard-in-times-square-to-help-brands-captivate-consumers/.

Cremin, Aedeen. *Archaeologica: The World's Most Significant and Cultural Treasures.* Lane Cove, Australia: Global Book, 2007.

"Coca-Cola: 'What's in a Name?' Times Square." *Shorty Awards.* Accessed April 5, 2021. https://shortyawards.com/8th/coca-cola-whats-in-a-name-times-square-2#:~:text=Times%20Square%20visitors%20could%20Tweet,the%20Share%20a%20Coke%20API.

Conner, Susan. "Good Enough Never Really Is." *Signs of the Times* (July 2006): 90–91.

Cook, Valentine, Jr. "The Great White Way." *Illuminating Engineer* 50, no. 3 (May 1906): 147.

Crary, Jonathan. "Spectacle, Attention, Counter-Memory," *October* 50 (Fall 1989): 97–108.

———. "Your Colour Memory: Illuminations of the Unforeseen." In *Olafur Eliasson: Your Colour Memory,* edited by Olafur Eliasson, Ismail Soyugenc, and Richard Torchia, 18–22. Glenside, PA: Arcadia University Art Gallery, 2006.

Crowe, Michael F. "Neon Signs: Their Origin, Use, and Maintenance." *APT Bulletin: The Journal of Preservation Technology* 23, no. 2 (1991): 30–37.

Daston, Lorraine, and Peter Galison. *Objectivity*. New York: Zone Books, 2010.

Debord, Guy. *The Society of the Spectacle* (1967). Translated by Donald Nicholson-Smith. New York: Zone Books, 1994.

De Heer, Jan. *The Architectonic Colour: Polychromy in the Purist Architecture of Le Corbusier*. Translated by George Hall. Rotterdam: 010 Publishers, 2009.

Delany, Samuel R. *Times Square Red, Times Square Blue*. New York University Press, 1999.

Deleuze, Gilles. "Postscript on the Societies of Control." In *Negotiations*, translated by Martin Joughin, 177–82. New York: Columbia University Press, 1995.

Dennett, Andrea Stulman. *Weird and Wonderful: The Dime Museum in America*. New York: New York University Press, 1997.

DeLyser, Dydia. "Tracing Absence: Enduring Methods, Empirical Research and a Quest for the First Neon Sign in the USA." *Area* 46, no. 1 (March 2014): 40–49.

DeLyser, Dydia, and Paul Greenstein. *Neon: A Light History*. San Francisco: Giant Orange Press, Museum of Neon Art, 2021.

Derrida, Jacques, and F. C. T. Moore, "White Mythology: Metaphor in the Text of Philosophy." *New Literary History* 6, No. 1 (Autumn 1974 [1971]): 5–74.

Detienne, Marcel, and Jean-Pierre Vernant. *Les Ruses de L'Intelligence*. Paris: Flammarion, 1993.

DiAngelo, Robin J. "White Fragility." *International Journal of Critical Pedagogy*, no. 3 (2011): 54–70.

———. *White Fragility: Why it's So Hard for White People to Talk About Racism*. Beacon Press, 2018.

Didion, Joan. "Marrying Absurd." In *Literary Las Vegas: Portrait of America's Most Fabulous City*, edited by Mike Tronnes, 162–166. Edinburgh: Mainstream, 1995.

———. *Slouching Towards Bethlehem*. New York: Farrar, Straus & Giroux, 1968.

DiLaura, David. "History." Illuminating Engineering Society. Accessed October 14, 2020. https://www.ies.org/about/history/.

Dimitriou, Penelope. "The Polychromy of Greek Sculpture to the Beginning of the Hellenistic Period." PhD dissertation, Columbia University, 1947.

Dougherty, Philip H. "Broadway Lights." *New York Times*, July 24, 1972, p. 39.

"Douglas Leigh." *Hearst's International* 122, no. 4 (April 1947): 8.

"Douglas Leigh." *Life* 1, April 1946, 48–51.

Douglas Leigh Papers, 1903–99. Archives of American Art, Smithsonian Institution. Washington D.C. Microfilms, 5840–48.

"Douglas Leigh Weds Model." *New York Times*, July 20, 1949, p. 29.

Dreiser, Theodore. *The Color of a Great City*. London: Constable & Co., 1930.

Dyer, Richard. *White: Essays on Race and Culture.* London: Routledge, 1997.

Echeverría, Bolívar, and Rodrigo Ferreira. *Modernity and "Whiteness."* Cambridge: Polity Press, 2019.

Edensor, Tim. *From Light to Dark: Daylight, Illumination, and Gloom.* Minneapolis: University of Minnesota Press, 2017.

"81-732 Special Times Square Signage Requirements." In Article VIII Special Purpose Districts, NYC Zoning Resolution. Accessed June 5, 2020. https://up.codes/viewer/new_york_city/nyc-zoning-resolution.

Elcott, Noam M. *Artificial Darkness: An Obscure History of Modern Art and Media.* Chicago: University of Chicago Press, 2018.

"Electric Executions: Testing the Wheatstone Bridge at the Edison Laboratory." *New York Times,* July 13, 1889. 8.

"Electric Sign Flashers." *Electrical Review and Western Electrician* 57, no. 24 (December 10, 1910): 1210.

"Electric Sign Monstrosities." *Scientific American* 103, no.13 (September 24, 1910): 230.

Eliel, Carol S. *L'Esprit Nouveau: Purism in Paris, 1918–1925.* Los Angeles: Los Angeles County Museum of Art, Harry N. Abrams, 2001.

Elliott, E. Leavenworth. "In Lightest New York." *Illuminating Engineer* 6, no. 4 (June 1911): 195.

Engles, Tim. "Towards a Bibliography of Critical Whiteness Studies." *Faculty Research and Creative Activity* (November 2006).

Ergin, Murat. "Turkey's Hard White Turn." *Aeon,* April 3, 2019. https://aeon.co/essays/the-fantastic-science-of-turkeys-whiteness-campaign.

Erickson, Amanda. "The Birth of Zoning Codes: A History; Or, How Americans Learned to Legislate Our NIMBY Impulses." *Bloomberg.* June 19, 2012. https://www.bloomberg.com/news/articles/2012-06-19/the-birth-of-zoning-codes-a-history.

Eskilson, Stephen John. "America the Spectacle: Discourses of Color and Light, 1914–1934." PhD dissertation, Brown University, 1995.

Eze, Emmanuel Chukwudi. "The Color of Reason: The Idea of 'Race' in Kant's Anthropology." *Bucknell Review* 38, no. 2 (1995): 200–241.

Farquharson, Alex, ed. *The Magic Hour: The Convergence of Art and Las Vegas.* Graz, Austria: Neue Galerie Graz am Landesmuseum Joanneum, 2001.

"Far Worse Than Hanging: Kemmler's Death Proves an Awful Spectacle; Electric Current Had to Be Turned on Twice Before the Deed Was Fully Accomplished." *New York Times,* August 7, 1890. 1–2.

Ferguson, Bruce "Wordsmith: An Interview with Jenny Holzer," *Art in America* 74, no. 12 (December 1986): 108–15.

"Financier Arrested." *New York Times,* December 12, 1929, p. 1.

Fiske, John. "Surveilling the City: Whiteness, the Black Man, and Democratic Totalitarianism." *Theory, Culture, and Society* 15, no. 2 (May 1998): 67–88.

"Forty Years of Flasher History." *Signs of the Times* 74, no. 1 (May 1933): 15–16.

Fossati, Giovanna, Victoria Jackson, Bregt Lameris, Elif Rongen-Kaynakçi, Sarah Street, and Joshua Yumibe. *The Colour Fantastic: Chromatic Worlds of Silent Cinema.* Amsterdam: Amsterdam University Press, 2018.

Foster, Gwendolyn Audrey. *Performing Whiteness: Postmodern Re/Constructions in the Cinema*. Albany: State University of New York Press, 2003.

Foucault, Michel. *The Archaeology of Knowledge*. Translated by A. M. Sheridan Smith. New York: Pantheon Books, 1972.

———. *Discipline and Punish*. Translated by Alan Sheridan. New York: Pantheon, 1978.

———. *Power/Knowledge: Selected Interviews and Other Writings, 1972–1977*. Edited by Colin Gordon. New York: Vintage Books, 2000.

———. "Truth and Power." In *Power/Knowledge: Selected Interviews and Other Writings 1972–1977*, edited by Colin Gordon, 109–33. New York: Pantheon Books, 1980.

Fowden, Elizabeth Key. "The Parthenon, Pericles, and King Solomon: A Case Study of Ottoman Archaeological Imagination in Greece." *Byzantine and Modern Greek Studies* 42, no. 2 (2018): 261–74. doi:10.1017/byz.2018.8.

Frankenberg, Ruth. *White Women, Race Matters: The Social Construction of Whiteness*. Minneapolis: University of Minnesota Press, 1993.

Freeberg, Ernest. *The Age of Edison: Electric Light and the Invention of Modern America*. New York: Penguin Press, 2013.

Freely, John. *Strolling through Athens: A Guide to the City*. London: Tauris Parke Paperbacks, 2004.

Friedman, Jeff. "Let There Be Neon (New York City)." Interview by Carolyn L. Kane. August 15, 2016.

Friedman, Josh Alan. *Tales of Times Square*. Updated ed. Los Angeles: Feral House; distributed by London: Turnaround, 2007.

Ferguson, Bruce. "Wordsmith: An Interview with Jenny Holzer." *Art in America* 74, no. 12 (December 1986): 108–15, 153.

Gatz, Konrad, and Wilhelm O. Wallenfang, in Collaboration with Werner Piepenburg. *Color in Architecture: A Guide to Exterior Design*. New York: Reinhold, 1961.

Gelder, Lawrence van. "Lights Out for Times Square News Sign?" *New York Times*, December 11, 1994.

Gelernter, David. *1939: The Lost World of the Fair*. New York: Free Press, 1995.

Gelder, Lawrence van. "Lights Out for Times Square News Sign?" *New York Times*, December 11, 1994.

Gilbert, Paul H. "A Living Legend in Lights." *Signs of the Times* 173, no 4 (August 1966).

Gitlin, Todd. *The Sixties: Years of Hope, Days of Rage*. Rev. ed. New York and London: Bantam, 1993.

Giuliani, Rudolph, "New York City's on Top Again: Let's Continue to Get Rid of Graffiti" Archives of Rudolph W. Giuliani (September 21, 1997) URL: http://www.nyc.gov/html/rwg/html/97/me970921.html. Accessed September 25, 2021.

Glueck, Grace. "To Get His Museum's Opening in '92." *New York Times*, October 3, 1989, 15.

Goethe, Johann Wolfgang von. *Theory of Colours* (1810). Translated by C. L. Eastlake. Cambridge, MA: MIT Press, 1970.

"Goodyear Blimp Comes Home as Salesman." *Signs of the Times* 116, no. 1 (May 1947): 40.

"Goodyear Blimp Goes Neon." *Sign of the Times* 115, no. 4 (April 1947): 106.

Gordon, Eric. *The Urban Spectator: American Concept Cities from Kodak to Google*. Lebanon, NH: Dartmouth College Press, 2010.

Gordon, Lewis R. "White Privilege and the Problem with Affirmative Action." In *"I Don't See Color": Personal and Critical Perspectives on White Privilege*, edited by Bettina Bergo and Tracey Nicholls, 25–38. University Park: Pennsylvania State University Press, 2015.

Gorfinkel, Elena. 'Tales of Times Square: Sexploitation's Secret History of Place." In *Taking Place: Location and the Moving Image*, edited by John David Rhodes and Elena Gorfinkel, 55–76. Minneapolis and London: University of Minnesota Press, 2011.

Gray, Christopher. "The Man behind Times Square's Smoke Rings." *New York Times*, October 25, 1998. sec. 11, p. 5.

———. "Steetscapes/50th Street from Broadway to Seventh Avenue: Once the Home of Horses, Now the Home of 'Cats.'" *New York Times*, September 13, 1998.

"The Greatest Event in the History of Outdoor Advertising" (advertisement). *Signs of the Times* 115, no. 2 (February 1947): 127.

Gude, Julian. "O. J. Gude and Me." Julians.name. December 18, 2005. https://julians.name/2005/12/18/oj-gude-and-me/.

Gude, O. J. "Art and Advertising Joined by Electricity." *Signs of the Times* 19, no. 79 (November 1912): 3.

———. "10-Minute Talk on Outdoor Advertising." *Signs of the Times* (June 1912): 77.

A Guide to Exterior Design (New York: Reinhold, 1961).

Gunning, Tom, Joshua Yumibe, Giovanna Fossati, and Jonathon Rosen. *Fantasia of Color in Early Cinema*. Amsterdam: EYE Filmmuseum; Amsterdam University Press, 2015.

Hale, Grace Elizabeth. *Making Whiteness: The Culture of Segregation in the South, 1890–1940*. New York: Vintage Books, 1998.

Hammer, Ivo. "White, Everything White? Josef Frank's Villa Beer (1930) in Vienna, and Its Materiality in the Context of the Discourse on 'White Cubes.'" *Built Heritage* 4, no. 2 (2020): 1–16.

Harris, Cheryl I. "Whiteness as Property." *Harvard Law Review* 106 no. 8 (1993): 1707–91.

Hart, David Bentley. "Why Do People Believe in Hell?" *New York Times*, January 10, 2020. https://www.nytimes.com/2020/01/10/opinion/sunday/christianity-religion-hell-bible.html

Harvey, David. *The Condition of Postmodernity*. 1990. Reprinted, Cambridge, MA: Blackwell, 2000.

Harris, Dianne Suzette. *Little White Houses: How the Postwar Home Constructed Race in America*. Minneapolis: University of Minnesota Press, 2013.

Haskin, Pamela. "'Saul, Can You Make Me a Title?': Interview with Saul Bass." *Film Quarterly* (Archive) 50, no. 1 (1996): 10–17. doi:10.2307/1213323.

Heidegger, Martin. *Basic Writings: From Being and Time (1927) to The Task of Thinking (1964)*. Edited by David Farrell Krell. Translated by John Sallis. New York: Harper & Row, 1977.

———. "The Age of the World Picture" (1954). In *The Question Concerning Technology and Other Essays*, edited by William Lovitt, 115–54. New York: Garland, 1977.

———. *Ponderings II–VI: Black Notebooks, 1931–1938*. Translated by Richard Rojcewicz. Bloomington: Indiana University Press, 2016.

Hibben, Samuel G. "The Growth of Ornamental Street Lighting." *Good Lighting* 7, no. 2 (April 1912): 82–84.

Hippocrates. "Airs, Waters, Places." In *Ancient Medicine; Airs, Waters, Places; Epidemics 1 and 3; The Oath; Precepts; Nutriment*. Translated by W. H. S. Jones. Loeb Classical Library 147. Cambridge, MA: Harvard University Press, 1923.

———. *On Airs, Waters, and Places*. Translated by Francis Adams. London: 1849. The Internet Classics Archive. http://classics.mit.edu/Hippocrates/airwatpl.mb.txt.

"The HIV/AIDS Epidemic in the United States: The Basics." *Kaiser Family Foundation*. March 25, 2019. https://www.kff.org/hivaids/fact-sheet/the-hivaids-epidemic-in-the-united-states-the-basics/.

Hodne, Lasse. "Winckelmann's Depreciation of Colour in Light of the *Querelle du coloris* and Recent Critique." *Journal of Art History* 89, no. 3 (July 2020): 191–210.

Holliday, S. N. "Through the Years." *Signs of the Times* (May 1931).

Horak, Jan-Christopher. *Saul Bass: Anatomy of Film Design*. Lexington: University Press of Kentucky, 2014.

Hughes, Gordon. "Power's Script; Or, Jenny Holzer's Art after 'Art after Philosophy.'" *Oxford Art Journal* 29, no. 3 (2006): 419–40.

Ibáñez Estévez, Juan José, Jesus González-Urquijo, Luis Cesar Teira Maylolini, and Talia Lazuén. "The Emergence of the Neolithic in the Near East: A Protracted and Multi-regional Model." *Quaternary International* 470 (March 2018): 226–52.

"The Illuminated Sign That Stopped Broadway in Its Tracks." *Star and Lamp* 24, no. 10 (January 1938): 2–4.

"Inventing Entertainment: The Early Motion Pictures and Sound Recordings of the Edison Companies." Library of Congress. Accessed January 7, 2023, https://www.loc.gov/collections/edison-company-motion-pictures-and-sound-recordings/articles-and-essays/biography/life-of-thomas-alva-edison/.

Irving, Debby. *Waking Up White and Finding Myself in the Story of Race*. Cambridge, MA: Elephant Room Press, 2014.

Isenstadt, Sandy. *Electric Light: An Architectural History*. Cambridge, MA: MIT Press, 2019.

———. "The Spaces of Shopping." In *The Material Culture of Shopping*, edited by Deborah Andrews, 1–32. Newark: University of Delaware Press, 2014.

Isenstadt, Sandy, Margaret Maile Petty, and Dietrich Neumann. *Cities of Light: Two Centuries of Urban Illumination*. London: Routledge, 2015.

Jacobs, Jane. *The Death and Life of Great American Cities*. 50th Anniversary edition. Introduction by Jason Epstein. New York: Modern Library, 2011.

Jacobson, Matthew Frye. *Whiteness of a Different Color: European Immigrants and the Alchemy of Race*. Cambridge, MA: Harvard University Press, 1998.

"Jacob Starr, 87, President of Artkraft Strauss, Is Dead." *New York Times*, May 24, 1976. 31.

Jameson, Fredric. *Postmodernism; or, The Cultural Logic of Late Capitalism*. Durham, NC: Duke University Press, 1991.

Janneau, Guillaume. "L'Exposition des arts techniques de 1925." *Le Bulletin de la Vie Artistique*, February 1, 1923. 64–58.

Jeanneret, Charles-Édouard. "Charles-Édouard Jenneret to William Ritter," November 1, 1911. In *Le Corbusier: A Life*, by Nicholas Fox Weber. New York: Alfred A. Knopf, 2008.

———. "Quelques Impressions." *La Feuille d'Avis de La Chaux-de-Fonds*, July 20, 1911.

Jeanneret, Charles-Édouard, and Amédée Ozenfant. *Après le Cubisme* (1918). Paris: Altamira, 1999.

Jenkins, W. C. "The 'Signs' of the Times." *National Magazine* 34, no. 1 (May 1911): 153–60.

Jones, Francis Arthur. "The Most Wonderful Electric Sign in the World, and How It Is Worked." *Strand Magazine* 42, no. 250 (October 1911): 443–48.

Jones, Leisha. "'Being Alone with Yourself Is Increasingly Unpopular': The Electronic Poetry of Jenny Holzer." *Journal of Narrative Theory* 48, no. 3 (2018): 423–51.

Jonnes, Jill. *Empires of Light: Edison, Tesla, Westinghouse, and the Race to Electrify the World*. New York: Random House, 2004.

Joselit, David, Joan Simon, Renata Salecl, and Jenny Holzer. *Jenny Holzer*. London: Phaidon Press, 1998.

Josephson, Matthew. *Edison: A Biography*. New York: John Wiley & Sons, 1959.

Kaempffert, Waldemar. *Ornamental Street-Lighting: A Municipal Investment and Its Return*. Cleveland, OH: National Electric Light Association, 1912.

Kahn, E. J. "Lights, Lights, Lights." *New Yorker*, June 7, 1941, pp. 24–25.

Kalaidjian, Walter. "Mainlining Postmodernism: Jenny Holzer, Barbara Kruger, and the Art of Intervention." *Postmodern Culture* 2, no. 3 (1992). doi:10.1353/pmc.1992.0021.

Kane, Carolyn L. *High-Tech Trash: Glitch, Noise, and Aesthetic Failure*. Oakland: University of California Press, 2019.

———. "Broken Color in a Modern World: Chromatic Failures in Purist Art and Architecture." *Journal of the International Colour Association* 14 (2015): 1–13.

———. *Chromatic Algorithms: Synthetic Color, Computer Art, and Aesthetics after Code*. Chicago: University of Chicago Press, 2014.

Kantack, Walter W. "A Study of Fine Lighting Today." *Art and Decoration* 35, no. 4 (August 1931): 48–49.

Kant, Immanuel. *Anthropology from a Pragmatic Point of View* (1772–96). Translated by Victor Lyle Dowdell. Carbondale: Southern Illinois University Press, 1978.

———. *The Critique of Judgement* (1790). Translated with analytical indexes by James Creed Meredith. Oxford: Clarendon Press, 1973.

———. *Critique of Judgment* (1790). Translated with an introduction by Werner S. Pluhar. Indianapolis: Hackett, 1987.

———. "On the Different Races of Man." In *Race and the Enlightenment: A Reader*, edited by Emmanuel Chukwudi Eze, 48. Cambridge: Blackwell, 1997.

Katz, Yarden. *Artificial Whiteness: Politics and Ideology in Artificial Intelligence*. New York: Columbia University Press, 2020.

Kelley, Tina. "A Museum to Visit from an Armchair: P.T. Barnum's Circus Archive Is Re-created for Web Browsers." *New York Times*, July 1, 2000, p. B5.

"Kemmler's Last Night: To Die in the Early Hours of This Morning; Witnesses to Be in the Prison at Daybreak—The Apparatus Ready and the Murderer Prepared." *New York Times*, August 6, 1890, p. 1.

Kirkham, Pat. "Bright Lights, Big City." *Sight & Sound* 6 (January 1996): 12.

Kittler, Friedrich. *Gramophone, Film, Typewriter*. Translated by Geoffrey Winthrop-Young and Michael Wutz. Stanford, CA: Stanford University Press, 1999.

Knight, David. *Ideas in Chemistry: A History of the Science*. London: Athlone Press, 2000.

Kracauer, Siegfried. *The Mass Ornament: Weimar Essays*. Edited and translated by Thomas Y. Levin. Cambridge, MA: Harvard University Press, 1995.

Krajewski, Markus. "The Great Lightbulb Conspiracy." *IEEE Spectrum* 51, no. 10 (September 2014): 56–61. https://spectrum.ieee.org/tech-history/dawn-of-electronics/the-great-lightbulb-conspiracy.

Lam, William M.C. *Perception and Lighting as Formgivers for Architecture*. New York: McGraw-Hill, 1977.

Landis, Bill, and Michelle Clifford. *Sleazoid Express: A Mind-Twisting Tour through the Grindhouse Cinema of Times Square*. New York: Simon & Schuster, 2002.

Le Corbusier. *L'Art Décoratif D'aujourd'hui*. Paris: Editions Crès, 1925. Translated by James Dunnett as *The Decorative Art of Today*. Cambridge, MA: MIT Press, 1987).

———. "Notes a la suite." *Cahiers d'art* 3 (1926): 46–52.

———. *Towards a New Architecture*. London: Architectural Press, 1927. Originally published as *Vers Une Architecture*. Paris: Editions Crès, 1923.

———. *Le Voyage d'Orient* (1966). Translated by Ivan Žaknić as *Journey to the East*. Cambridge: MIT Press, 1987.

———. *When the Cathedrals Were White*. Translated by Francis E. Hyslop Jr. New York: McGraw-Hill, 1964.

Le Corbusier and Amédée Ozenfant. (1964) 2000. "Purism." In *Modern Artists on Art*, edited by Robert L. Herbert, 52–65. New York: Dover.

Leach, William. *Land of Desire: Merchants, Power, and the Rise of a New American Culture*. New York: Pantheon Books, 1993.

Lears, T.J. Jackson. *Fables of Abundance: A Cultural History of Advertising in America*. New York: BasicBooks, 1994.

———. *No Place of Grace: Antimodernism and the Transformation of American Culture, 1880–1920*. New York: Pantheon Books, 1981.

Leigh, Douglas. "This Business of Selling Big Spectaculars." *Signs of the Times* 78, no. 4 (December 1934): 18.

"Leigh-Epok." *Tide*, August 15, 1937, pp. 28–29.

"Leigh Is Re-elected." *New York Times*, January 18, 1964, p. 26.

"Leigh's Biggest." *New Yorker*, August 7, 1937, p. 10.

Levy, Caryl Christian. "Las Vegas as Public Art." Master's thesis, University of Southern California, 1994. ProQuest Dissertations Publishing (EP58308).

Lichtenstein, Jacqueline. *The Eloquence of Color: Rhetoric and Painting in the French Classical Age*. Translated by Emily McVarish. Berkeley: University of California Press, 1993.

"Lighting a Revolution." Smithsonian National Museum of American History. Accessed January 7, 2023, https://americanhistory.si.edu/lighting/.

Linton, Harold. *Color in Architecture: Design Methods for Buildings, Interiors, and Urban Spaces*. New York: McGraw-Hill, 1990.

Lippit, Akira Mizuta. *Atomic Light (Shadow Optics)*. Minneapolis: University of Minnesota Press, 2005.

Lipsitz, George. *How Racism Takes Place*. Philadelphia: Temple University Press, 2011.

———. *The Possessive Investment in Whiteness*. Philadelphia: Temple University Press, 2006.

Little, David. "Colab Takes a Piece, History Takes It Back: Collectivity and New York Alternative Spaces." *Art Journal* 66, no. 1 (2007): 60–74.

Livingstone, David N., and Anne Godlewska. *The Geographical Tradition: Episodes in the History of a Contested Enterprise*. Oxford: Blackwell, 1992.

Lloyd, David. "Race under Representation." *Oxford Literary Review* 13, no. 1 (1991): 62–94.

Long, Kat. *The Forbidden Apple: A Century of Sex and Sin in New York City*. Brooklyn, NY: Ig Pub, 2009.

Luckiesh, Matthew. "A Half-Century of Artificial Lighting." *Industrial and Engineering Chemistry* 18, no. 9 (1926): 920–22.

Madoff, Steven Henry. "Jenny Holzer Talks to Steven Henry Madoff." *Artforum International* 41, no. 8 (April 2003): 82–83, 238.

Major, Mark, Johnathan Spiers, and Anthony Tischhauser. *Made of Light: The Art of Light and Architecture*. Basel: Birkhäuser, 2005.

"The Man Who Lights Up the Great White Way." *Signs of the Times*, 20, no. 85 (May 1913): 14, 34, 37.

Marconi, Clemente, and Deborah Steiner. *The Oxford Handbook of Greek and Roman Art and Architecture*. New York: Oxford University Press, 2015.

Martin, Douglas. "Douglas Leigh, the Man Who Lit Up Broadway, Dies at 92." *New York Times*, December 16, 1999, A1, B1.

Marvin, Carolyn. "The Electric Light as a Communications Medium." In *Imagining Tomorrow, History, Technology, and the American Future*, edited by Joseph Com, 202–17. Cambridge, MA: MIT Press, 1986.

Marx, Karl. "The Fetishism of the Commodity of its Secret." In *Capital, Volume 1: A Critique of Political Economy* (1867), translated by Ben Fowkes. London: Penguin, 1976.

Mattern, Shannon Christine. *Code and Clay, Data and Dirt: Five Thousand Years of Urban Media*. Minneapolis: University of Minnesota Press, 2017.

McCown, James. *Colors: Architecture in Detail*. Edited by Oscar Riera Ojeda. Gloucester: Rockport, 2004.

McDonald, Timothy B. "Signage: Neon and Other Technologies." *Architecture* 77 (1988): 126–28.

McFarland, J. Horace. "Why Billboard Advertising as at Present Conducted is Doomed." *Chautauquan* 51 (June–August 1908): 19–46.

McIntosh, Peggy. *White Privilege and Male Privilege: A Personal Account of Coming to See Correspondences through Work in Women's Studies*. Wellesley, MA: Wellesley College, Center for Research on Women, 1988.

McKendry, Joe. *One Times Square: A Century of Change at the Crossroads of the World*. Jaffrey, NH: David R. Godine, 2012.

McKinney, Karyn D. *Being White: Stories of Race and Racism*. New York: Routledge, 2005.

McNearney, Allison "The Times Square Pro-Choice Art Piece That Was Censored, but Not Forgotten." *Daily Beast*, January 20, 2019. https://www.thedailybeast.com/the-times-square-pro-choice-art-piece-that-was-censored-but-not-forgotten.

Melville, Herman. *Moby Dick*. London: Richard Bently, 1851. Available at Lit2Go. Accessed January 7, 2023. https://etc.usf.edu/lit2go/42/moby-dick/702/chapter-42-the-whiteness-of-the-whale/.

Menkman, Rosa. "Behind the White Shadows of Image Processing: Shirley, Lena, Jennifer, and the Angel of History." In *Faceless: Re-inventing Privacy through Subversive Media Strategies*, edited by Bogomir Doringer and Brigitte Felderer, 160–80. Berlin: De Gruyter, 2018.

Melzer, Zach. "Screen Clusters: Urban Renewal, Architectural Preservation, and the Infrastructures of Urban Media." PhD dissertation, Concordia University, 2020.

"M&M's Caramel Launch Celebrated in Times Square." *PR Newswire*, May 11, 2017. https://www.prnewswire.com/news-releases/mms-caramel-launch-celebrated-in-times-square-300456459.html.

Michaud, Eric. "Barbarian Invasions and the Racialization of Art History." *October*, January 1, 2012, pp. 59–76.

Miller, Samuel C. *Neon Techniques and Handling*. Edited by Edwards R. Samuels. Cincinnati: Signs of the Times, 1977.

Mirzoeff, Nicholas. *White Sight: Visual Politics and Practices of Whiteness*. Cambridge, MA: MIT Press, 2023.

Misek, Richard. *Chromatic Cinema: A History of Screen Colour*. Chichester, UK: Wiley-Blackwell, 2010.

"More Promotion—More Business." *Signs of the Times* 89, no. 4 (August 1938): 11–12.

Morrison, Toni. *Playing in the Dark: Whiteness and the Literary Imagination*. 1993. Reprinted, New York: Vintage Books 2015.

"Moving Signs along Broadway." *Edison Monthly* 4, no. 7 (December 1911): 225–27.

"Mrs. Douglas Leigh: Wife of Maker of Spectacular Electric Signs Was 22." *New York Times*, November 27, 1941, p. 23.

Mulvin, Dylan. *Proxies: The Cultural Work of Standing In*. Cambridge, MA: MIT Press, 2021.

Mumford, Lewis. *The Culture of Cities*. New York: Harcourt Brace Jovanovich, 1938.

Munson, Richard. *From Edison to Enron: The Business of Power and What It Means for the Future of Electricity*. Westport, CT: Praeger, 2005.

Neale, Stephen. *Cinema and Technology: Image, Sound, Colour*. Bloomington: Indiana University Press, 1985.

"Neon Converts to 'Plastilux 500.'" *New York Times*, May 30, 1950, p. 28.

Neumann, Dietrich, ed. *Architecture of the Night: The Illuminated Building*. Munich: Prestel, 2002.

"The New Age of Color." *Saturday Evening Post*, January 21, 1928, p. 22.

"New Designs for Street Lighting Units." *Municipal Engineering* 49, no. 6 (December 1915): 224.

"A New Incandescent Light: A German Electrician's Invention." *New York Times*, April 30, 1882, p. 2.

Newton, Isaac. *Opticks; Or, a Treatise of the Reflexions, Refractions, Inflexions and Colours of Light*. London: Smith & Walford, 1704.

Nietzsche, Friedrich. (1872) 1993. *The Birth of Tragedy: Out of the Spirit of Music*. Edited by Michael Tanner. Translated by Shaun Whiteside. London: Penguin Books.

———. *The Birth of Tragedy and Other Writings*. Translated by Raymond Geuss and Ronald Speirs. Cambridge: Cambridge University Press, 2011.

———. *On the Genealogy of Morals* (1887). Translated by Walter Kaufmann. New York: Vintage Books, 1989.

Nissim-Sabat, Marilyn. "Revisioning 'White Privilege.'" In *"I Don't See Color": Personal and Critical Perspectives on White Privilege*, edited by Bettina Bergo and Tracey Nicholls, 39-52. University Park: Penn State University Press, 2015.

Noble, David F. *America by Design: Science, Technology, and the Rise of Corporate Capitalism*. New York: Alfred A. Knopf, 1977.

Novakov, Anna, "The Artist as Social Commentator: A Critical Study of the Spectacolor Lightboard Series 'Messages to the Public.'" PhD dissertation, New York University, 1993.

NYC Planning Zoning Resolution. "81-732: Special Times Square Signage Requirements." City of New York. Last amended February 2, 2011. https://zr.planning.nyc.gov/article-viii/chapter-1/81-732.

Nye, David E. *American Illuminations: Urban Lighting, 1800–1920*. Cambridge, MA: MIT Press, 2018.

———. *The American Technological Sublime*. Cambridge, MA: MIT Press, 1994.

———. *Electrifying America: Social Meanings of a New Technology, 1880–1940*. Cambridge, MA: MIT Press, 1990.

———. *Image Worlds: Corporate Identities at General Electric, 1890-1930*. Cambridge, MA: MIT Press, 1985.

Oatman-Stanford, Hunter. "Let There Be Light Bulbs: How Incandescents Became the Icons of Innovation." *Collectors Weekly*, July 16, 2015. https://www.collectorsweekly.com/articles/let-there-be-light-bulbs/.

"Old Gold Spectacular Provides New Free Show on Broadway." *Signs of the Times* (August 1938): 13–14.

Ornamental Street-Lighting: A Municipal Investment and Its Return. New York: National Electric Light Association, 1912.

"Our 'White Way.'" *Los Angeles Times*, November 24, 1910. II4.

"Outdoor Advertising Timeline: 1850–1899." Duke University Digital Archives. Accessed October 4, 2021. https://blogs.library.duke.edu/digital-collections/road/timeline/1850-1899/.

Osdene, Stefan. "American Neon Signs: Illumination and Consumerism." PhD dissertation, University of Wisconsin–Madison, 2014.

Ozenfant, Amédée, and Pierre Jeanneret. *L'Esprit Nouveau* (October 1920).

Pascucci, Ernest. "Whiteness: White Forms, Forms of Whiteness." *ANY: Architecture New York*, no. 16 (November 1996): 14–15.

Pavia, Will. "How Could I Be on Twitter? I Have Watercolours to Attend to, Man." *Times* (London), April 2, 2018. https://www.thetimes.co.uk/article/jenny-holzer-how-could-i-be-on-twitter-i-have-watercolours-to-attend-to-man-sogg58r9t.

Petty, Margaret Maile. "Cultures of Light: Electric Light in the United States, 1890s-1950s." PhD dissertation, Victoria University of Wellington, 2016.

Plato. *The Collected Dialogues of Plato.* Edited by Edith Hamilton and Huntington Cairns. Translated by Lane Cooper. New York: Pantheon Books, 1961.

———. *The Republic.* Translated by Allan Bloom. New York: Basic Books, 1968.

Porter, Charlie, "The Next Fashion Collaboration: Off-White and Jenny Holzer." *Financial Times*, June 16, 2017. https://www.ft.com/content/b3315e22-52b9-11e7-a1f2-db19572361bb.

Porter, Tom. *Architectural Color: A Design Guide to Using Color on Buildings.* New York: Whitney Library of Design, 1982.

———. *Colour Outside.* London: Architectural Press, 1982.

Porter, Tom, and Byron Mikellides, eds. *Color for Architecture.* New York: Van Nostrand Reinhold, 1976.

Porter, Tom, and Byron Mikellides, eds. *Colour for Architecture Today.* London: Taylor & Francis, 2009.

Purdy, Daniel. "The Whiteness of Beauty: Weimar Neo-Classicism and the Sculptural Transcendence of Color." In *Colors 1800/1900/2000: Signs of Ethnic Difference*, edited by Birgit Tautz, 83–99. Amsterdam: Editions Rodopi, 2004.

Reich, Leonard S. "Lighting the Path to Profit: GE's Control of the Electric Lamp Industry, 1892–1941." *Business History Review* 66, no. 2 (Summer 1992): 305–34.

"Report of the Sentencing Project to the United Nations Human Rights Committee Regarding Racial Disparities in the United States Criminal Justice System." Sentencing Project. August 2013. http://sentencingproject.org/wp-content/uploads/2015/12/Race-and-Justice-Shadow-Report-ICCPR.pdf.

Ribbat, Christoph. *Flickering Light: A History of Neon*. London: Reaktion Books, 2011.

Riley, Charles A. *Color Codes: Modern Theories of Color in Philosophy, Painting and Architecture, Literature, Music, and Psychology*. Hanover, NH: University Press of New England, 1994.

Rinaldi, Thomas E. *New York Neon*. New York: W. W. Norton, 2012.

Rochlin, Robert. "Bringing Advertising to Life." *Cornell Engineer* 7, no. 1 (October 1941): 10–11, 22.

Roediger, David R. *The Wages of Whiteness: Race and the Making of the American Working Class*. London: Verso, 1991.

Rogers-Lafferty, Sarah. *Jenny Holzer and Cindy Sherman: Personae*. Cincinnati: Contemporary Arts Center, 1986.

Rossell, Edward Graham Daves. "Compelling Vision: From Electric Light to Illuminating Engineering, 1880–1940." PhD dissertation, University of California, Berkeley, 1998.

Roth, Lorna. "Looking at Shirley, the Ultimate Norm: Colour Balance, Image Technologies, and Cognitive Equity." *Canadian Journal of Communication* 34 (2009): 111–36.

Sagalyn, Lynne B. *Times Square Roulette: Remaking the City Icon*. Cambridge, MA: MIT Press, 2003.

Said, Edward W. *Culture and Imperialism*. 1993. Reprinted, New York: Vintage Books, 2012.

Saxon, A. H. "P. T. Barnum and the American Museum." *Wilson Quarterly* 13 (1989): 130–39.

Scavuzzo, Giuseppina. "Compositions for Chromatic Keyboards: Colour and Composition in Le Corbusier's Works." *Colour and Light in Architecture: First International Conference Proceedings* (2010): 432–38.

Schivelbusch, Wolfgang. *Disenchanted Night: The Industrialization of Light in the Nineteenth Century*. Translated by Angela Davies. Oxford: Berg, 1988.

Schultze, Quentin J. "Legislating Morality: The Progressive Response to American Outdoor Advertising 1900-1917." *Journal of Popular Culture* 17, no. 4 (Spring 1984): 37-44.

Sconce, Jeffrey. "Trashing the Academy." *Screen* 36, no. 4 (Winter 1995): 371–93.

Sebastian, Virginia. "Add Pendulum and Chimes to Gillette Spectacular." *Signs of the Times* 92, no. 2 (June 1939): 55–56.

———. "Along Broadway," *Signs of the Times* 109, no. 4 (April 1945): 65.

———. "Along Broadway," *Signs of the Times* 110, no. 1 (May 1945): 61.

———. "Along Broadway," *Signs of the Times* 110, no. 3 (July 1945): 61.

———. "Along Broadway," *Signs of the Times* 111, no. 2 (October 1945): 61.

———. "Along Broadway," *Signs of the Times* 112, no. 1 (January 1946): 95.

———. "Along Broadway," *Signs of the Times* 113, no. 3 (July 1946): 109.

———. "Along Broadway," *Signs of the Times* 114, no. 3 (November 1946): 104.

———. "Along Broadway," *Signs of the Times* 115, no. 2 (February 1947): 126.

———. "Along Broadway," *Signs of the Times* 115, no. 4 (April 1947): 119.
———. "Along Broadway," *Signs of the Times* 117, no. 3 (November 1947): 119.
———. "Along Broadway," *Signs of the Times* 118, no. 4 (April 1948): 122.
———. "Along Broadway," *Signs of the Times* 119, no. 1 (May 1948): 166.
———. "Along Broadway," *Signs of the Times* 119, no. 2 (June 1948): 81.
———. "Along Broadway," *Signs of the Times* 119, no. 3 (July 1948): 89.
———. "Along Broadway," *Signs of the Times* 120, no. 1 (September 1948): 121.
———. "Along Broadway," *Signs of the Times* 123, no. 3 (November 1949): 94
———. "Along Broadway," *Signs of the Times* 127, no. 3 (March 1951): 94.
———. "Along Broadway," *Signs of the Times* 133, no. 2 (February 1953): 93.
———. "Along Broadway," *Signs of the Times* 137, no. 2 (June 1954): 119.
———. "Along Broadway," *Signs of the Times* 140, no. 2 (June 1955): 96.
Sellmer, Robert. "Douglas Leigh." *Life Magazine* 20, no. 13 (April 1, 1946): 47–51.
Simmel, Georg. "The Metropolis and Mental Life." In *The Blackwell City Reader*, 2nd ed., edited by Gary Bridge and Sophie Watson, 103–11. Oxford: Wiley Blackwell, 2002.
Singer, Ben. *Melodrama and Modernity: Early Sensational Cinema and Its Contexts*. New York: Columbia University Press, 2001.
Skelton, Helen. "A Colour Chemist's History of Western Art." *Review of Progress in Coloration and Related Topics* 29, no. 1 (1999): 43–64.
Solon, Léon Victor. *Polychromy: Architectural and Structural—Theory and Practice*. New York: Architectural Record, 1924.
———. "Side-Lights on Architectural Polychromy." *Pennsylvania Academy Summer School* (1922): 83–84.
Solway, Diane "The Story behind Virgil Abloh and Jenny Holzer's Potent, Political Off-White Show at Pitti Uomo." *W Magazine,* June 16, 2017. https://www.wmagazine.com/story/virgil-abloh-jenny-holzer-off-white-spring-2018-mens-pitti-uomo/.
Spielvogel, Carl. "Takes 'White Way' to Reach the Top." *New York Times*, August 9, 1953. 1, 3.
Stallings, Tyler. *Whiteness, a Wayward Construction*. Laguna Beach, CA: Laguna Art Museum, 2003.
Starr, Tama, and Ed Hayman. *Signs and Wonders*. New York: Currency/Doubleday, 1998.
Stern, Rudi. *Let There Be Neon*. New York: Abrams, 1979.
Spivak, Gayatri Chakravorty. "Can the Subaltern Speak?" in *Marxism and the Interpretation of Culture*, edited by Cary Nelson and Larry Grossberg. London: Macmillan, 1988.
Steiner, Rochelle Elayne. "Framing Words: Visual Language in Contemporary Art." PhD dissertation, University of Rochester, 1996. ProQuest Dissertations Publishing.
Street, Sarah, and Joshua Yumibe. *Chromatic Modernity: Color Cinema and Media of the 1920s*. New York: Columbia University Press, 2019.

Summitt, James Bruce. "Greek Architectural Polychromy from the Seventh to Second Centuries B.C.: History and Significance." PhD dissertation, University of Michigan, 2000.

Talbot, Margaret. "The Myth of Whiteness in Classical Sculpture." *New Yorker*, October 22, 2018. https://www.newyorker.com/magazine/2018/10/29/the-myth-of-whiteness-in-classical-sculpture.

"The Talking Sign." *Electrical Review and Western Electrician* 59, no. 3 (July 15, 1911): 140.

Tardon, Raphael. "Richard Wright Tells Us: The White Problem in the United States." In *Conversations with Richard Wright*, edited by Keneth Kinnamon and Michel Fabre. Jackson: University Press of Mississippi, 1993.

Taussig, Michael. *What Color Is the Sacred?* Chicago: University of Chicago Press, 2009.

Taylor, William R., ed. *Inventing Times Square: Commerce and Culture at the Crossroads of the World.* 1991. Reprinted, Baltimore: Johns Hopkins University Press, 1996.

Tell, Darcy. *Times Square Spectacular: Lighting Up Broadway.* Collins, NY: Smithsonian Books, 2007.

Thompson, Hunter S. *Fear and Loathing in Las Vegas: A Savage Journey to the Heart of the American Dream.* 1971. Reprinted, New York: Vintage Books, 1998.

Thompson, Kirsten Moana. "Rainbow Ravine: Colour and Animated Advertising in Times Square." In *The Colour Fantastic: Chromatic Worlds of Silent Cinema,* edited by G. Fossati, V. Jackson, B. Lameris, E. Rongen-Kaynakçi, S. Street, and J. Yumibe, 161–77. Amsterdam: Amsterdam University Press, 2018.

Thompson, Krista A. *Shine: The Visual Economy of Light in African Diasporic Aesthetic Practice.* Durham, NC: Duke University Press, 2015.

"Times Sq. Will Get Malls of Flowers." *New York Times*, March 3, 1964, p. 70.

"Times Tower Sold or Exhibit Hall: Douglas Leigh Buys 24-Story Building in the Square." *New York Times*, March 16, 1961, pp. 1, 31.

Tocqueville, Alexis de. *Democracy in America.* Vol. 1. Hauppauge, NY: Nova Science, 2019.

"Tomorrow's Weather." *Signs of the Times* 91, no. 2 (February 1939): 84.

Toy, Maggie. *Colour in Architecture.* London: Academy Editions, 1996.

Traub, James. *The Devil's Playground: A Century of Pleasure and Profit in Times Square.* New York: Random House, 2004.

"Triumphant Industries: The General Electric Company," *Forum* 14 (February 18, 1893): 7–8.

"Truth and Reconciliation Commission of Canada." Government of Canada. February 19, 2019. https://www.rcaanc-cirnac.gc.ca/eng/1450124405592/1529106060525.

"Two Spectaculars in the Making." *Signs of the Times* 89, no. 3 (July 1938): 28–30.

"Tydol Now Using Leigh Blimp." *Signs of the Times* 115, no. 4 (April 1947): 123.

Ulmer, Bruno, and Thomas Plaichinger. *Les Escritures De La Nuit: Un Siecle D'Illuminations Et De Publicite Lumineuse.* Paris: Syros-Alternatives, 1987.

"The Value of Good Lighting." *Municipal Engineering* 43, no. 5 (November 1912): 318–21.

Van Riper, Frank. "Ford to New York: Drop Dead." *New York Daily News*, October 30, 1975.

Venturi, Robert, Denise Scott Brown, and Steven Izenour. *Learning from Las Vegas*. 1972. Reprinted, Cambridge, MA: MIT Press, 2017.

Vitruvius. *Ten Books on Architecture*. Translated by Ingrid D. Rowland. Cambridge: Cambridge University Press, 1999.

Waldman, Diane. *Jenny Holzer: New York—Solomon R. Guggenheim Museum*. New York: Harry N. Abrams, 1989.

"Watts in a Name." *Edison Monthly* 13, no. 4 (April 1920): 68–70.

Weigel, Margaret. "The Commoditable Block Party: Electric Signs in Manhattan, 1881–1917." MS thesis, Massachusetts Institute of Technology, 2002.

Whiting, Frederic A. "The Minister Militant." *Chautauquan* (June 1908): 59–60.

Wigley, Mark. "Chronic Whiteness." e-flux Architecture: Sick Architecture. November 2020. https://www.e-flux.com/architecture/sick-architecture /360099/chronic-whiteness/.

———. *White Walls, Designer Dresses: The Fashioning of Modern Architecture*. Cambridge, MA: MIT Press, 1995.

Wildman, Stephanie M., and Adrienne D. Davis. "Making Systems of Privilege Visible." In *Critical White Studies: Looking behind the Mirror*, edited by Richard Delgado and Jean Stefancic, 314–19. Philadelphia: Temple University Press, 1997.

Wilkerson, Isabel. *Caste: The Origins of Our Discontents*. New York: Random House, 2020.

Wiggs, Janey L. "Color Vision." In *Ophthalmology*, edited by Myron Yanoff and Jay S. Duker, 181–202. St. Louis, MO: Mosby, 2000.

Winchell, Walter. "On Broadway." *Daily Mirror*, 1935, n.p.

Winckelmann, Johann Joachim. *The History of Ancient Art*. 4 vols. Boston: Little, Brown, & Company, 1856.

Winckelmann, Johann Joachim, and Alex Potts. *History of the Art of Antiquity*. Los Angeles: Getty Research Institute, 2006.

Wittgenstein, Ludwig. *Remarks on Colour*. Edited by G.E.M. Anscombe. Translated by Linda L. McAlister and Margarete Schättle. Berkeley: University of California Press, 1977.

Wolfe, Tom. "Electrographic Architecture." *Architectural Design* 7 (1969): 379–82.

———. "Las Vegas (What?) Las Vegas (Can't Hear You! Too Noisy) Las Vegas!!!" *Esquire* 61, no. 2 (1964) n/p.

Wong, Tracy. "Sign Makers of the Starrs." *Sign Builder Illustrated* (February 2003): 73–80.

Wood, L.A.S. "Ornamental Street Lighting." *Municipal and County Engineering* 61, no. 6 (December 1921): 208.

Woodruff, Clinton Rogers, ed. "The Billboard Nuisance." *American Civic Association, Department of Nuisances* (Philadelphia) 2, no. 2 (June 1908).

"The World's Largest Spectacular." *Signs of the Times* 82, no. 4 (April 1936): 7–9.

Wrigley's Chewing Gum. Advertisement. *New York Herald*, April 29, 1920. 6.

Wu, Lida Z. "Fabricating Images at the Color Factory." *Frames Cinema Journal*. Issue 17. Accessed May 2, 2021. https://ojs.st-andrews.ac.uk/index.php/FCJ/article/view/2074.

Xenophon. *Memorabilia; Oeconomicus; Symposium; Apology*. Translated by E. C. Marchant and O. J. Todd. Revised by Jeffrey Henderson. Loeb Classical Library 168. Cambridge, MA: Harvard University Press, 2013.

Yancy, George. "Whiteness as Insidious: On the Embedded and Opaque White Racist Self." In *I Don't See Color: Personal and Critical Perspectives on White Privilege*, edited by Bettina Bergo and Tracey Nicholls, 103–118. University Park: Pennsylvania State University Press, 2015.

YESCO (Young Electric Sign Company). *A Legacy of Light: The History of Young Electric Sign Company*. Salt Lake City: Modern8, 2001.

Yue, Genevieve. "The China Girl on the Margins of Film." *MIT Press Direct* 153 (2015): 96–116.

Yumibe, Joshua. *Moving Color: Early Film Mass Culture Modernism*. New Brunswick, NJ: Rutgers University Press, 2012.

———. "Fabricating Images at the Color Factory." In "The Politics of Colour Media," edited by Kirsty Sinclair Dootson. Special issue, *Frames Cinema Journal* 17 (Summer 2020).

Zemplén, Gábor Áron. *The History of Vision, Colour, and Light Theories*. Bern: Bern Studies in the History and Philosophy of Science, 2005.

Zielinski, Siegfried. *Deep Time of the Media: Toward an Archaeology of Hearing and Seeing by Technical Means*. Translated by Gloria Custance. Cambridge, MA: MIT Press, 2006.

Index

Page numbers in *italics* refer to illustrations.